25 HOUSES

UNDER 3000 SQUARE FEET

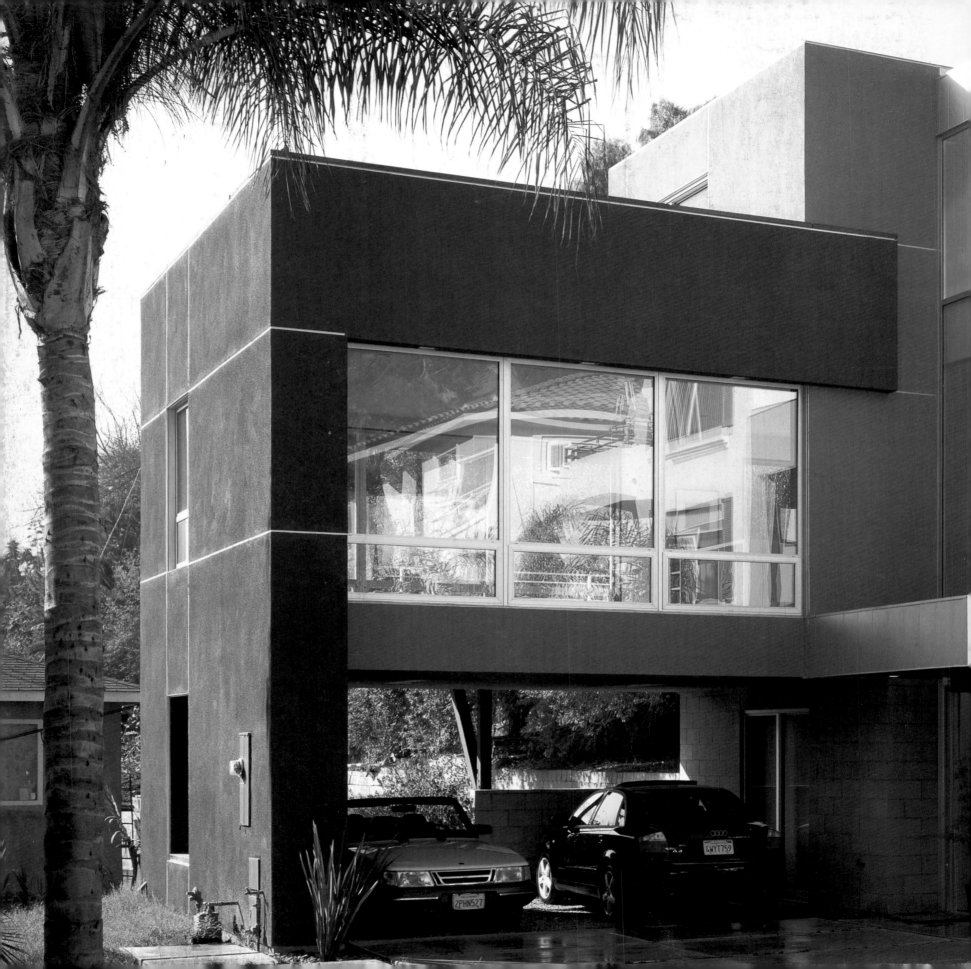

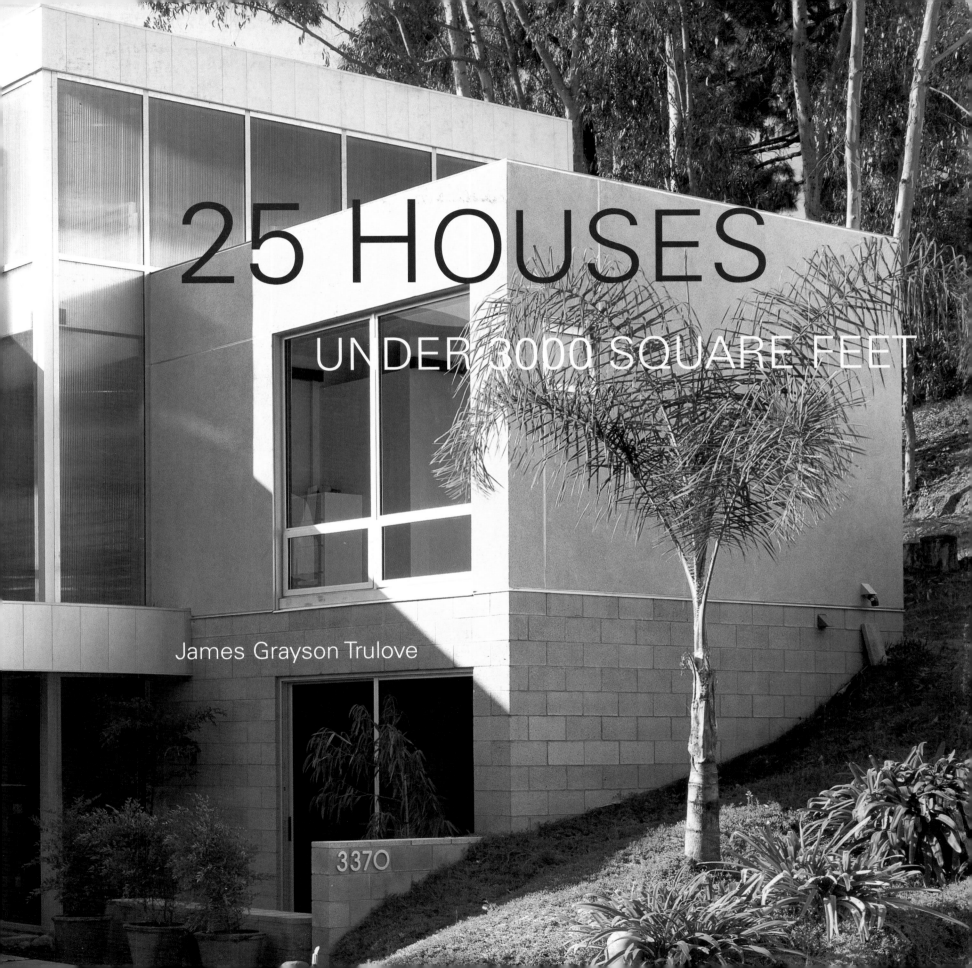

25 HOUSES

UNDER 3000 SQUARE FEET

James Grayson Trulove

HARPERCOLLINS BOOKS MAY BE PURCHASED FOR EDUCATIONAL,
BUSINESS, OR SALES PROMOTIONAL USE. FOR INFORMATION, PLEASE WRITE:
SPECIAL MARKETS DEPARTMENT, HARPERCOLLINS PUBLISHERS INC.,
10 EAST 53RD STREET, NEW YORK, NY 10022.

FIRST EDITION

FIRST PUBLISHED IN 2005 BY
COLLINS DESIGN
An Imprint of HARPERCOLLINS*Publishers*
10 EAST 53RD STREET
NEW YORK, NEW YORK 10022-5299
TEL: (212) 207-7000
FAX: (212) 207-7654
COLLINSDESIGN@HARPERCOLLINS.COM
WWW.HARPERCOLLINS.COM

DISTRIBUTED THROUGHOUT THE WORLD BY:
HARPERCOLLINS*Publishers*
10 EAST 53RD STREET
NEW YORK, NY 10022
FAX: (212) 207-7654

PACKAGED BY:
GRAYSON PUBLISHING, LLC
JAMES G. TRULOVE, PUBLISHER
1250 28TH STREET NW
WASHINGTON, DC 20007
202-337-1380
JTRULOVE@AOL.COM

LIBRARY OF CONGRESS CATALOGING-IN-PUBLICATION DATA

TRULOVE, JAMES GRAYSON.
 25 HOUSES UNDER 3000 SQUARE FEET / BY JAMES TRULOVE.-- 1ST.
 P. CM.
 ISBN 0-06-083308-4 (PBK. WITH VINYL JACKET)
 1 ARCHITECTURE, DOMESTIC--UNITED STATES. 2. SMALL HOUSES--UNITED
STATES. 3. ARCHITECT-DESIGNED HOUSES--UNITED STATES. I. TITLE:
TWENTY-FIVE HOUSES UNDER THREE THOUSAND SQUARE FEET. II. TITLE.
 NA7205.T78 2005
 728'.37--DC22

 2005019686

MANUFACTURED IN CHINA
FIRST PRINTING, 2005
1 2 3 4 5 6 7 8 9 / 06 05 04 03

FULL TITLE PAGE: CASA MAX;
PHOTOGRAPHY BY DAVID HEWITT AND ANNE GARRISON

CONTENTS

Foreword	7
Eureka Street House	8
Pfanner House	16
Fritz Residence	30
Munger House	38
Pine Creek House	50
Dilworth House	58
Hillsdale House	70
Casa Max	82
Artist's House and studio	94
Davis House	106
Stack Residence	118
Malibu Residence	126
Weekend House	134
Collingwood Street House	144
Daniel Residence	154
View Avenue Residence	162
Burke House	170
Harrington Residence	180
Guide House	188
Burton House	196
Fisher/Castellano House	210
Seward Park Residence	220
Fung/Blatt House	230
Floating Meadows	238
Boathouse	248

FOREWORD

This is the third book in my series on smaller houses. The first two, *25 Houses under 2500 Square Feet* and *25 Houses under 1500 Square Feet* seem to have reached an appreciative audience of architects and home owners who believe that living in a richly crafted home where every square foot matters trumps the big, synthetic houses that are springing like weeds across the country.

An interesting trend that I spotted when considering houses for this volume is the number of home owners choosing to remodel and expand existing, older small homes rather than razing them and building large dwellings often grossly out of scale with others in the neighborhood. In other cases, where the existing house is demolished, some architects and their clients are taking great care to design and build a new house that is in scale and context with the other houses on the street.

Thinking small often translates into thinking "green," as well. Many houses featured here are exceptional examples of green architecture where sustainable materials are used and extraordinary steps are taken in the interest of energy conservation, from sod roofs and rammed earth walls to solar energy and the use of low maintenance materials.

The interest in small homes has also led to a growing interest in prefabricated homes, and I have included one such project that can be ordered in sizes from one to three bedrooms and that is an example of good, sustainable residential architecture.

Left: Burton House; architecture by Luce et Studio; photography by Paúl Rivera, Arch Photo

Eureka Street House

3000 Square Feet

Philip Mathews Architect
Photography: Tom Rider

LOCATED ON A SMALL CORNER INFILL LOT IN SAN FRANCISCO, THE DESIGN OF THIS THREE BEDROOM TOWHOUSE TAKES FULL ADVANTAGE OF ITS SOUTH ORIENTATION AND CORNER SITE BY THE EXTENSIVE USE OF GLASS TO BRING MAXIMUM LIGHT INTO THE INTERIOR. FOUR CORNER BUTT-JOINT GLASS WINDOWS PROVIDE VIEWS UP STREET CORRIDORS AND DISTINGUISH THE EXTERIOR DESIGN.

THE ROOFTOP DECK GIVES ADDITIONAL EXTERIOR SPACE ON THE TINY LOT, AS WELL AS A PANORAMIC VIEW OF DOWNTOWN SAN FRANCISCO. A TWO-STORY LIVING AREA ALSO CONTAINS A PROFESSIONAL LIBRARY AND SERVES AS A MEETING SPACE FOR THE ARCHITECT/OWNER AND HIS CLIENTS. ROOMS ON THE SECOND AND THIRD FLOORS ARE ORIENTED AROUND THIS OPEN LIVING AREA, GIVING A SENSE OF ADDED SPACIOUSNESS TO THIS 30-FOOT-WIDE HOUSE. BELOW, THE GARAGE, WITH ITS ETCHED GLASS DOOR, IS FLOODED WITH LIGHT AND IS UTILIZED AS A DAYTIME STUDIO AND WORKSPACE.

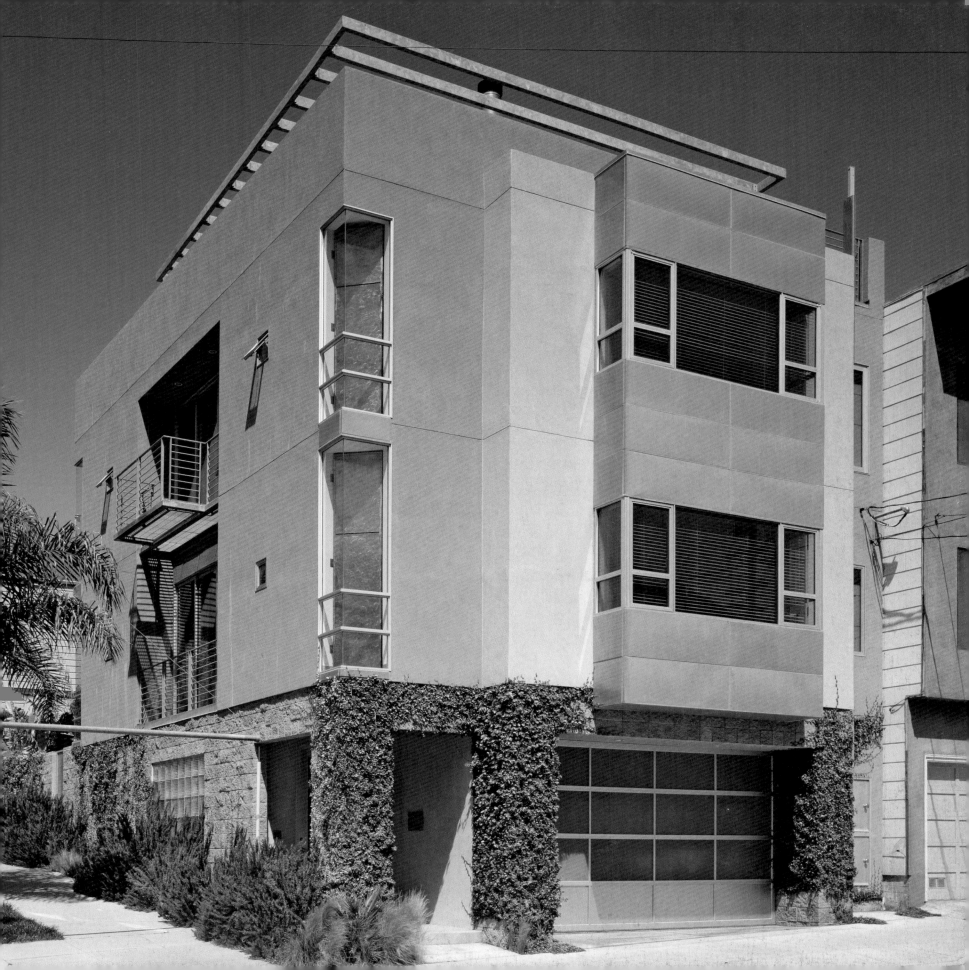

Section

Previous Pages and Right:
Located on a corner lot,
the house utilizes extensive
glazing on three sides.

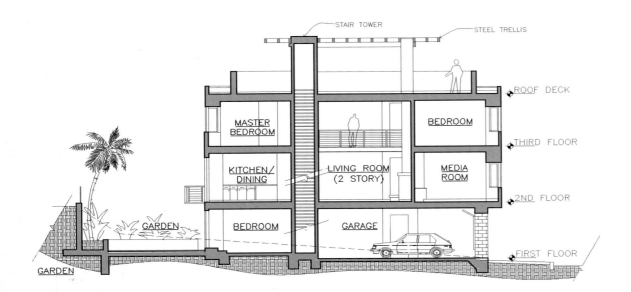

STAIR TOWER

STEEL TRELLIS

ROOF DECK

MASTER
BEDROOM

BEDROOM

THIRD FLOOR

KITCHEN/
DINING

LIVING ROOM
(2 STORY)

MEDIA
ROOM

2ND FLOOR

GARDEN

BEDROOM

GARAGE

FIRST FLOOR

GARDEN

First Floor Plan

GARDEN

BATH

BEDROOM

ENTRY

GARAGE

PORCH

Second Floor Plan

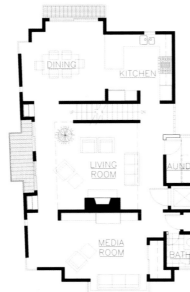

DINING

KITCHEN

LIVING
ROOM

LAUNDRY

MEDIA
ROOM

BATH

Third Floor Plan

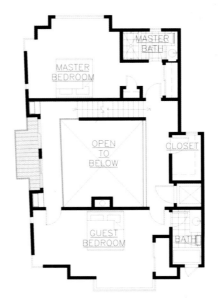

MASTER
BATH

MASTER
BEDROOM

OPEN
TO
BELOW

CLOSET

GUEST
BEDROOM

BATH

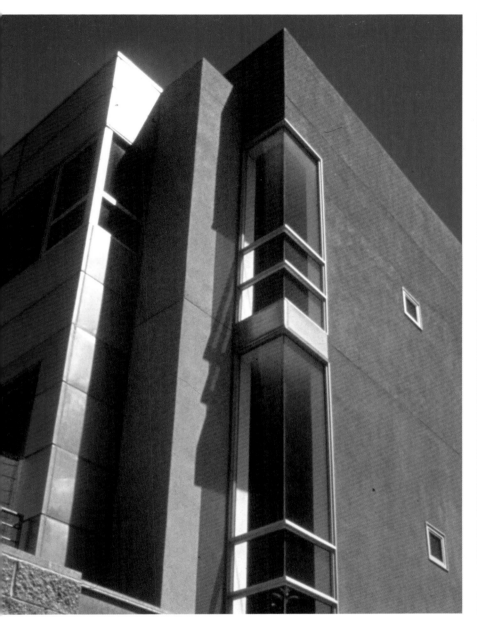

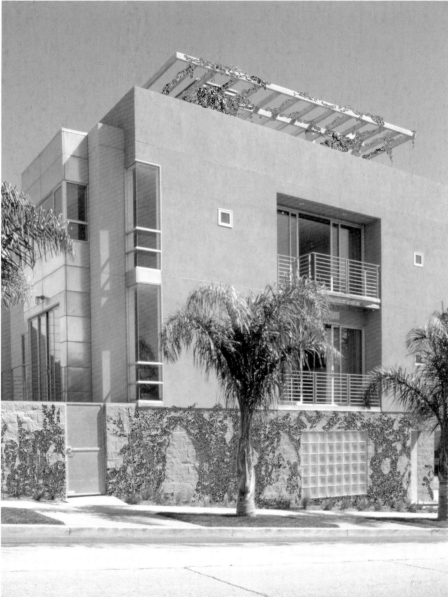

Above: Old sidewalks were replaced with planting strips along the wall of the building.

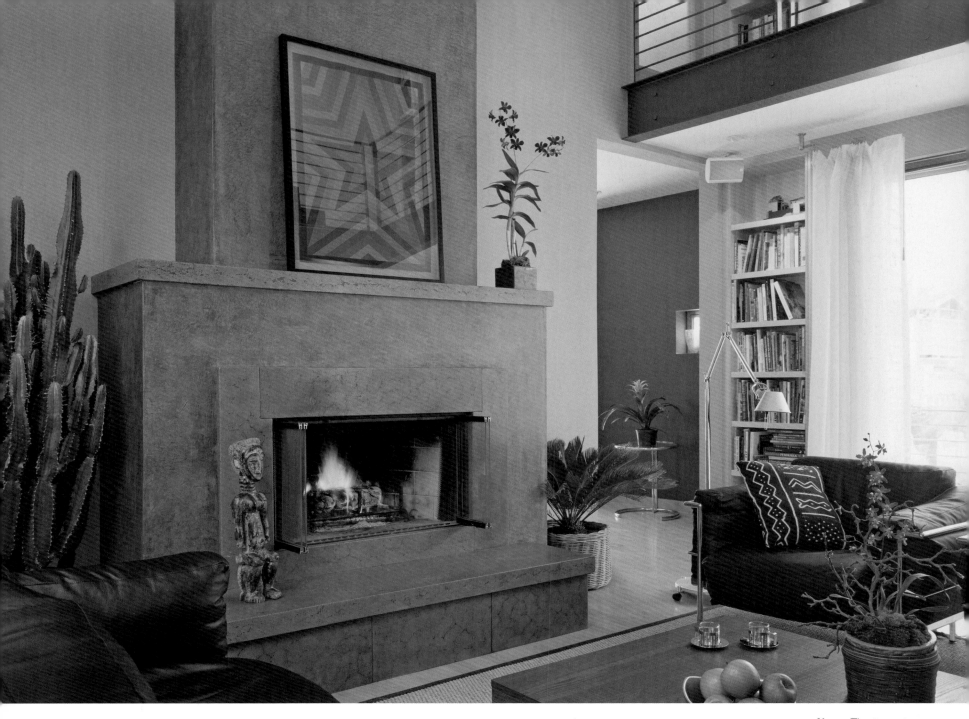

Above: The two-story living area contains a professional library for the architect/owner.

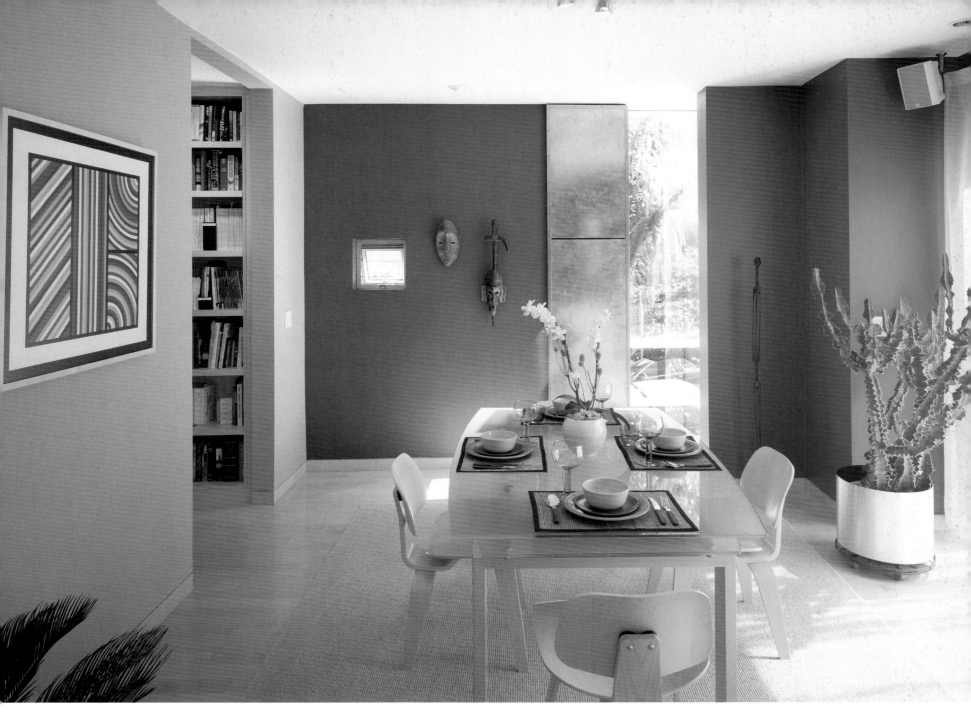

Above: Butt-joint, glass windows bring light into the dining area.

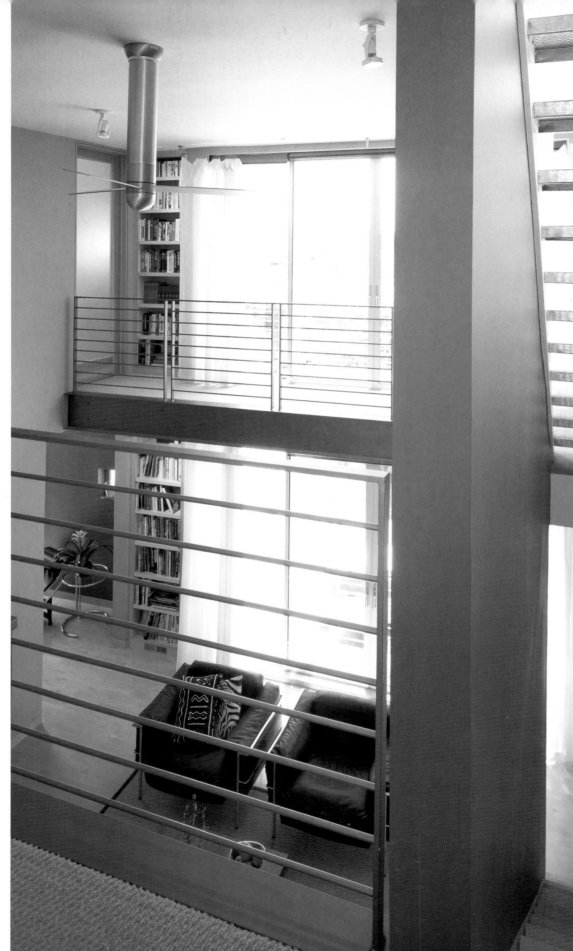

Right: A view of the open stairs and the two-story living area

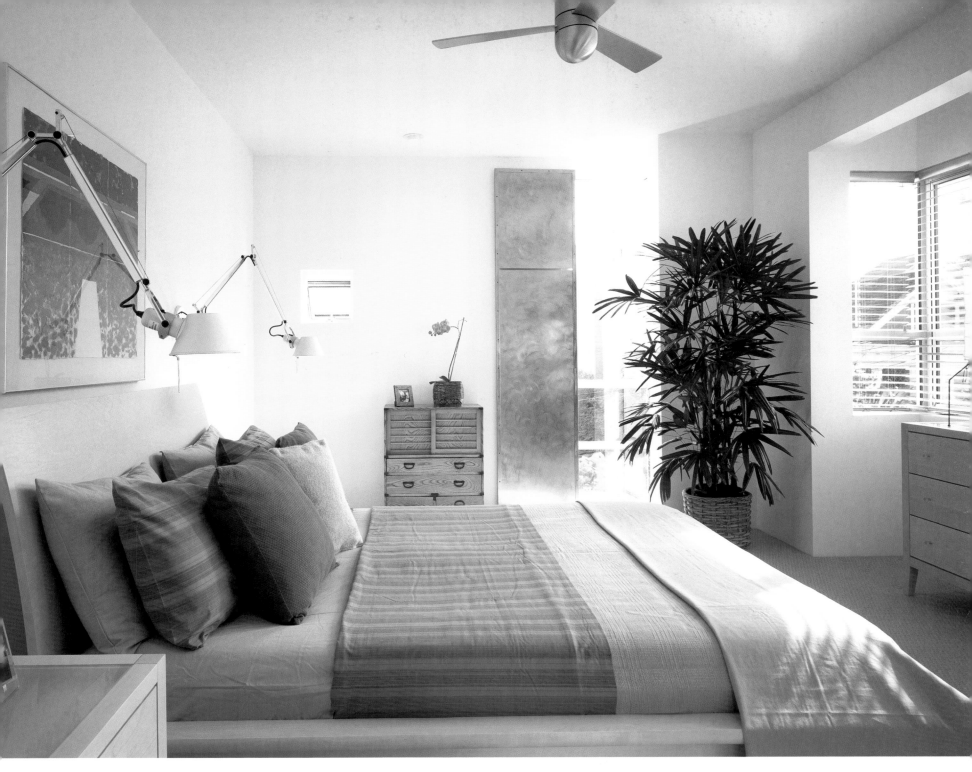

Above: The master bedroom

Pfanner House

3000 Square Feet

Zoka Zola Architecture + Urban Design
Photography: Roland Halbe, Doug Fogelson

CREATING A SENSE OF OPENNESS WAS A GUIDING PRINCIPAL IN THE DESIGN OF THIS SINGLE-FAMILY TOWNHOUSE ON AN UNDERSIZED CORNER LOT IN CHICAGO. THE HOUSE ABUTS THE SIDEWALK TO THE NORTH, PERMITTING A SIDE GARDEN ON THE SOUTH SIDE. THE GARDEN PROVIDES SEPARATION FROM THE NEIGHBORING HOUSE WITH SUFFICIENT ROOM FOR FOUR COTTONWOOD TREES THAT PROVIDE SHADE AND ADDITIONAL PRIVACY. IN THIS NEIGHBORHOOD, BUILDING CODES RESTRICT THE HEIGHT OF HOUSES TO TWO STORIES. FORTUNATELY, THE CODES DEFINE THE BASEMENT AS A HABITABLE SPACE IF 50 PERCENT IS FOUR FEET OR MORE BELOW GRADE. AS A RESULT, WITH CAREFUL SPACE PLANNING, THE ARCHITECT WAS ABLE TO LOCATE THE GARAGE, STUDIO, MEZZANINE AND STAIRS IN THIS BASEMENT AREA, ALLOWING FOR TWO ADDITIONAL FLOORS FOR THE MAIN PUBLIC AND PRIVATE SPACES. HERE, THE HOUSE OPENS TO THE STREET THROUGH EXTENSIVE USE OF BALCONIES, TERRACES, AND WINDOWS. AN OPEN STAIRWAY THREADS UP THROUGH THE HOUSE VISUALLY CONNECTING THE VARIOUS LEVELS.

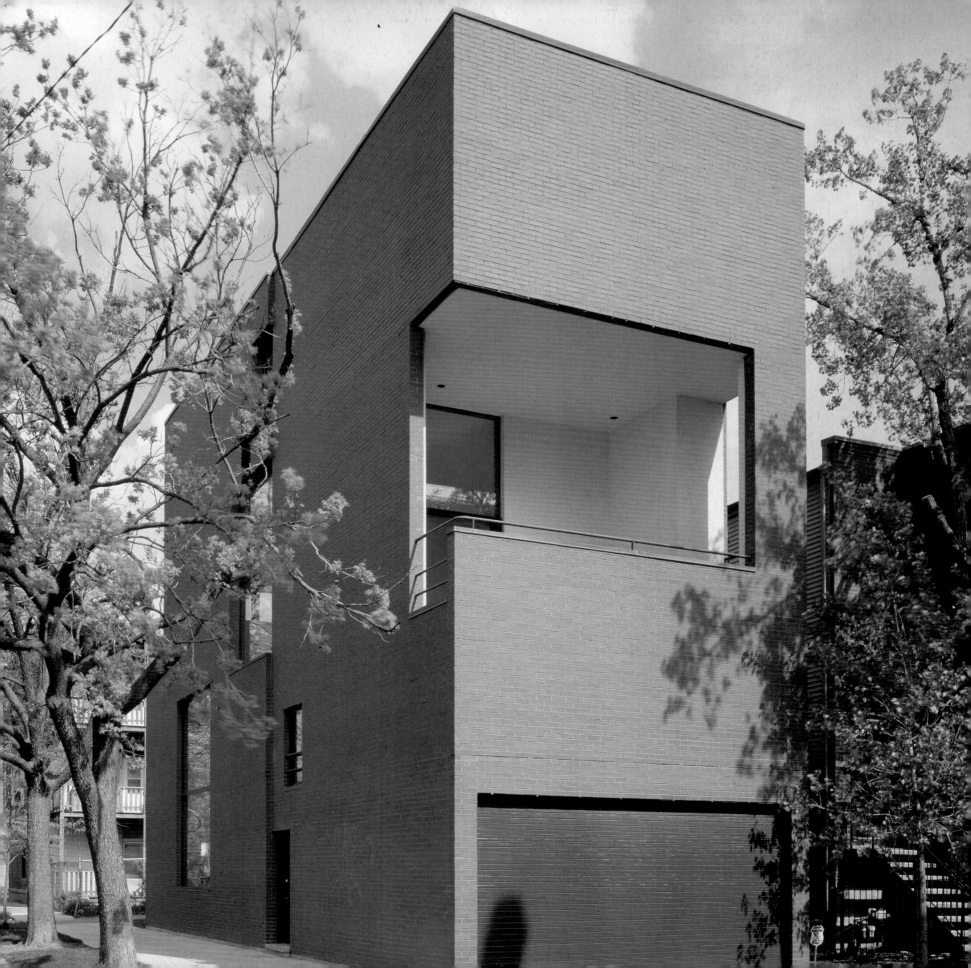

Second Floor

First Floor

FIRST FLOOR

Basement - Mezzanine Level

Basement - Entrance Level

Basement - Studio Level

Previous Pages: A large and welcoming terrace extends from the living room and overlooks the street.
Below Right: The house as seen within the context of its Victorian neighbors

North/South Section

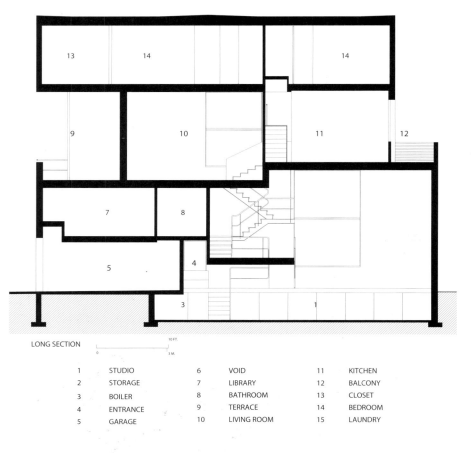

LONG SECTION

1	STUDIO	6	VOID	11	KITCHEN	
2	STORAGE	7	LIBRARY	12	BALCONY	
3	BOILER	8	BATHROOM	13	CLOSET	
4	ENTRANCE	9	TERRACE	14	BEDROOM	
5	GARAGE	10	LIVING ROOM	15	LAUNDRY	

North Elevation

South Elevation

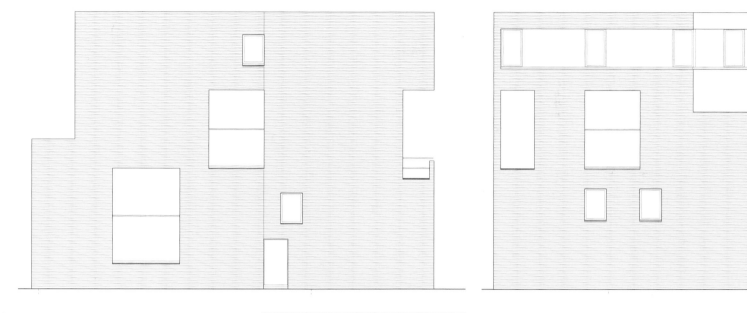

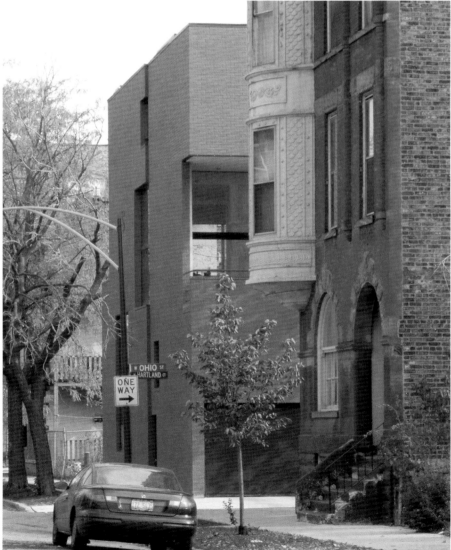

East Elevation

West Elevation

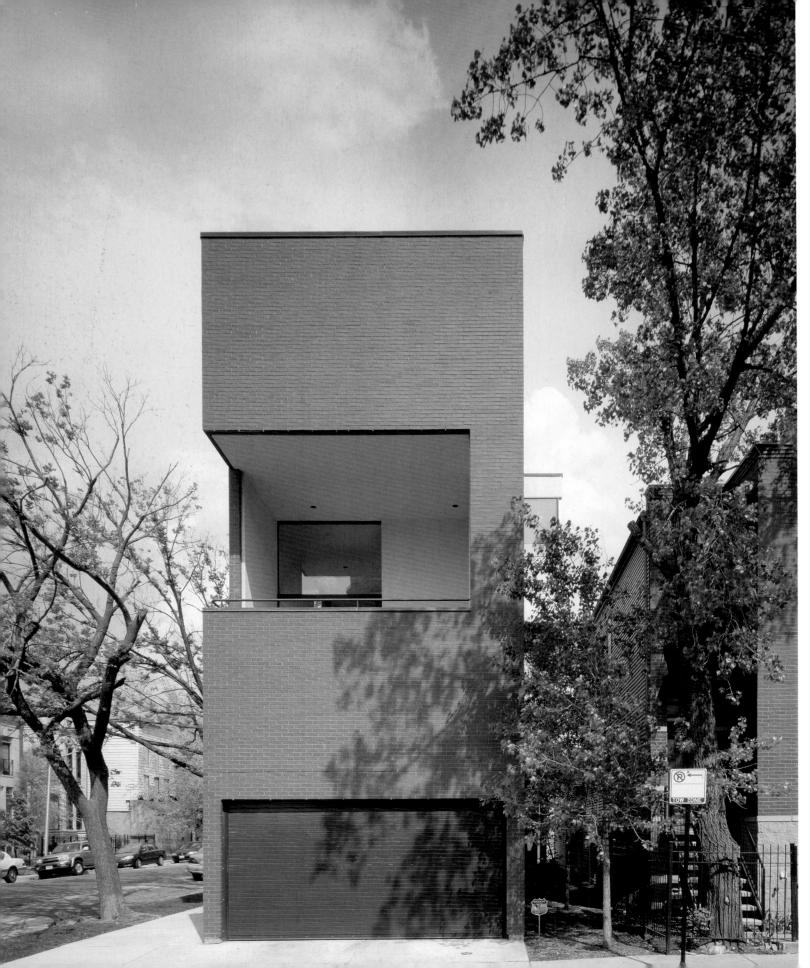

Left: The modern house is clad in orange brick as are most of the older Victorian houses surrounding it.

Right: Large windows punctuate the north elevation and open the house to the street. This is also the formal entry for the property.

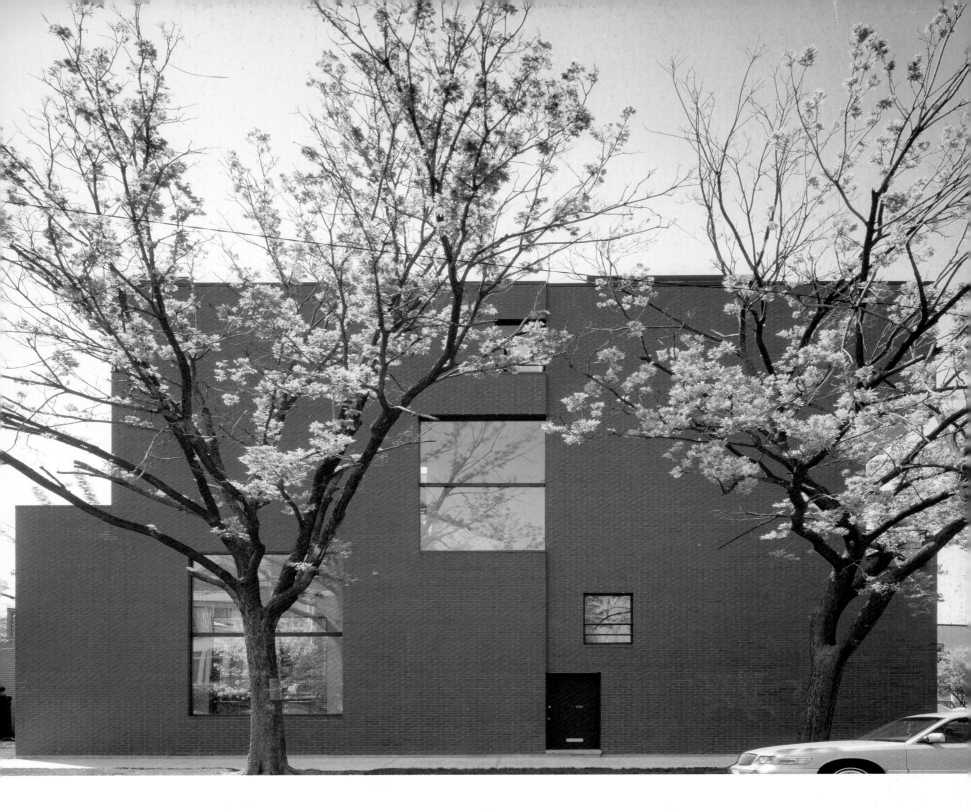

Left: The transparency of this narrow townhouse is remarkable. The basement-level studio is open and flooded with light.

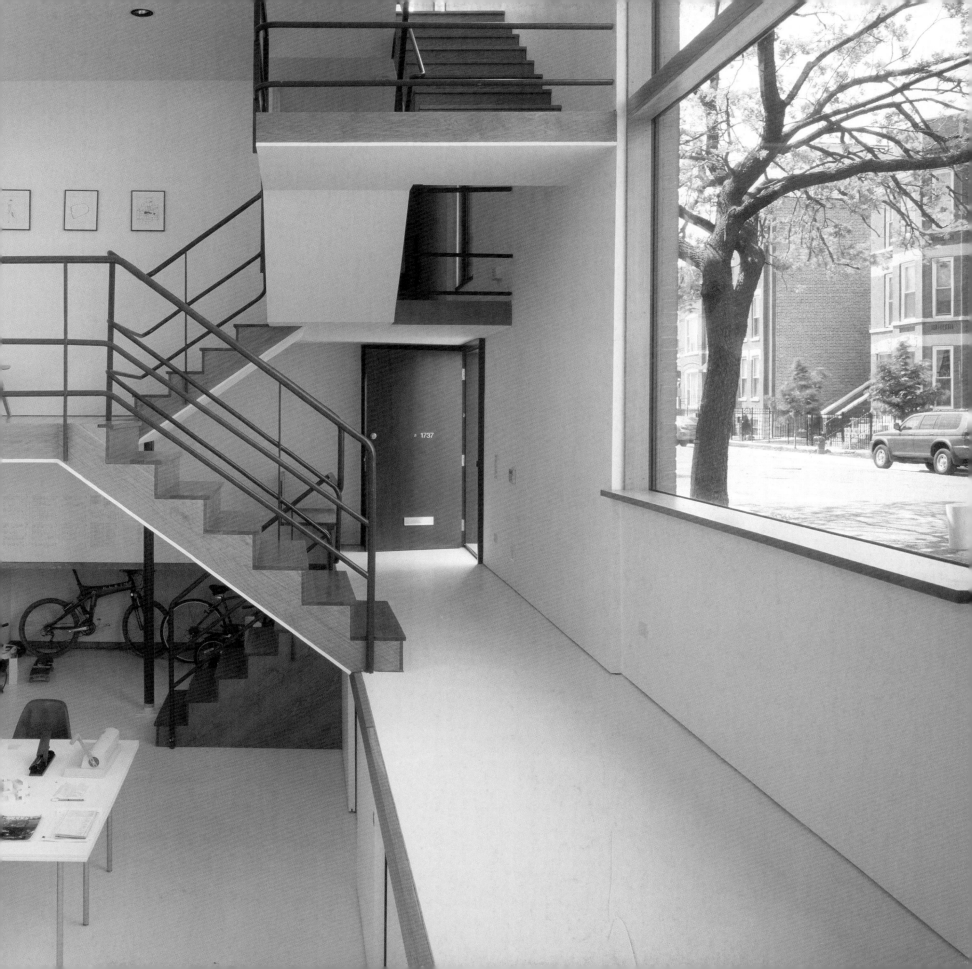

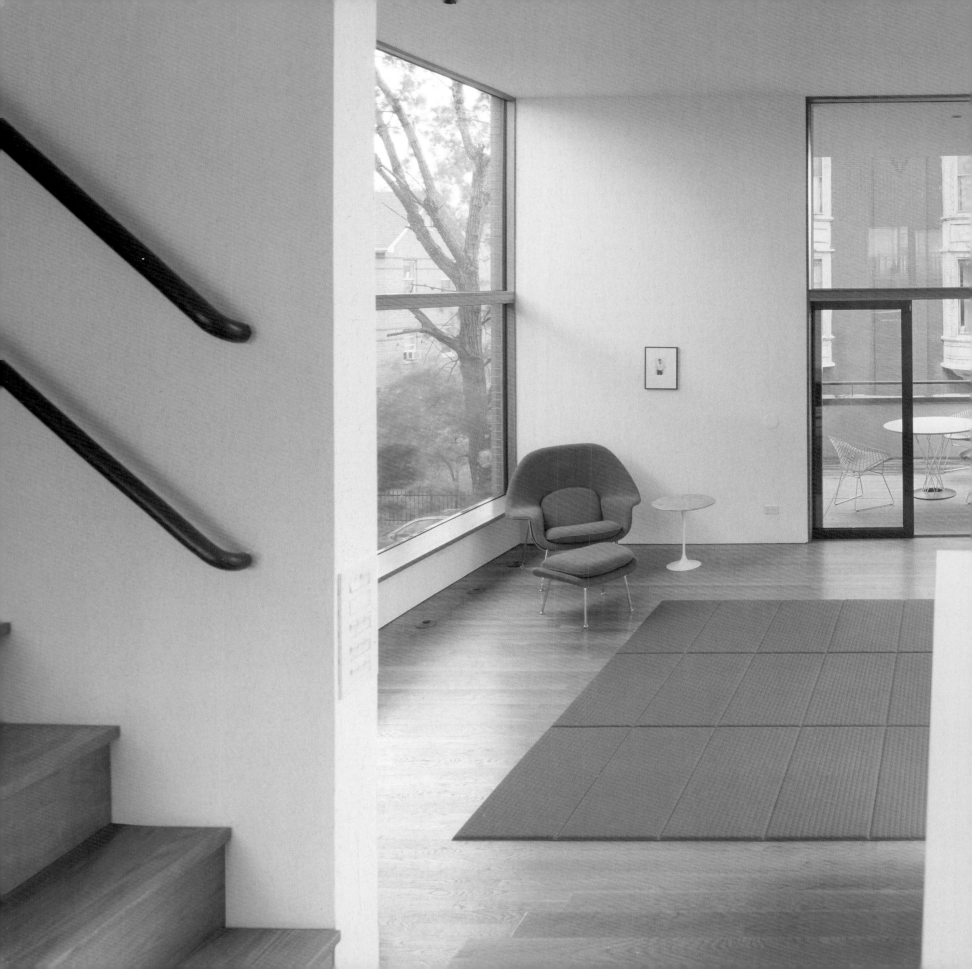

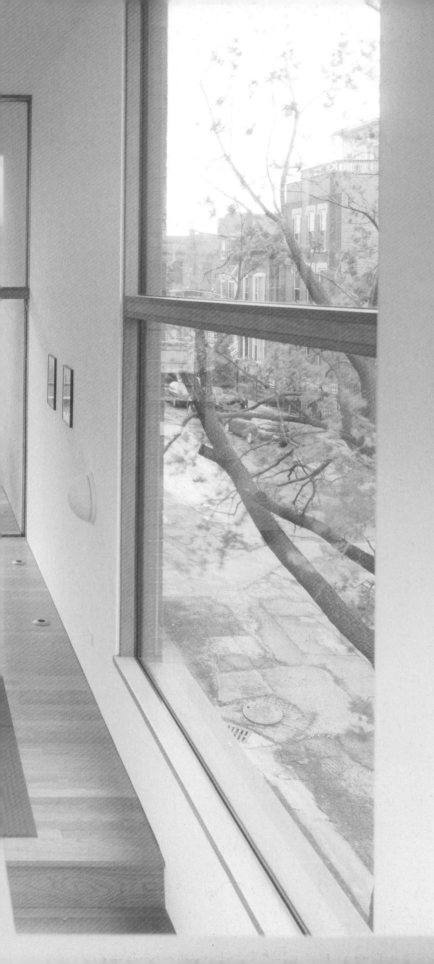

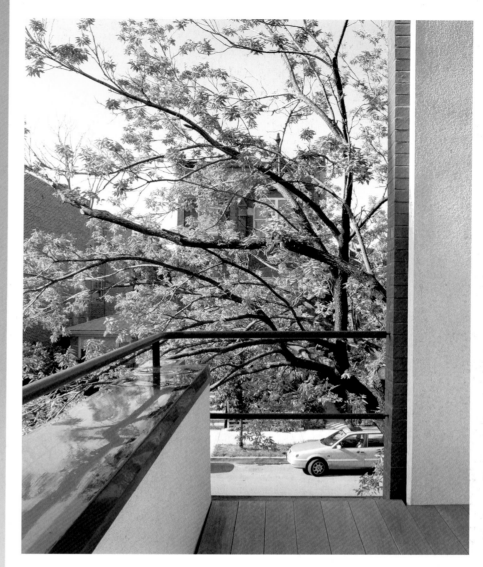

Left and Above: The living room is flanked by large windows and opens to a large terrace overlooking the street.

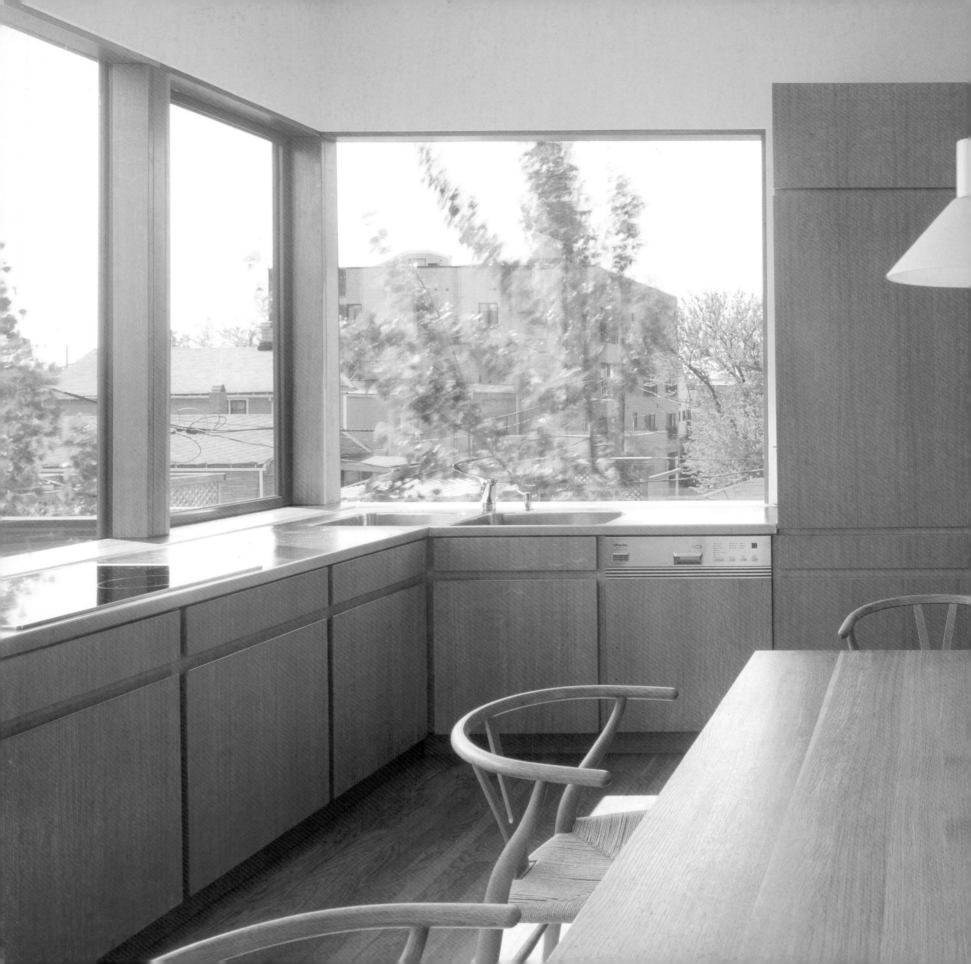

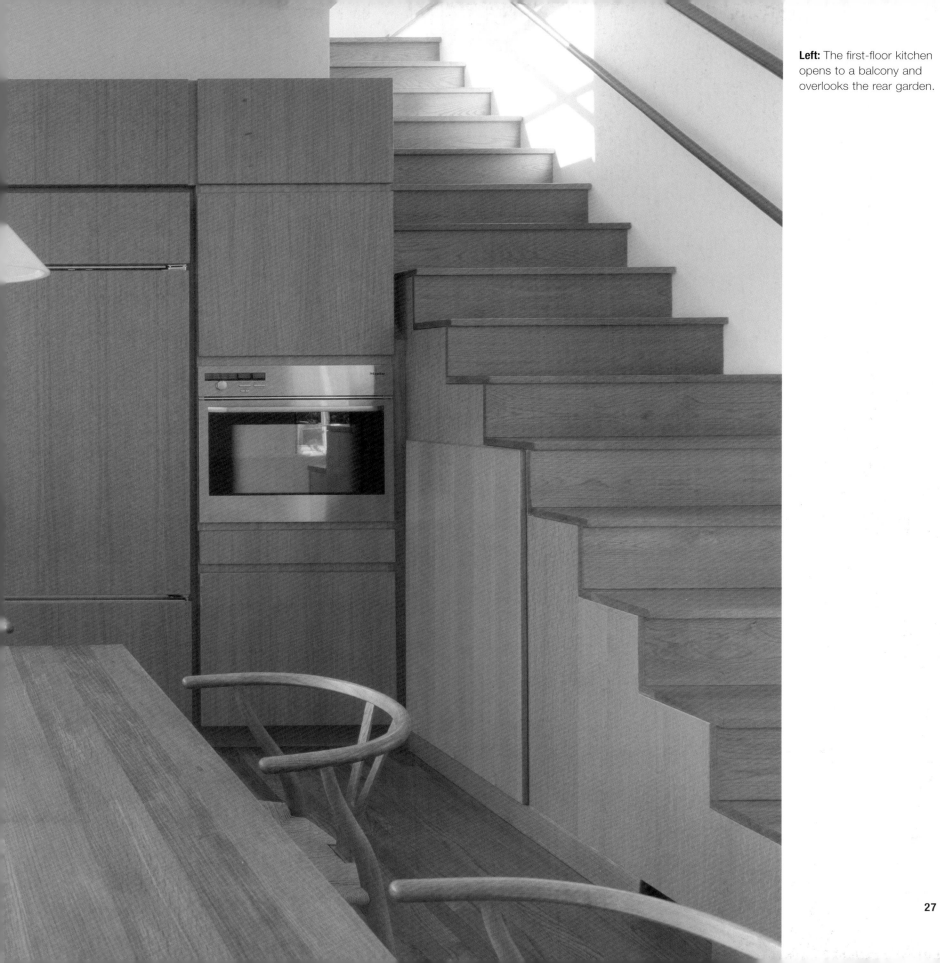

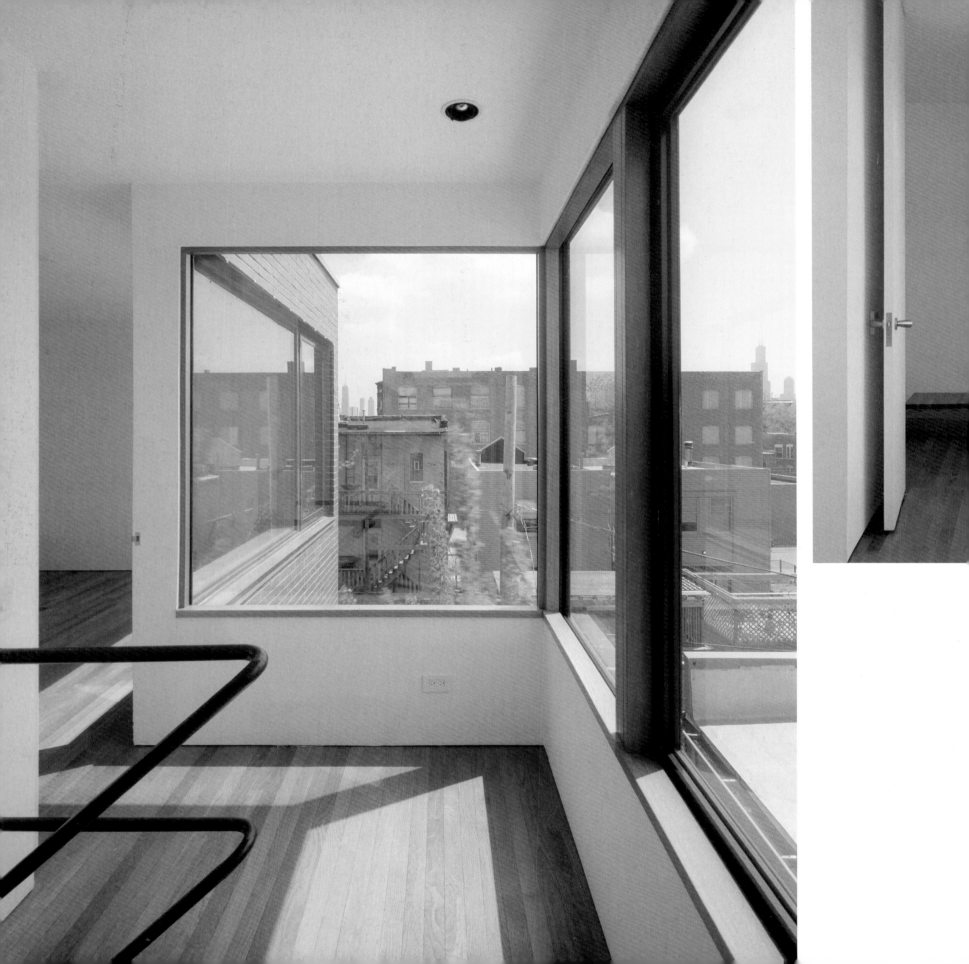

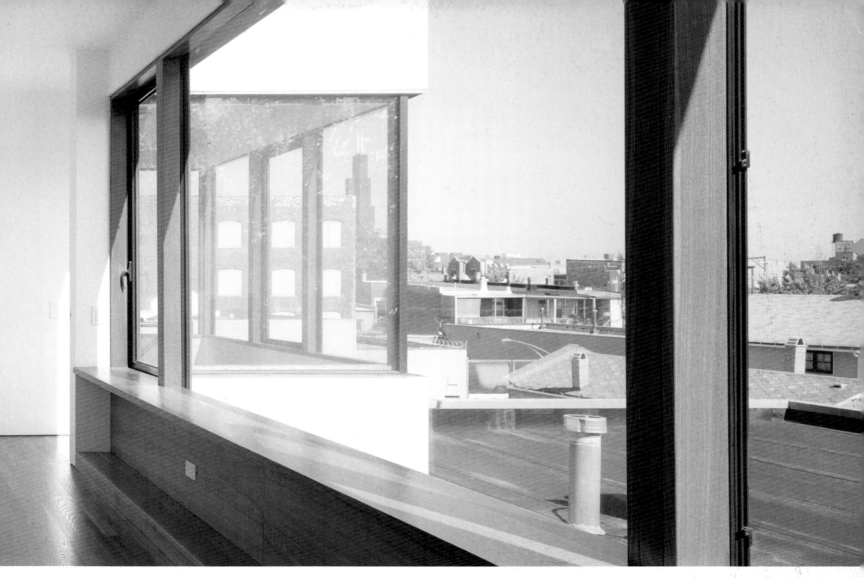

Left: Detail of bay window at the second level
Above and Right: The openness of the house continues on the second floor where the bedrooms and main bathrooms are located.

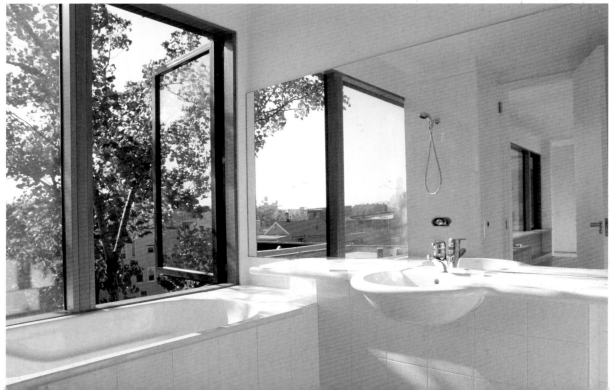

Fritz Residence

2600 Square Feet

OJMR Architects
Photography: Ciro Coelho

DESIGNED FOR A RETIRED COUPLE, THIS HOUSE HAS GUEST BEDROOM SUITES AND A LARGE COMMUNAL SPACE FOR ENTERTAINING. IT IS LOCATED IN A DESERT COMMUNITY IN CALIFORNIA, AND ITS L-SHAPED PLAN IS FOCUSED TOWARD THE MAIN OUTDOOR SPACE, THE SWIMMING POOL. TWO SIMPLE VOLUMES ARE CONNECTED TOGETHER TO DEFINE A CORNER WITH ONE WING CONTAINING THE GUEST BEDROOMS AND THE OTHER THE MASTER SUITE. THE TWO WINGS ARE CONNECTED AT THE OPEN LIVING, DINING, AND KITCHEN AREA.

HALLWAYS ARE LOCATED ALONG THE EAST AND SOUTH SIDES OF THE WINGS CONNECTING THE LATERALLY SPACED ROOMS, WHICH CAN BE CLOSED OFF FROM THE COMMUNAL AREA WITH LARGE SLIDING GLASS WALLS. ALL ROOMS HAVE ACCESS TO THE POOL VIA LARGE SLIDING GLASS DOORS.

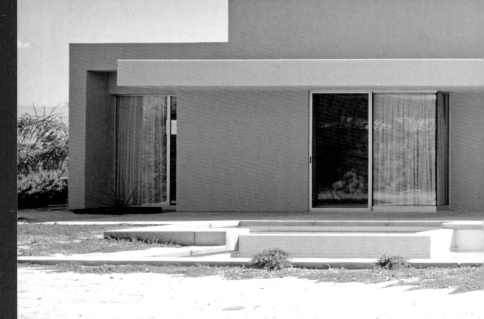

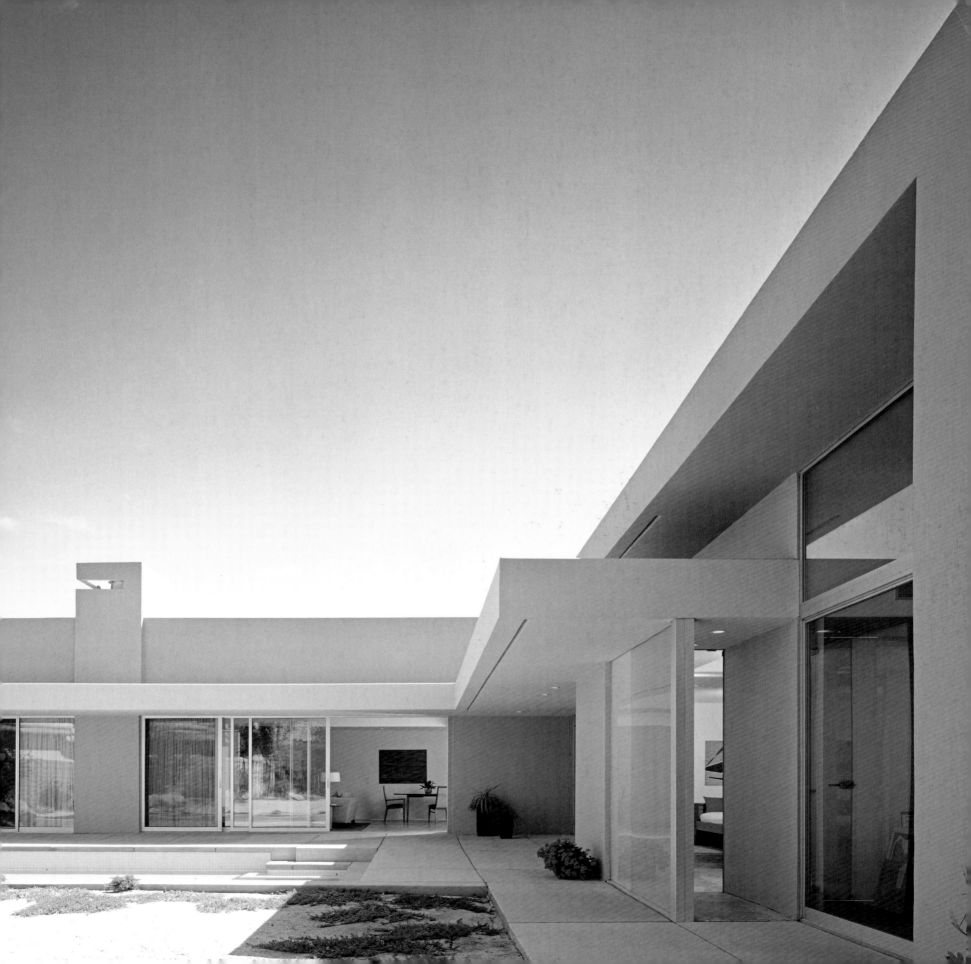

Previous Pages: The L-shaped plan allows all of the rooms easy access to the outdoors and pool.
Right: The pool at night
Below Right: The entry and garage

Floor Plan

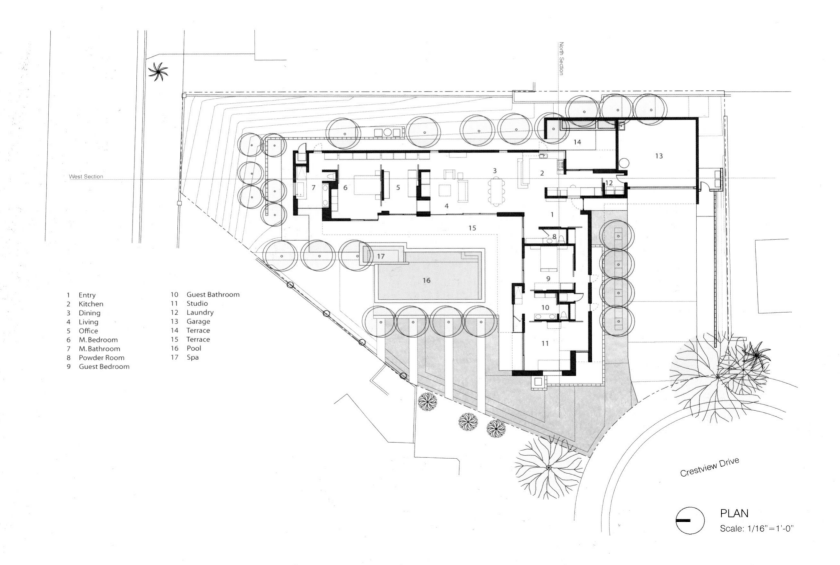

1 Entry
2 Kitchen
3 Dining
4 Living
5 Office
6 M.Bedroom
7 M.Bathroom
8 Powder Room
9 Guest Bedroom
10 Guest Bathroom
11 Studio
12 Laundry
13 Garage
14 Terrace
15 Terrace
16 Pool
17 Spa

Crestview Drive

PLAN
Scale: 1/16" = 1'-0"

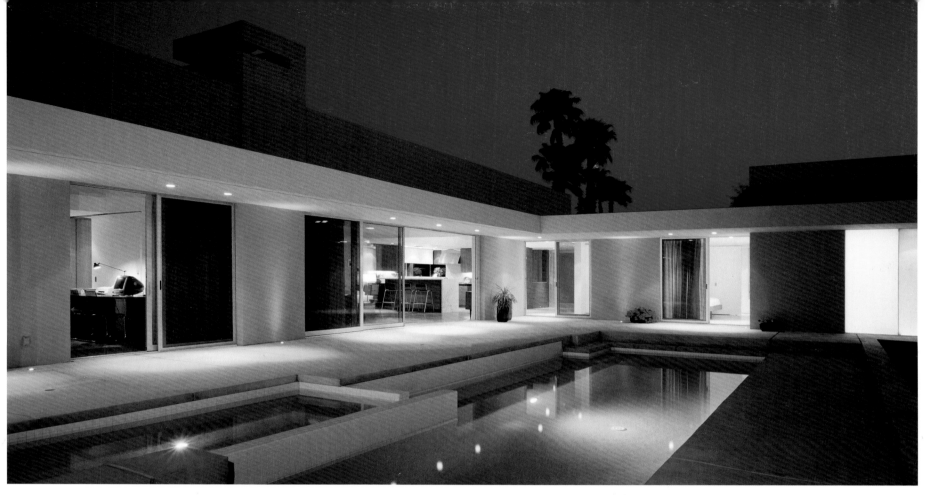
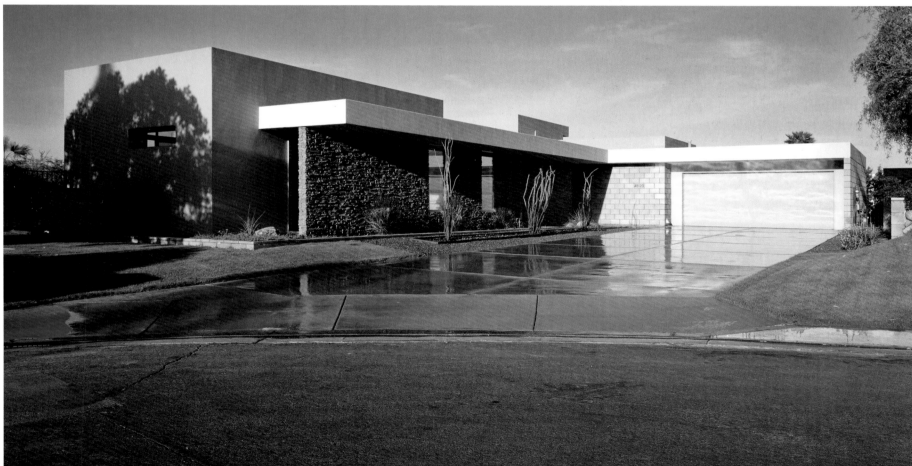

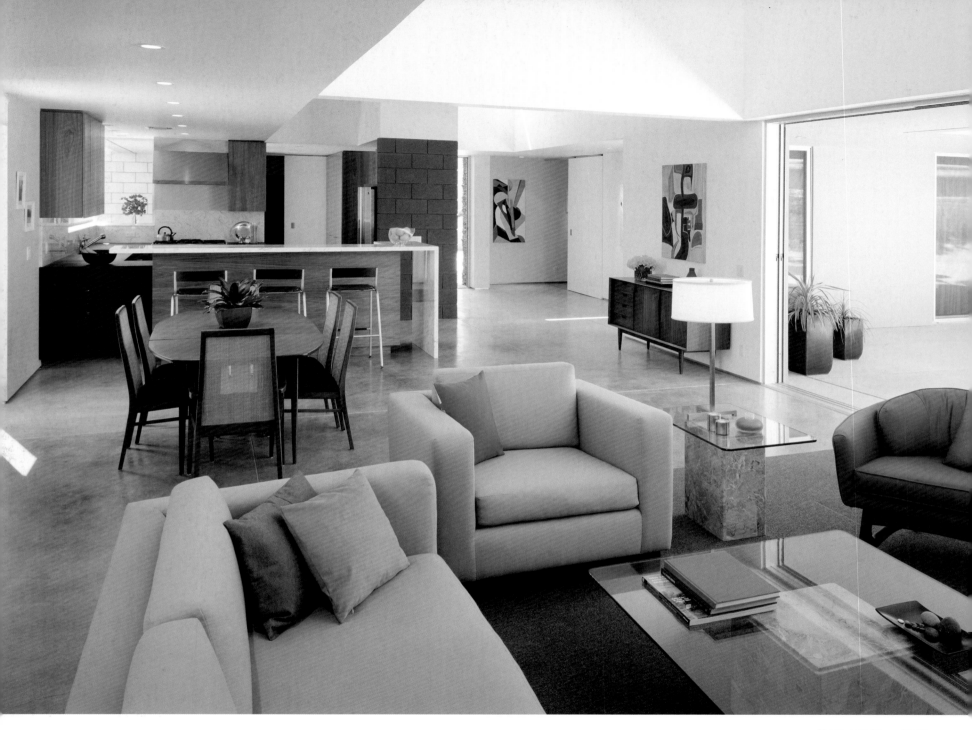

Above and Above Right:
The kitchen, living, and dining areas have polished concrete floors and exposed concrete block walls. Clerestory windows bring light and air into the space.

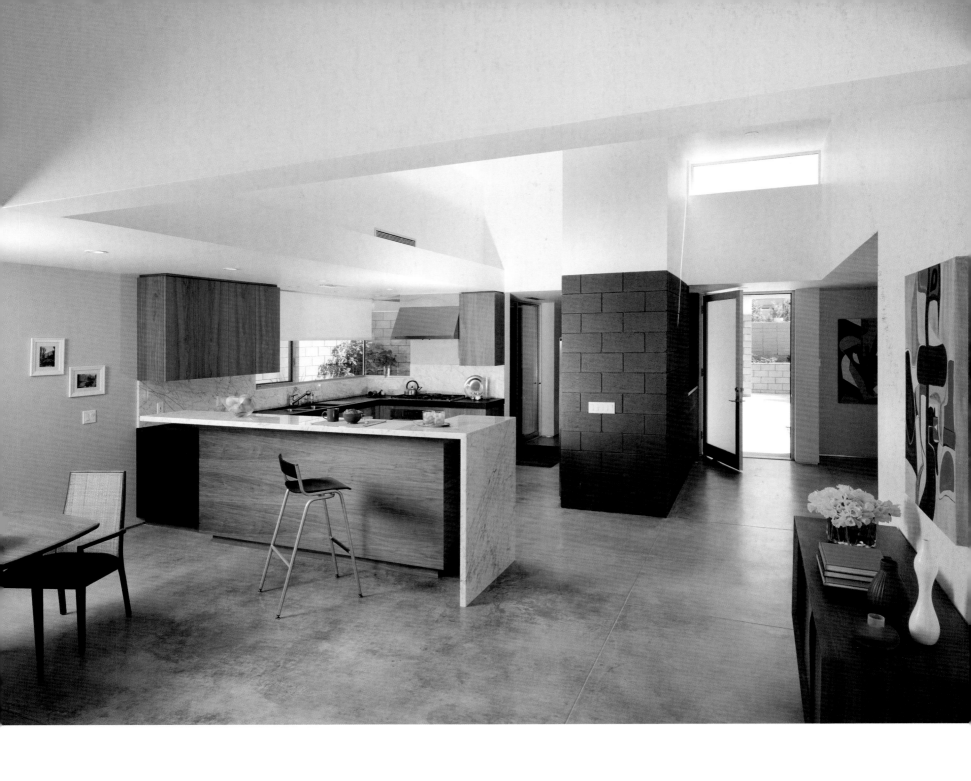

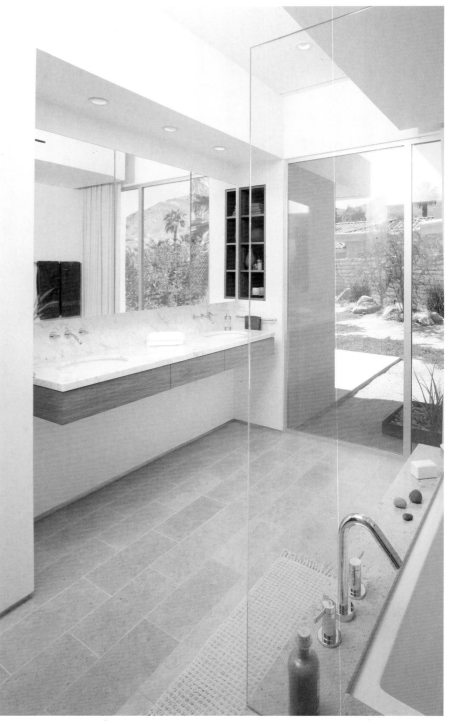

Above Left: A view down
the corridor connecting
the guest rooms from the
living area
Above and Right: The
bedrooms and bathrooms
have direct access to
the pool.

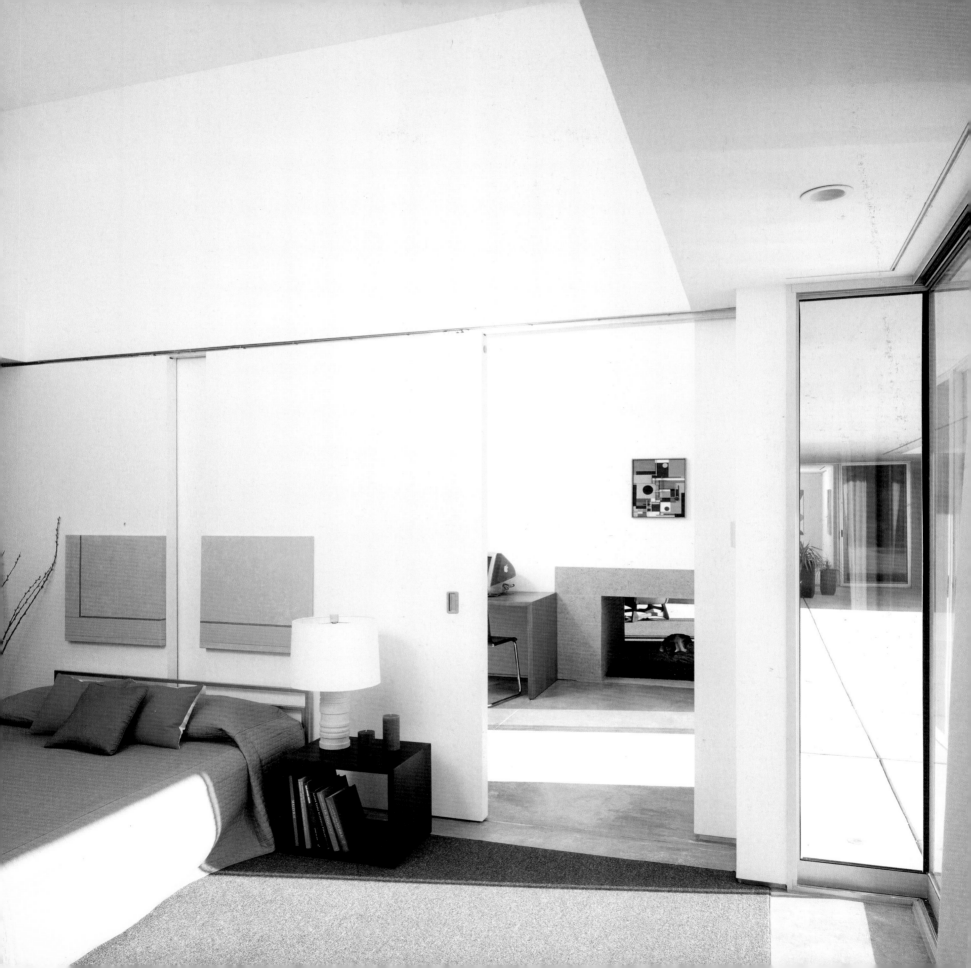

Munger House

2170 Square Feet

**Architects: Donlyn Lyndon
with Frank Architects**
Photography: Jim Alinder

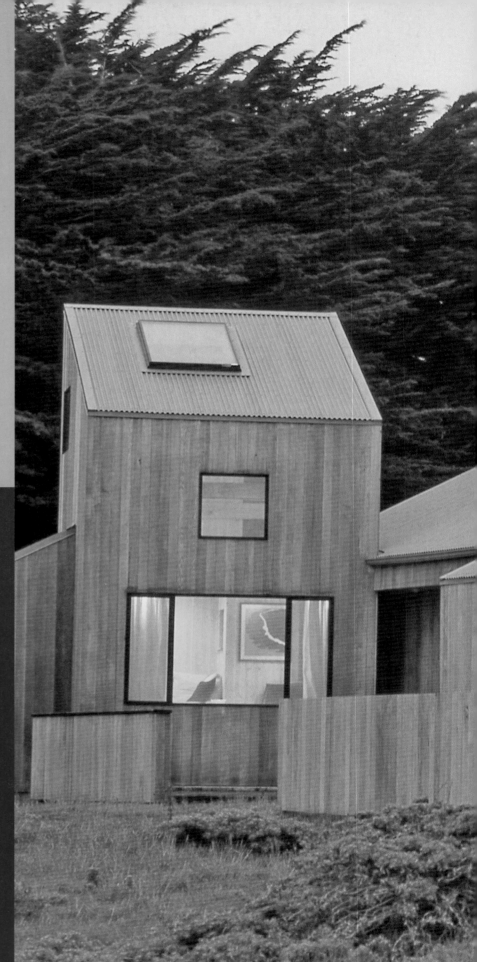

LOCATED IN THE SEA RANCH OF NORTHERN CALIFORNIA, THIS SECOND HOME HAS BEEN DEVELOPED AS A SET OF SHED ROOF BUILDING FORMS SHELTERING A SUN-DRENCHED COURTYARD FROM THE STRONG NORTHWEST WINDS. AN ARRANGEMENT OF HIGH WINDOWS ILLUMINATES THE MAIN LIVING SPACES AND PROVIDES SHIFTING PATTERNS OF LIGHT AND VIEWS THROUGHOUT THE DAY.

INSIDE IS A GREAT HALL WITH A MEZZANINE OVER THE KITCHEN AT ONE END AND A FEW STEPS LEADING UP INTO THE CORNER TOWER AT THE OTHER. AT THE MEZZANINE LEVEL IS A STUDY THAT OPENS ONTO A BALCONY SET INTO THE ROOF ON THE NORTHWEST CORNER ABOVE THE BATHROOM. THE MASTER BEDROOM, DRESSING, AND BATH AREAS ARE ON THE MAIN LEVEL ON THE WEST SIDE OF THE HOUSE, WHILE THE SEPARATE EASTERN WING SHELTERS THE COURT FROM THE ADJOINING ROAD AND CONTAINS A GUEST ROOM WITH BATH AND A PAINTING STUDIO/GARAGE SPACE.

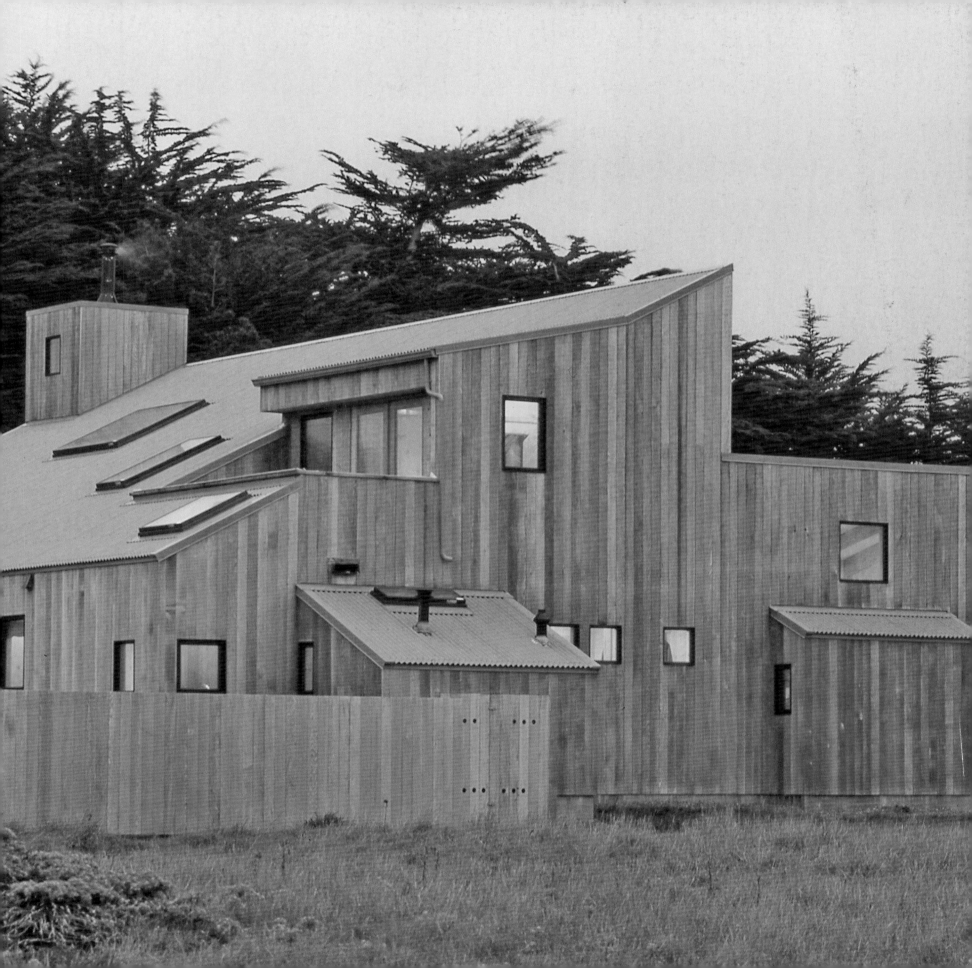

Loft Plan

First Floor Plan

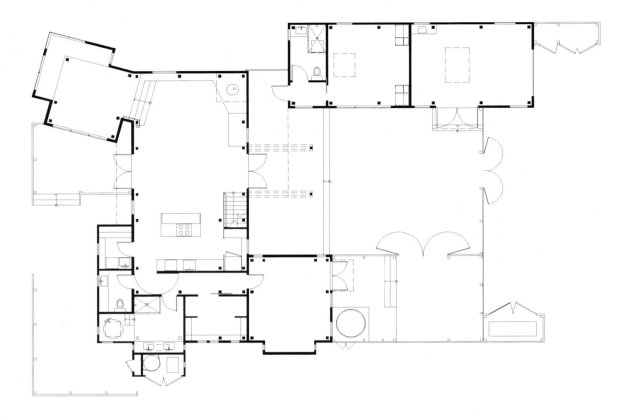

Site Plan

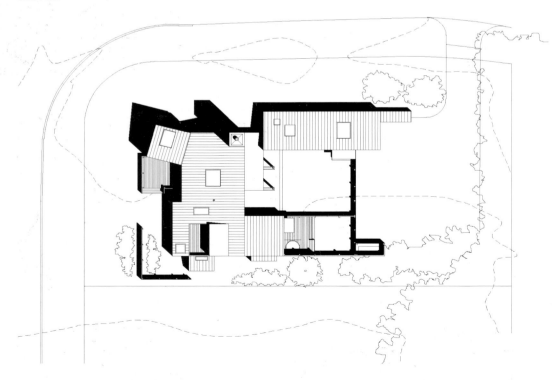

Previous Pages: A view of the compound at night from the southwest, with corner viewing tower on the left, and on the right, the large encompassing roof and dormered study with inset balcony over the bathroom.

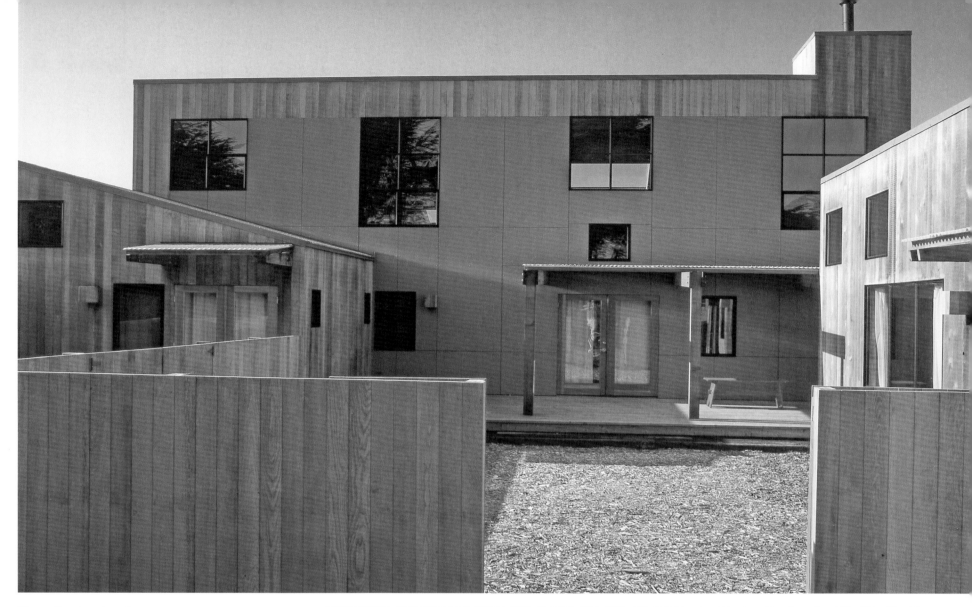

Above: Courtyard on the south side of the house, with master bedroom wing on the left and the guest house/studio wing on the right.
Right: Detail of the translucent canopy over the garden entrance to the master bedroom

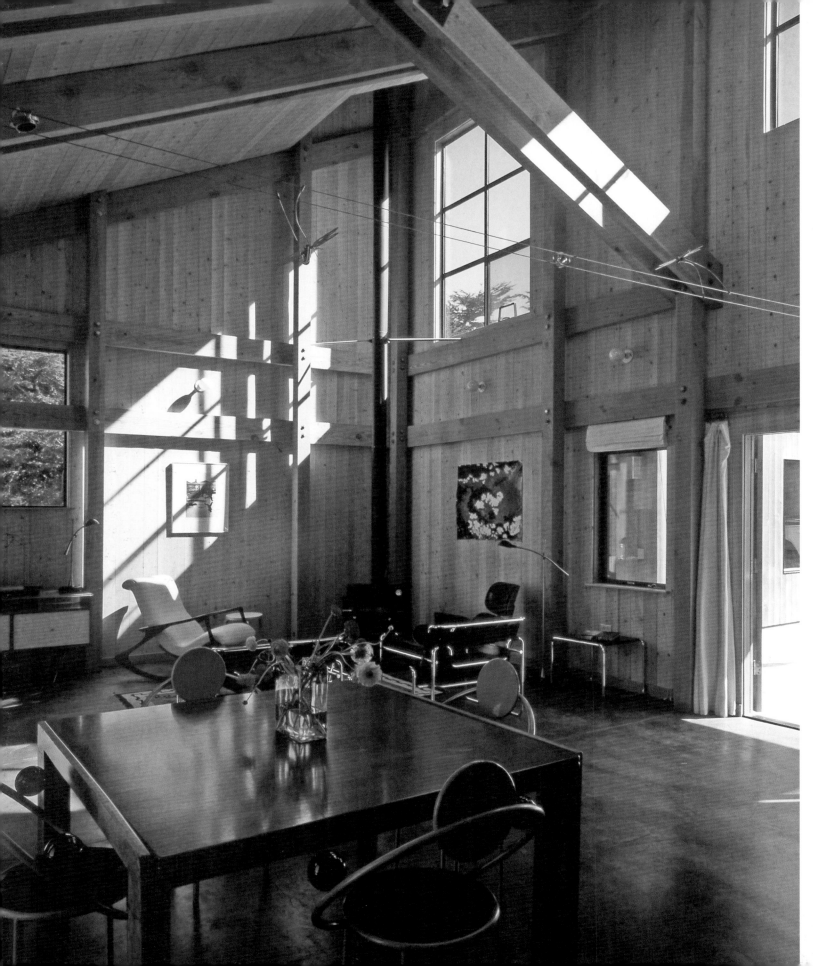

Left: South light streams into the great hall, which opens through window doors to the courtyard. The floor is stained concrete slab, and the walls and roof are wood-paneled SIP panels.
Right: A view of the dining area and kitchen with the study on the mezzanine above the kitchen

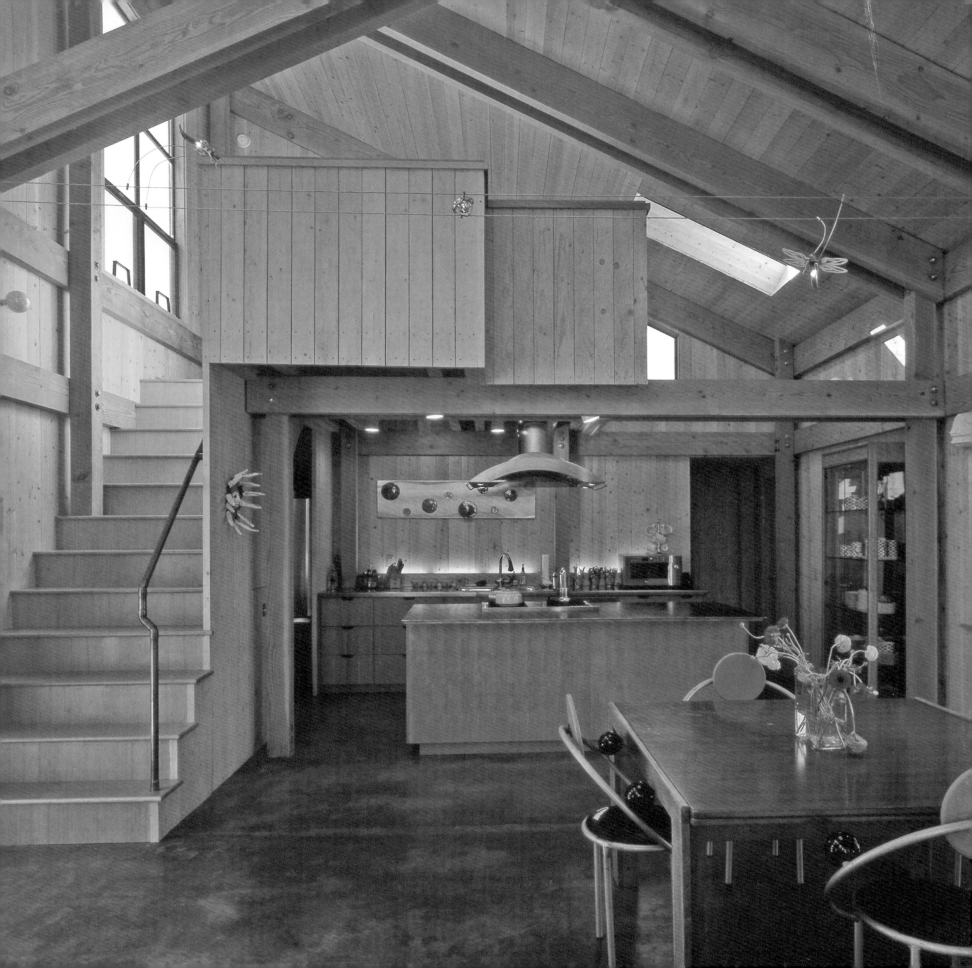

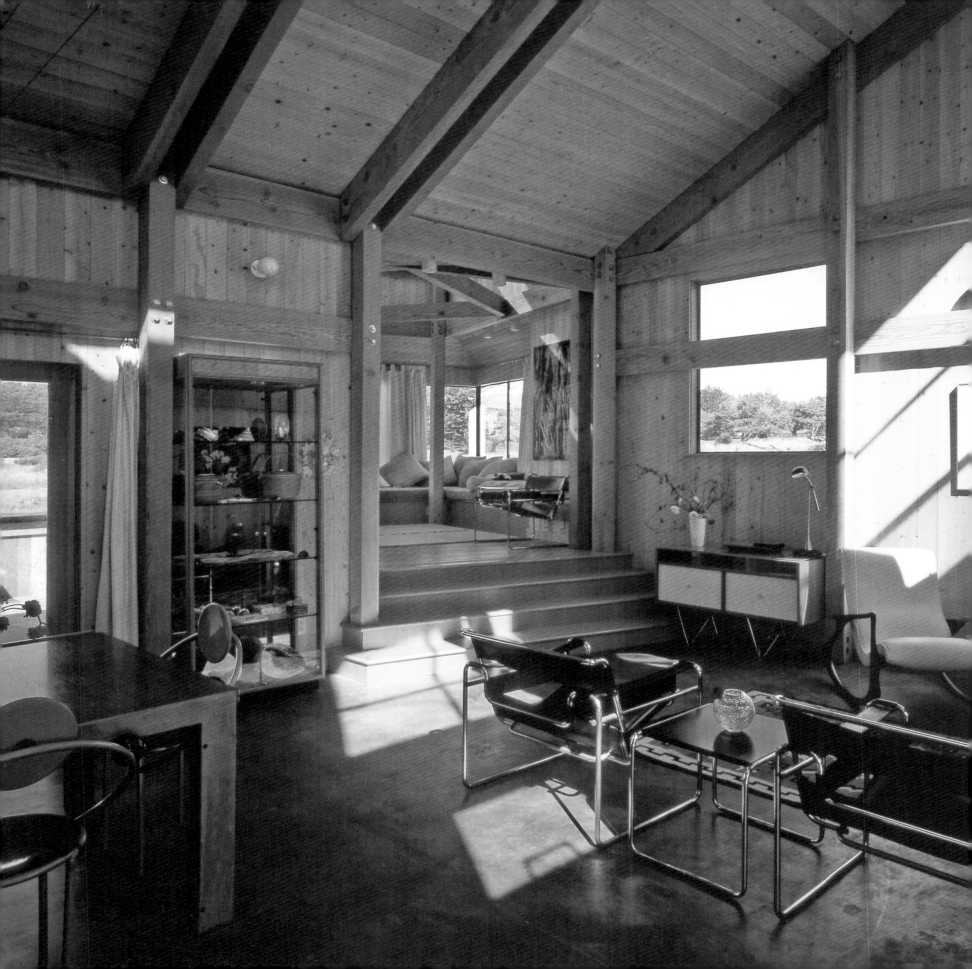

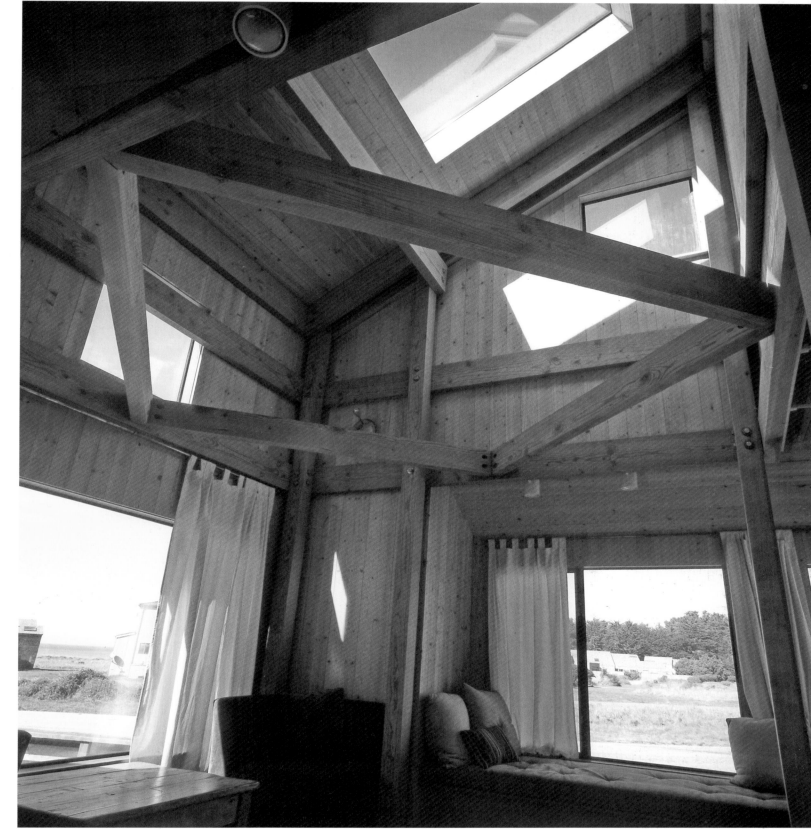

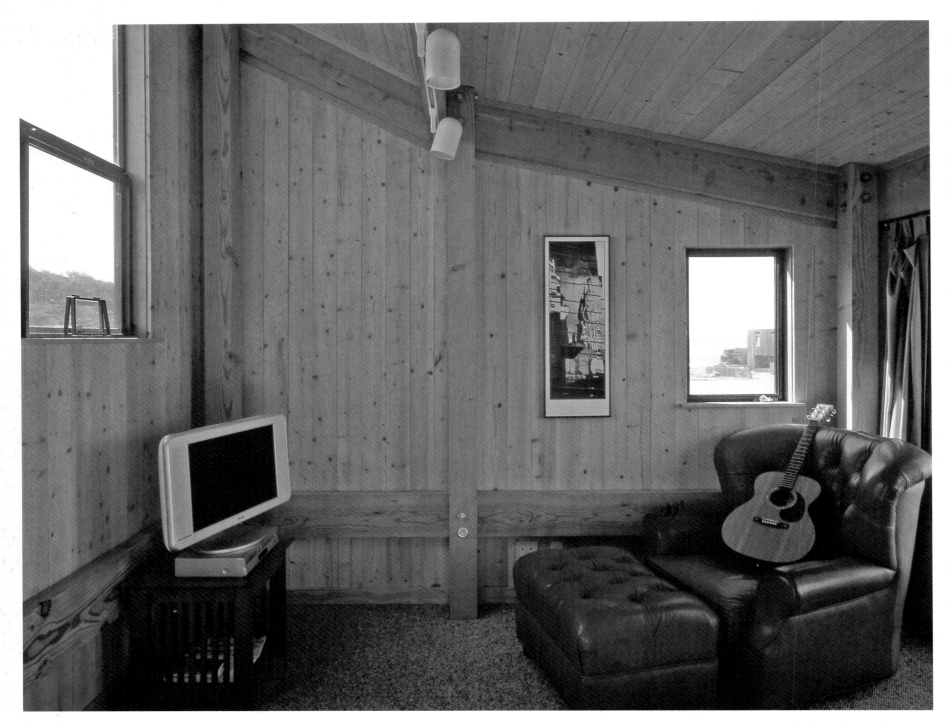

Above: The mezzanine-level study

Right: The master bedroom has a headboard niche that receives light (and ocean sound) from each side.

Following Pages: A view from the street at dusk with the guest area and garage to the left and master suite to the right

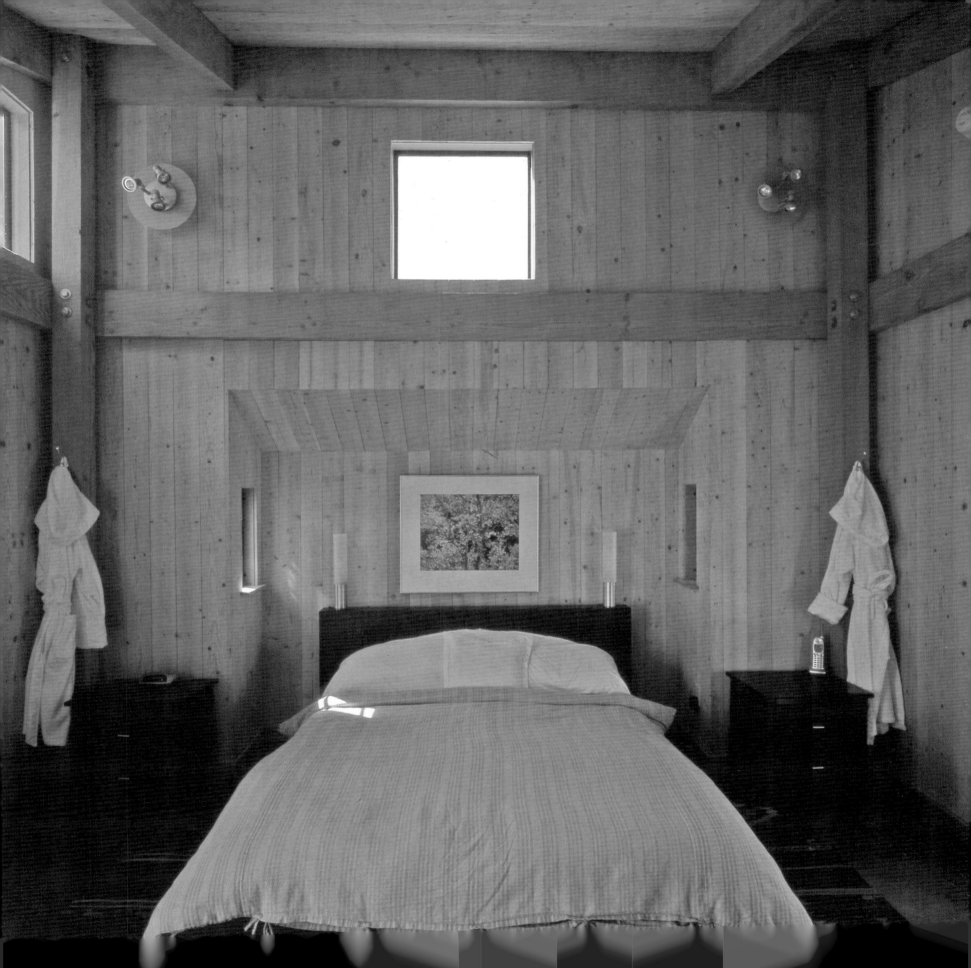

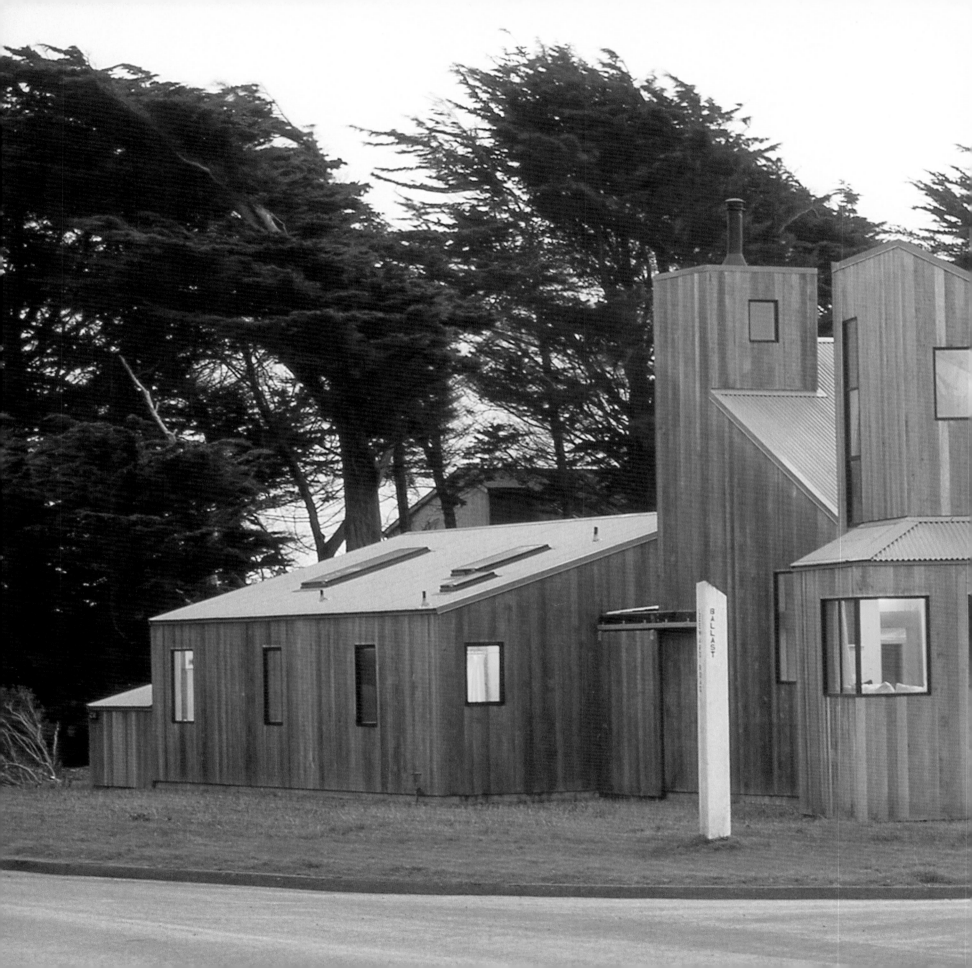

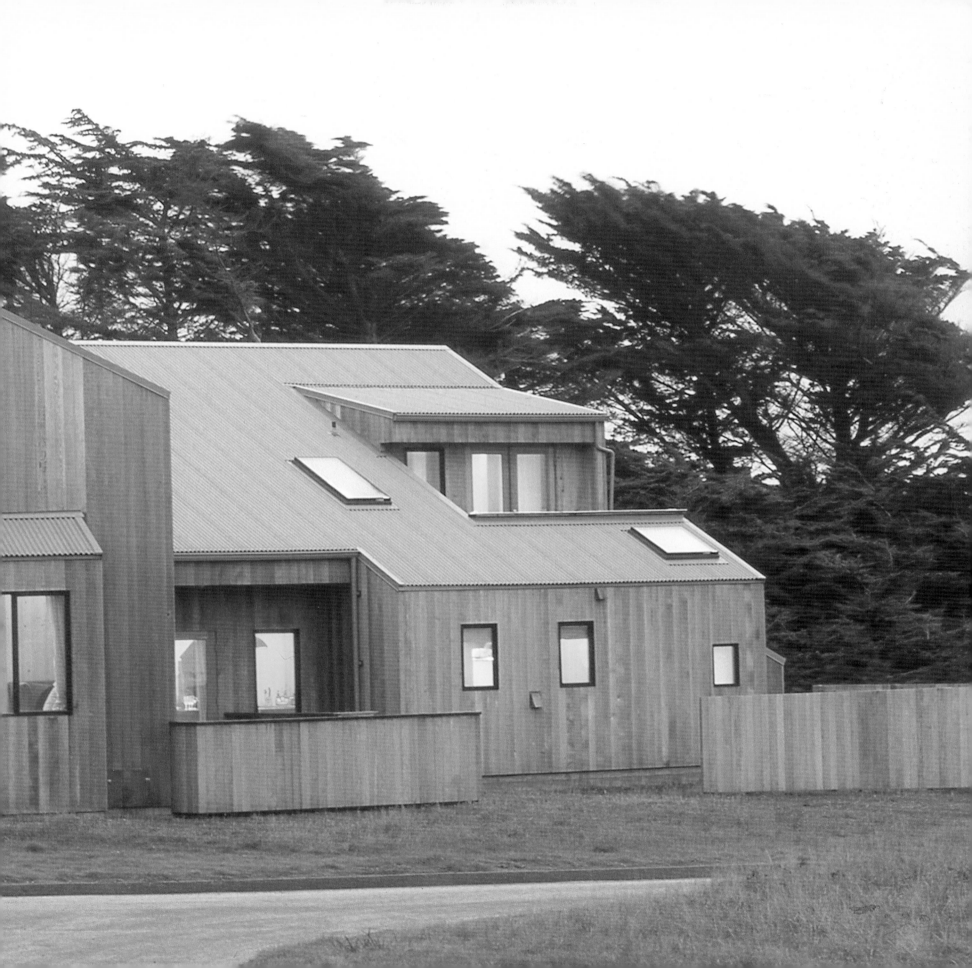

Pine Creek House

1500 Square Feet

Roger Ferris + Partners Architects
Photography: Woodruff & Brown

FACED WITH THE CHALLENGE OF DESIGNING A HOUSE ON AN UNUSUALLY NARROW PIECE OF WATERFRONT PROPERTY ON THE LONG ISLAND SOUND, THE ARCHITECT DREW SOME OF HIS INSPIRATION FROM BOATING AND BOAT SLIPS. THE TWO-STORY HOUSE TAKES ADVANTAGE OF SPECTACULAR WATER VIEWS WHILE PRESERVING PRIVACY FROM ADJACENT PROPERTIES. THE LOFT-LIKE INTERIOR SPACES ARE OPEN WITH CURTAIN WALLS OF GLASS AT BOTH ENDS OF THE HOUSE. SIDE WALLS WITH FEW OPENINGS PROVIDE A VISUAL BARRIER FROM NEIGHBORS.

THE HOUSE IS CLAD IN STAINED CYPRESS AT EITHER END, AND THE LOW, RECTANGULAR MIDSECTION IS CLAD IN CONTRASTING DARK CYPRESS. THIS AREA CONTAINS THE ENTRY HALL, STAIR, BATHROOMS, AND SUPPORT SPACES ON BOTH LEVELS. THE END ROOMS HAVE VIEWS OF THE WATER TO THE SOUTH AND INLAND TO THE NORTH. THE WINDOWS HAVE RETRACTABLE SHADES FOR SCREENING FOR SUN CONTROL AND PRIVACY. HORIZONTAL CYPRESS LOUVERS PROVIDE THE BEDROOMS WITH ADDITIONAL PROTECTION.

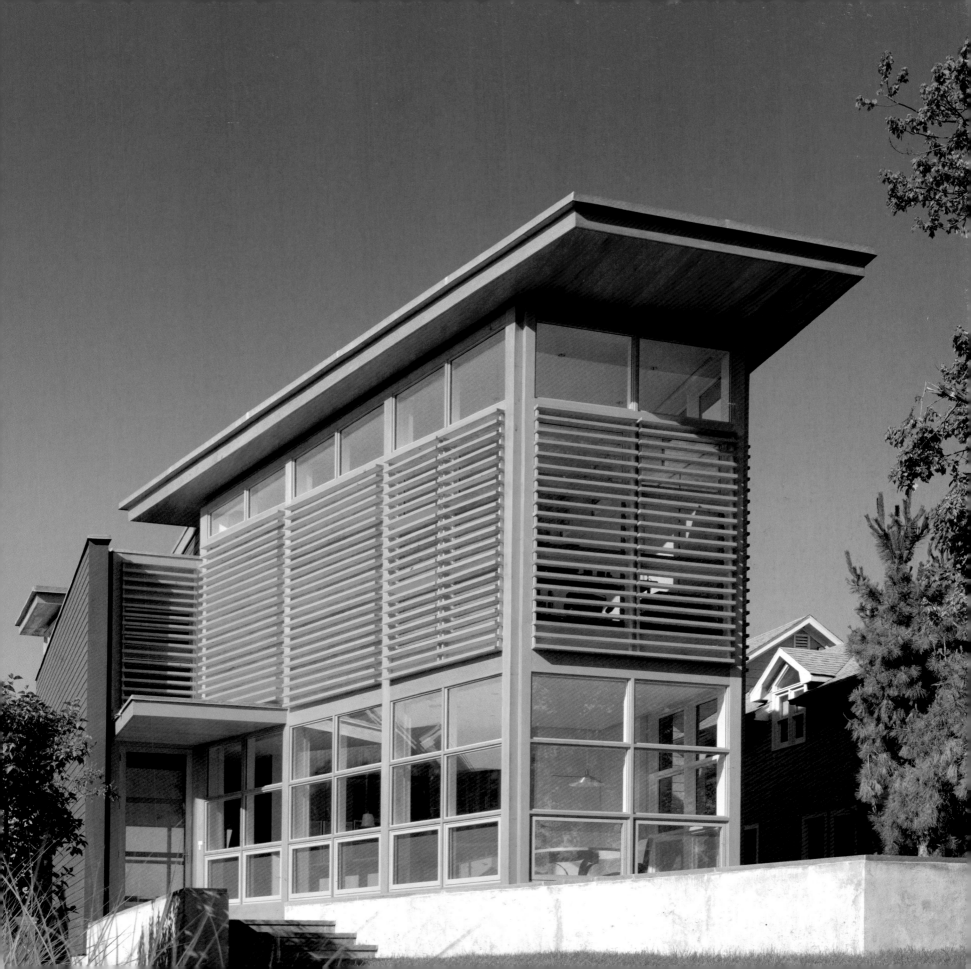

Second Floor Plan

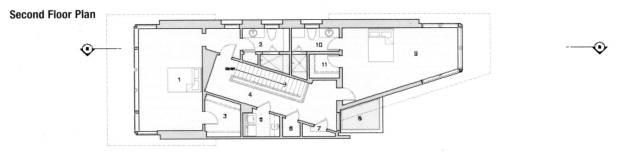

1. Master Bedroom
2. Master Bathroom
3. Master Closet
4. Stair Hall
5. Laundry
6. Closet
7. Linen
8. Roof Below
9. Bedroom
10. Bathroom
11. Closet

0 2 5 15

First Floor Plan

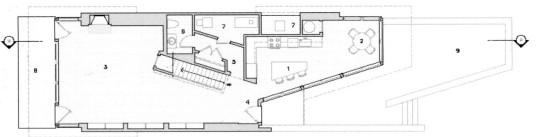

1. Kitchen
2. Dining Room
3. Living Room
4. Entry
5. Hall
6. Powder Room
7. Mechanical
8. Wood Deck
9. Lawn Terrace

0 2 5 15

Section A

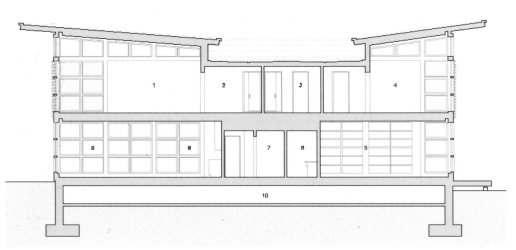

Previous Pages: The angled wood-framed glass wall on the north elevation leads to the front door at the midpoint of the house.
Right: The living area and master bedroom above have wide views of the Sound.

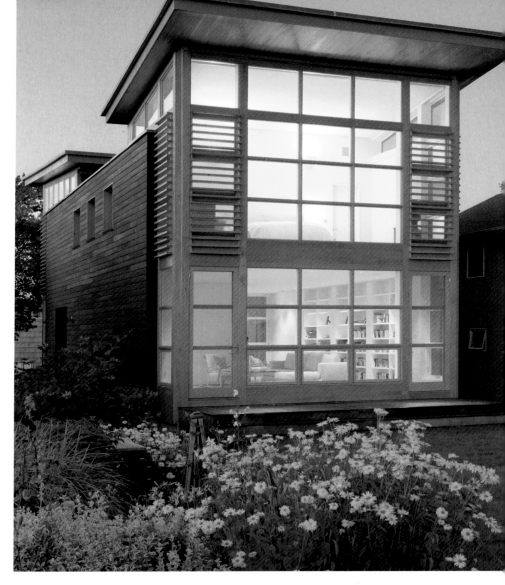

Site Plan

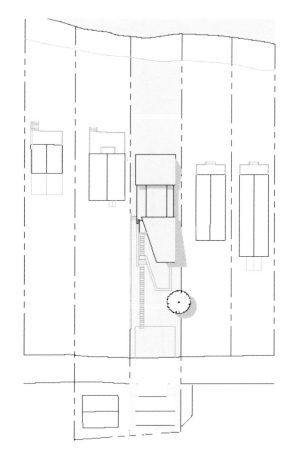

West Elevation

North Elevation

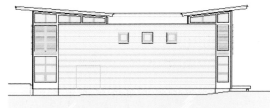
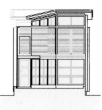

East Elevation

South Elevation

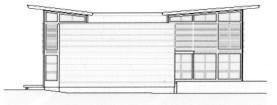

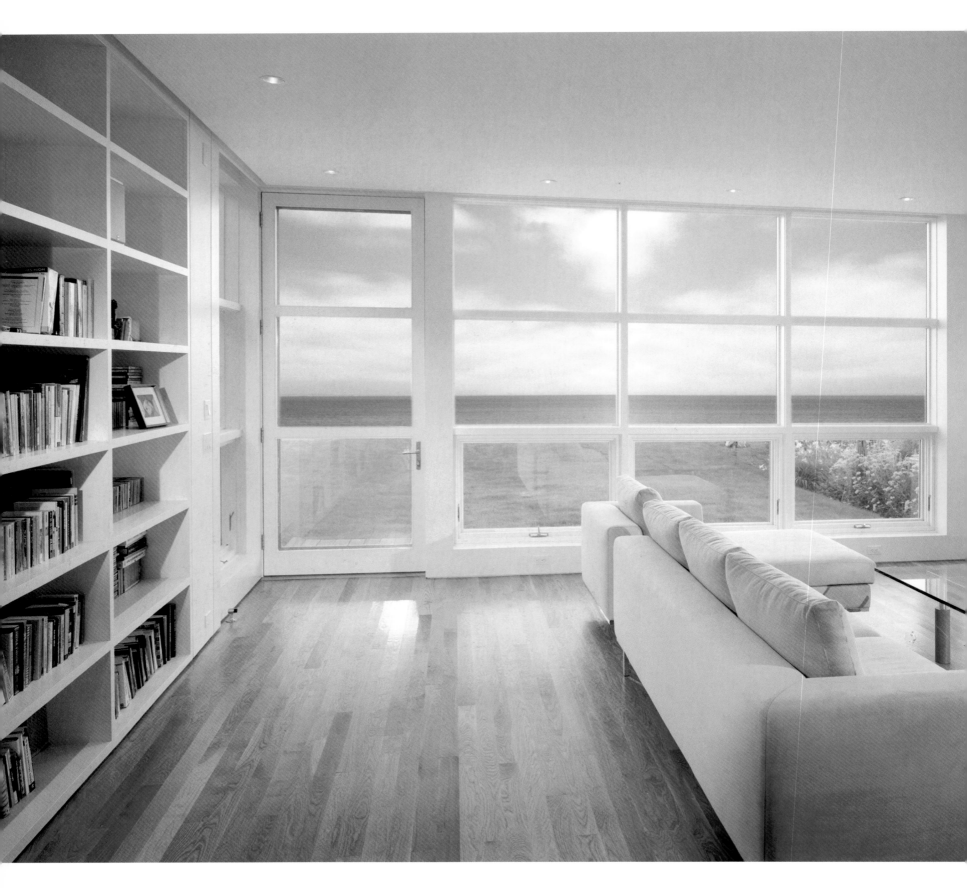

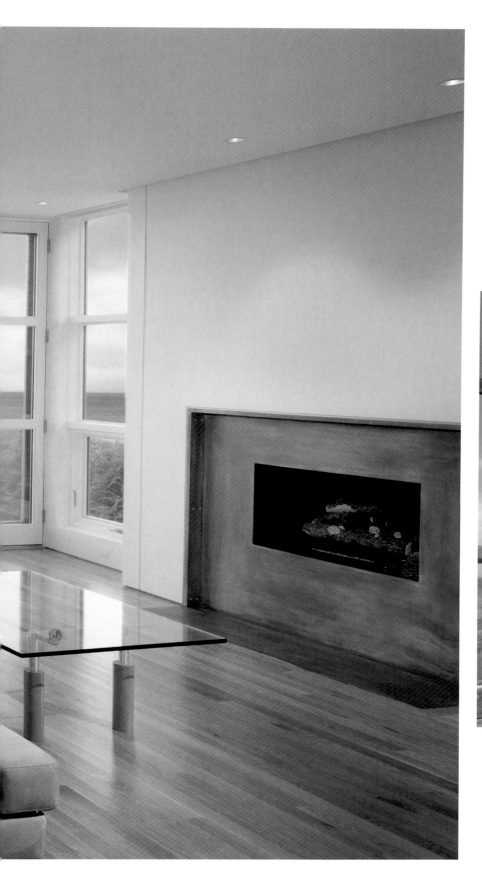

Left: White oak floors were used in the living room and elsewhere in the house.
Below: A view from the master bedroom

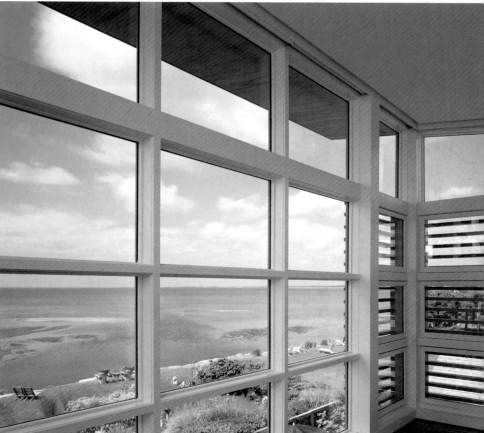

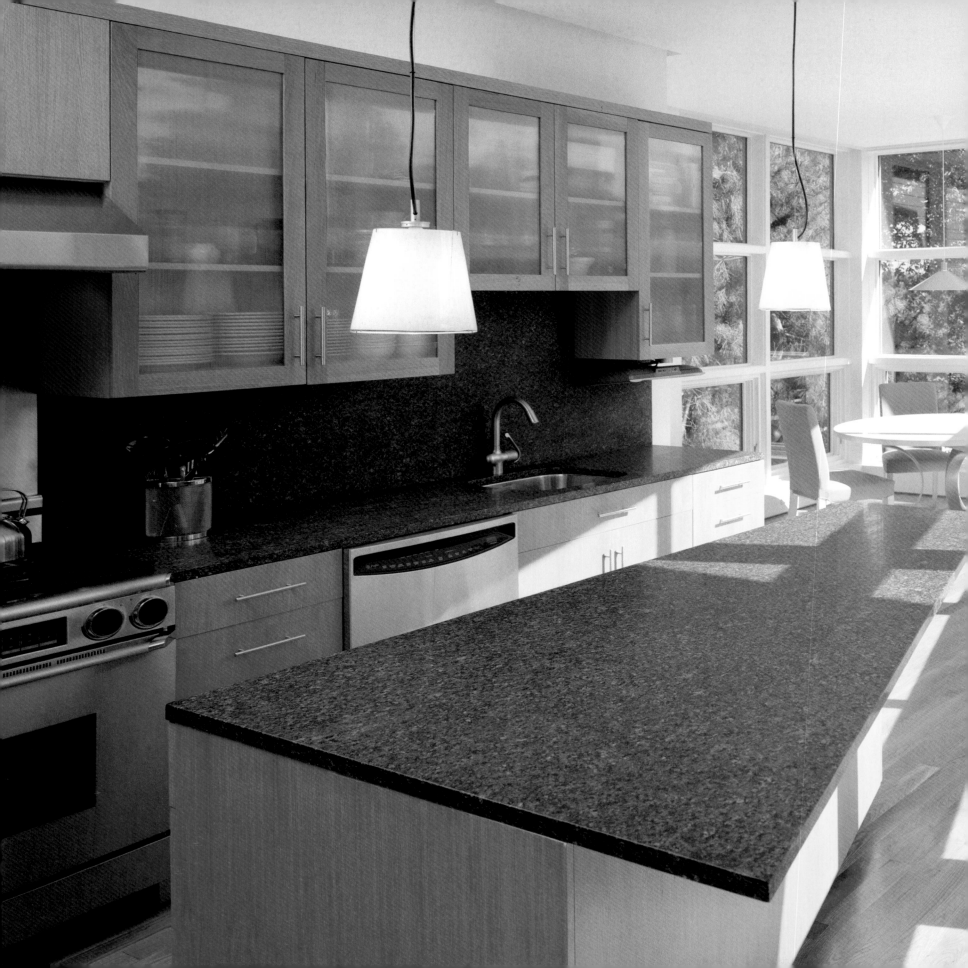

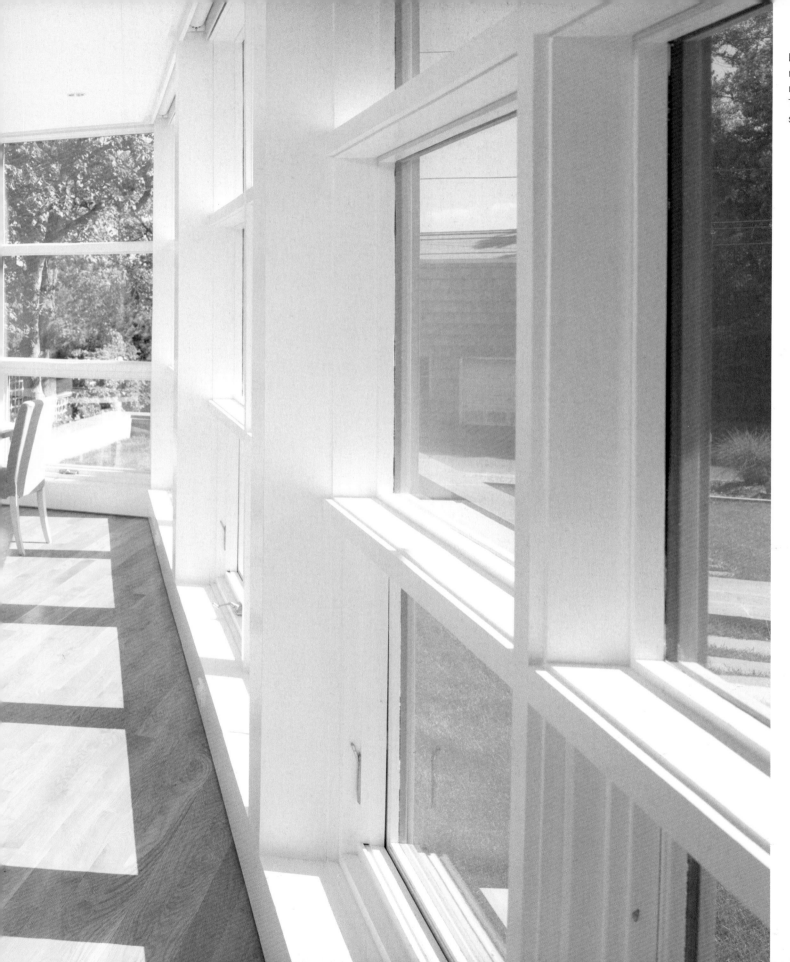

Dilworth House

2600 Square Feet

Leslie Gallery-Dilworth, Craig Hoopes, Architects
Photography: Wyatt Gallery

THE OWNERS, ONE OF WHOM IS AN ARCHITECT, PURCHASED THIS 5-ACRE LOT NEAR SANTA FE SEVERAL YEARS AGO WHILE ON THEIR HONEYMOON PLANNING ONE DAY TO BUILD THEIR DREAM HOME.

THE JUST COMPLETED RESULT IS A TIGHT VILLAGE-LIKE COMPOUND CONSISTING OF A LARGE OPEN LIVING, DINING, KITCHEN AREA; A MASTER BEDROOM WING; GUEST QUARTERS; AND A GARAGE WITH HOME OFFICE. A TRIANGULAR INDOOR GATHERING SPACE UNIFIES THEM AND ACTS AS A HUB. IN ORDER TO CONTAIN COSTS AND SQUARE FOOTAGE, THE HOUSE IS DESIGNED WITH NO HALLS AND EVERY WALL IS EFFICIENTLY UTILIZED, EITHER FOR HANGING THE COUPLE'S ART COLLECTION OR FOR THEIR SIZABLE LIBRARY. THERE IS NO ATTIC, BASEMENT, OR LARGE STORAGE ROOM.

CARE WAS TAKEN TO DESIGN THE HOUSE SO THAT IT SITS COMFORTABLY AND UNOBTRUSIVELY WITHIN THE RUGGED DESERT LANDSCAPE. THE HOME BOASTS A NUMBER OF SUSTAINABLE FEATURES INCLUDING RADIANT HEATING AND CROSS-VENTILATION AND CEILING FANS FOR COOLING.

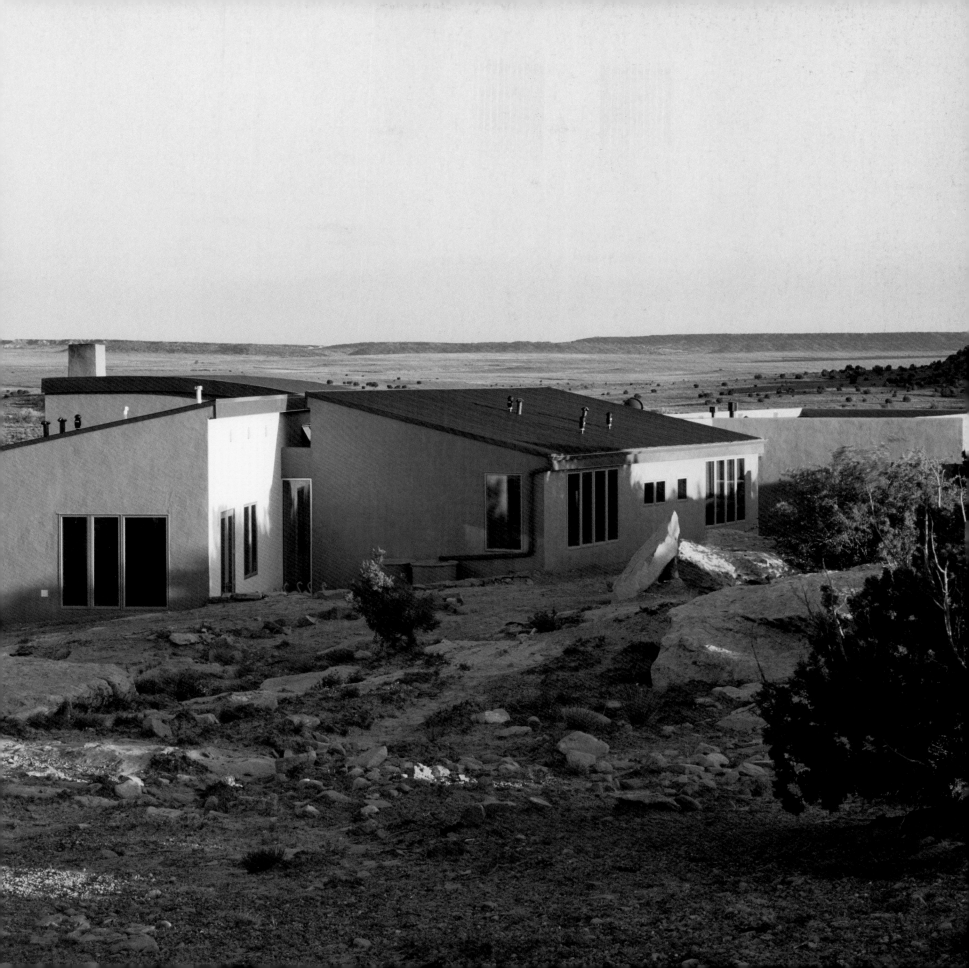

Floor Plan

1 Garage
2 Entry Hall
3 Courtyard & Pool
4 Living
5 Portal
6 Patio
7 Library
8 Guest Bedroom
9 Guest Bedroom
10 River Rock Court
11 Master Bedroom
12 Master Bathroom
13 Portal

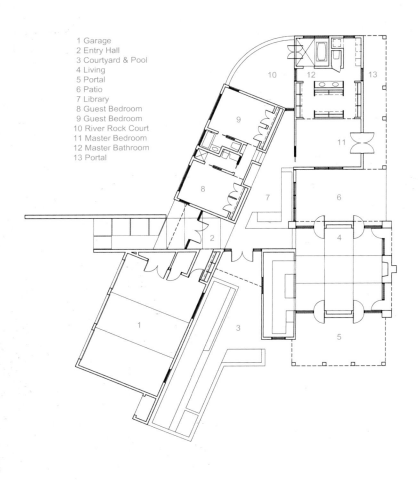

Elevation

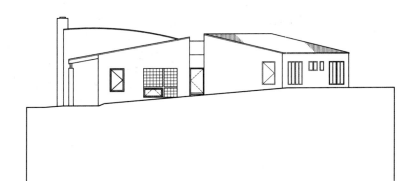

Section

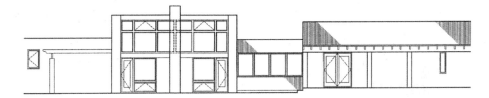

Site Plan

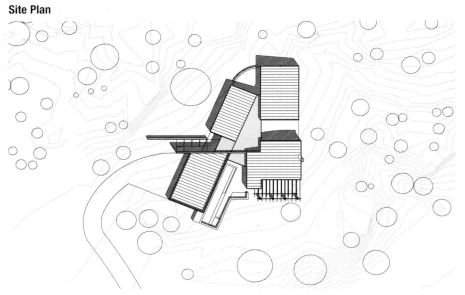

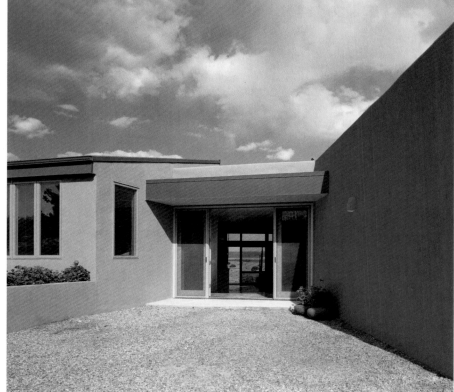

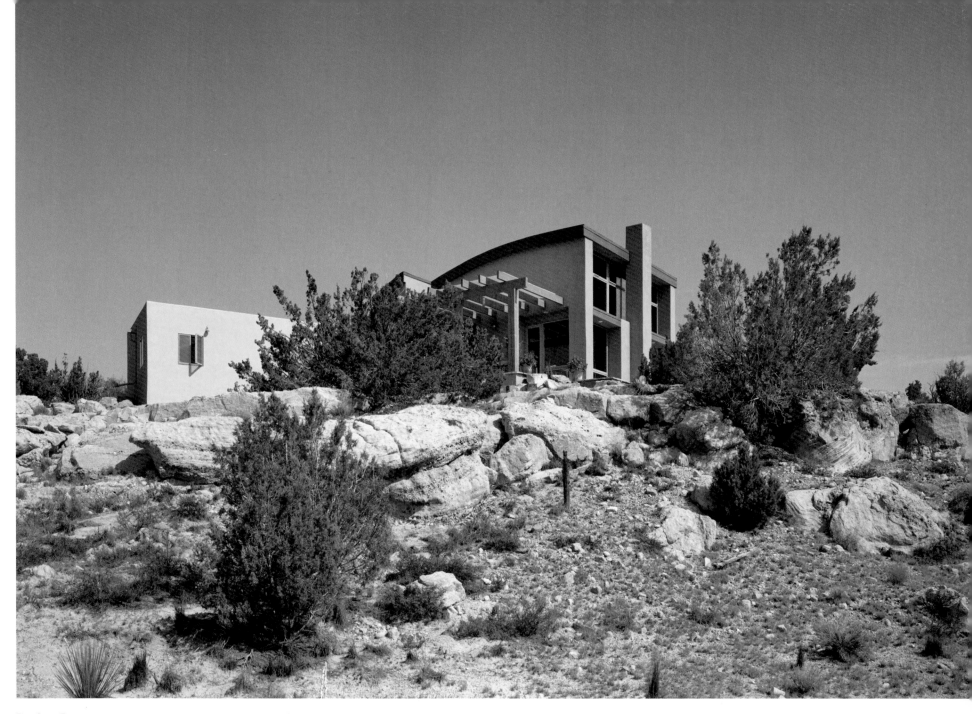

Previous Pages:
The house is wood-frame
construction with stucco
on a concrete slab.
Left: The entry

Above: Corrugated roofs
on the bedroom wings
and the living room are
sloped and drain into a
water catchment system
where the water is used
for the garden and a
to-be-built lap pool.

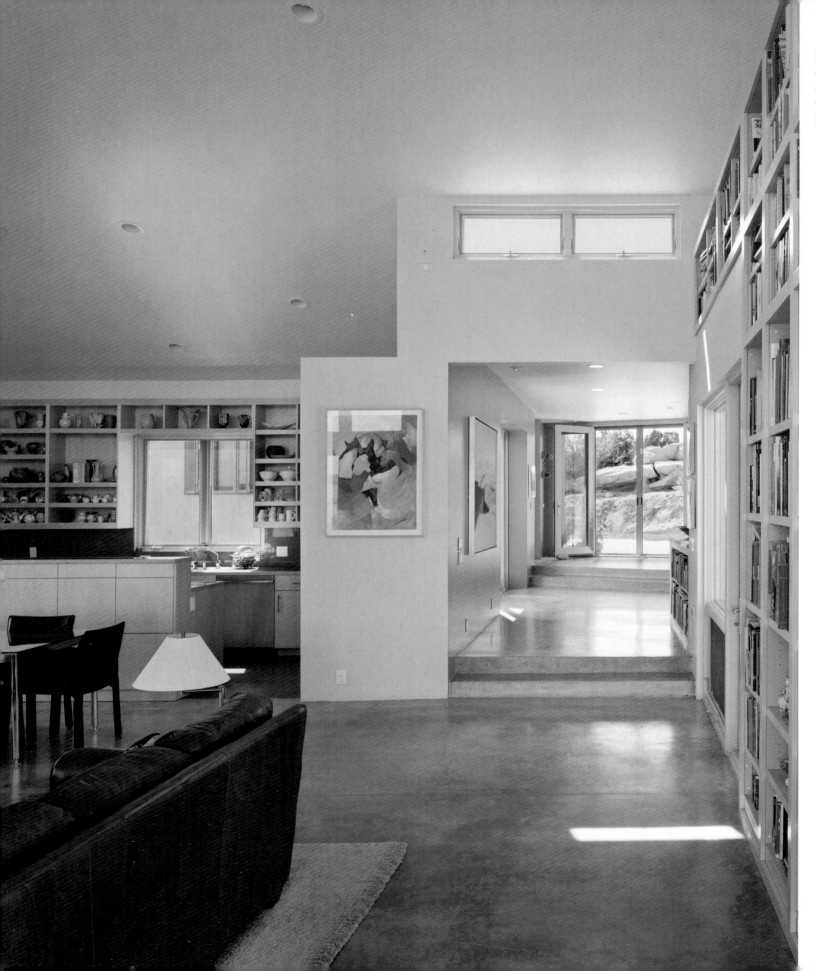

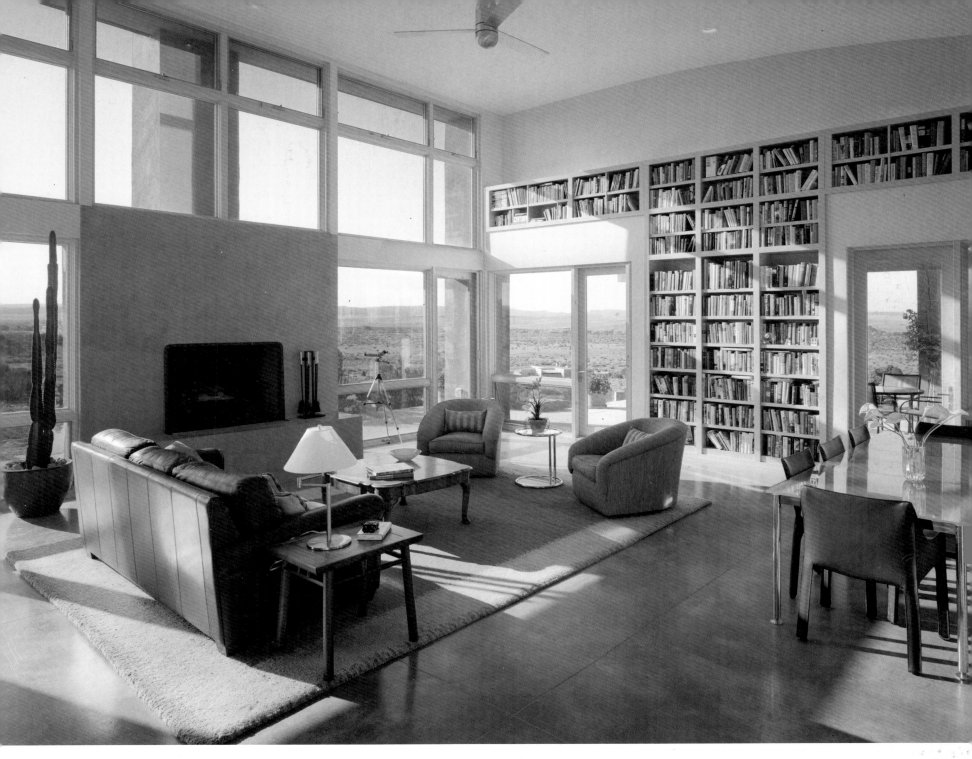

Above: Walls surrounding the living area have built-in bookcases where the ceilings soar to 18 feet.

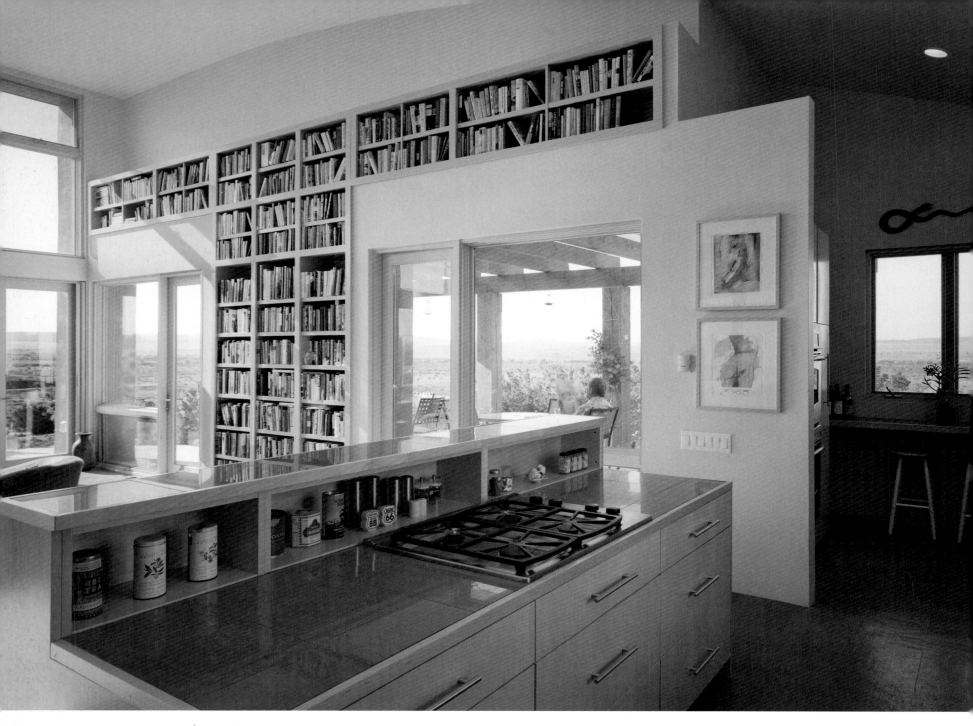

Above and Right: All of the cabinetry in the house, including the bookshelves, are wheatboard with maple veneer from certified forests. The open kitchen was designed to fit unobtrusively within the living area.

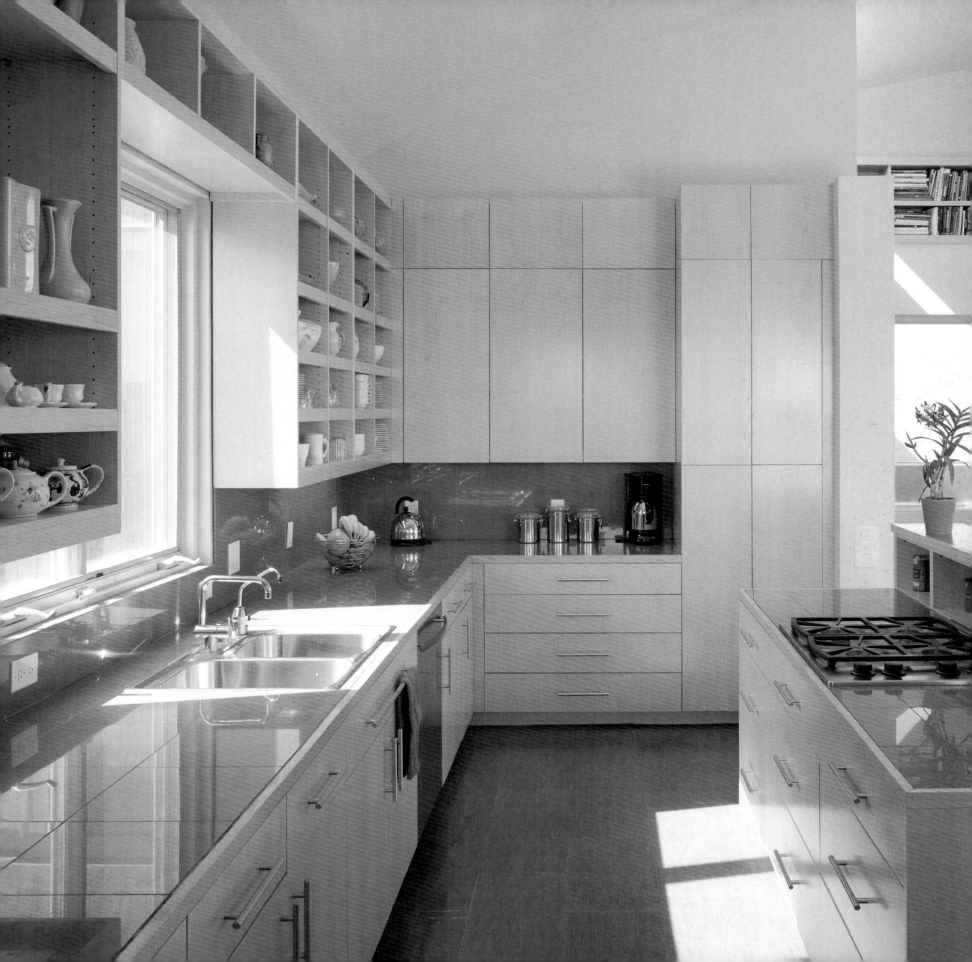

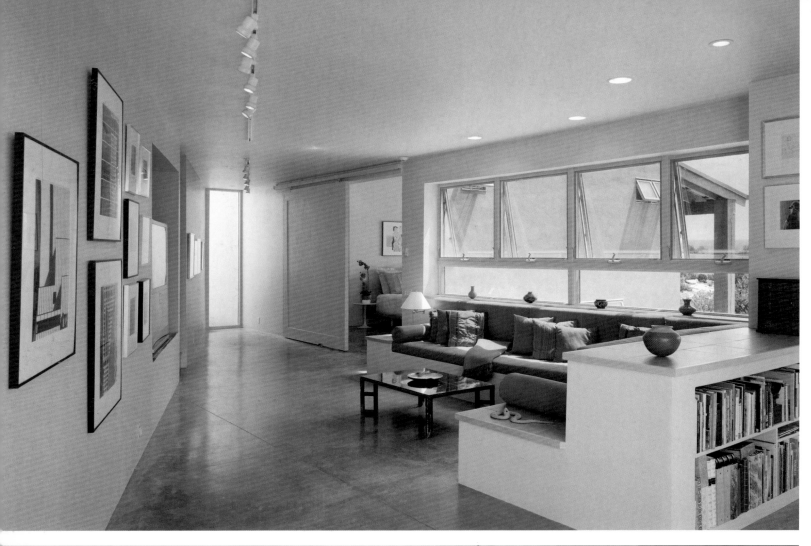

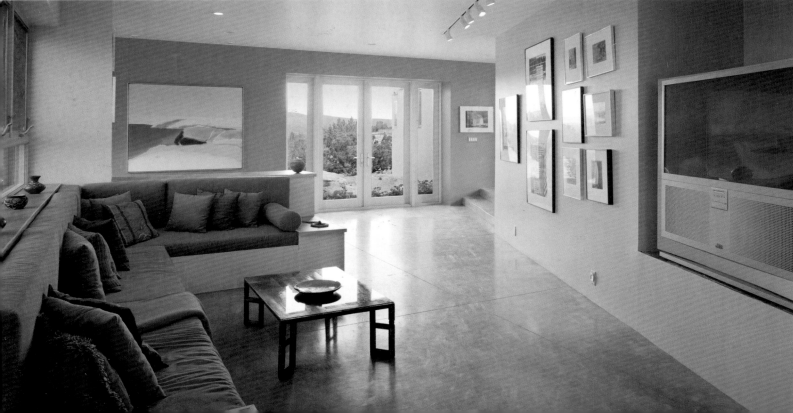

Left and Below Left: The triangular heart of the house from which all activities radiate

Above Right: A sliding barn door connects the master bedroom to the triangular hub.

Below Right: French doors in the master bathroom open directly to a private walled garden.

Following Pages: The living room side of the house as viewed from the valley

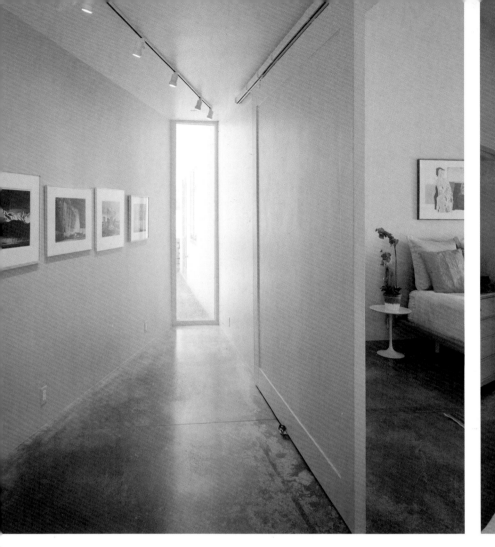
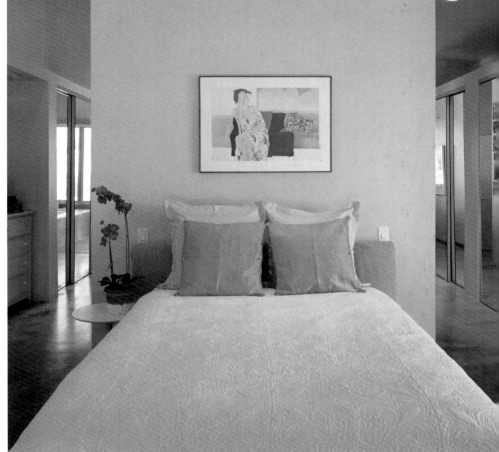
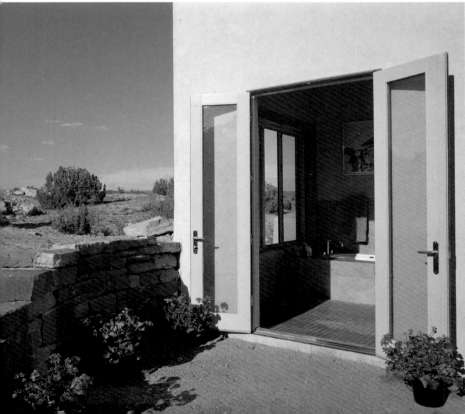
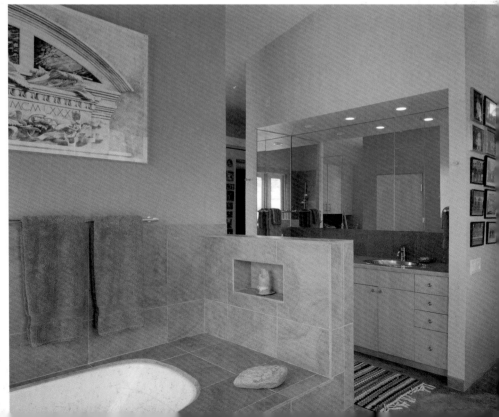

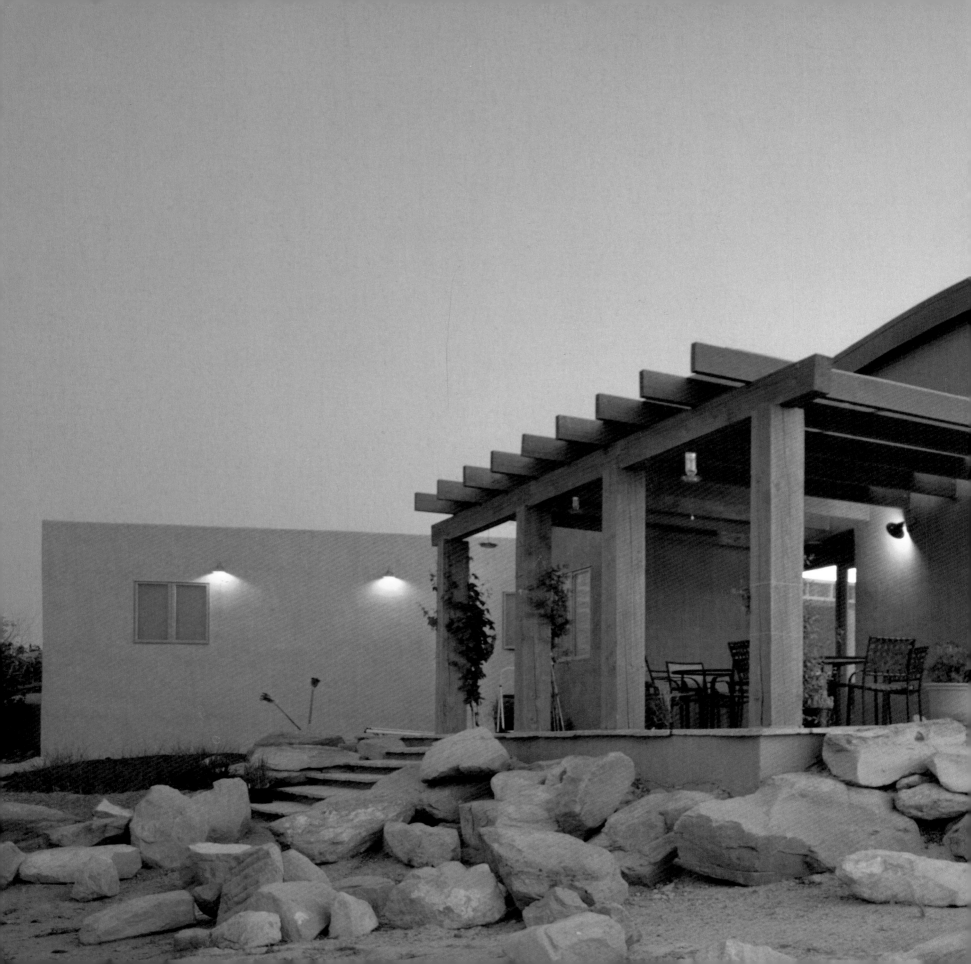

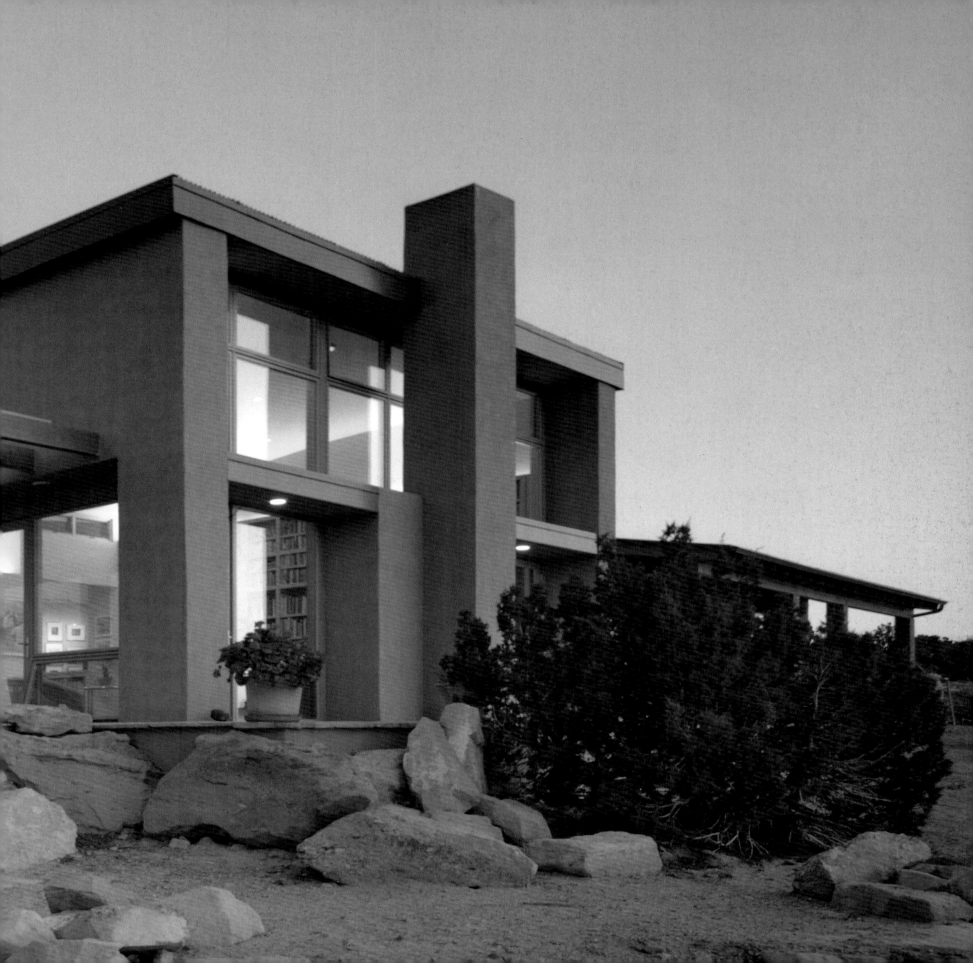

Hillsdale House

2400 Square Feet

Andrew Berman Architect
Photography: Victoria Samburnais

Situated on a hilltop with panoramic views west and north over the Hudson River Valley, this second home is organized as two wings on either side of a breezeway. The main wing has a large open space for the living, dining, and kitchen areas. A wall of concealed storage separates this open space from the master bedroom and a guest room.

A den, two bedrooms, and utility spaces are in the smaller wing. The den and living area open onto an exterior patio. Consideration of natural lighting, views of the landscape, and cross-ventilation guided the positioning of windows and the roof planes.

The wood-framed building is sheathed in corrugated and flat-panel aluminum because it is low maintenance and it also acts as a subtle mirror of the landscape, responding to the shifting light and colors of the land and sky.

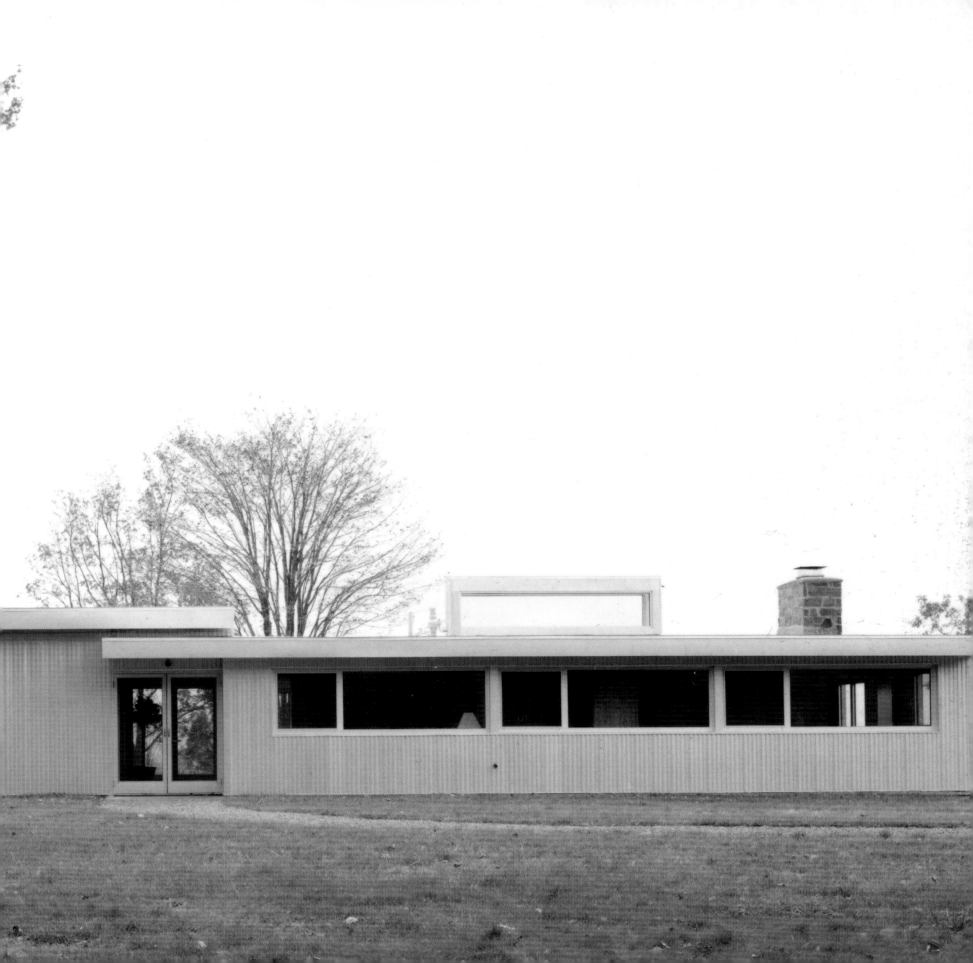

Floor Plan

Previous Pages and Below
Right: The living area opens onto a large patio.
Right: The entry façade

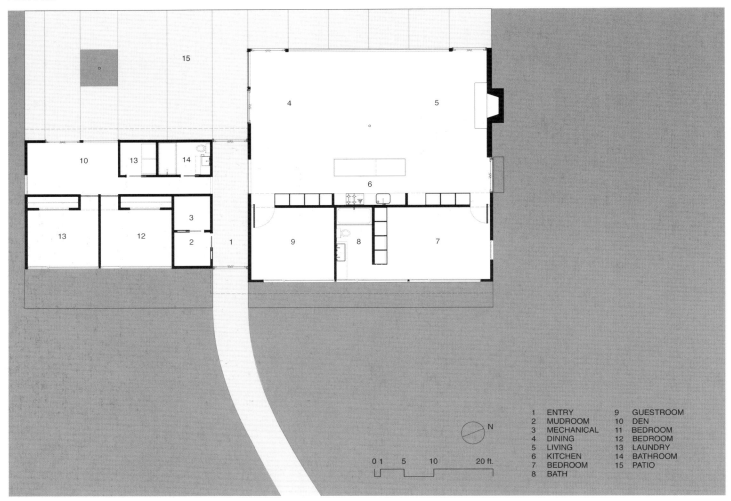

1	ENTRY	9	GUESTROOM
2	MUDROOM	10	DEN
3	MECHANICAL	11	BEDROOM
4	DINING	12	BEDROOM
5	LIVING	13	LAUNDRY
6	KITCHEN	14	BATHROOM
7	BEDROOM	15	PATIO
8	BATH		

N

0 1 5 10 20 ft.

Section

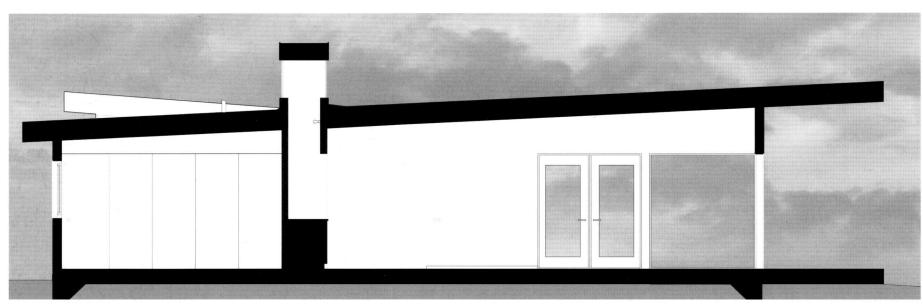

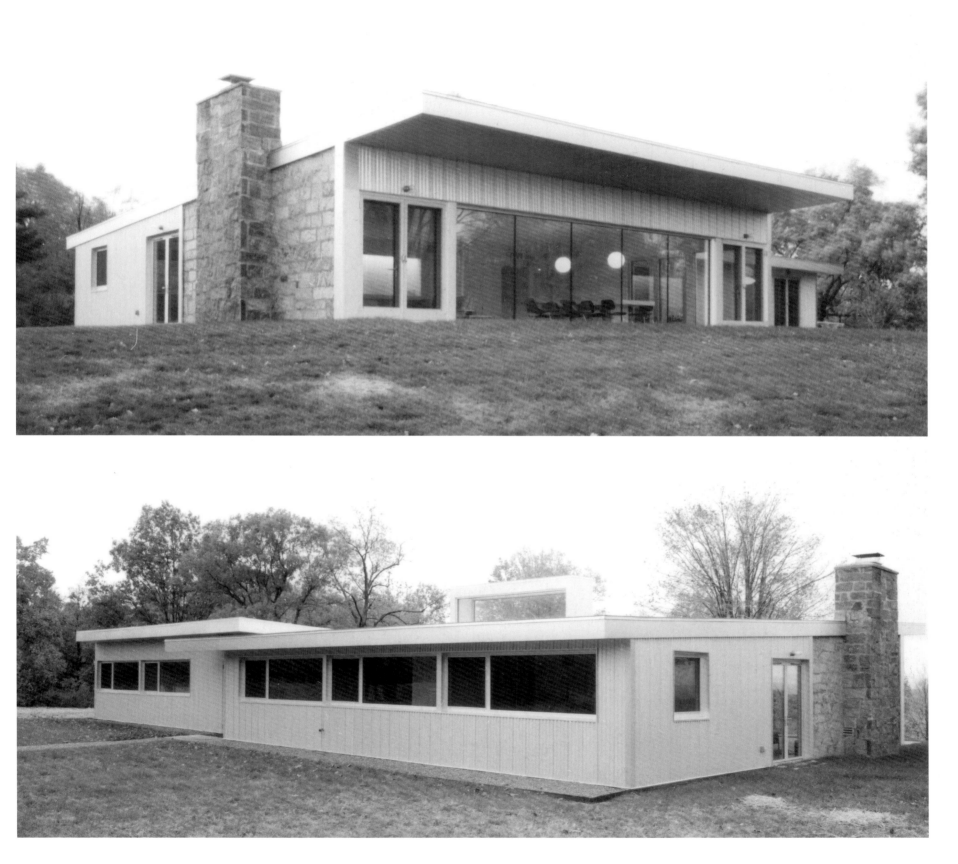

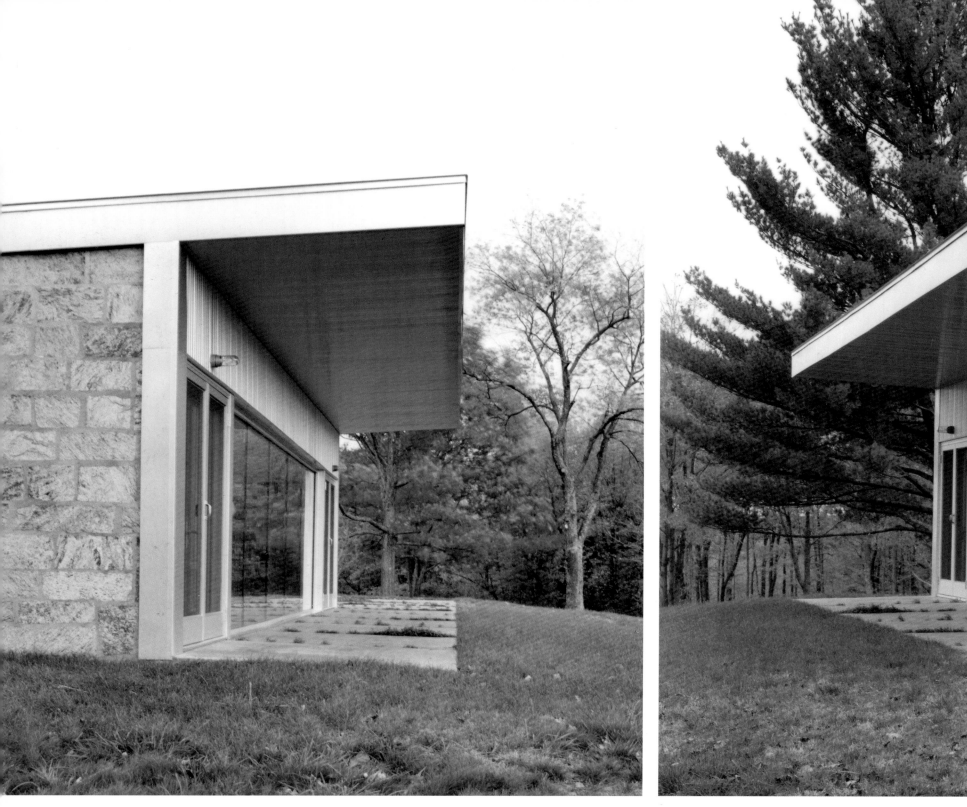

Above Left and Left:
The exterior is sheathed
in aluminum.

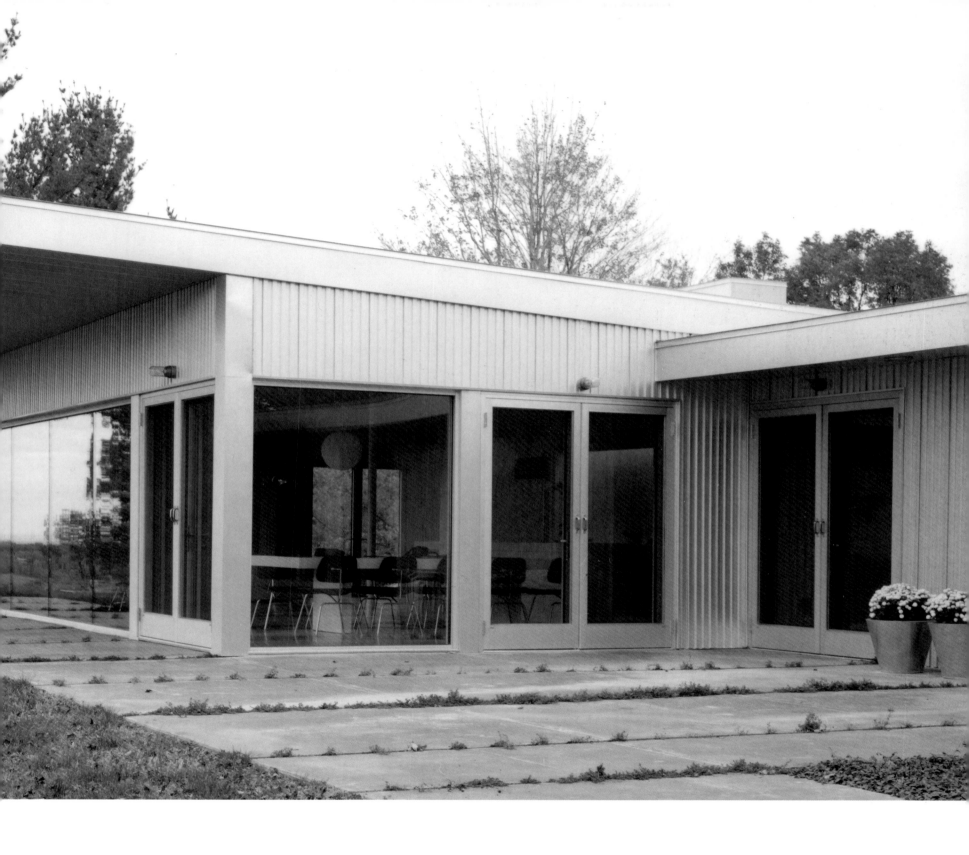

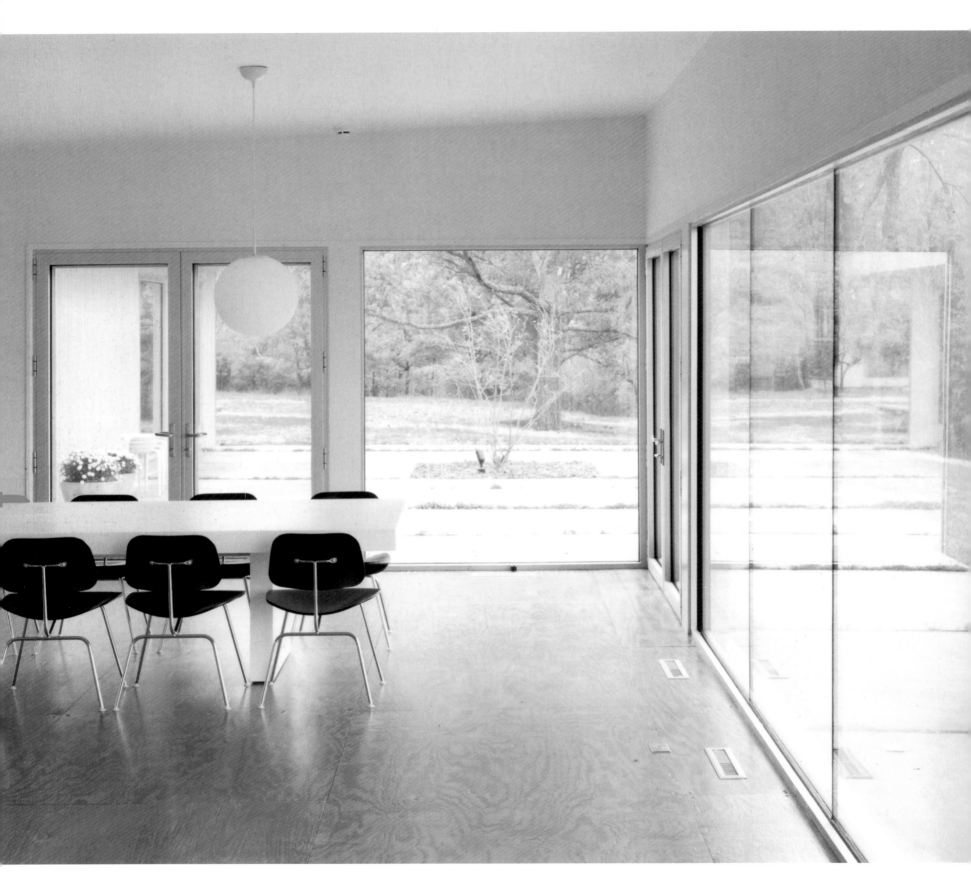

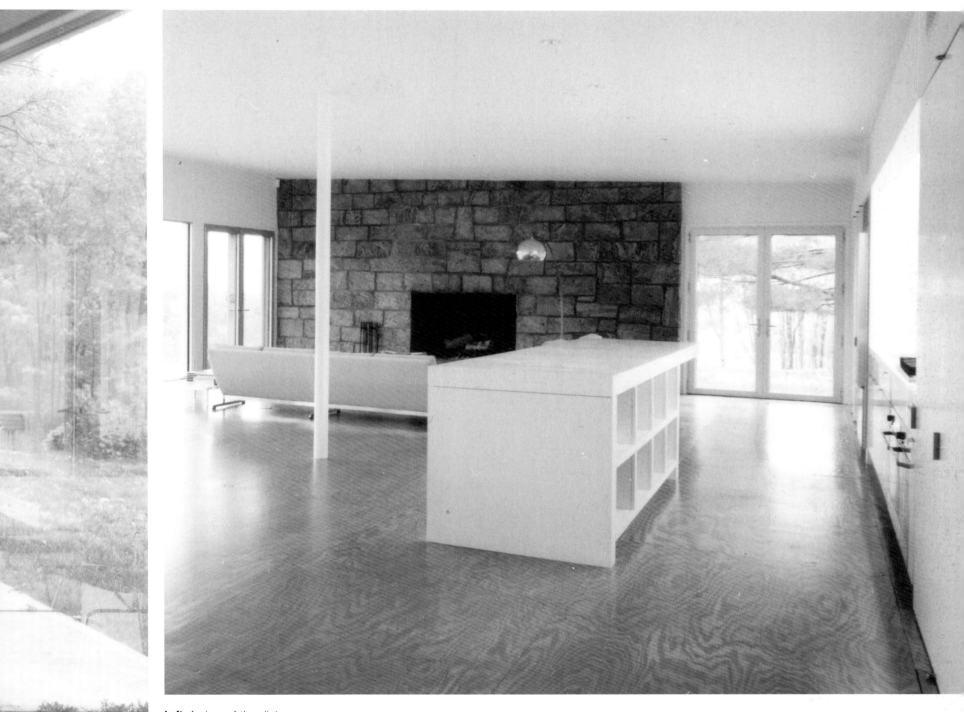

Left: A view of the dining area and patio with the smaller wing containing guest bedrooms to the left
Above: The living area as seen from the kitchen; the floors are inexpensive sheet plywood.

Above: An island separates the kitchen from the living area.
Right: From the kitchen, a view of the breezeway and guest bedroom wing beyond

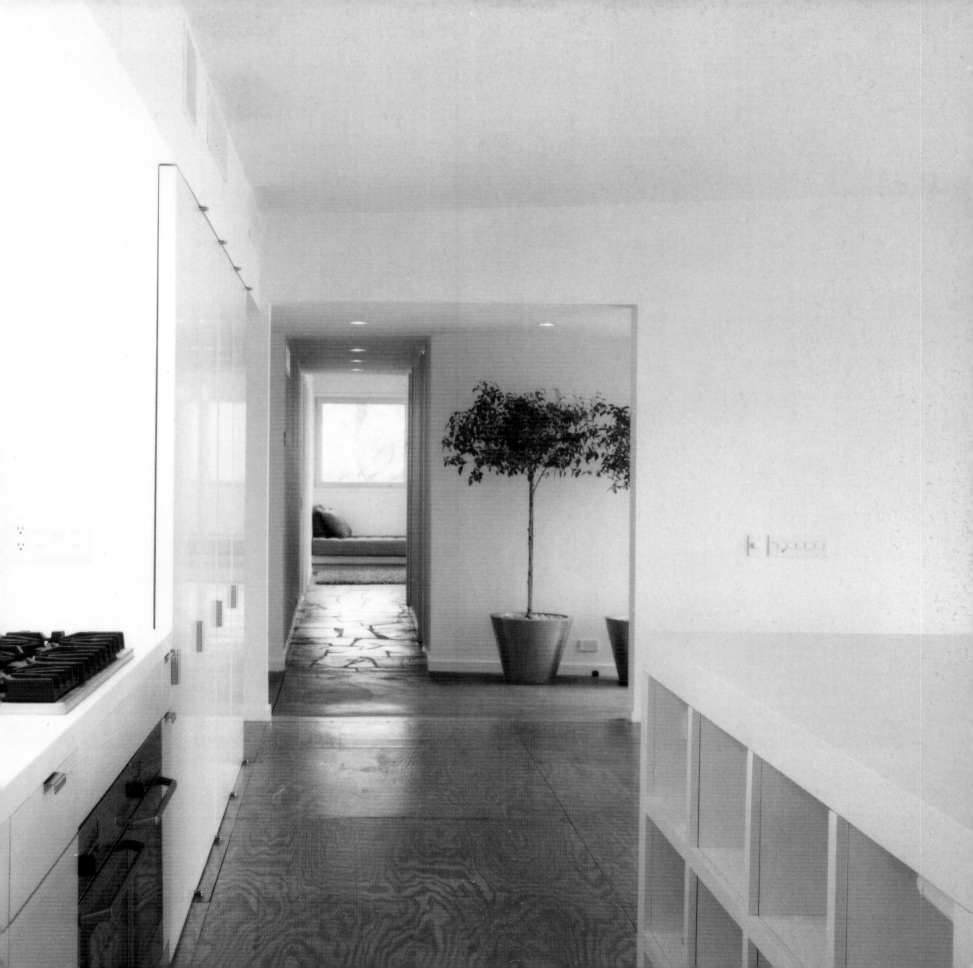

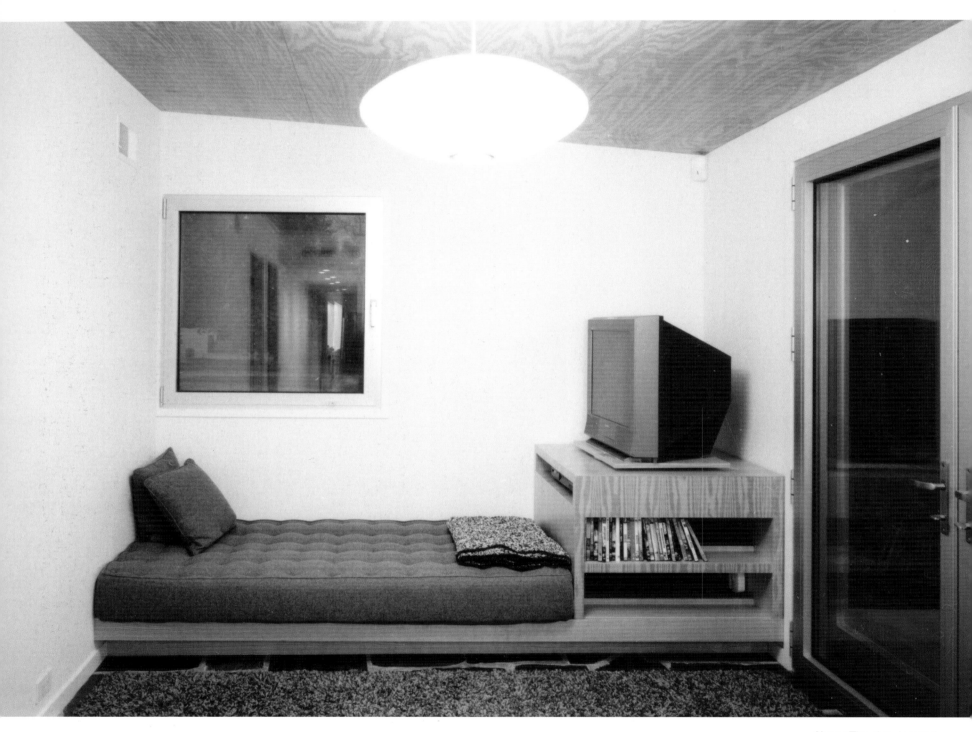

Above: The den, located in the guest wing, opens onto the patio.
Right: A view from the master bedroom to the master bathroom

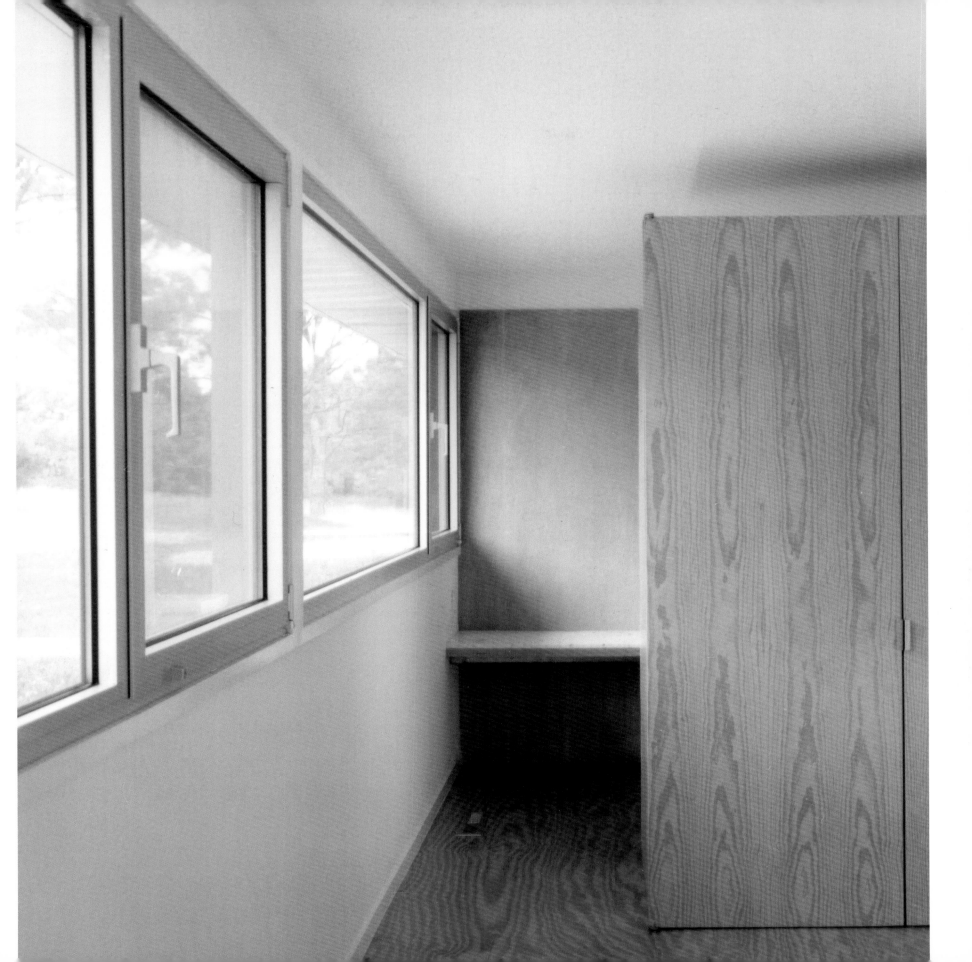

Casa Max

2350 Square Feet

Architects Magnus
Photography: David Hewitt and Anne Garrison

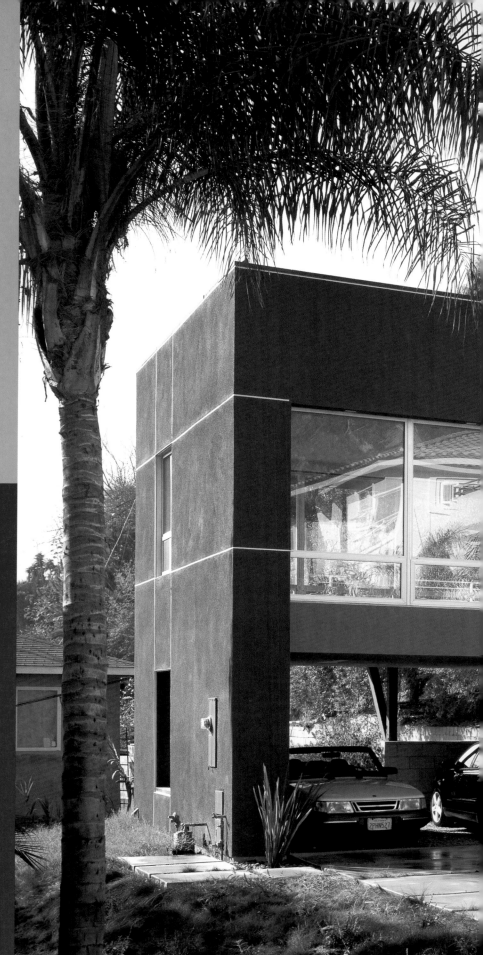

THE INSPIRATION FOR THE DESIGN OF THIS DWELLING, LOCATED ON A HILLSIDE IN SAN DIEGO, WAS TO CREATE A HOME THAT CAPTURED THE TWO DIFFERENT CULTURAL IDENTITIES OF THE OWNER/ARCHITECTS. THE PLASTER WALLS AND THE NATURAL COLORS REFLECT ONE OWNER'S MEXICAN HERITAGE. THE CENTRAL OPEN ATRIUM WITH A ROCK GARDEN RECALLS THE JAPANESE CULTURE OF THE OTHER.

THE ENTRANCE IS LOCATED AT THE BASE OF A THREE-STORY TOWER WHERE A STUDIO, WINE CELLAR/STORAGE, AND A GUEST BEDROOM SUITE ARE LOCATED. THIS LEVEL IS MADE OF EXPOSED CONCRETE BLOCK THAT ANCHORS THE BUILDING INTO THE HILLSIDE. ON THE SECOND LEVEL IS AN OPEN LIVING, DINING, AND KITCHEN AREA AND A SECOND BEDROOM SUITE. EXTENSIVE GLAZING ON THIS LEVEL BRINGS IN LIGHT FROM ALL SIDES. THE MASTER SUITE IS LOCATED ON THE THIRD FLOOR WITH A PRIVATE DECK OFFERING VIEWS OF AN ADJACENT CANYON AND DOWNTOWN SAN DIEGO.

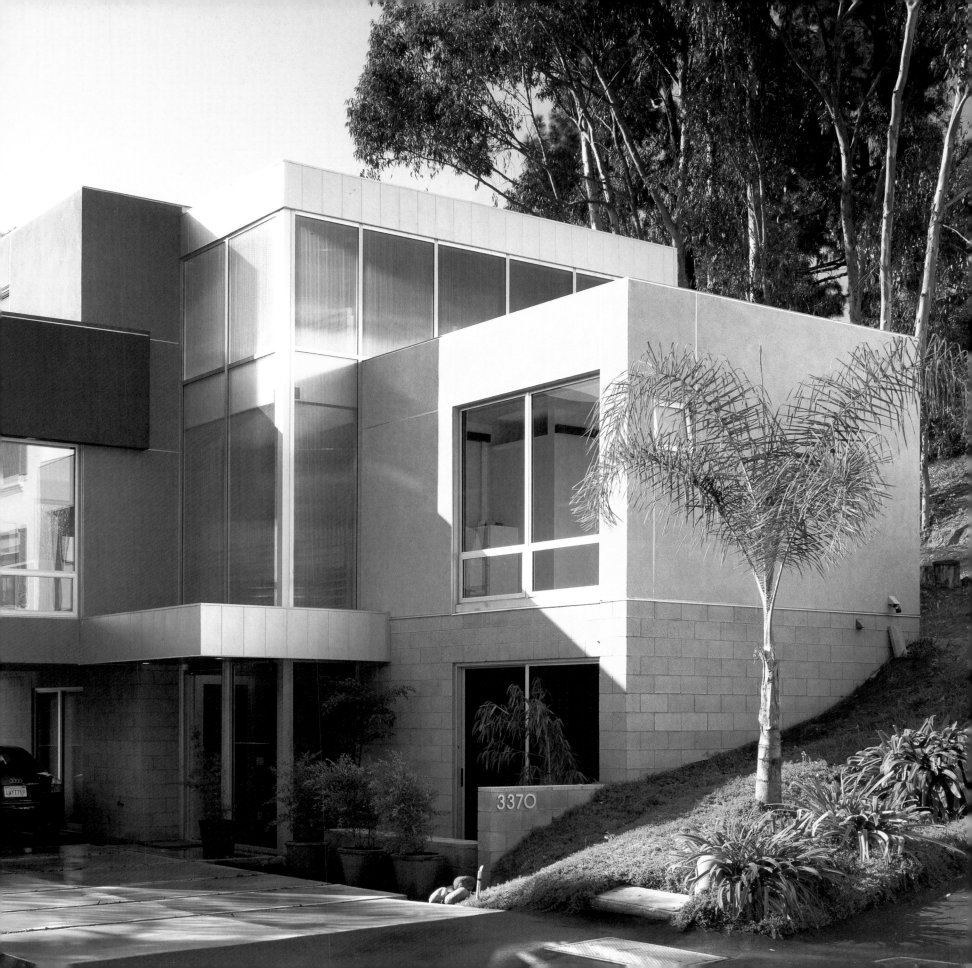

Upper Level

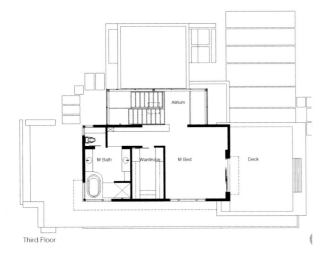

Atrium

M Bath Wardrobe M Bed Deck

Third Floor

Main Level

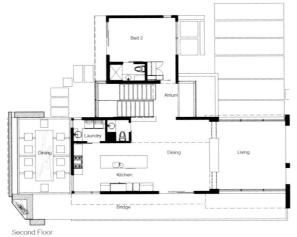

Bed 2

Atrium

Laundry

Dining

Kitchen

Dining Living

Bridge

Second Floor

Ground Level

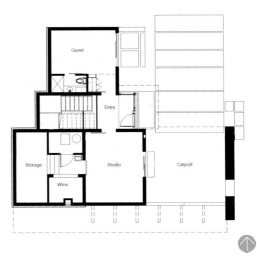

Guest

Entry

Storage Studio Carport

Wine

Sections

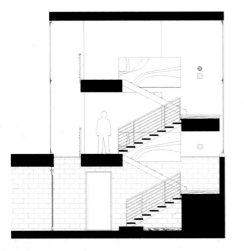

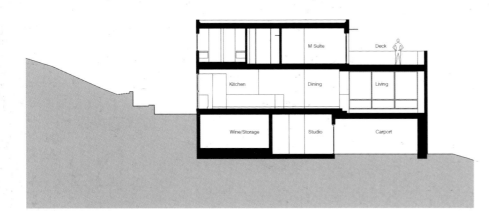

M Suite Deck

Kitchen Dining Living

Wine/Storage Studio Carport

Previous Pages and Right: Extensive polycarbonate glazing creates a diffused, soft light that fills the home during daytime.

Below: A Japanese rock garden greets visitors at the entrance.

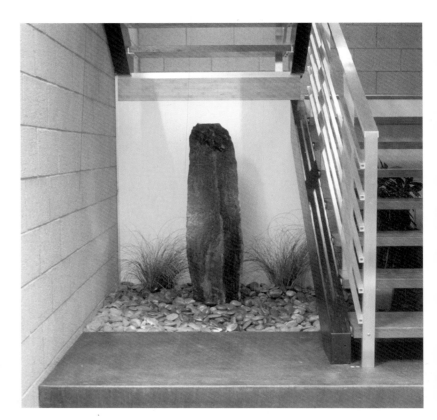

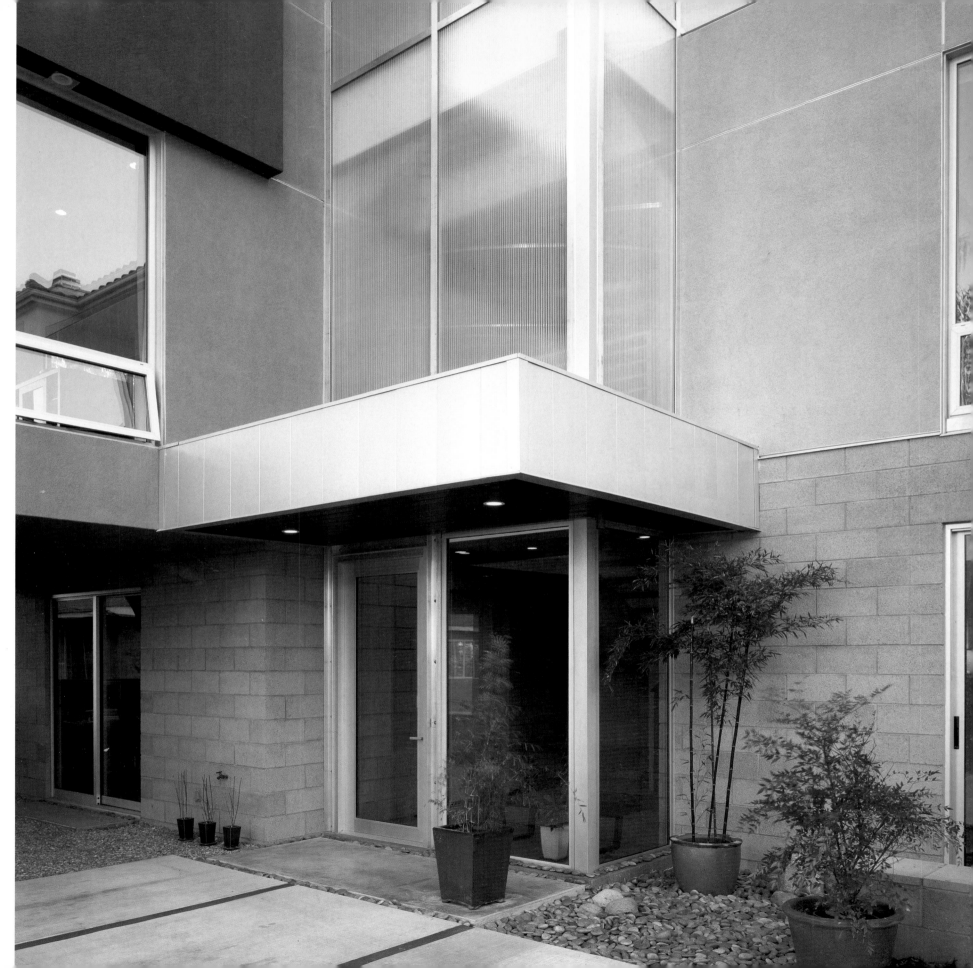

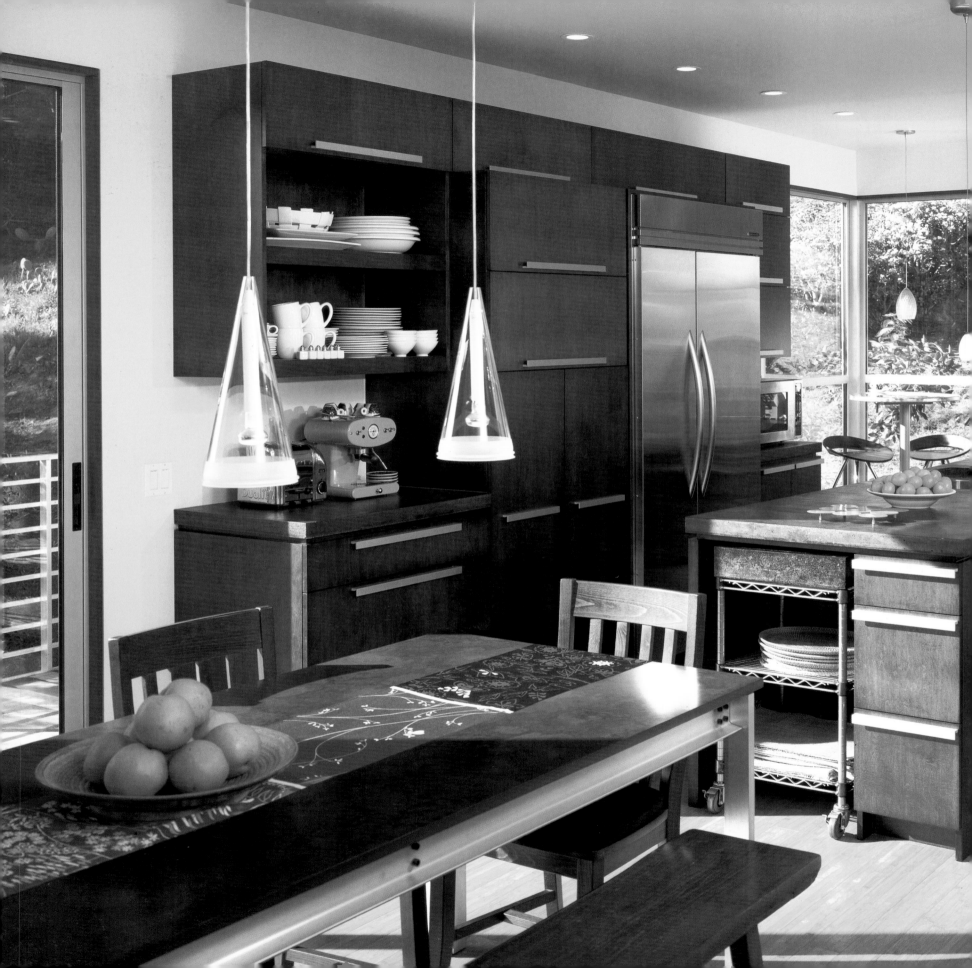

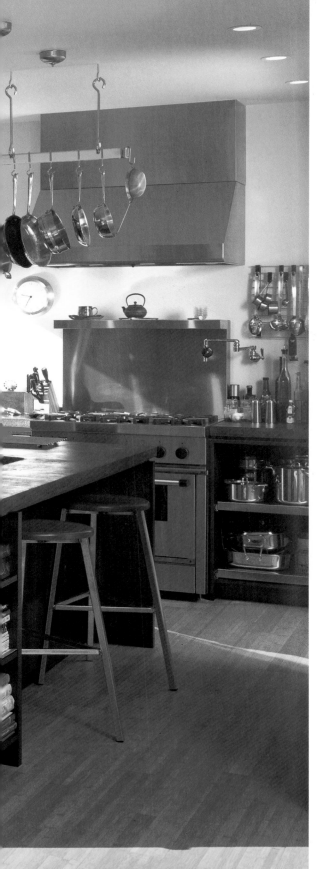

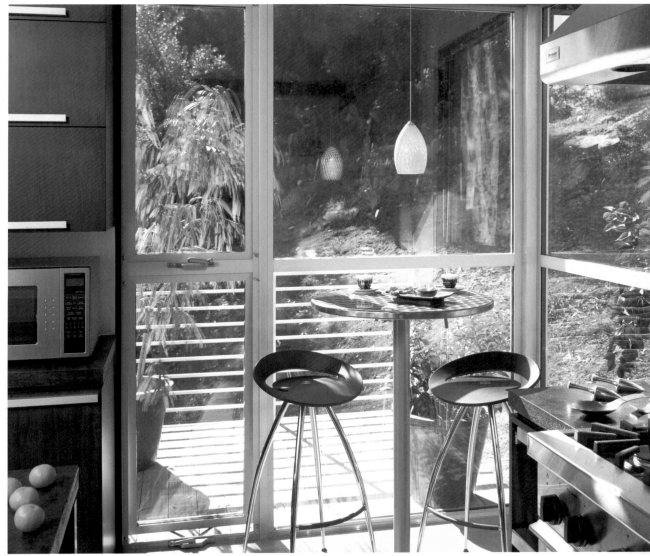

Left: The main level is open, allowing for casual entertaining. The dining table is custom designed by the architects and the kitchen island is reinforced concrete.
Above: Commercial-grade aluminum window and door systems were used throughout the house.

Right: The house is painted in warm earth tones as seen here in the main level living/media area.

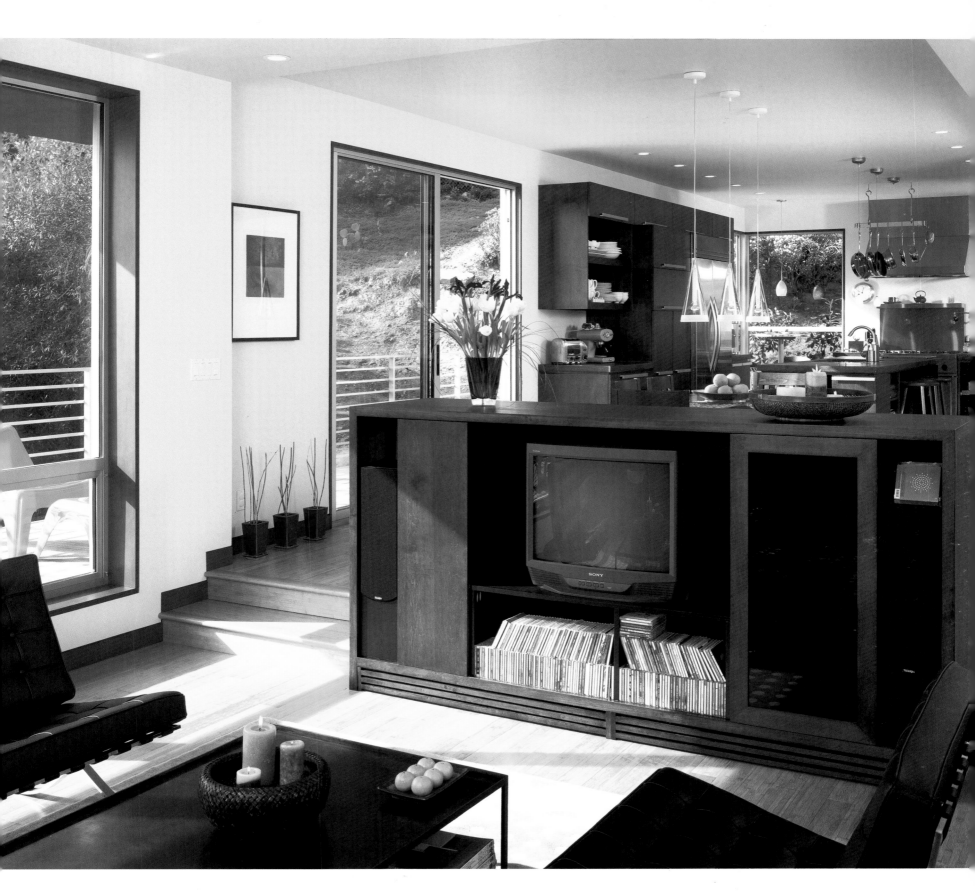

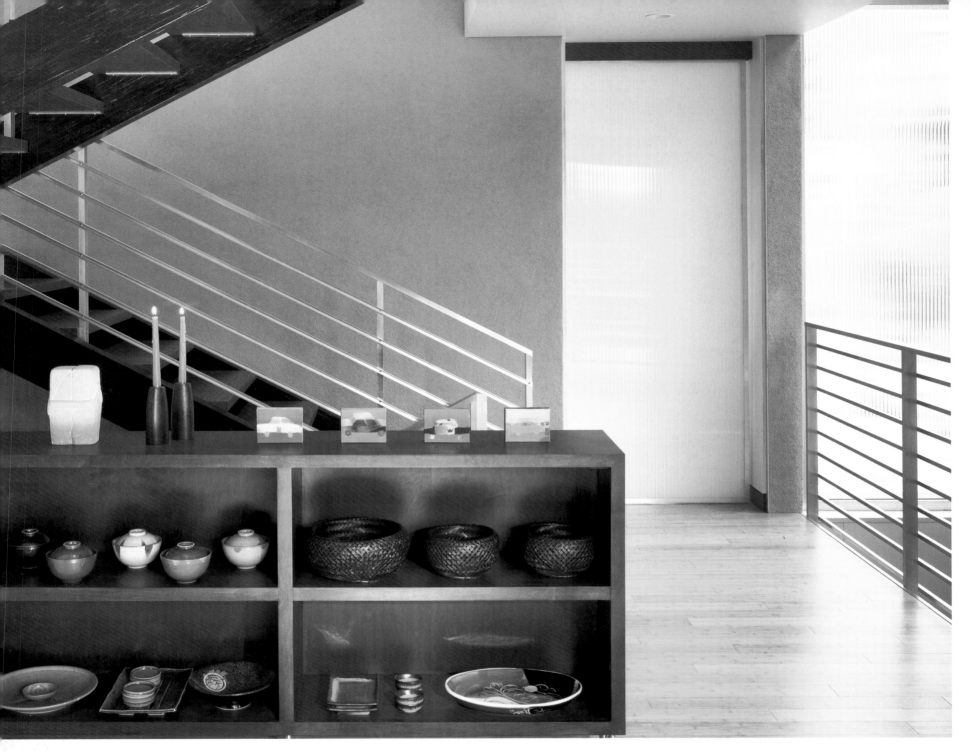

Above: A view of the entry to the main level second bedroom. The floors are bamboo.

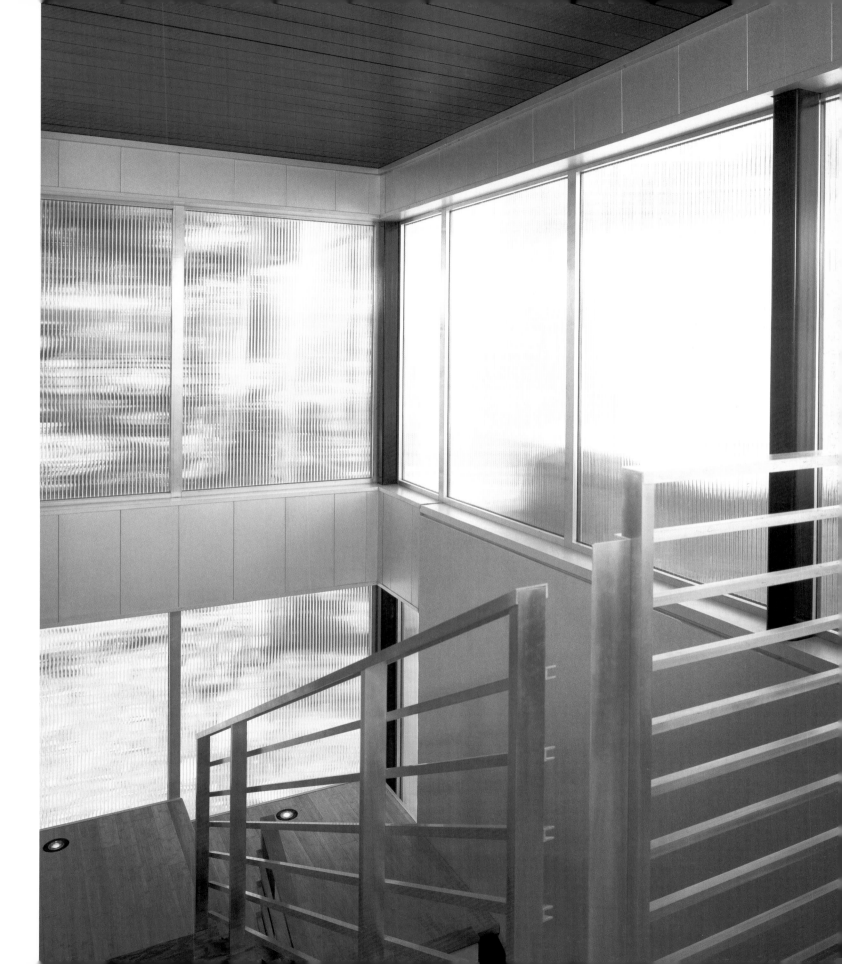

Right: A view from the third level of the tower that is enclosed with a polycarbonate glazing system.

Above: The concrete block foundation is left exposed in the architects' studio on the ground level.
Right: At night, the polycarbonate glazing in the tower is seen as a glowing lantern from the street.

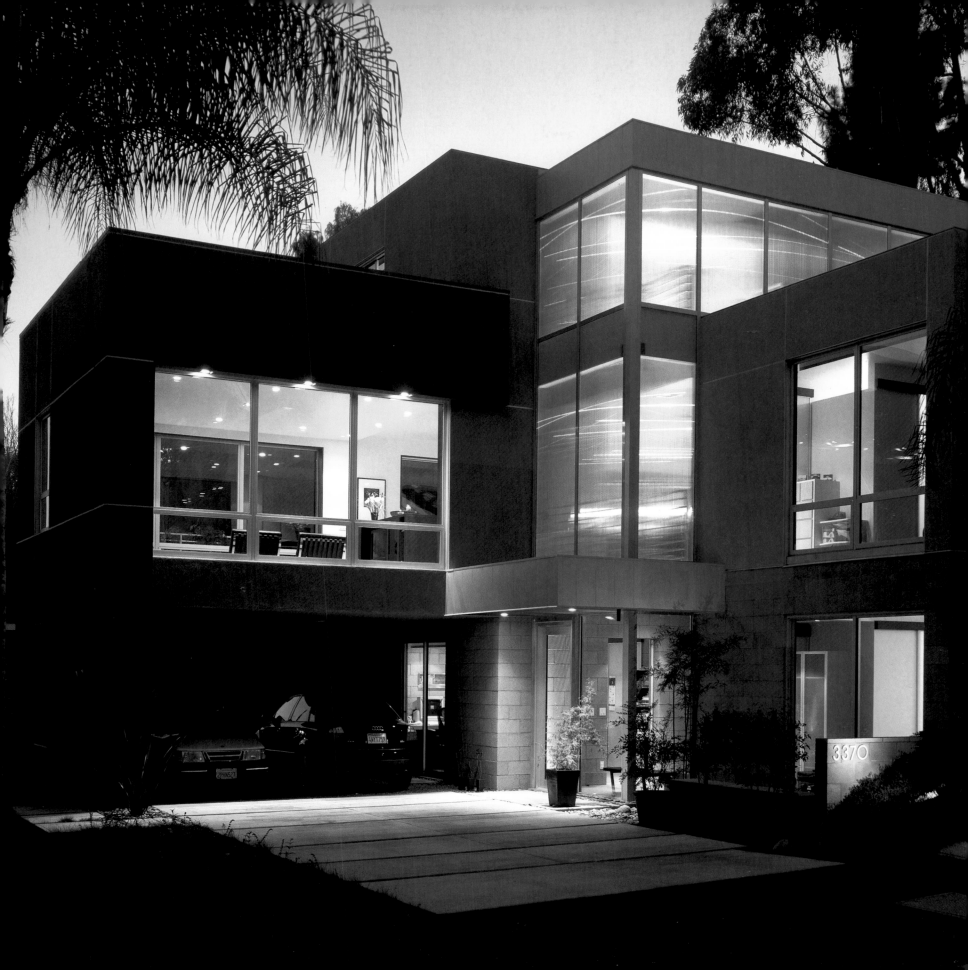

Artist's House and Studio

2200 Square Feet

Mack Scogin Merrill Elam Architects
Photography: Tim Hursley

The site for this 2200-square-foot house and adjoining artist's studio is a heavily wooded seven-and-one-half-acre hillside in southwest Atlanta. The house and studio are connected on the upper level by a library that floats over the entry and contains many of the sources used by the artist in creating his paintings. Lifted above the ground, it allows the landscape and woods to flow between the house and studio.

On the main level of the house, the functional spaces are concentrated in the center, surrounded by the living spaces that overlook the landscape. The stair weaves its way up through the mezzanine level to the bedrooms and an office. The upper level inverts the main level plan, enclosing the bedroom spaces within the bathrooms, closets, and the stairs.

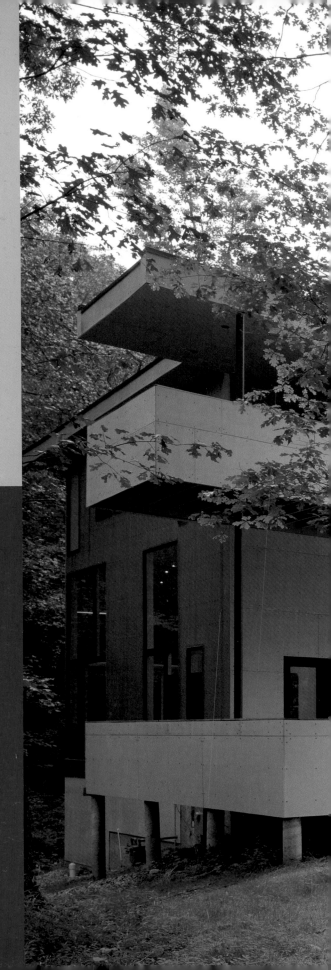

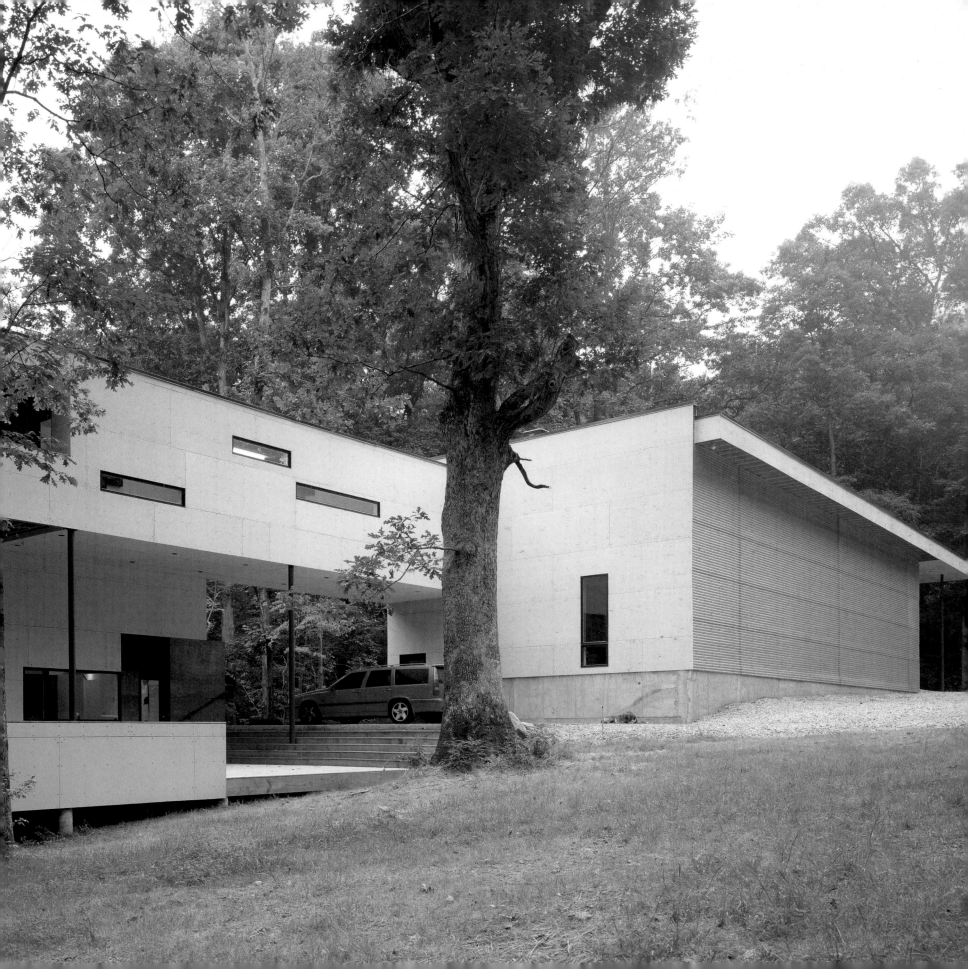

Upper Level Plan

Previous Pages: The house and studio are connected by a second floor floating library.

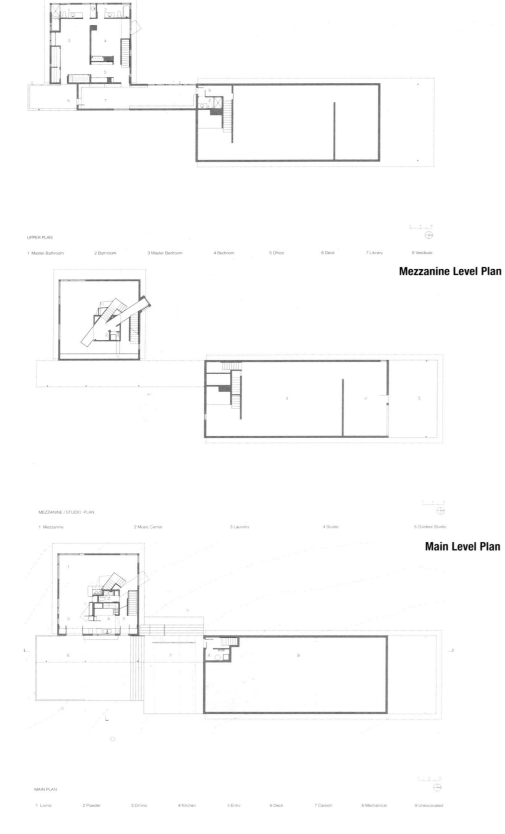

UPPER PLAN

1 Master Bathroom 2 Bathroom 3 Master Bedroom 4 Bedroom 5 Office 6 Deck 7 Library 8 Vestibule

Mezzanine Level Plan

MEZZANINE / STUDIO PLAN

1 Mezzanine 2 Music Center 3 Laundry 4 Studio 5 Outdoor Studio

Main Level Plan

Site Plan

MAIN PLAN

1 Living 2 Powder 3 Dining 4 Kitchen 5 Entry 6 Deck 7 Carport 8 Mechanical 9 Unexcavated

North Elevation

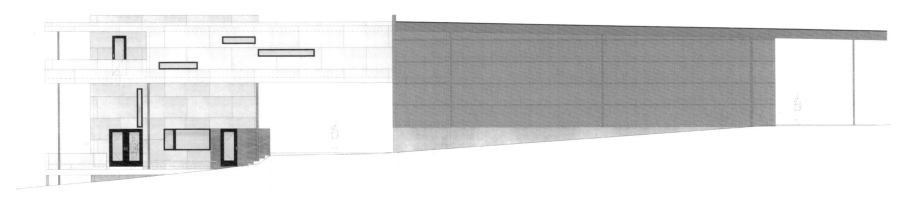

South Elevation

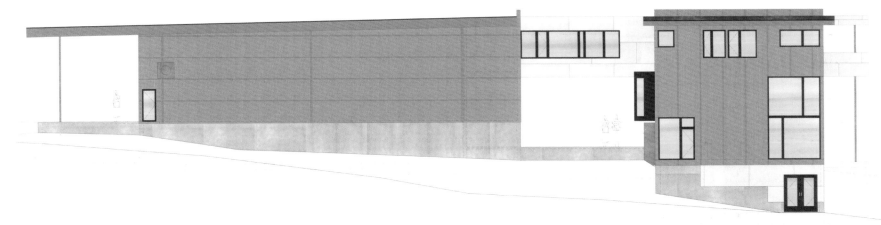

East Elevation

West Elevation

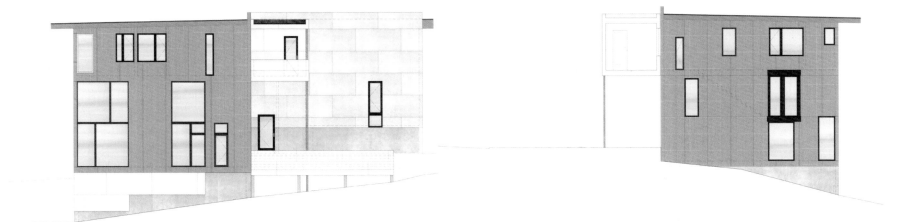

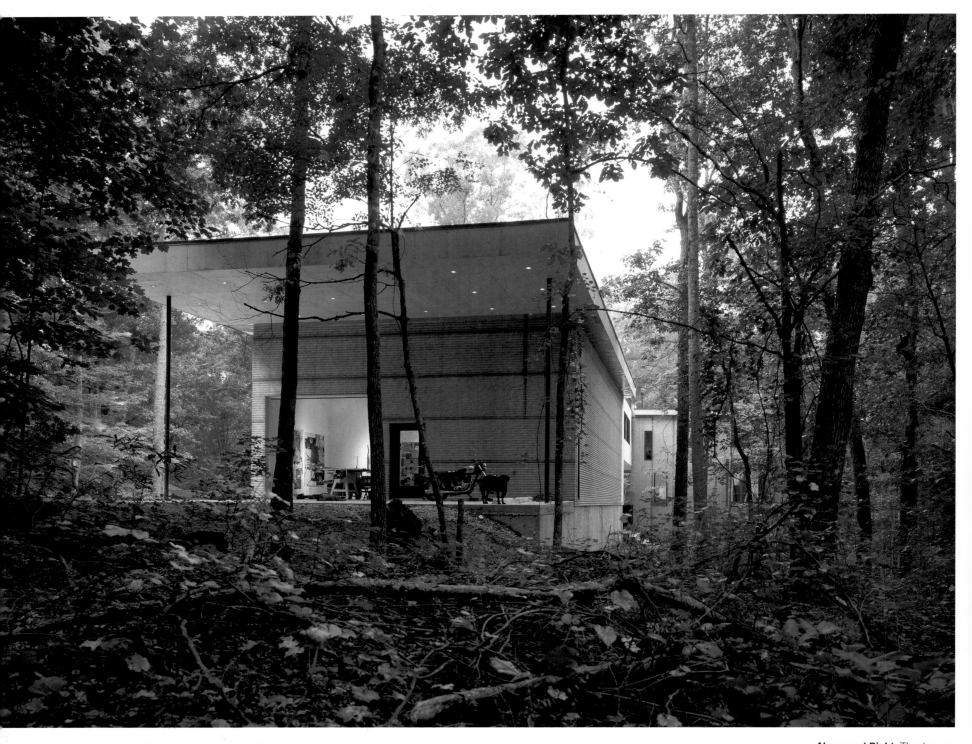

Above and Right: The house and studio are wood and steel framing with concrete fiberboard, corrugated fiberglass siding, and membrane roofing.

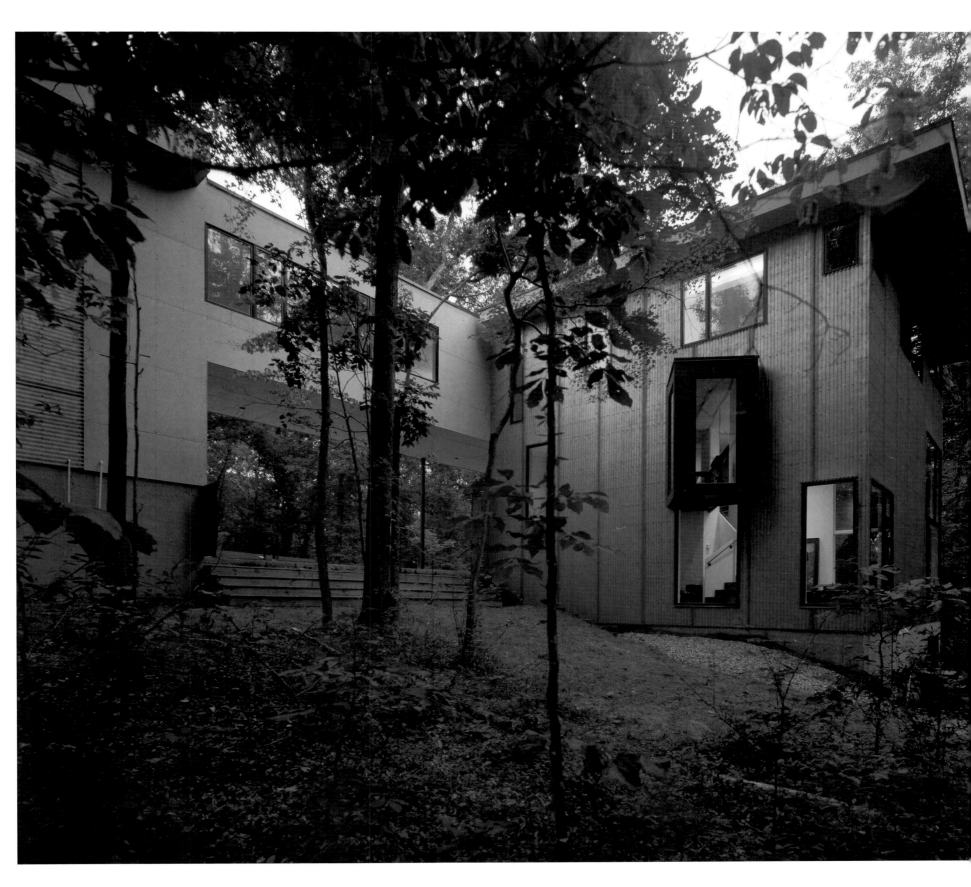

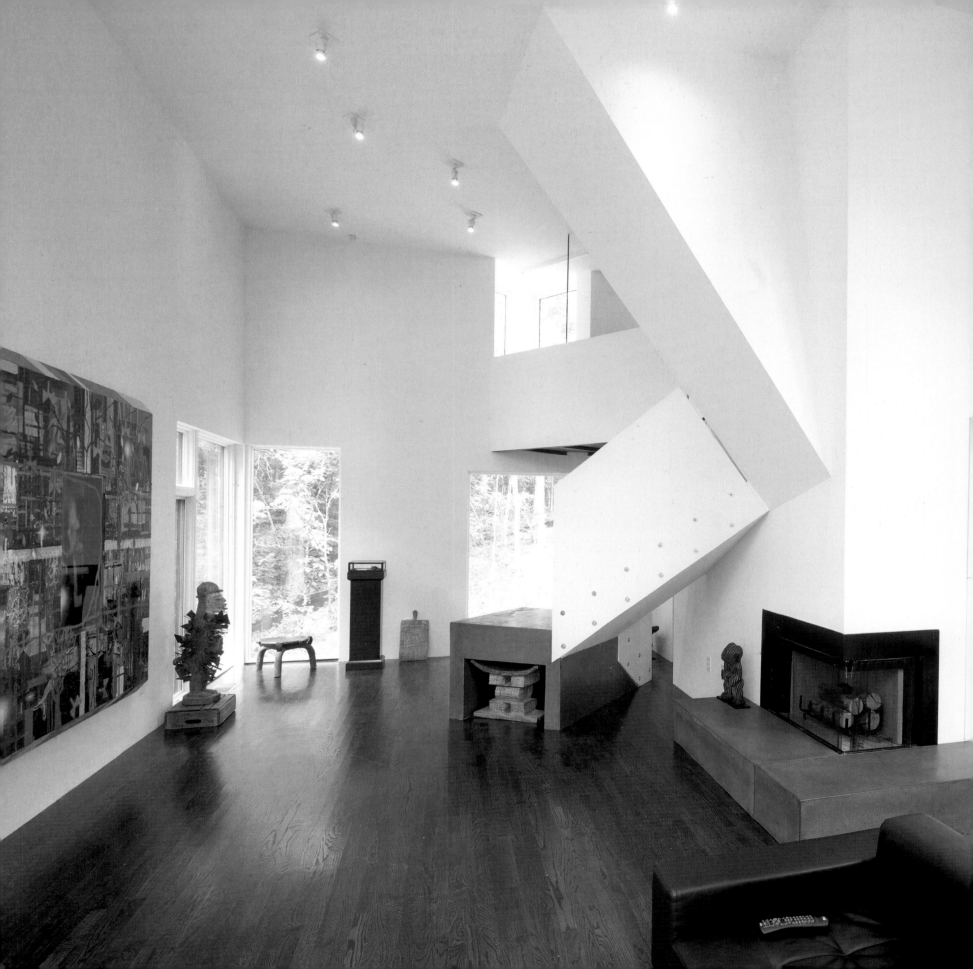

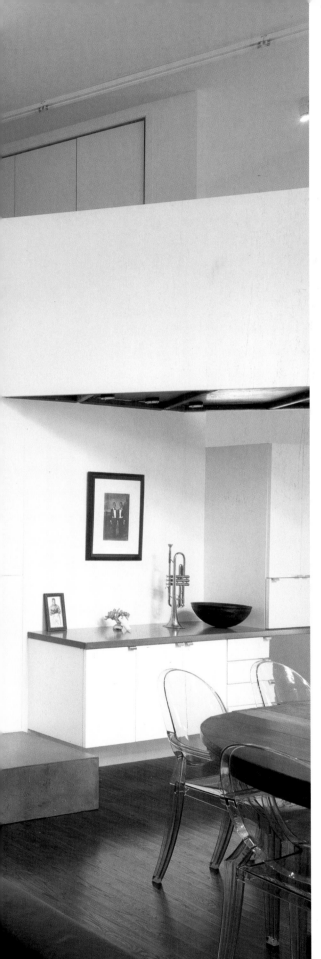

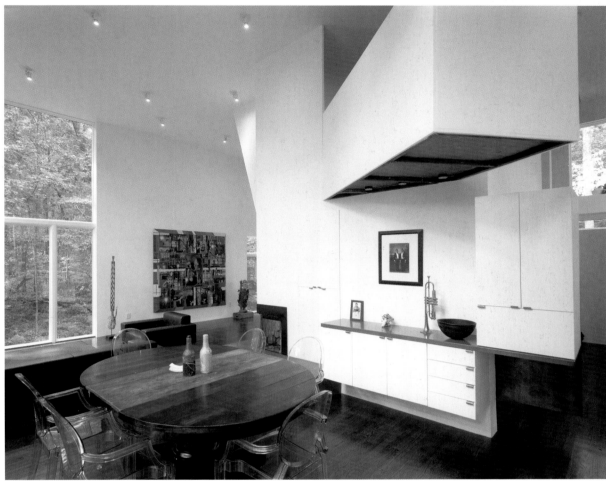

Left and Above: On the main level, the living and dining areas radiate from a central core that contains the kitchen, a powder room, and the staircase.

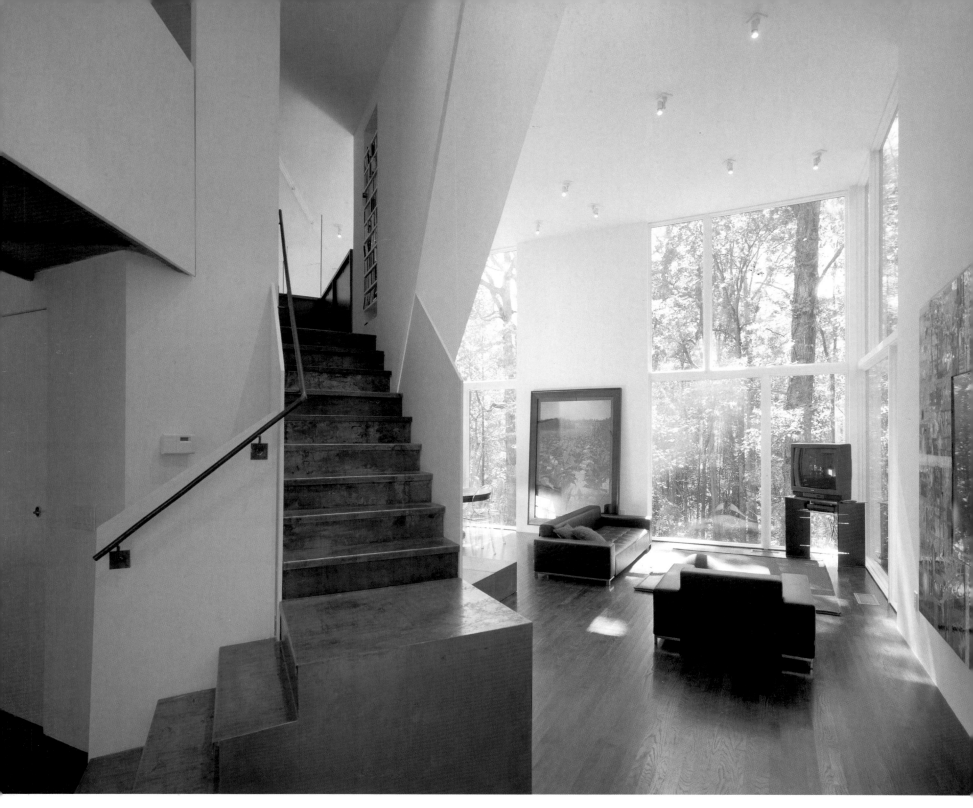

Above: The living and dining areas appear to float among the trees.

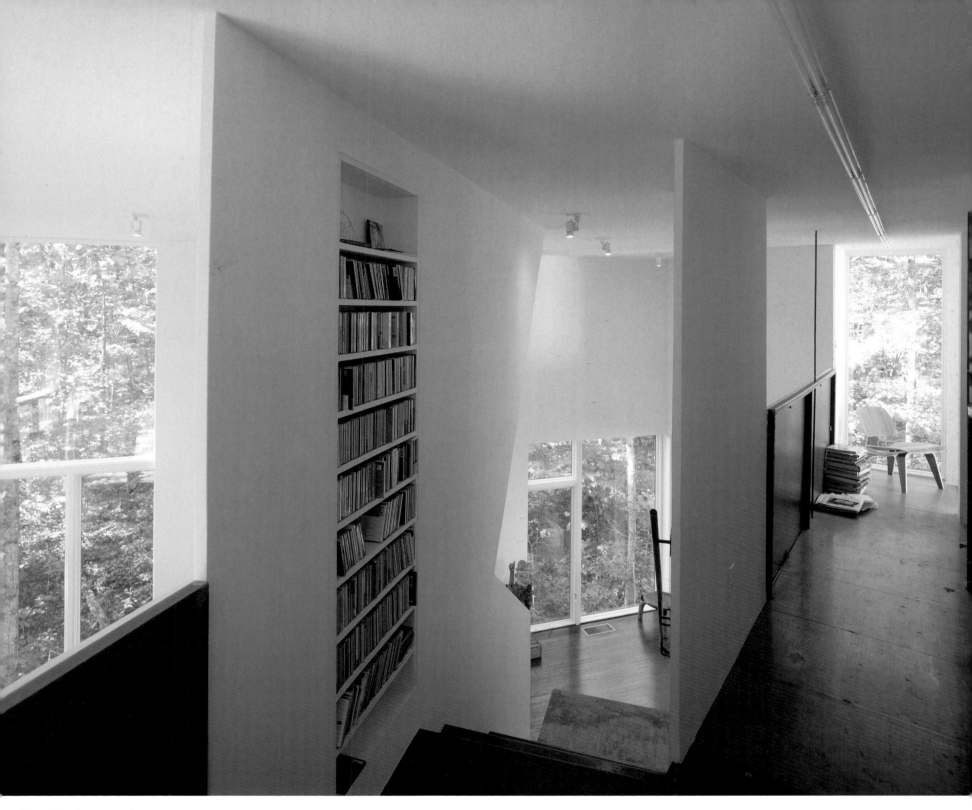

Above: The house and studio are connected by a second floor library.

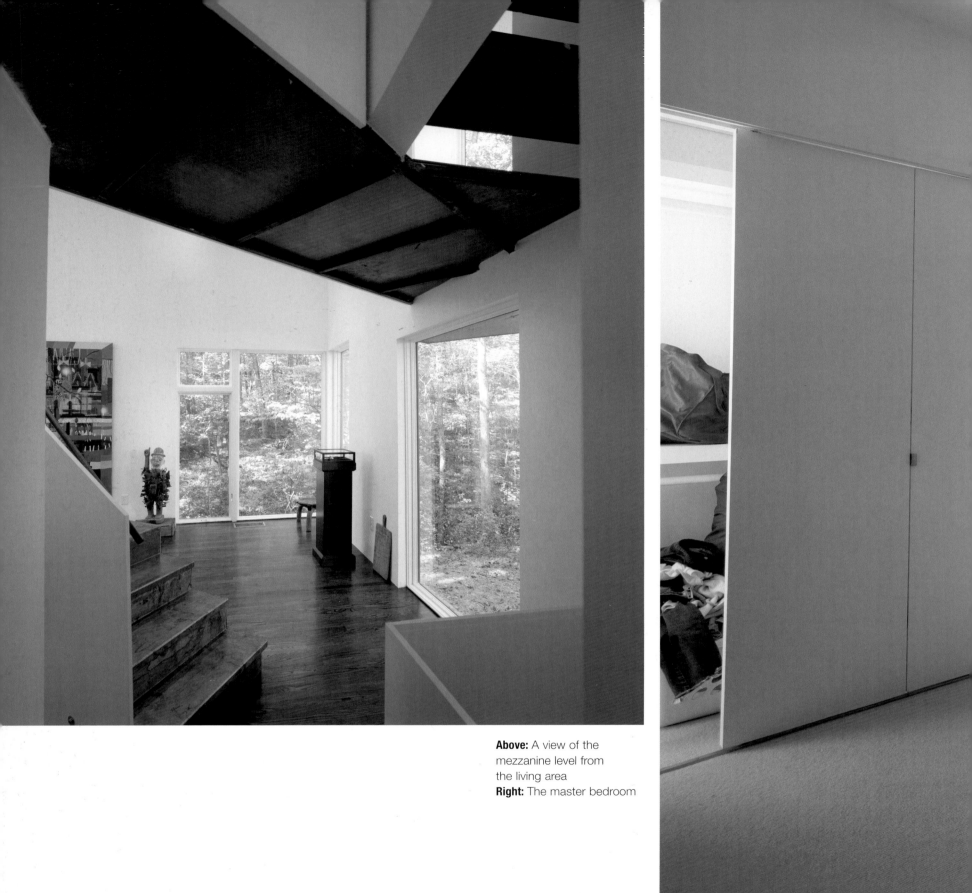

Above: A view of the mezzanine level from the living area
Right: The master bedroom

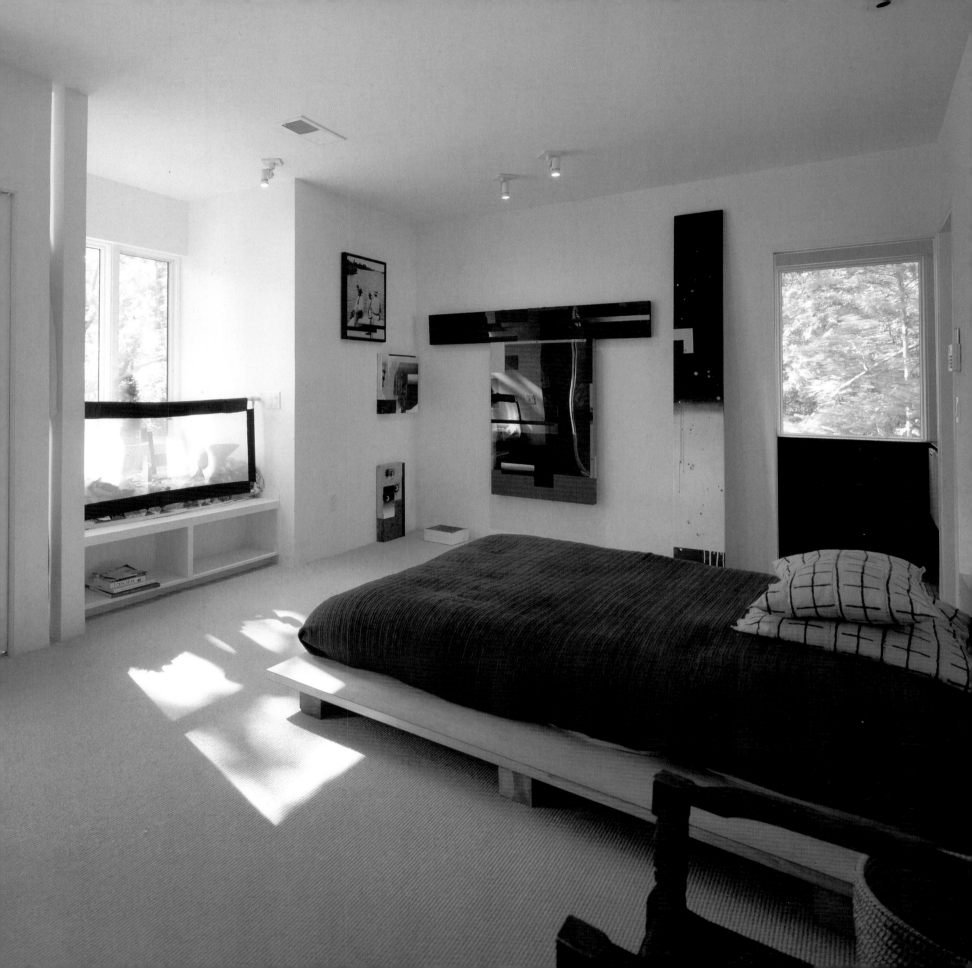

Davis House

2900 Square Feet

Davis Davis Architects
Photography: David Hewitt and Anne Garrison

THREE EXISTING MATURE PECAN TREES, RARE IN THIS PART OF SAN DIEGO, JUST NORTH OF DOWNTOWN, WERE CRITICAL IN ORGANIZING THIS SITE. TO ACCOMMODATE THEM THE HOUSE WAS DESIGNED AS A LONG NARROW BAR AT THE WESTERN EDGE OF THE LOT, OPPOSITE THE TREES. THIS ORIENTATION ALLOWED THE ARCHITECTS TO OPEN THE EAST WALL WITH LARGE EXPANSES OF GLASS AND SLIDING GLASS DOORS OPENING ONTO AN OUTDOOR ROOM WITH A FIREPLACE. THIS CALIFORNIA ROOM IS AN EXTENSION OF THE FAMILY ROOM, AND IS A PLEASANT SPOT FOR BREAKFAST AND EVENINGS BY THE FIRE.

A WIDTH OF 18 FEET FOR THE HOUSE WAS USED AS A STARTING POINT FROM WHICH TO SHIFT THE BUILDING IN AND OUT TO ACCOMMODATE FUNCTIONAL ISSUES AND THE AESTHETICS OF THE HOUSE. THE LIBRARY CUBE THAT PUSHES OUT AT THE STREET ENTRANCE CREATES PRIVACY FOR THE OPEN EAST FAÇADE AND ALSO SERVES AS AN ANCHOR FOR THE LONG TWO-STORY MASS. ABOVE THE LIBRARY IS A DECK OFF THE MASTER BEDROOM. A 5-FOOT MODULE WAS USED TO ORGANIZE THE 75-FOOT LENGTH OF THE HOUSE.

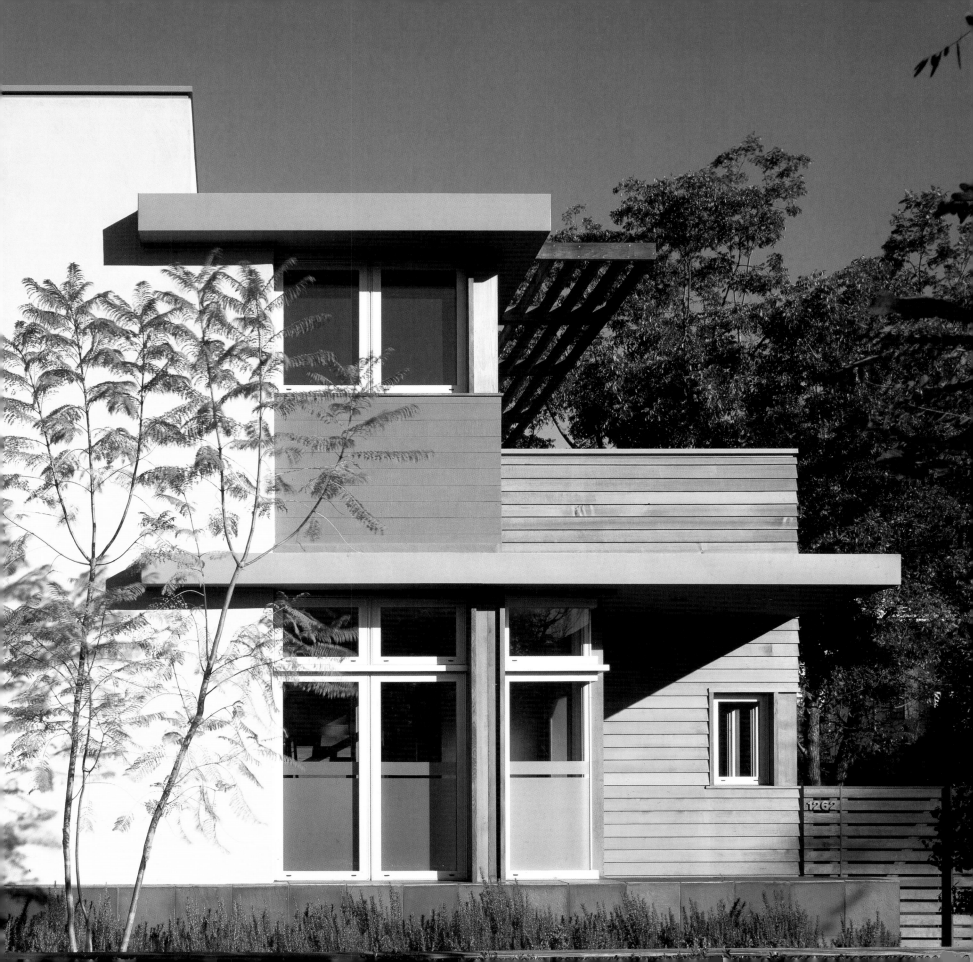

Second Floor Plan

First Floor Plan

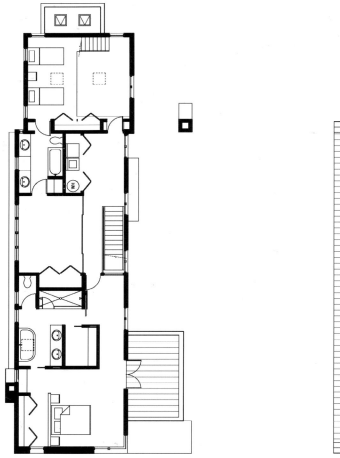
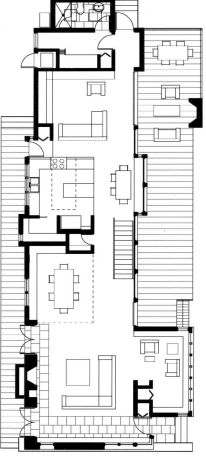

West-East Section

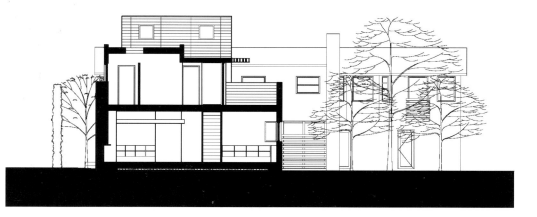

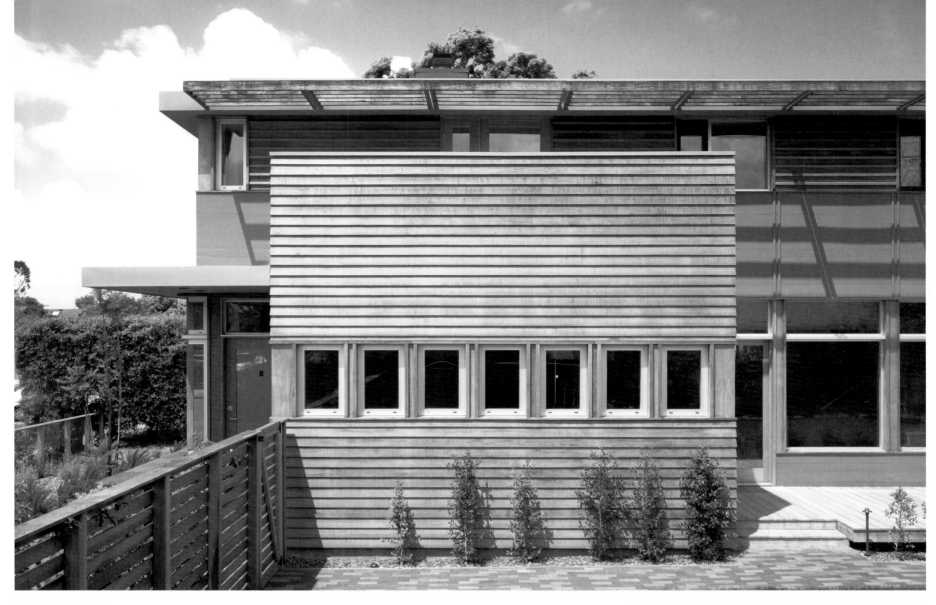

Previous Pages: Stucco, beveled wood siding, and aluminum-framed windows adorn the exterior.
Above: The library cube and a wooden fence provide privacy from the street for the east garden.
Right: The entry with the master bedroom deck over the library cube

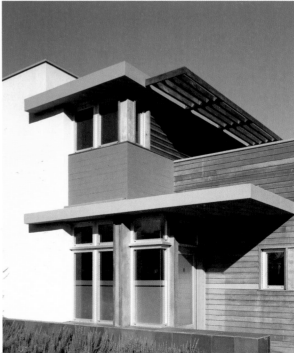

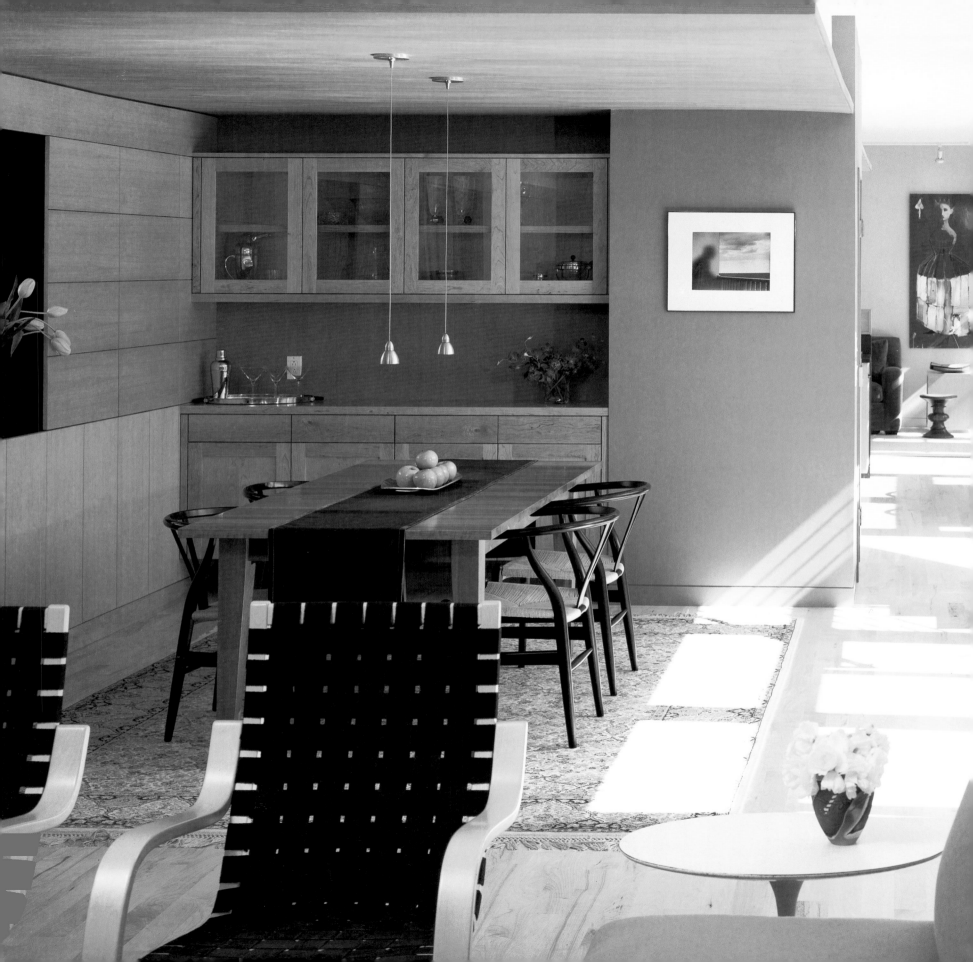

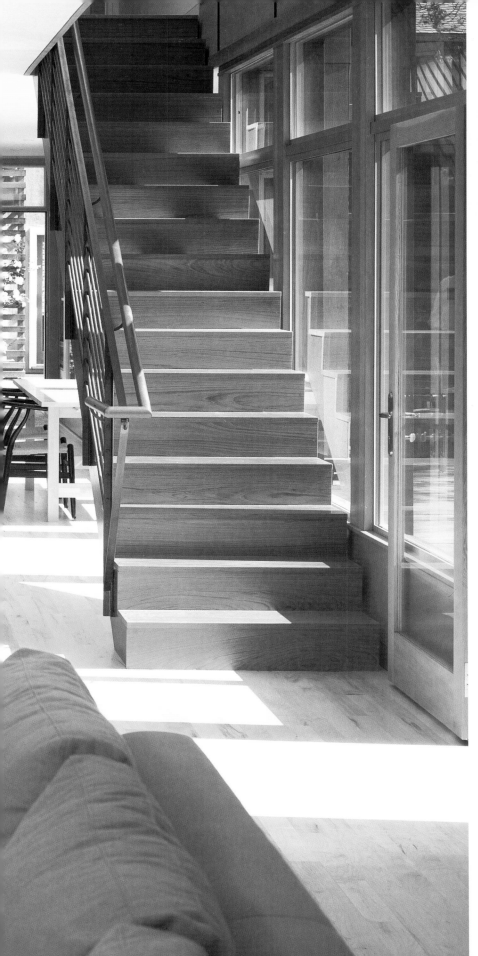

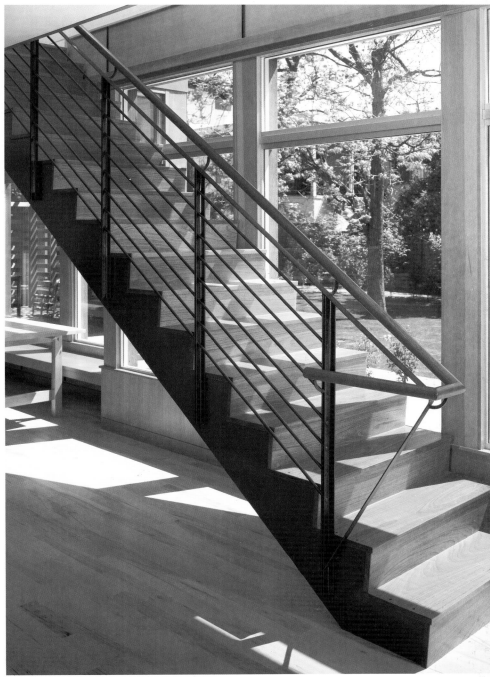

Left: The living, dining, and kitchen areas all open onto the east garden.
Above: The staircase is constructed of Brazilian cherry with steel guardrails.

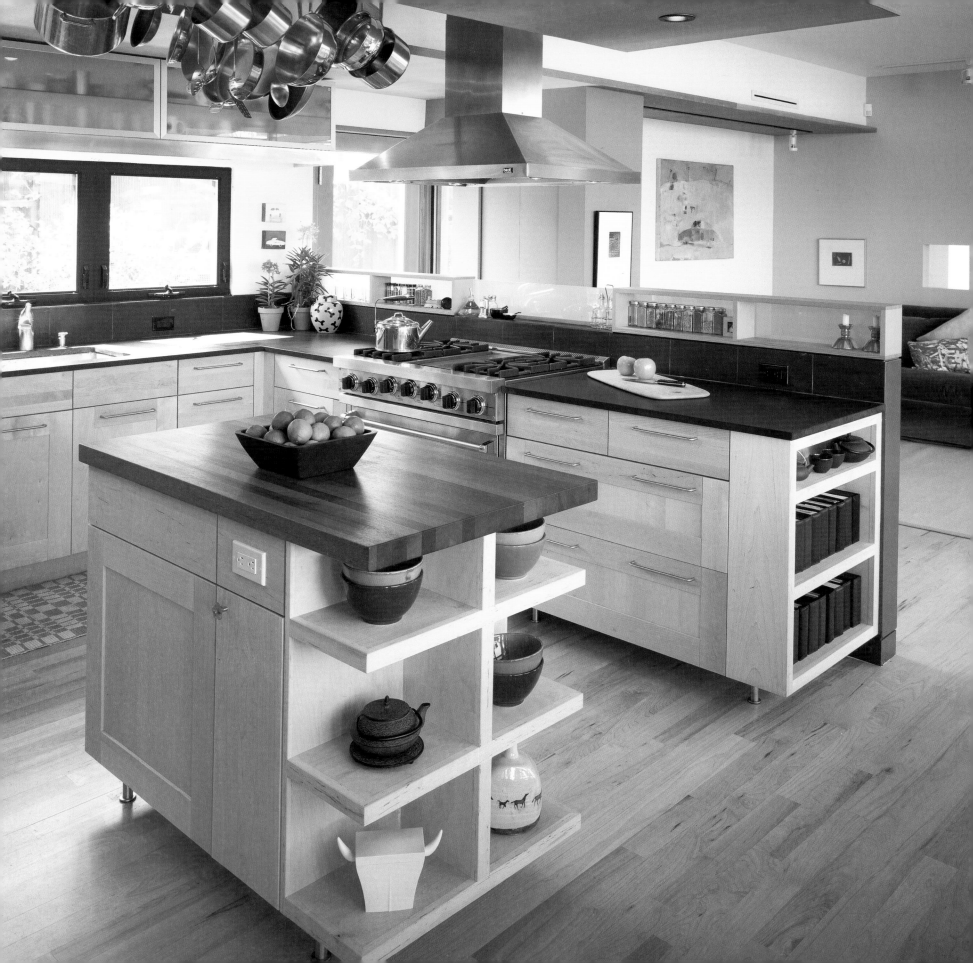

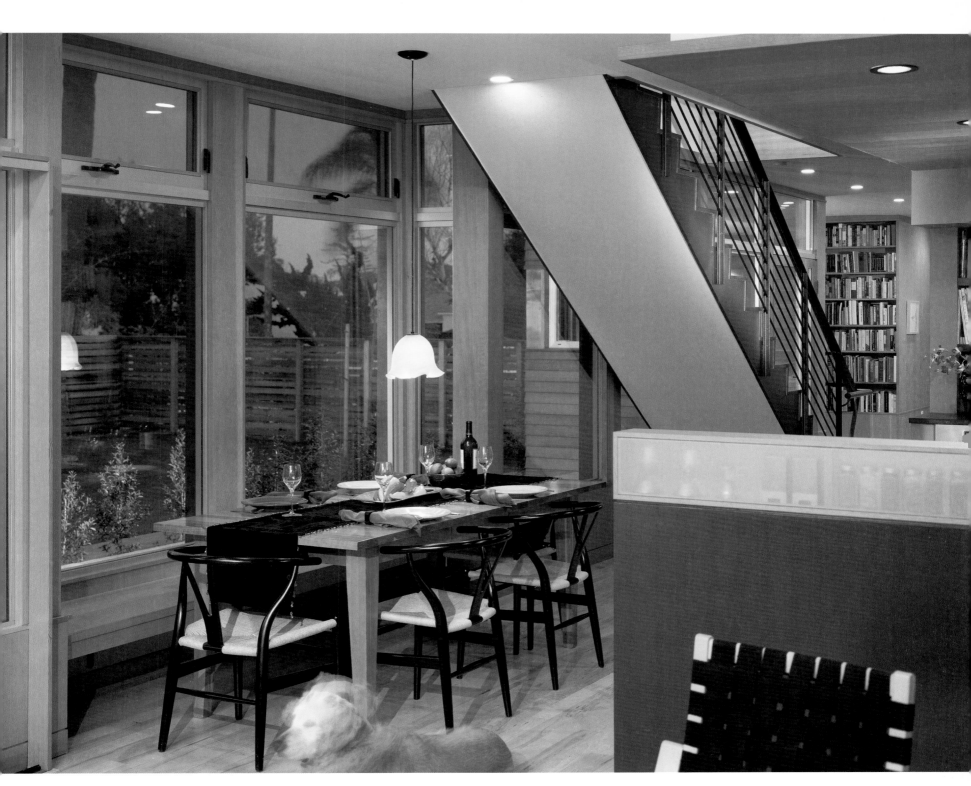

Left: The kitchen
Above: A breakfast area is
tucked under the staircase
overlooking the garden.

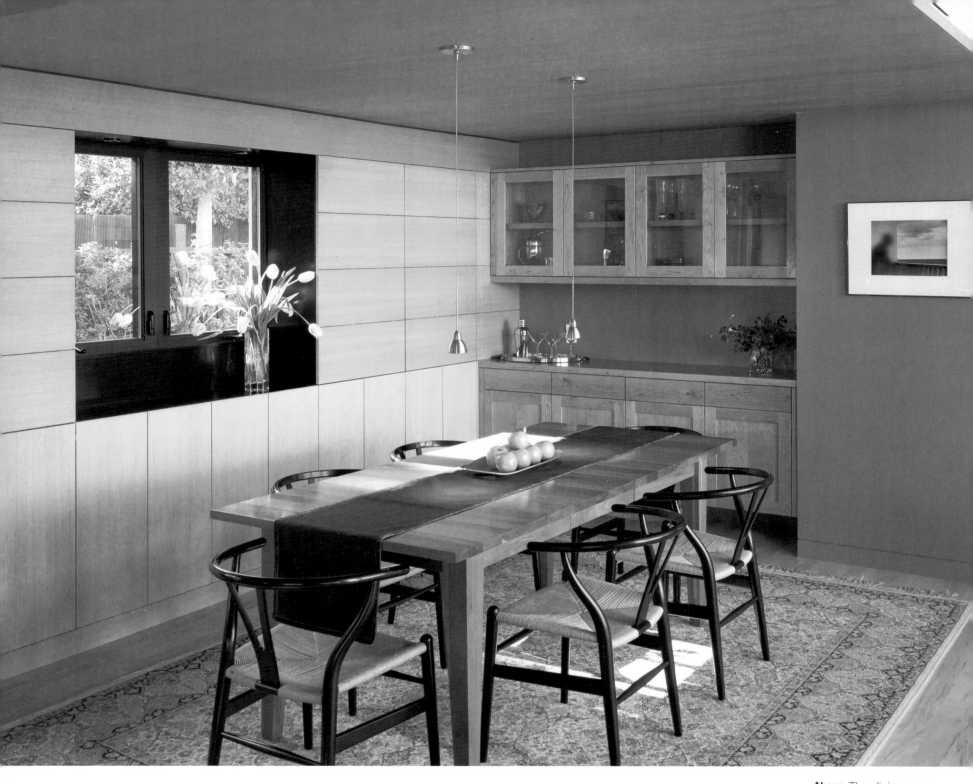

Above: The dining area
Right: A view of the master bedroom entrance from the top of the stairs
Following Pages: The east garden at dusk

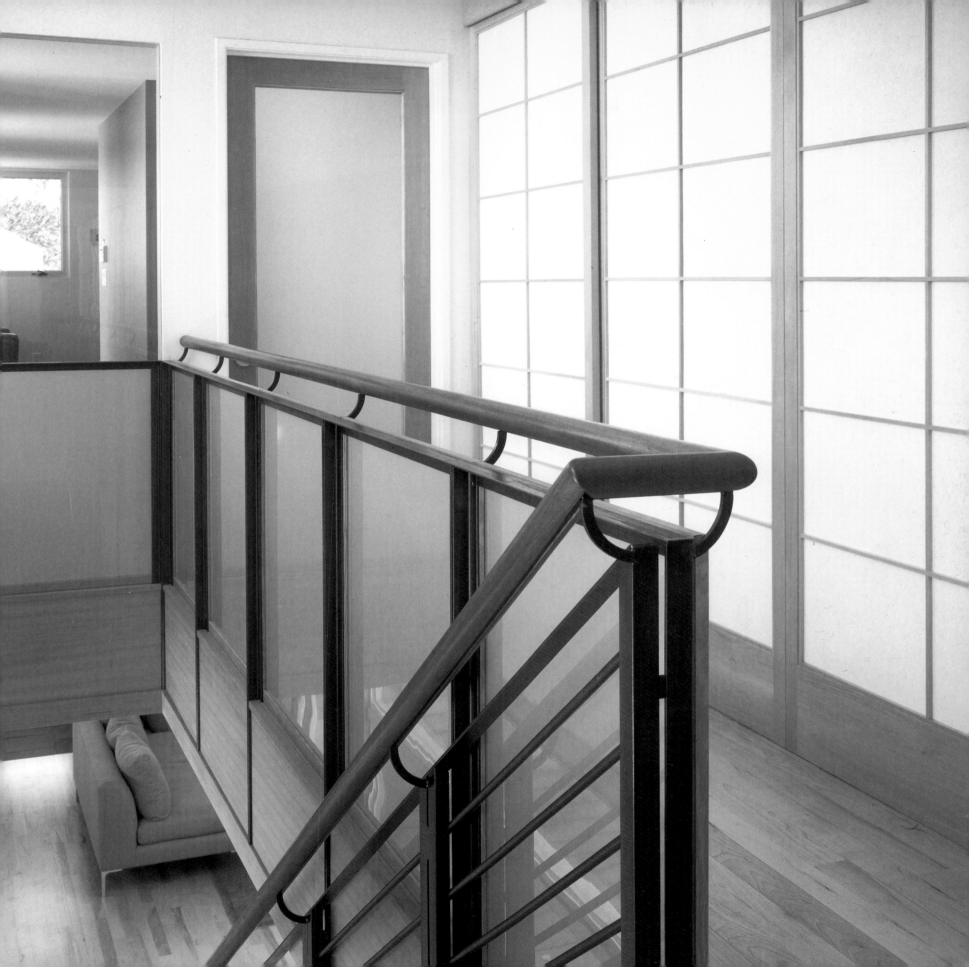

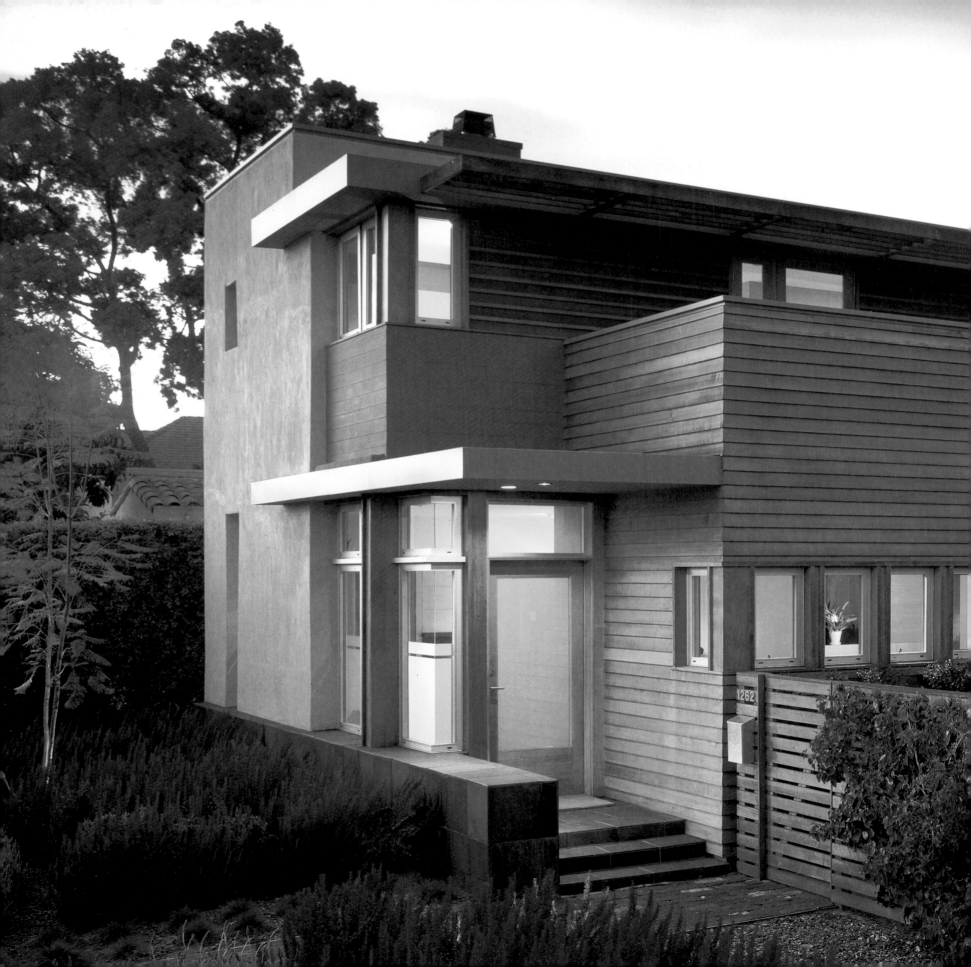

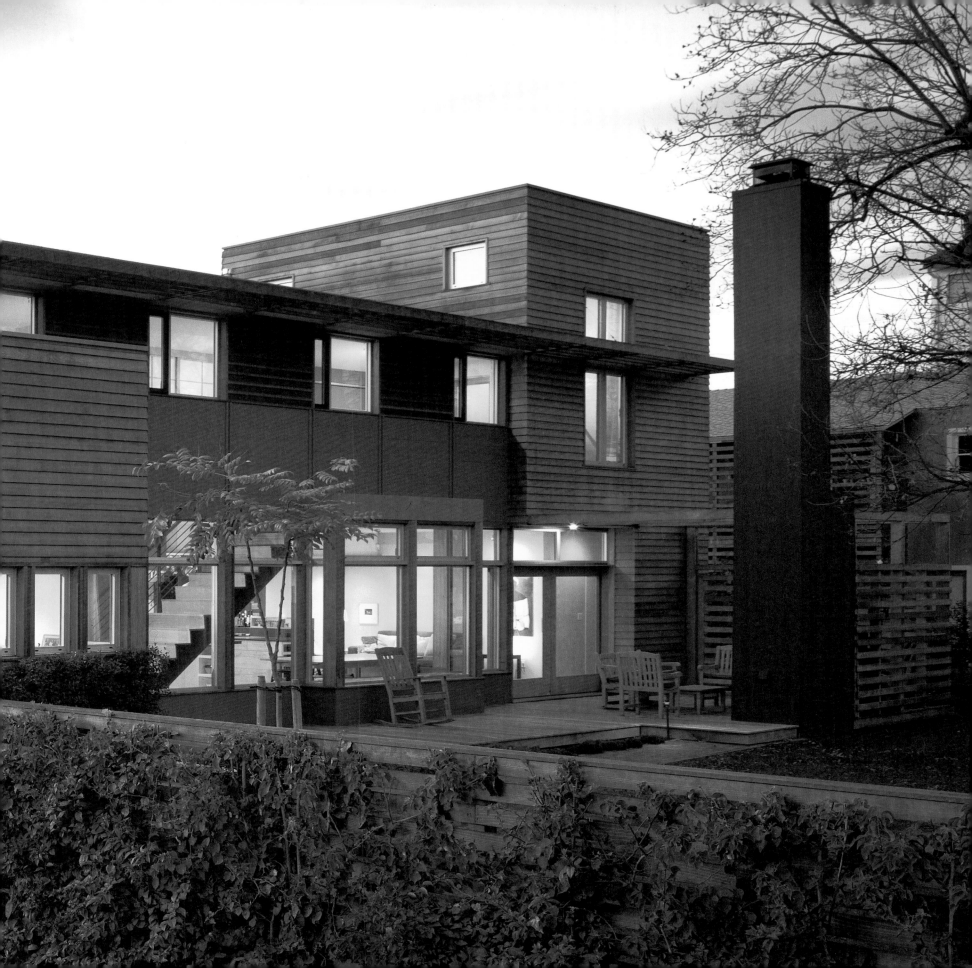

Stack Residence

2500 Square Feet

Vandeventer + Carlander Architects
Photography: Steve Keating

NESTLED INTO A SLOPING SITE OVERLOOKING SEQUIM BAY IN WASHINGTON STATE, THIS HOME BLENDS MODERN DESIGN WITH NATURAL MATERIALS. IT IS ENTERED FROM THE EAST VIA A FOOTBRIDGE THAT LEADS FROM THE PARKING AREA TO THE FRONT DOOR ON THE MAIN LEVEL. ON THIS UPPER FLOOR ARE LOCATED ALL LIVING SPACES AS WELL AS THE MASTER SUITE. BELOW ARE TWO GUEST ROOMS WITH BATH.

CAREFUL CRAFTSMANSHIP AND ATTENTION TO DETAIL DISTINGUISH THIS HOUSE. AMERICAN CHERRY WAS USED FOR THE FLOORS, LOWER WALL PANELS, AND BASE CABINETS. WALLS AND THE VAULTED CEILING ON THE UPPER LEVEL ARE SHEATHED WITH ALASKAN YELLOW CEDAR. TERRACED RETAINING WALLS AND A PORTION OF THE MASTER BEDROOM WING ARE CLAD IN "COURSED RUBBLE" STONE VENEER USING A DRY-STACK LOOK THAT ENHANCES THE STONE'S NATURAL BEAUTY. THE EXTERIOR SIDING IS TONGUE-AND-GROVE ALASKAN YELLOW CEDAR.

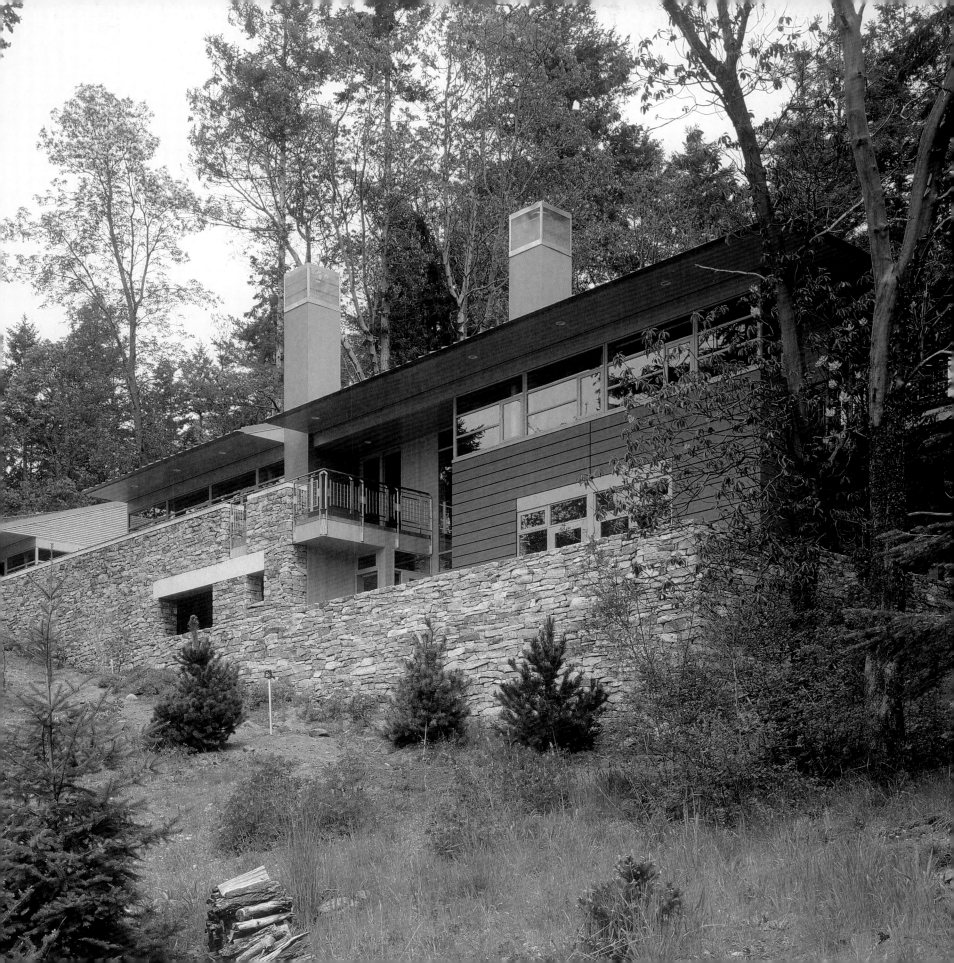

Main Floor Plan

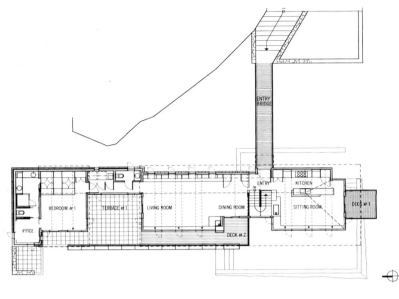

BEDROOM #1 | OFFICE | TERRACE #1 | LIVING ROOM | DINING ROOM | ENTRY | KITCHEN | SITTING ROOM | DECK #1 | DECK #2 | ENTRY BRIDGE

Site Plan

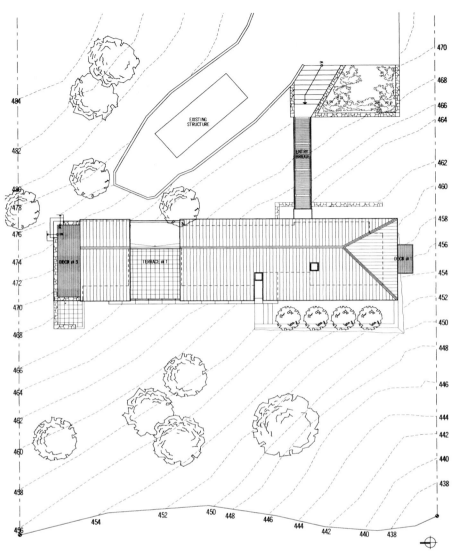

EXISTING STRUCTURE | ENTRY BRIDGE | DECK #3 | TERRACE #1 | DECK #1

Lower Floor Plan

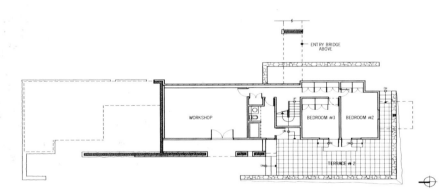

ENTRY BRIDGE ABOVE | WORKSHOP | BEDROOM #3 | BEDROOM #2 | TERRACE #2

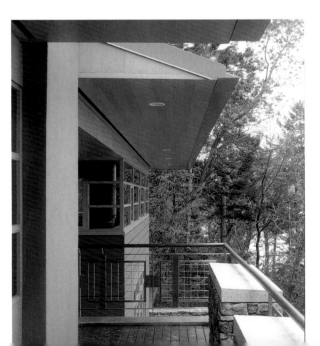

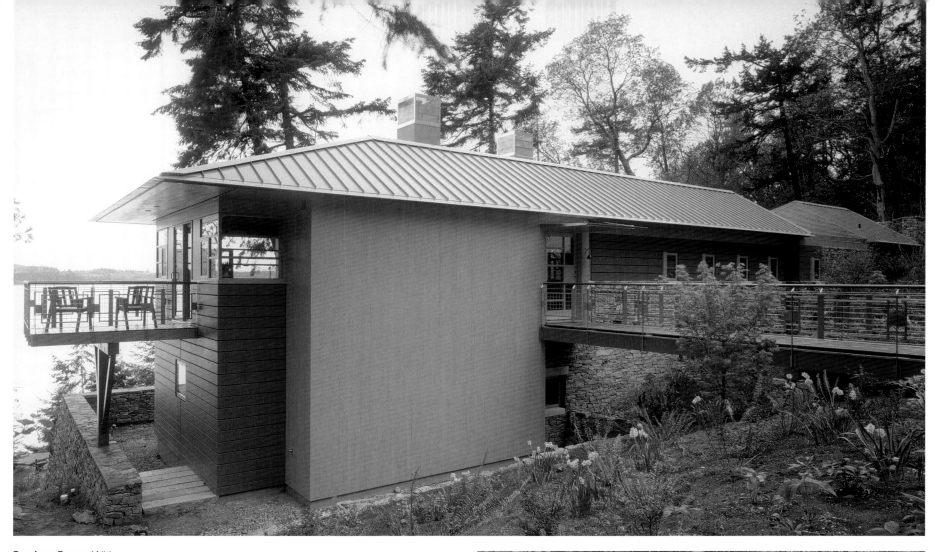

Previous Pages: With a series of terraces and level changes, the house is firmly anchored to its site.
Left: A terrace separates the master bedroom from the living room beyond.
Above: A footbridge connects the parking area to the front door on the upper level.

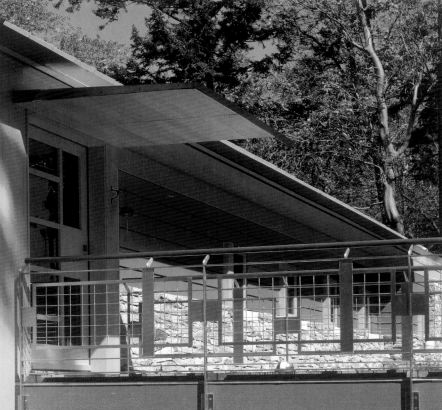

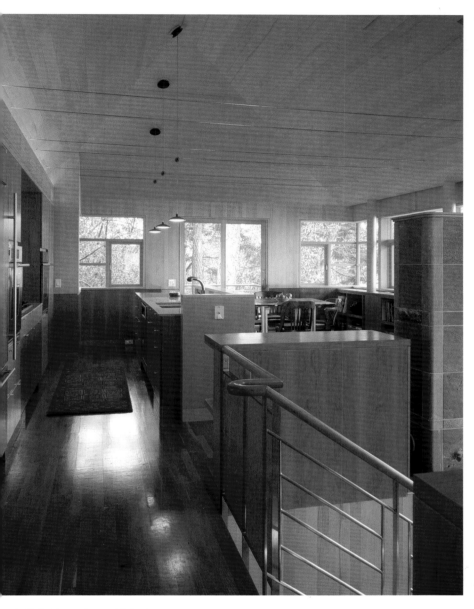
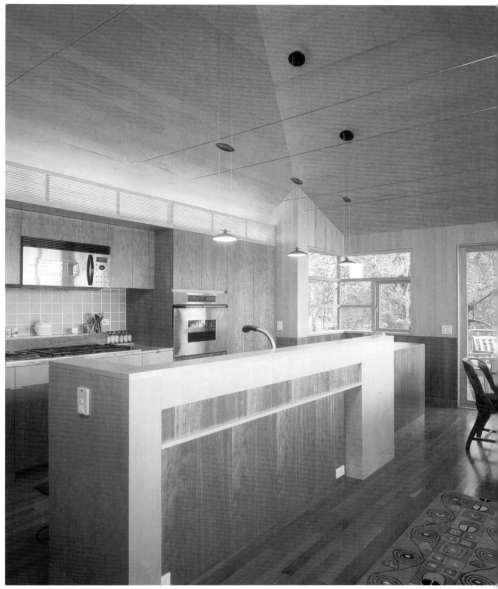

Left: In the entry, a 10-foot-high window above the lower-level stair landing provides expansive views of Sequim Bay.
Above and Above Right: A rich palette of American cherry and Alaskan yellow cedar was used in the kitchen and throughout the interior.

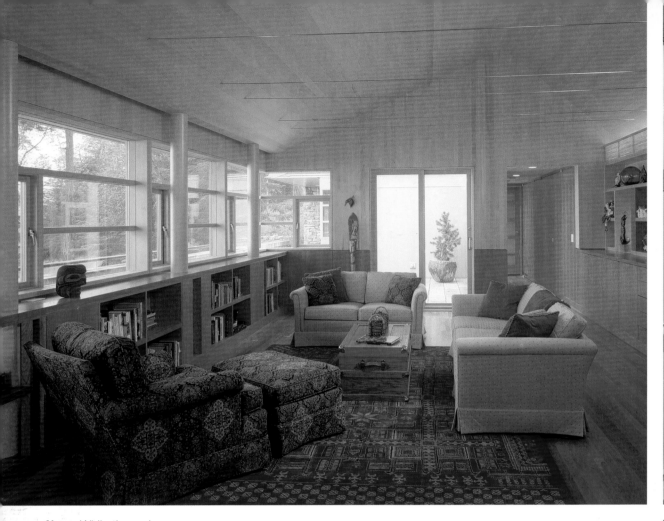

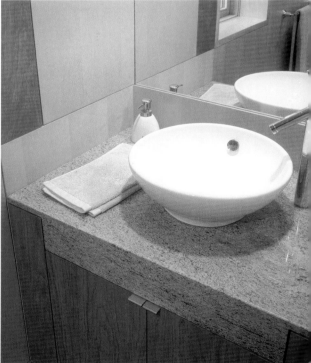

Above: While the main
floor is divided by stairs,
a vaulted ceilng, clad
in Alaskan yellow cedar,
connects the living,
dining, and sitting areas.
Above Left: Upper
level corridor
Left: Powder room vanity

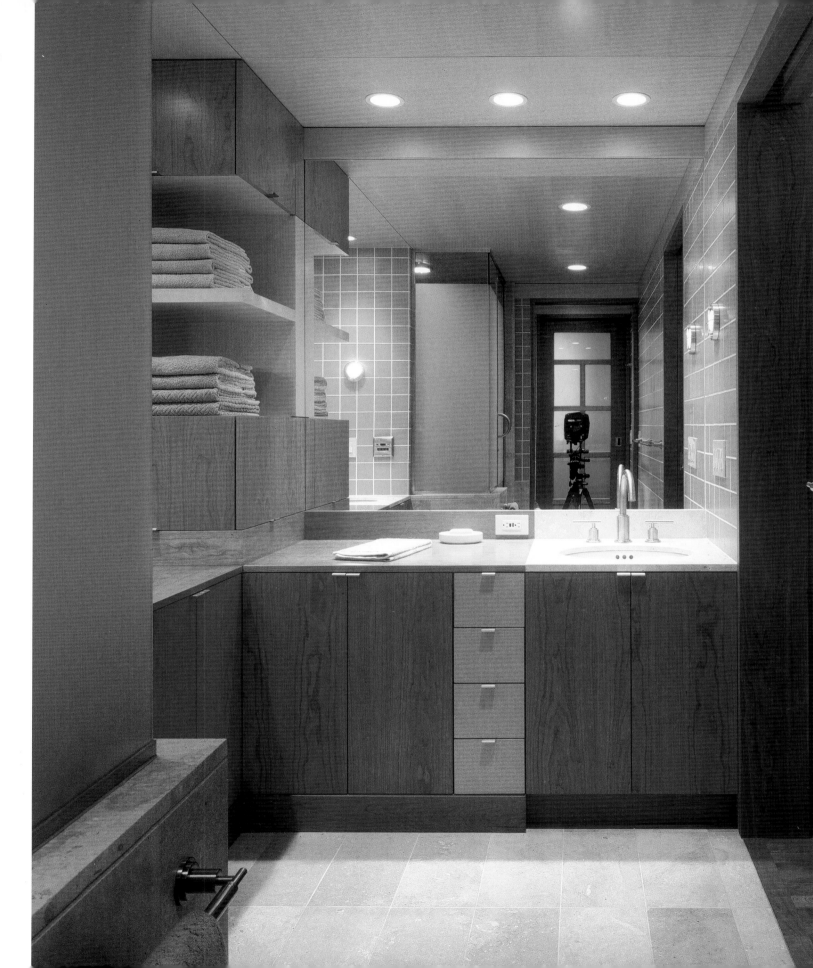

Right: Master bathroom

Malibu Residence

2900 Square Feet

Shubin + Donaldson Architects
Photography: Tom Bonner

THIS PROJECT IS A RENOVATION OF A 1970S MODERN HOUSE IN MALIBU WITH DIRECT ACCESS TO THE BEACH. AN INTERIOR ENTRY COURTYARD IS LAID WITH RECTANGULAR CEMENT PAVERS AND BORDERED BY SMOOTH RIVER ROCK AND TUFTED GRASSES. IT INTRODUCES THE PRIMARY DESIGN ELEMENT OF THE HOME—A SEAMLESS UNION BETWEEN INTERIOR AND EXTERIOR SPACES. THE GROUND-FLOOR LIVING ROOM AND ADJACENT SITTING ROOM OPEN ONTO SUNLIT TERRACES AND IMPRESSIVE VIEWS OF THE OCEAN. THE KITCHEN OVERLOOKS THIS MAIN LIVING SPACE. UPSTAIRS, THE MASTER SUITE FACES ONTO A SECOND LARGE TERRACE WITH POCKET-GLASS DOORS THAT FOLD AWAY, CONVERTING THE STEPPED UPPER TERRACE INTO A SLEEPING PORCH. FROSTED GLASS LINES THE WALLS AND WINDOWS OF THE MASTER BATH. THREE LAYERS OF FLOOR-TO-CEILING GLASS FORM A TRANSLUCENT DOOR THAT CLOSES THE SPACE OFF FROM THE BEDROOM, OR OPENS IT UP TO THE MASTER SUITE, PORCH, AND THE OCEAN.

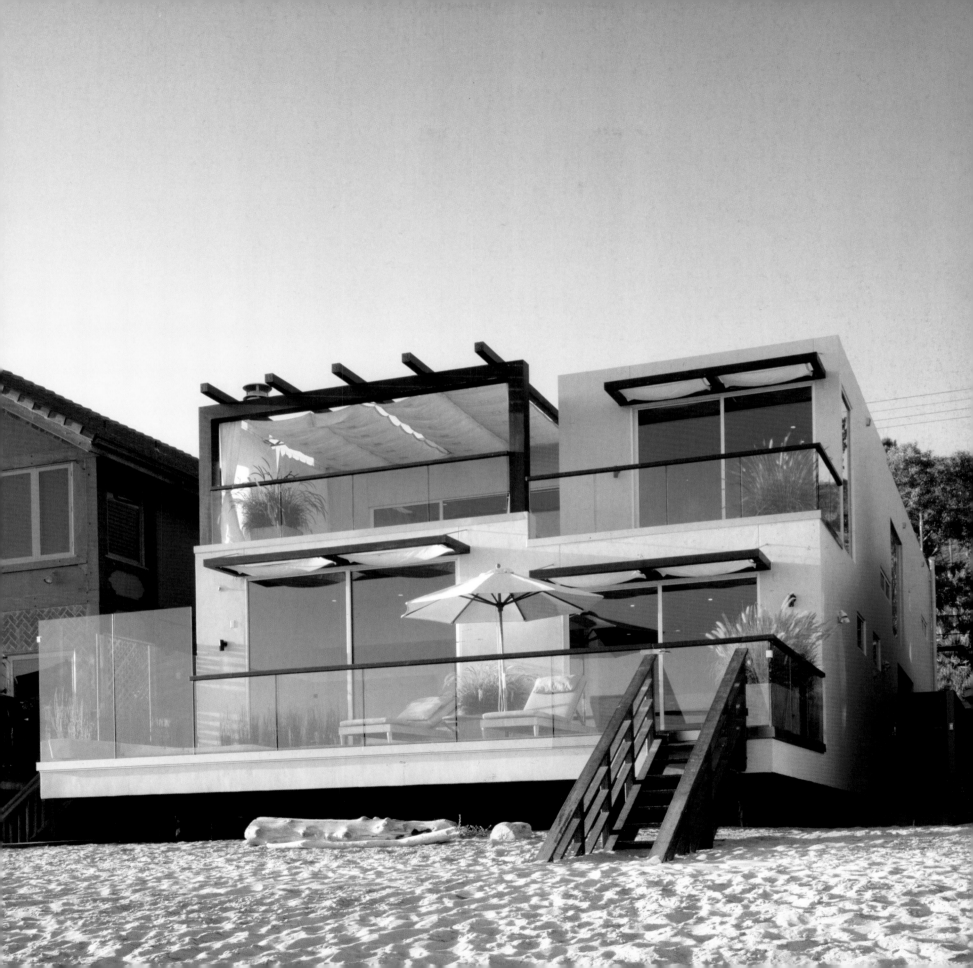

Second Floor Plan

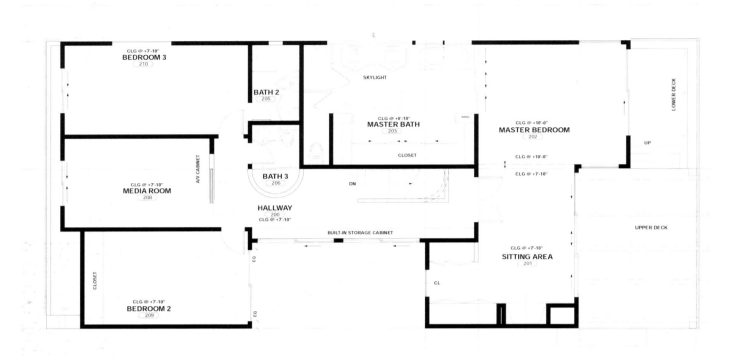

CLG @ +7'-10"
BEDROOM 3
210

SKYLIGHT

LOWER DECK

BATH 2
205

CLG @ +8'-10"
MASTER BATH
203

CLG @ +10'-0"
MASTER BEDROOM
202

CLOSET

UP

A/V CABINET

CLG @ +10'-0"

CLG @ +7'-10"

CLG @ +7'-10"
MEDIA ROOM
208

BATH 3
206

DN

HALLWAY
200
CLG @ +7'-10"

BUILT-IN STORAGE CABINET

UPPER DECK

CLG @ +7'-10"
SITTING AREA
201

EQ

CLOSET

CL

CLG @ +7'-10"
BEDROOM 2
209

EQ

First Floor Plan

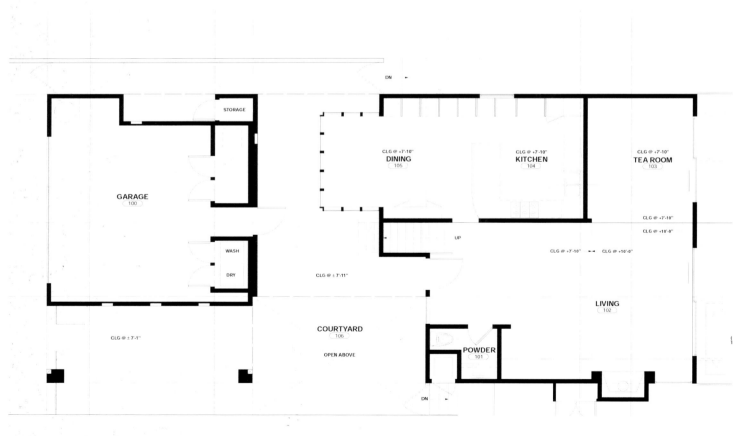

DN

STORAGE

CLG @ +7'-10"
DINING
105

CLG @ +7'-10"
KITCHEN
104

CLG @ +7'-10"
TEA ROOM
103

GARAGE
100

CLG @ +7'-10"

WASH

CLG @ +10'-0"

DRY

UP

CLG @ +7'-10" CLG @ +10'-0"

CLG @ ± 7'-11"

LIVING
102

CLG @ ± 7'-1"

COURTYARD
106

POWDER
101

OPEN ABOVE

DN

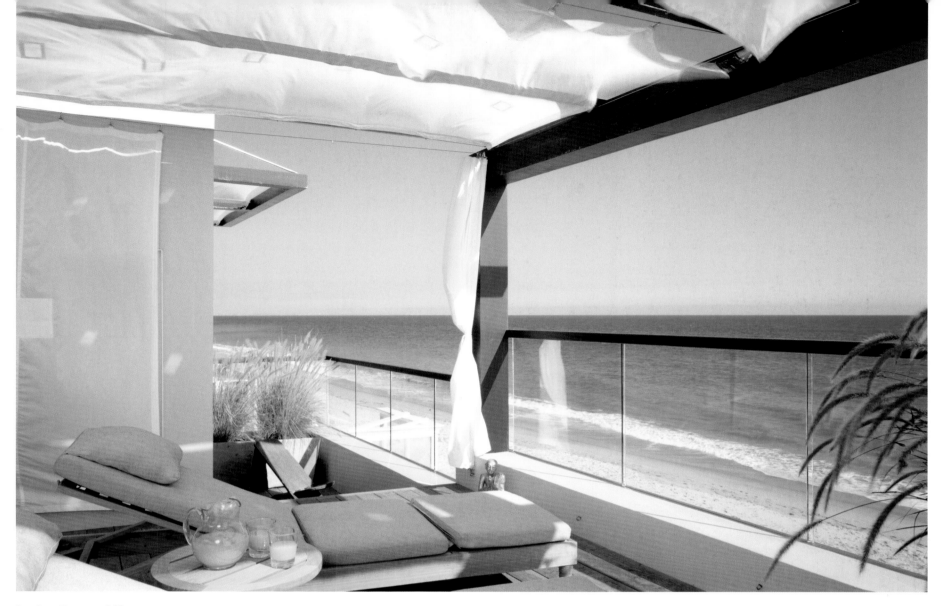

Previous Pages and Above:
The all-glass rear façade
allows unobstructed views
of the ocean.
Right: The entry courtyard

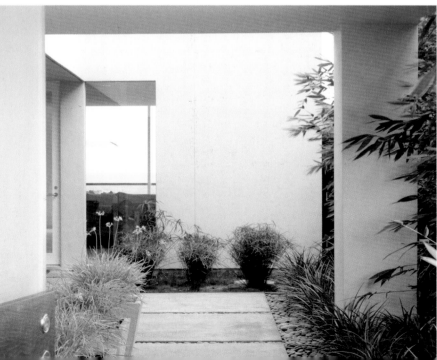

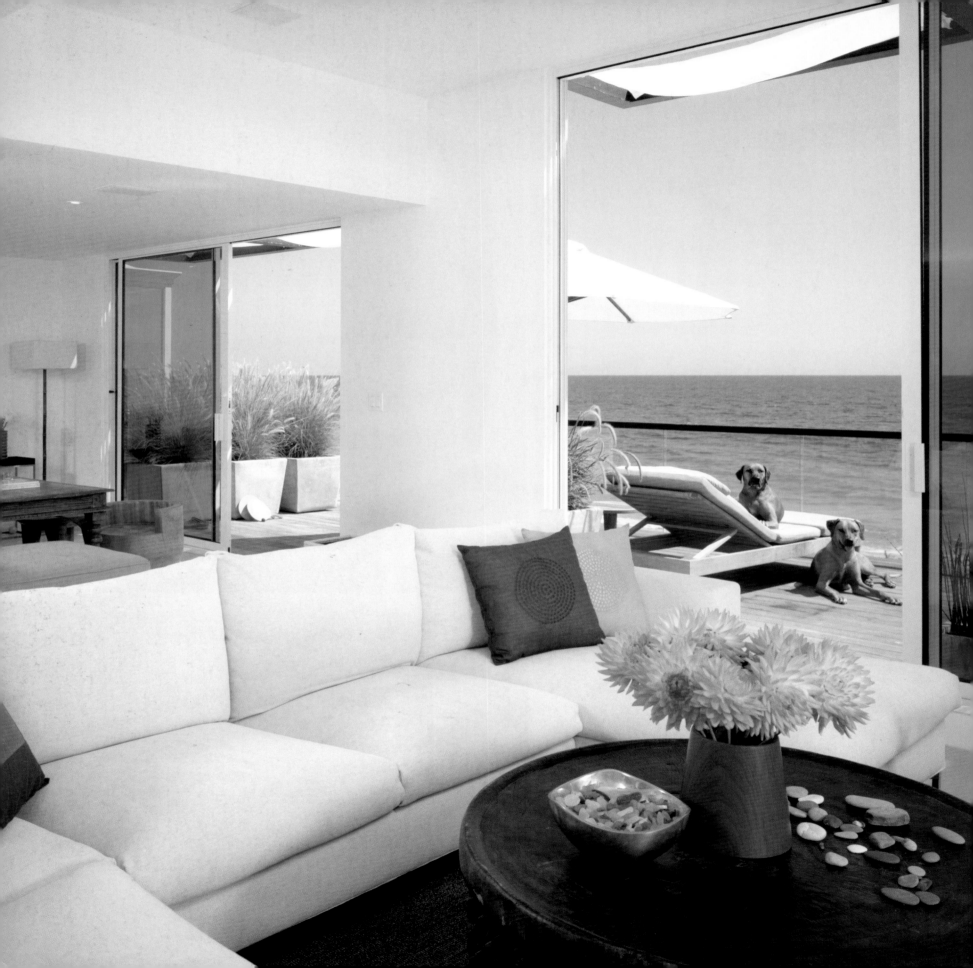

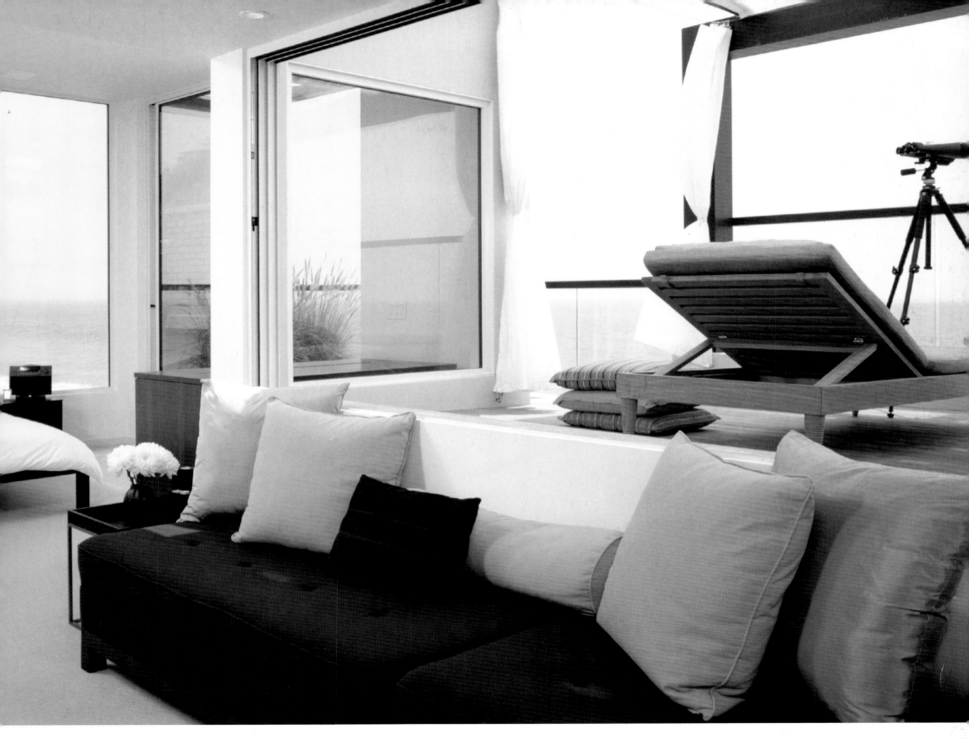

Left and Above: The interior design palette of natural woods and limestone, white walls and fabrics, and frosted and clear plate-glass creates a crisp and airy environment.

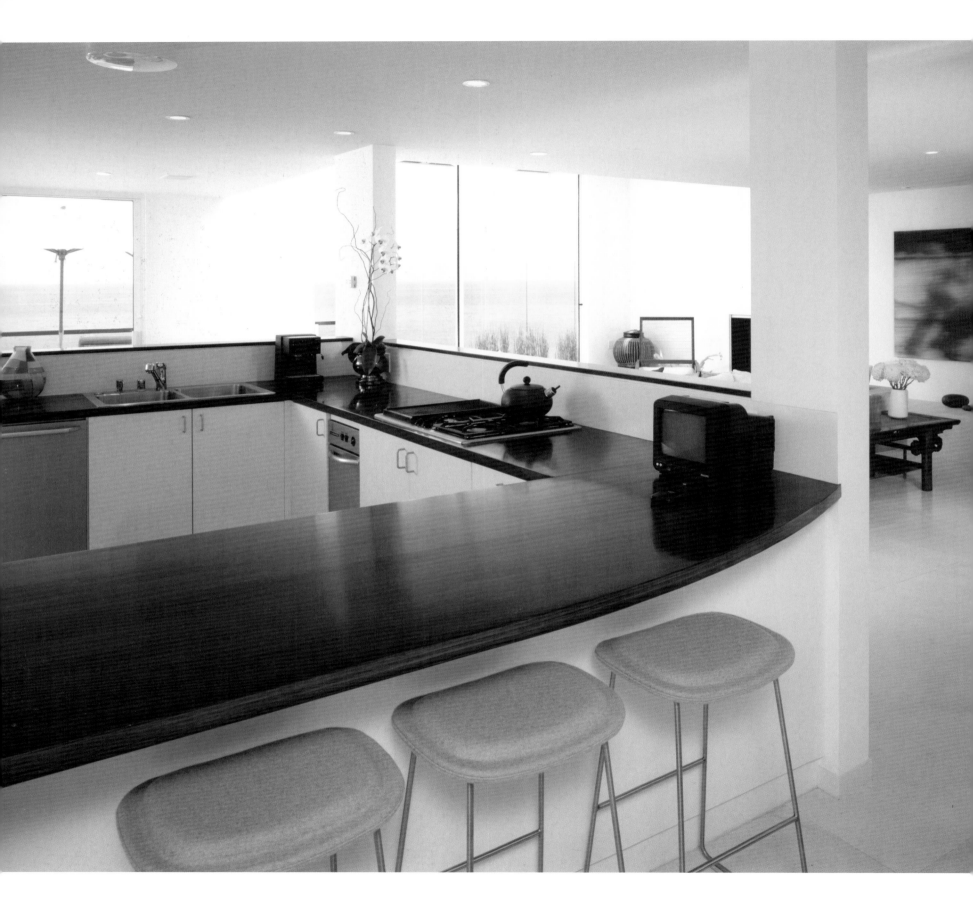

Left: The open kitchen overlooks the first-floor living area and the ocean beyond.
Right: The master bedroom
Below and Below Right: The master bath is lined with frosted glass. Translucent doors enclose the space for privacy or can be opened to the porch and views of the ocean.

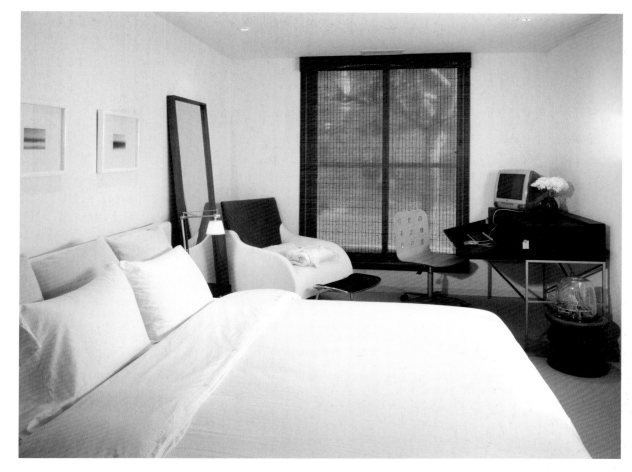

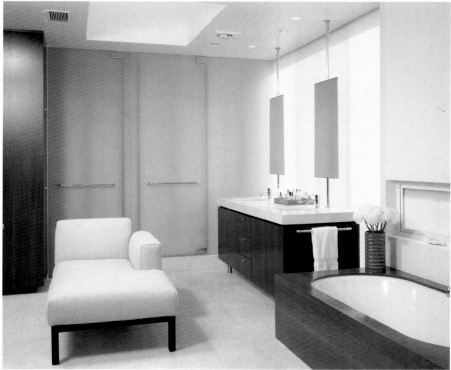

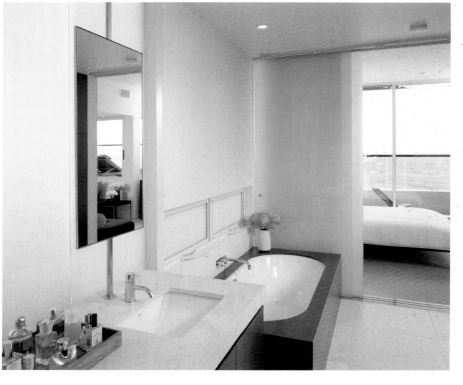

Weekend House

1200 Square Feet

David Jay Weiner, Architect
Photography: Tony Morgan

This weekend house for a Japanese client is located on a sloping 7-acre site overlooking the Berkshire Mountains. With a study area, a living area, a master bedroom suite, and wine cellar, the dwelling has the compactness and interior sparseness akin to traditional Japanese architecture and serves as a peaceful retreat from the busy city life of the owner.

The design of the house is conceived of as a single sweeping volumetric "sheet" enclosure that wraps and folds into itself to form and define two major interior spaces—a living, dining, and cooking area and the master bedroom suite. The house was designed to be relatively inexpensive both in construction and maintenance. As much of the site as possible has been left untouched and restored for the growth of natural wildflowers that dominate the surrounding landscape in the summer.

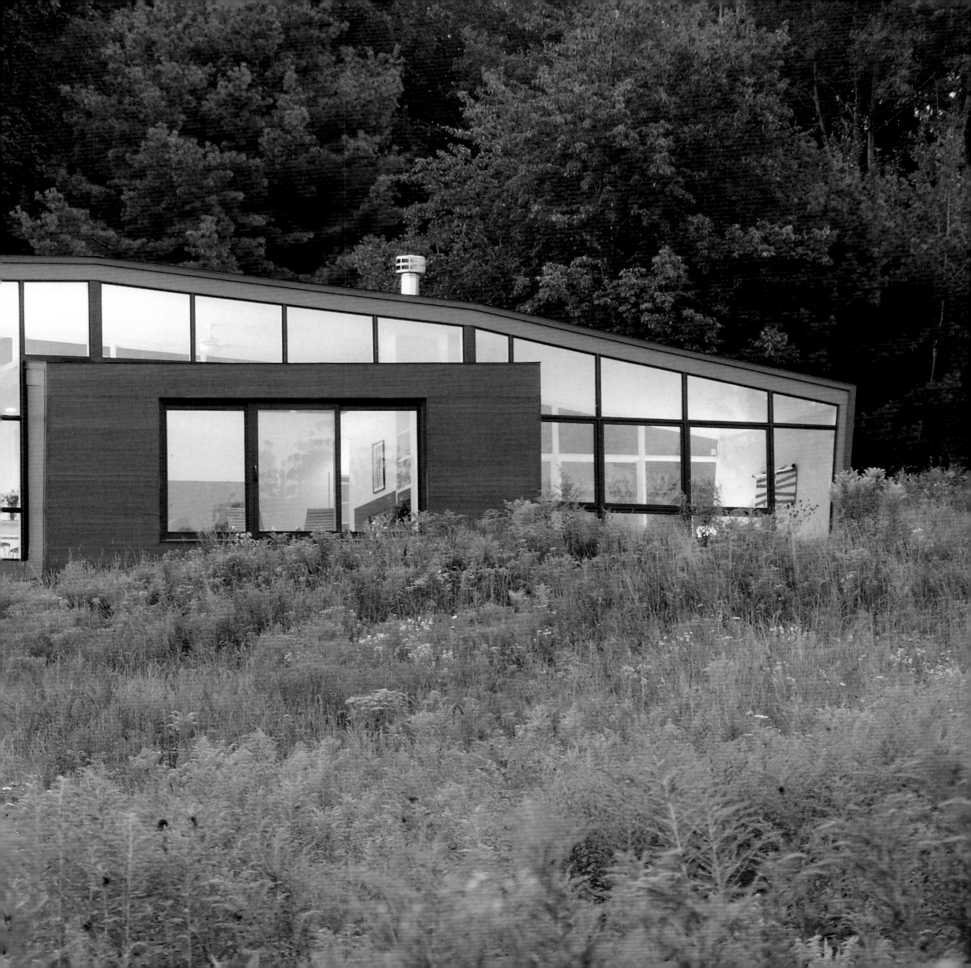

Floor Plan

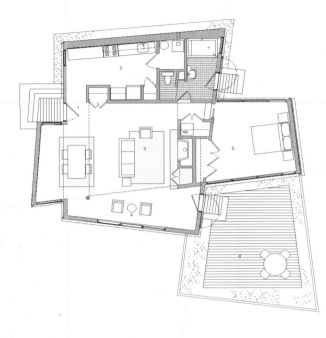

Site Plan

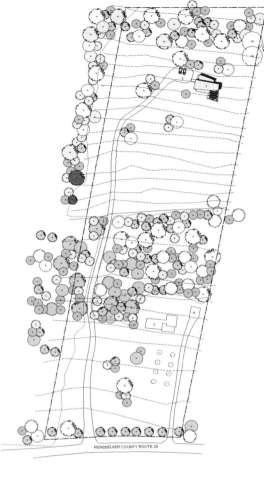

Previous Pages and Right:
The house was designed to fit tightly within the landscape. It rests on a poured-in-place concrete foundation and employs standard wood construction with tongue-and-groove cedar siding.

FLOOR PLAN

1 Entrance
2 Kitchen
3 Dining / Living
4 Engawa
5 Bedroom
6 Deck

RENSSELAER COUNTY ROUTE 28

Elevations

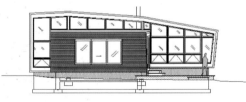

1 SOUTH ELEVATION
A-1

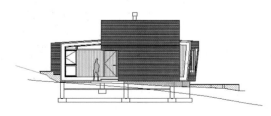

2 EAST ELEVATION
A-1

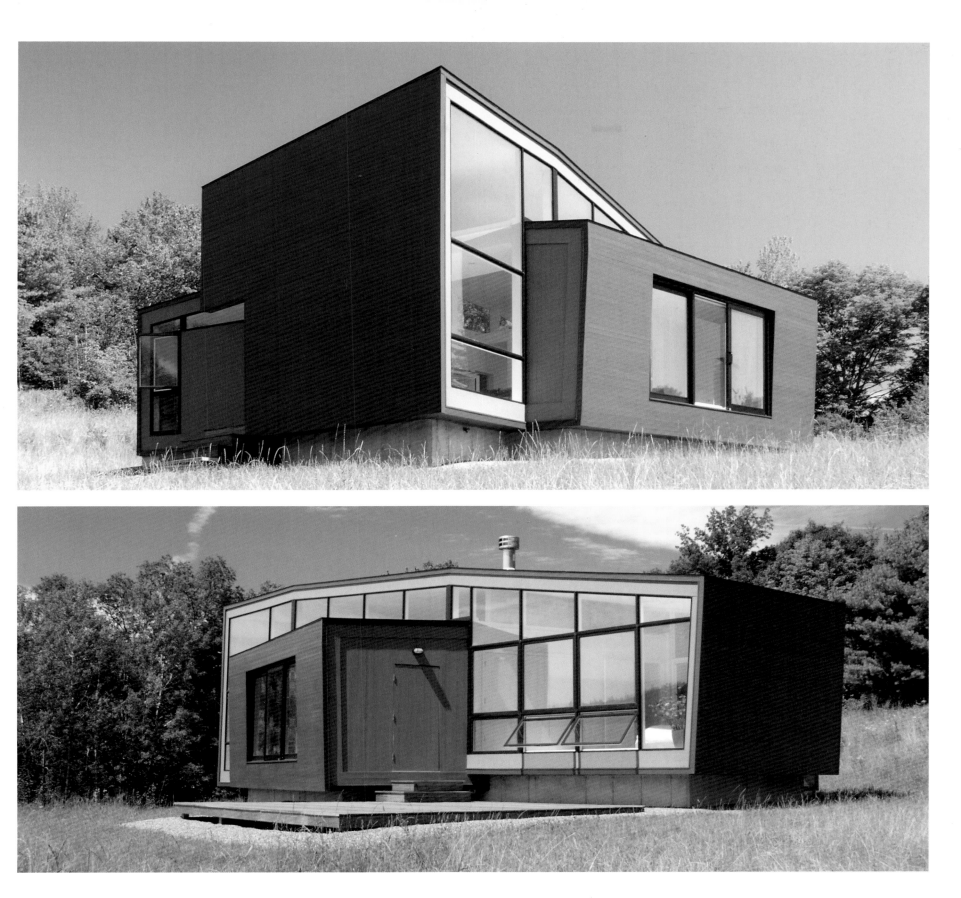

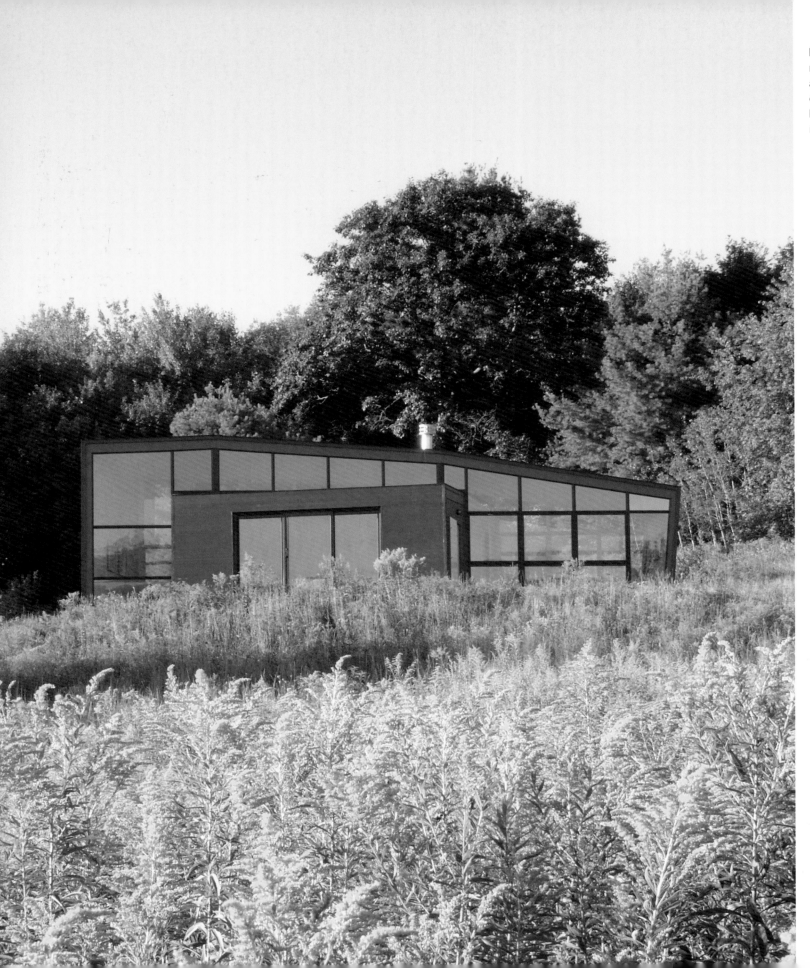

Left: The house sits amid native wildflowers that are prevalent in this area during the summer months. **Right:** A view into the master bedroom

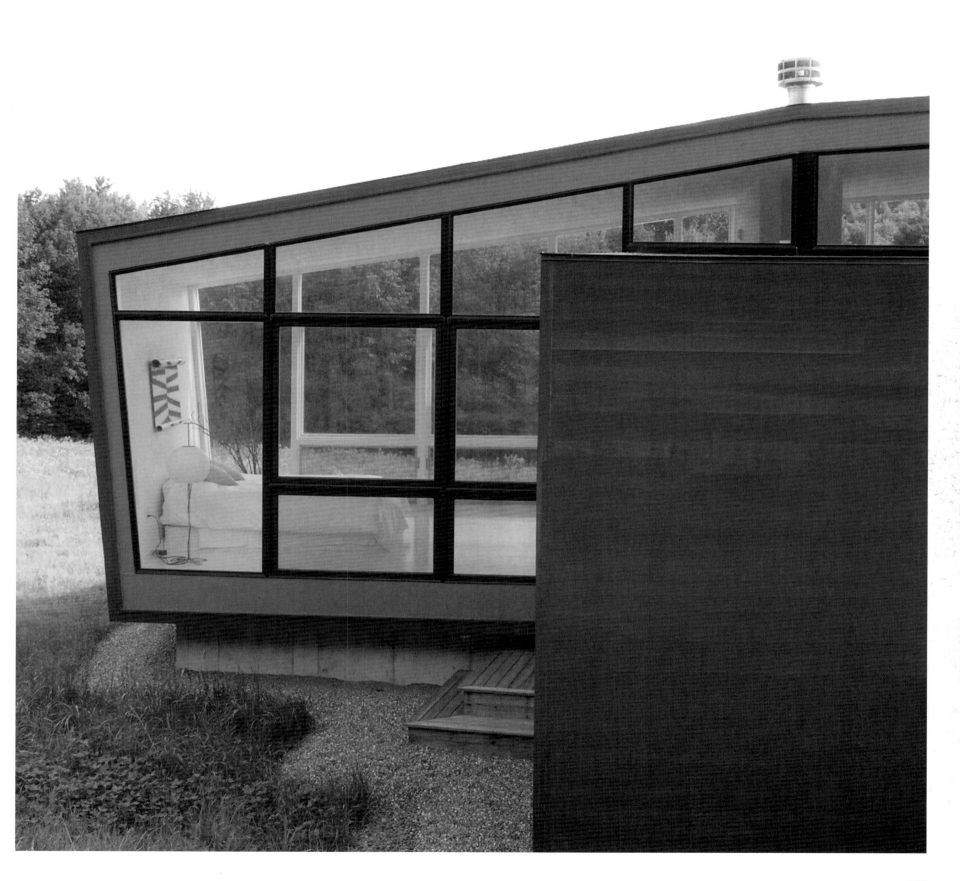

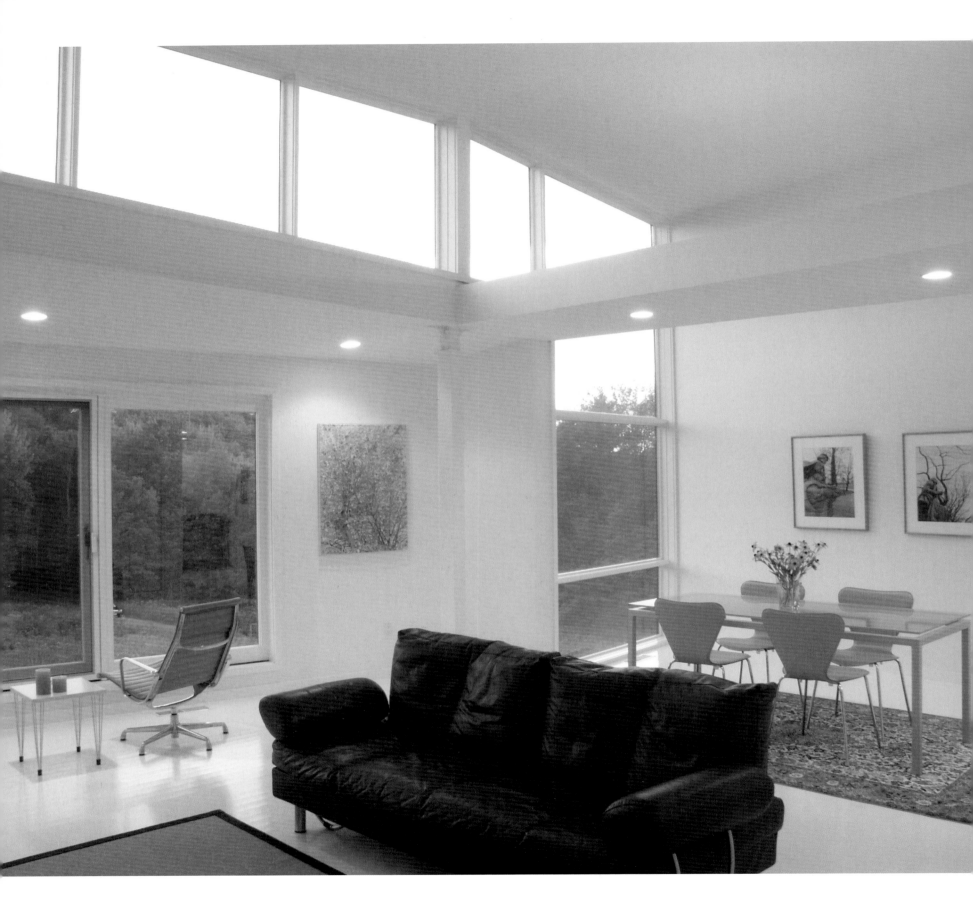

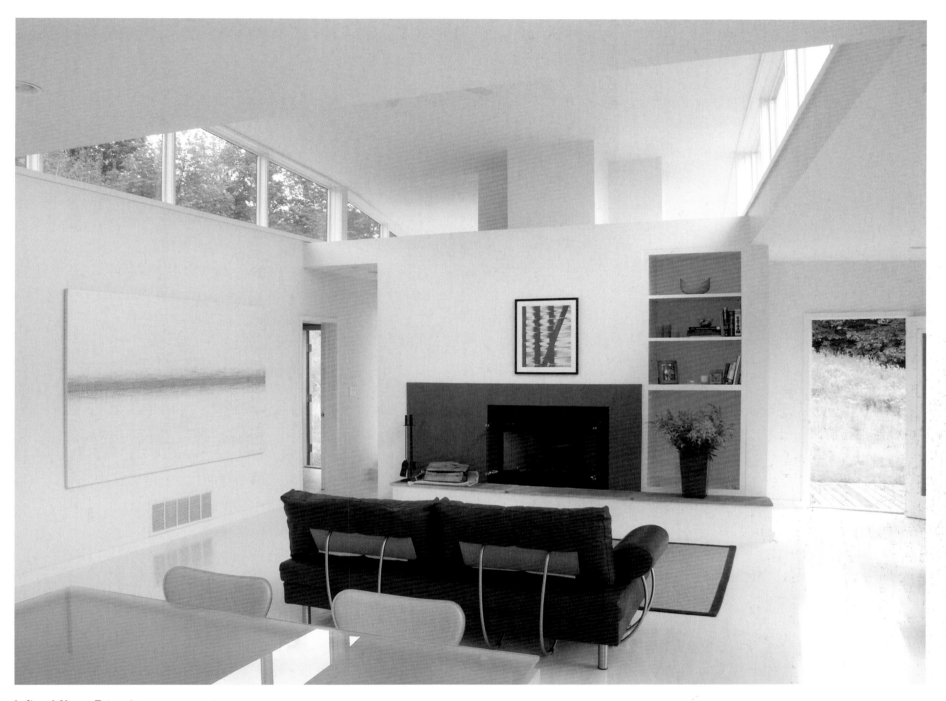

Left and Above: Extensive glazing including clerestory windows in the living area bathe the space in natural light and unite it with the surrounding natural landscape.

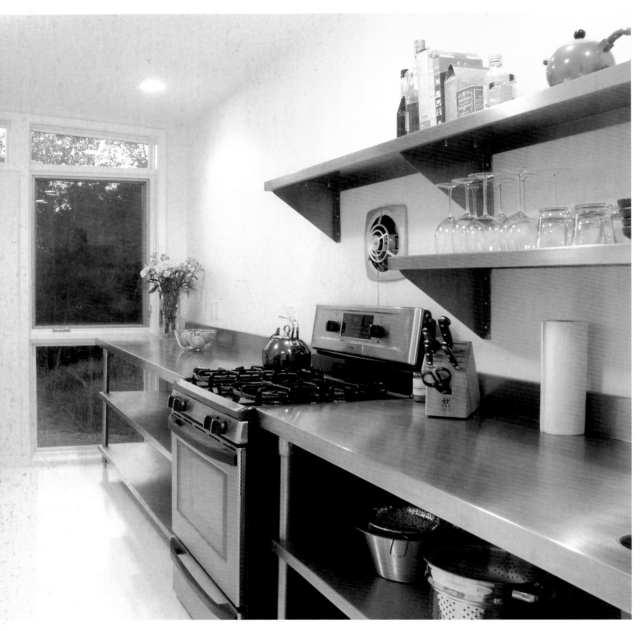

Above Left: The kitchen
Above: In the bathroom, glass tile was used to form the bathtub and shower and for the walls.
Right: The master bedroom appears to float within the landscape.

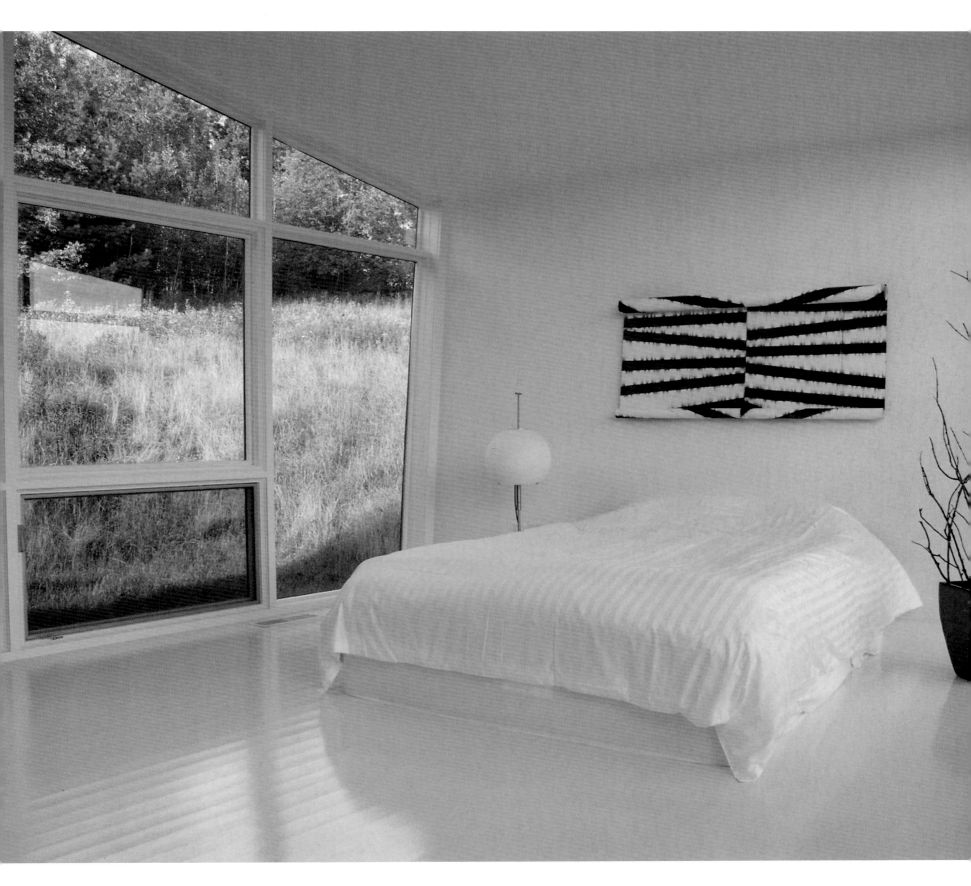

Collingwood Street House

2500 Square Feet

Philip Mathews Architect
Photography: Tom Rider

Setting it apart from the smaller houses around it, the long, linear form of this new two-unit townhouse in San Francisco is designed with angles and stepping forms. Its multiple exterior colors and building materials also result in its unique and elongated appearance. However, its overall height was reduced by subtracting parapet walls at the roof and by lowering the garage level below the sidewalk.

A central two-story space in the upper unit connects rooms at either end of the house without need for long, dark corridors. A bridge with a glass block skylight above unites the top floor bedrooms. Glass block along the south wall brings in abundant light and acts as a passive solar window. On the north side, the dining area receives light from a sloping two-story, partially etched glass wall. The lower unit has a small deck and access to an extensively landscaped private garden.

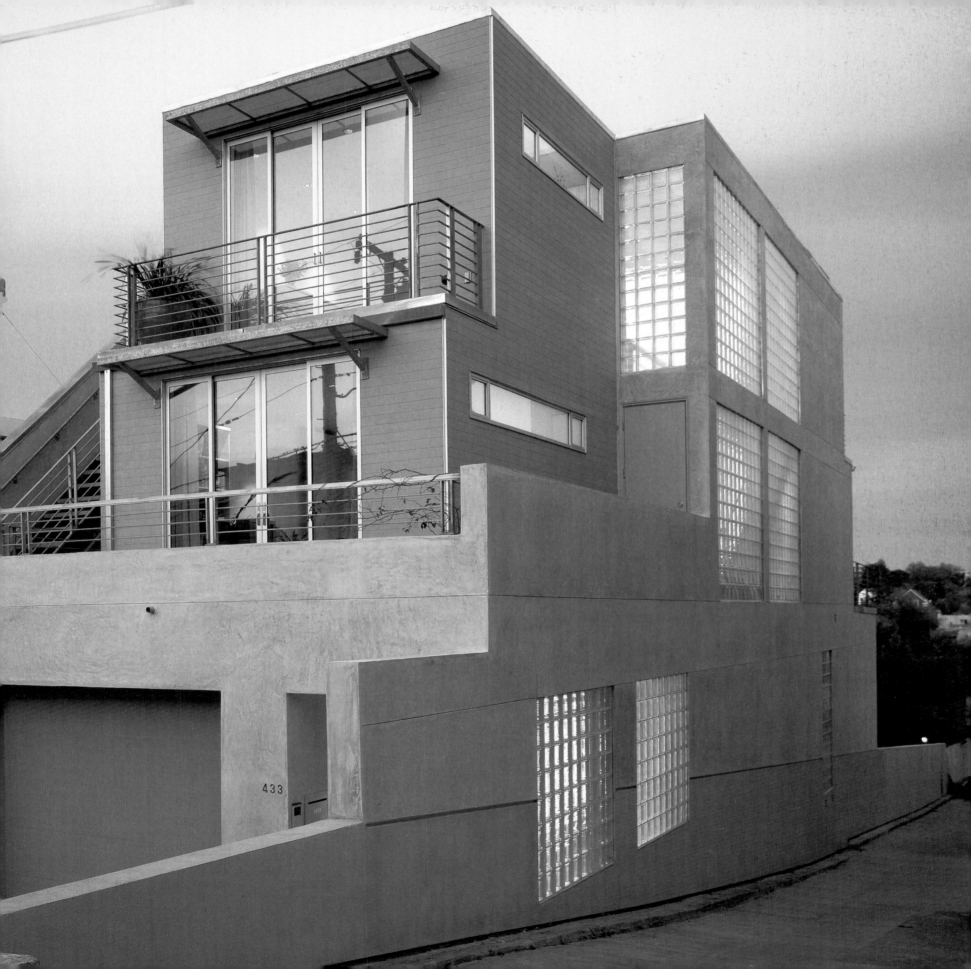

East Elevation

Previous Pages: The faceted and stepping forms of the townhouse result in four decks for the upper unit. They are surrounded by open steel railings to avoid blocking the view.

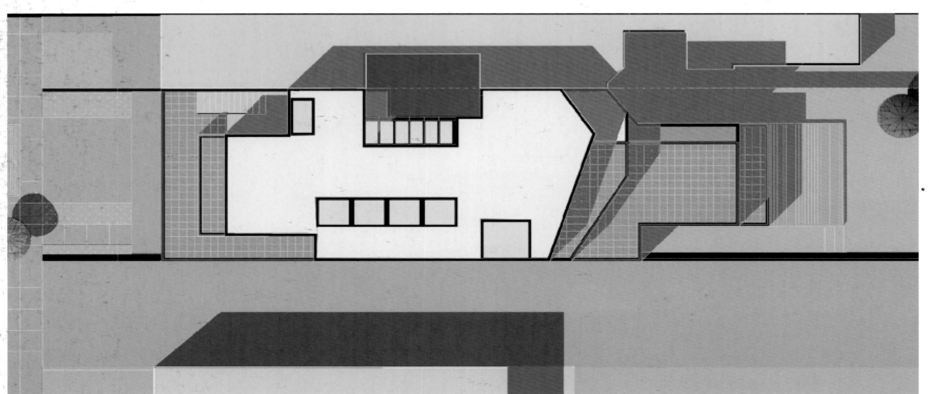

Site Plan

Section

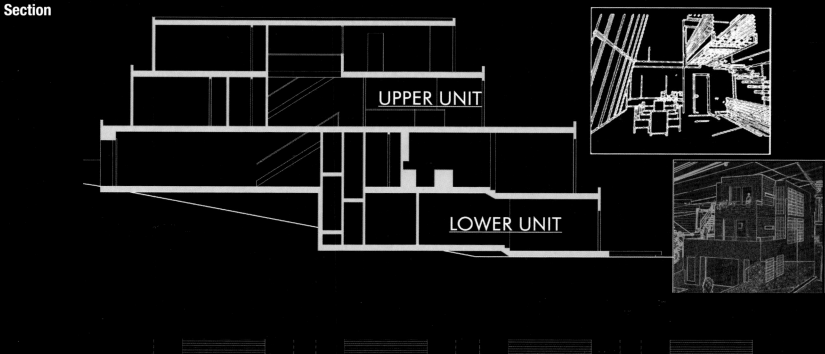

UPPER UNIT

LOWER UNIT

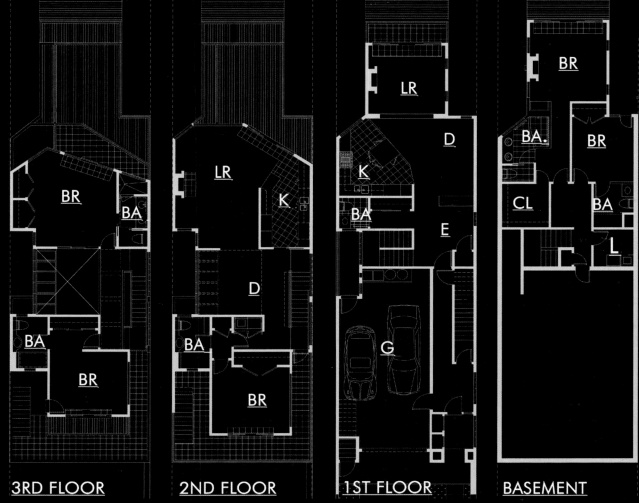

3RD FLOOR | **2ND FLOOR** | **1ST FLOOR** | **BASEMENT**

3rd Floor: BR, BA, BA, BR

2nd Floor: LR, K, D, BA, BR

1st Floor: LR, D, K, BA, E, G

Basement: BR, BA., BR, CL, BA, L

Left: A slopping glass wall on the north side brings light into the dining area.
Right: The second floor living area

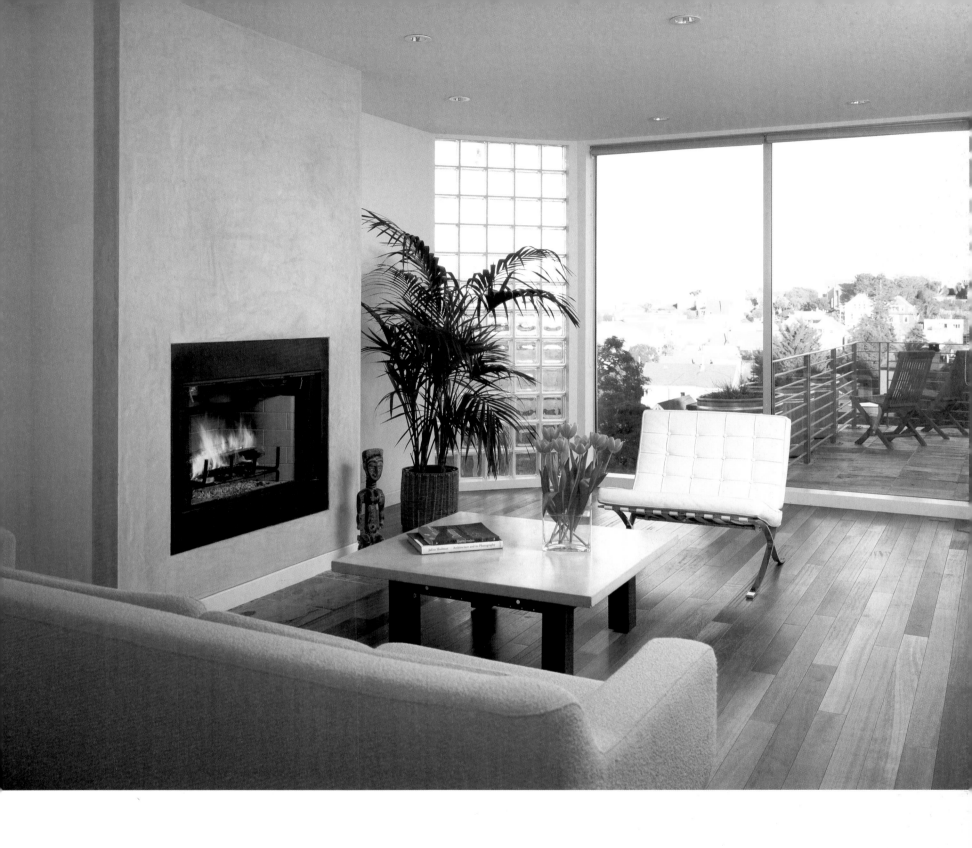

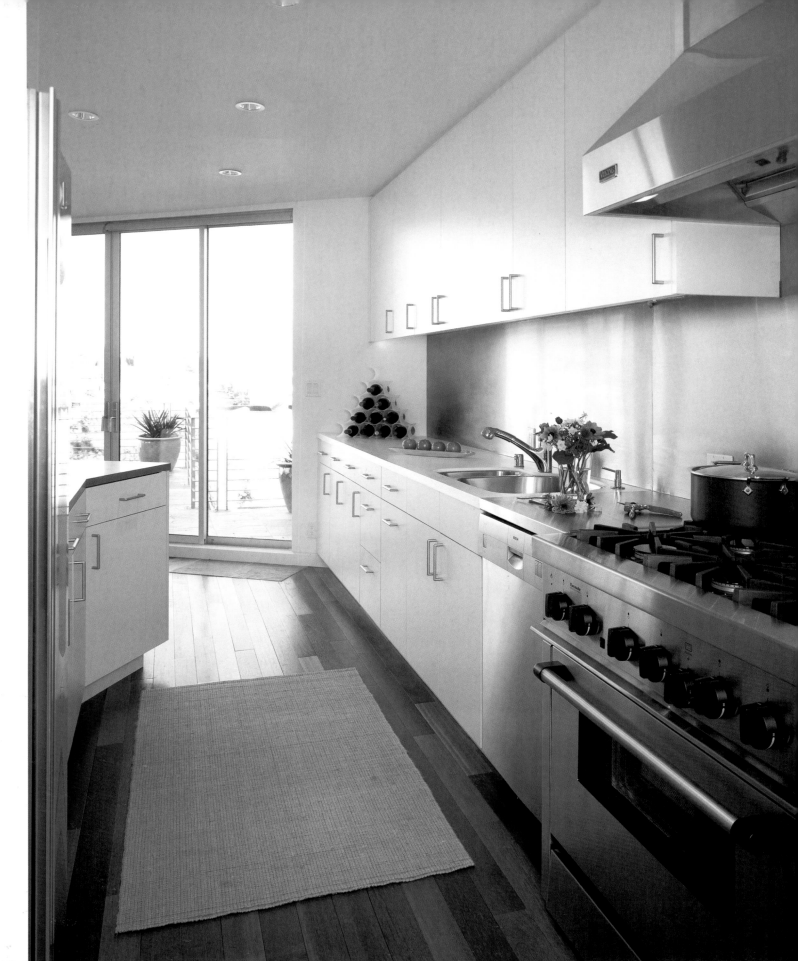

Right: The kitchen is located on the first floor.
Far Right: All second and third floor rooms open into the central atrium.

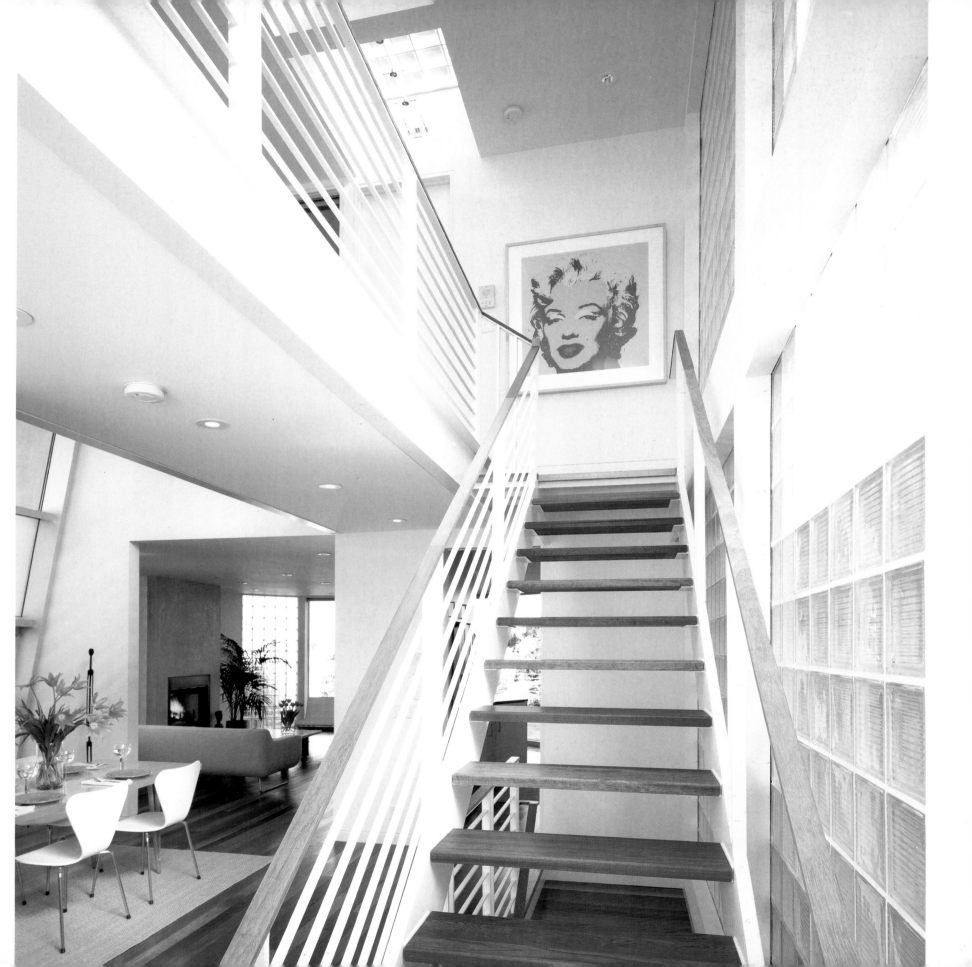

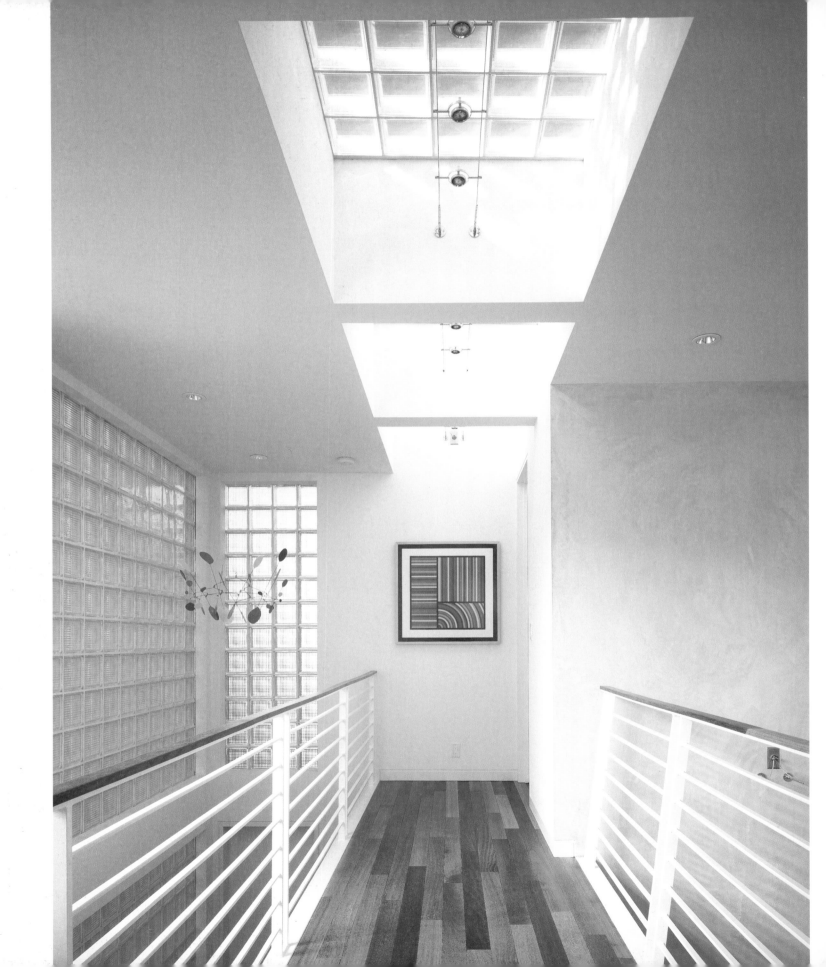

Right: A glass block skylight floods the third floor with light.

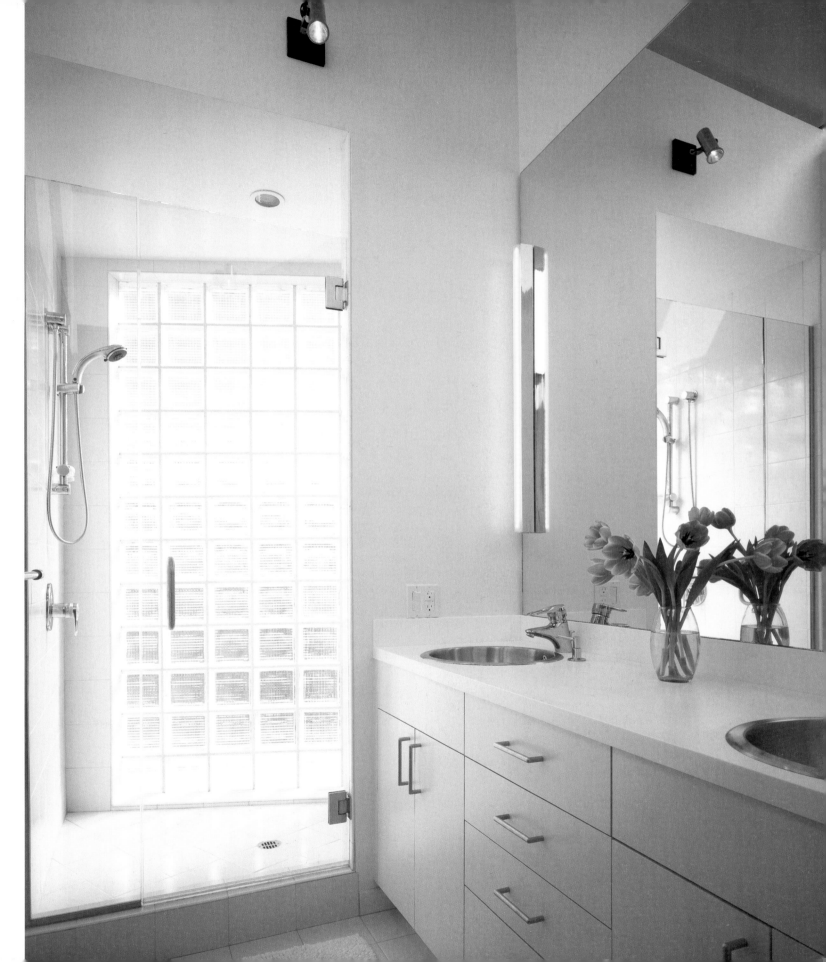

Right: Glass block was also used for the exterior wall of the shower in the master bathroom.

Daniel Residence

2000 Square Feet

FAB Architecture
Photography: Paul Bardagjy

THE EXISTING 1940S COTTAGE IN AUSTIN, TEXAS LOOKS MUCH THE SAME FROM THE STREET AS IT DID BEFORE THE ARCHITECTS DESIGNED A TWO-STORY PAVILION IN BACK AND EXTENSIVELY REMODELED THE INTERIOR. THE ADDITION INCLUDES A FAMILY ROOM, A UTILITY ROOM, A LARGER KITCHEN ON THE GROUND LEVEL AND A MASTER BEDROOM ON THE SECOND FLOOR.

BUILT WITHIN A LIMITED BUDGET, ECONOMY WAS ACHIEVED BY MAKING THE MOST OF COMMON BUILDING MATERIALS, SUCH AS STAINED, CONCRETE SLAB FLOORS AND EXPOSED, NATURAL WOOD-CEILING FRAMING. THE INTERIOR ARCHITECTURE OF THE ADDITION IS CHARACTERIZED BY A SUBTRACTIVE PROCESS. SIMPLE SPACES HAVE BEEN CARVED OUT CREATING LEDGES AND NICHES; A SUSPENDED SOFFIT DEFINES AN INTIMATE SITTING AREA. A SOFT PALETTE OF PAINT COLORS PUNCTUATED BY EBONIZED FLOORS AND WOOD LEDGES GIVES THE HOME WARMTH WHILE CONTRIBUTING TO A CLEAN, MODERN AESTHETIC.

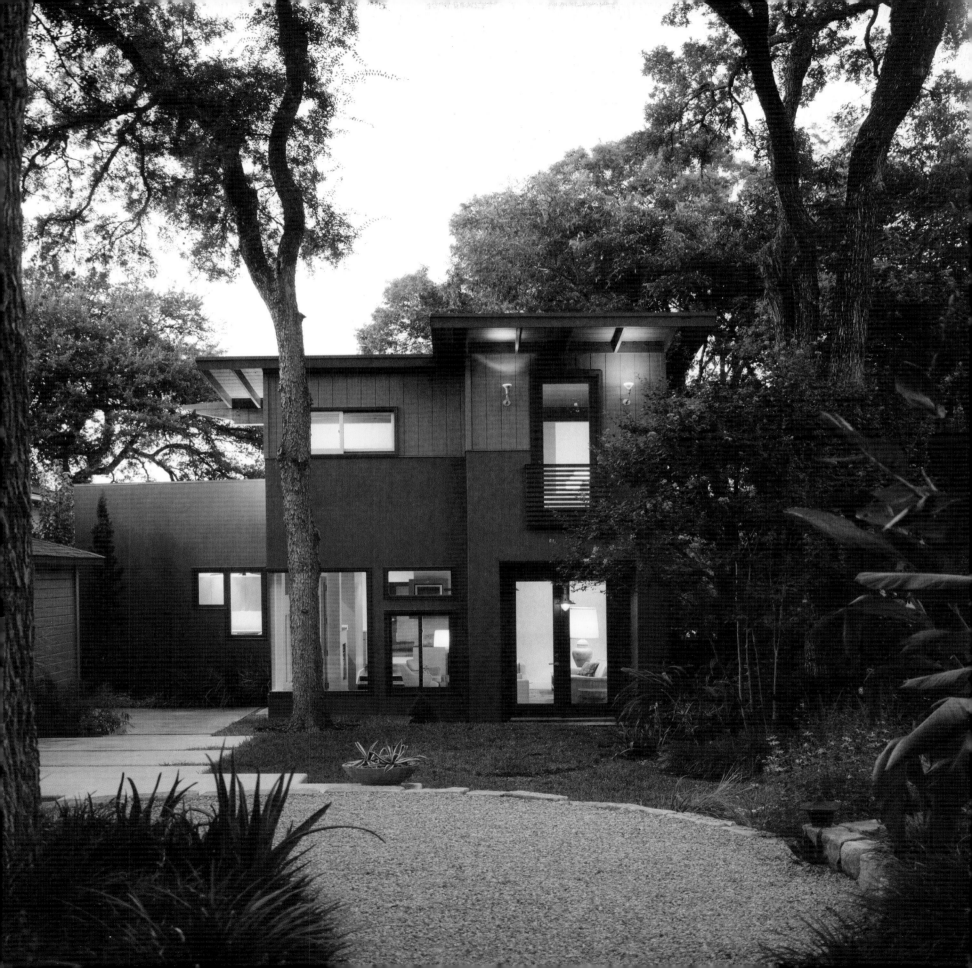

Floor Plan

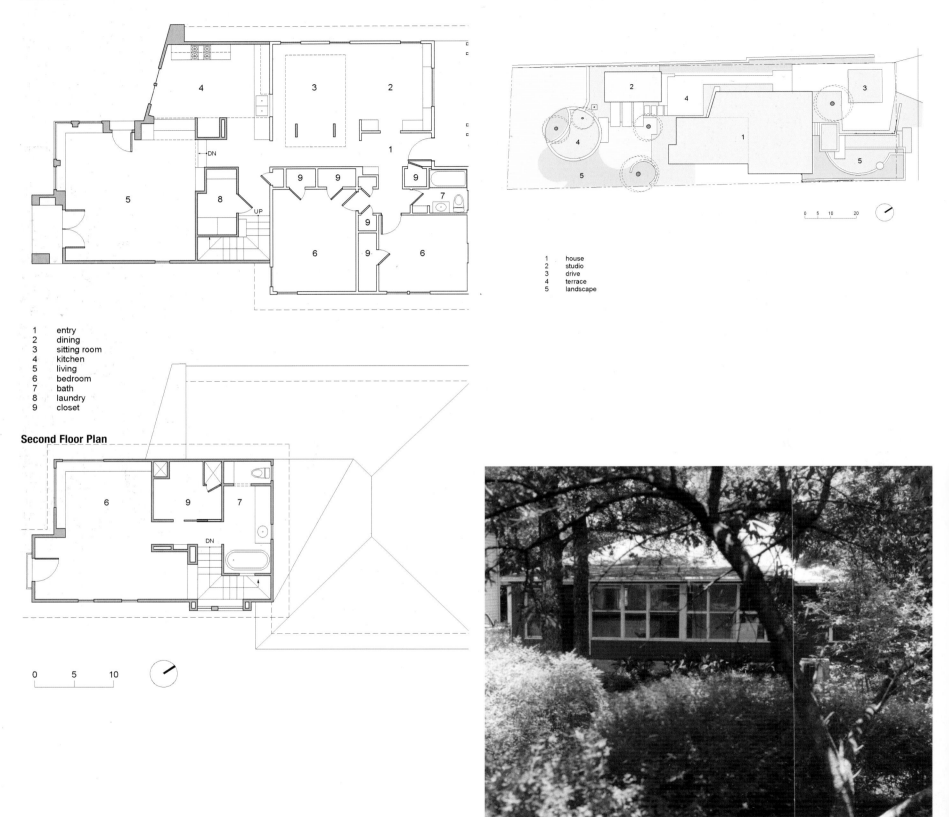

DN
UP

1 entry
2 dining
3 sitting room
4 kitchen
5 living
6 bedroom
7 bath
8 laundry
9 closet

Second Floor Plan

DN

0 5 10

Site Plan

0 5 10 20

1 house
2 studio
3 drive
4 terrace
5 landscape

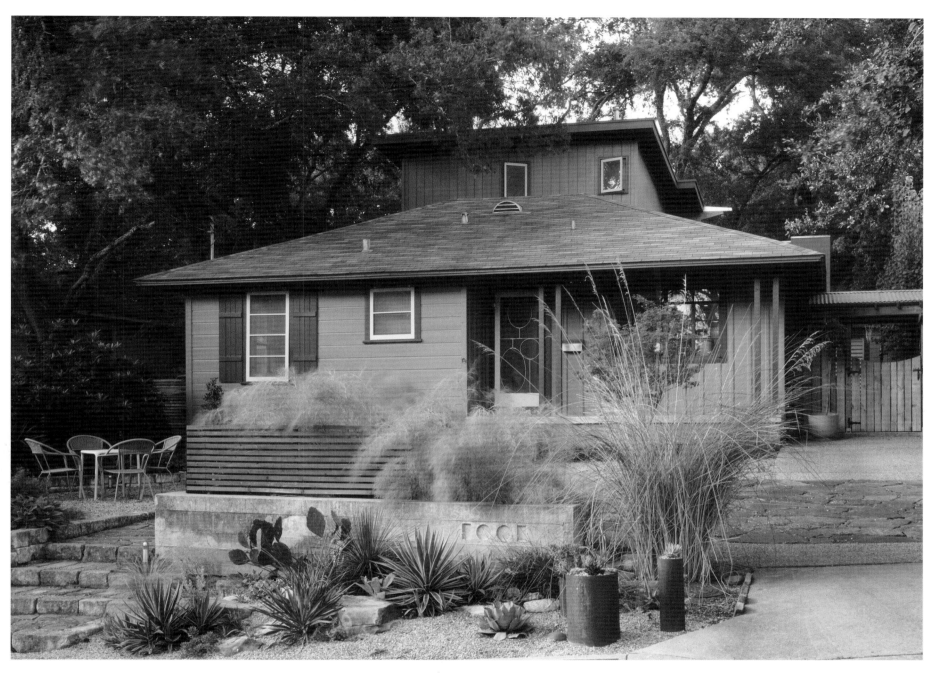

Previous Pages: The two story addition more than doubled the square footage of the small bungalow.
Above: The street façade remains much as it was before the renovation.
Left: The rear elevation before the addition

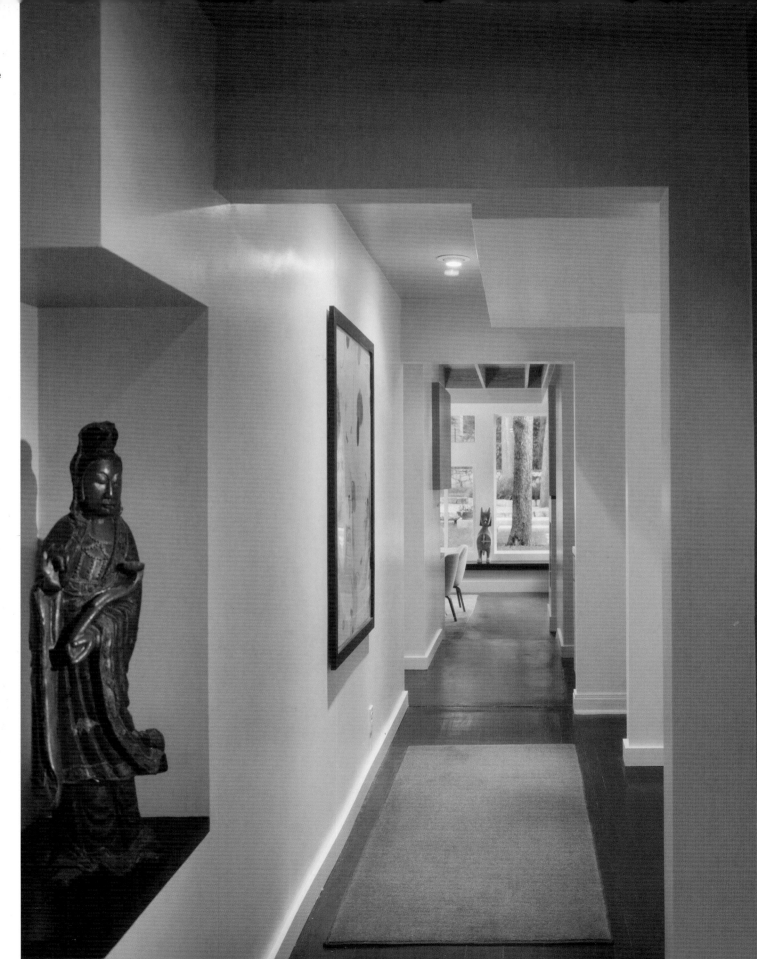

Right: The entry corridor with a niche added for the display of art

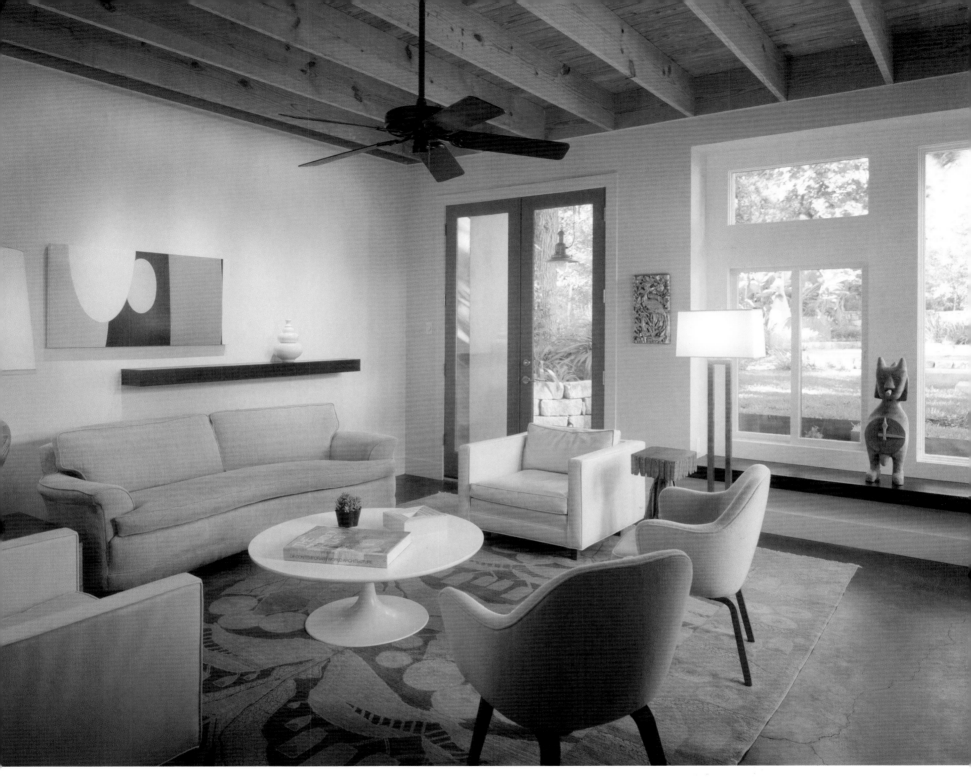

Above: The living room with exposed natural wood ceiling framing

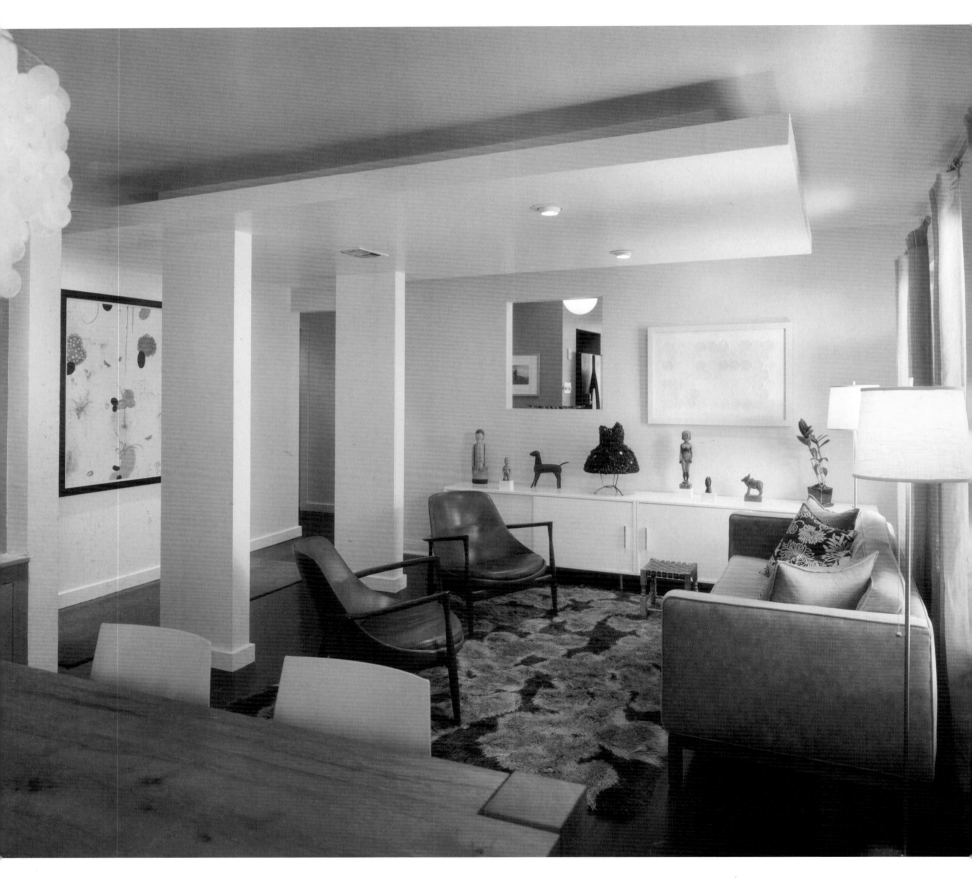

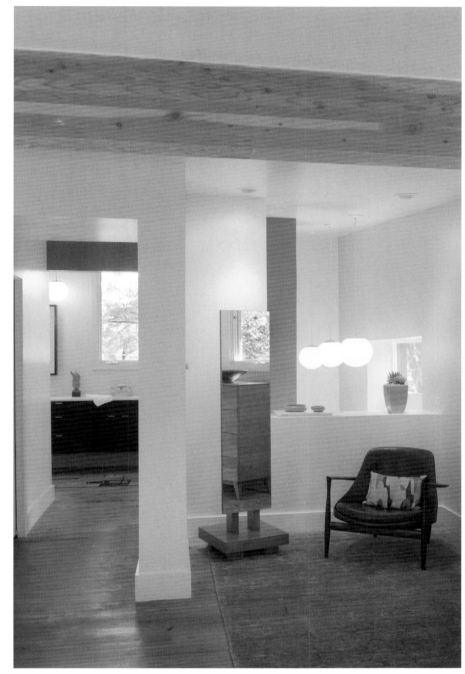

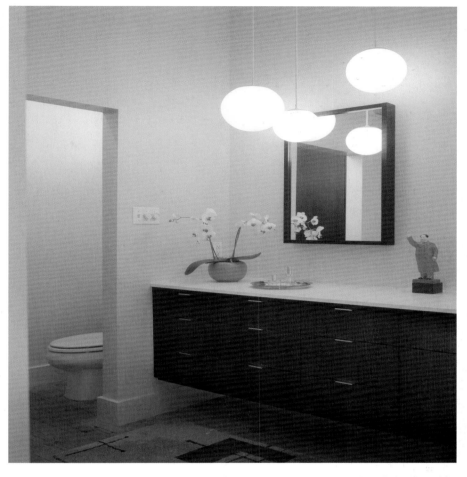

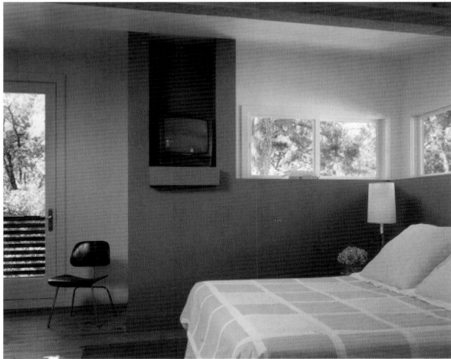

Left: The sitting room with the dropped ceiling as seen from the dining area
Above: The master bathroom and stairwell as viewed from the master bedroom

Above Right: The master bath vanity
Right: The master bedroom

View Avenue Residence

2570 Square Feet

Heliotrope Architects
Photography: Art Grice

Although sited atop a knoll overlooking Puget Sound, the existing 1960s era two-story residence took little advantage of potential views. To capture these views, the roof and main level were removed, making room for two new floors and a loft. The living spaces were placed on the top floor with the entry level situated mid-way between the two floors. The completed house consists of three 'boxes:' the entry, the main living spaces, and finally, the private quarters. Horizontal planes slice into these volumes, providing overhangs for windows and doors, and creating exterior deck space.

Interior spaces were arranged to relate specifically to one of two primary views. Openings that frame these views extend to ceilings or perpendicular walls. A separate 1000-square-foot mother-in-law apartment is on the ground level.

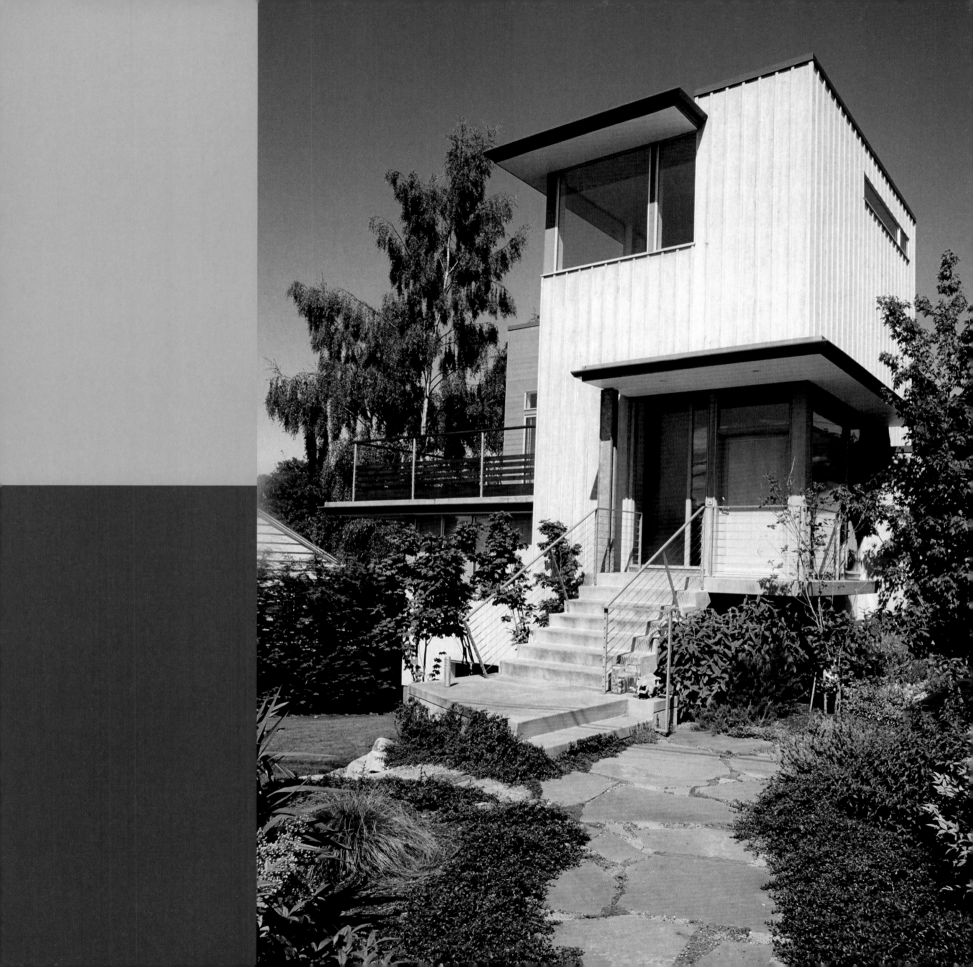

Third Floor Plan

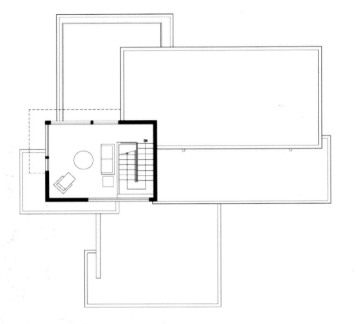

Second Floor Plan

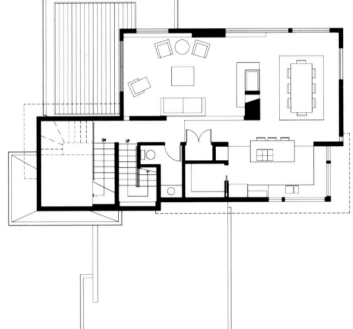

Previous Pages: Vertical cedar siding sheathes the exterior where the entry is at mid-level, between floors.
Right: The house was extended vertically to capture views.

First Floor Plan

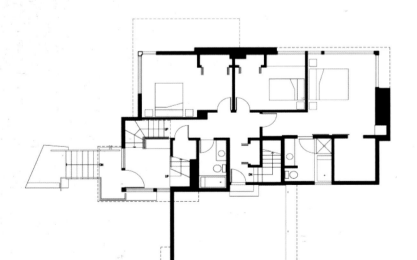

North Elevation

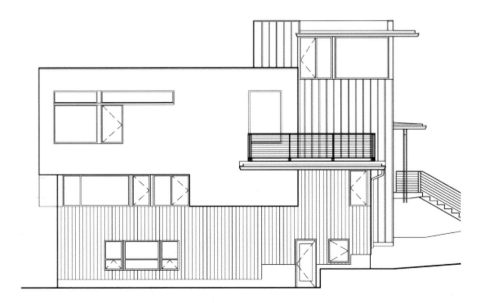

LEVEL 1 PLAN

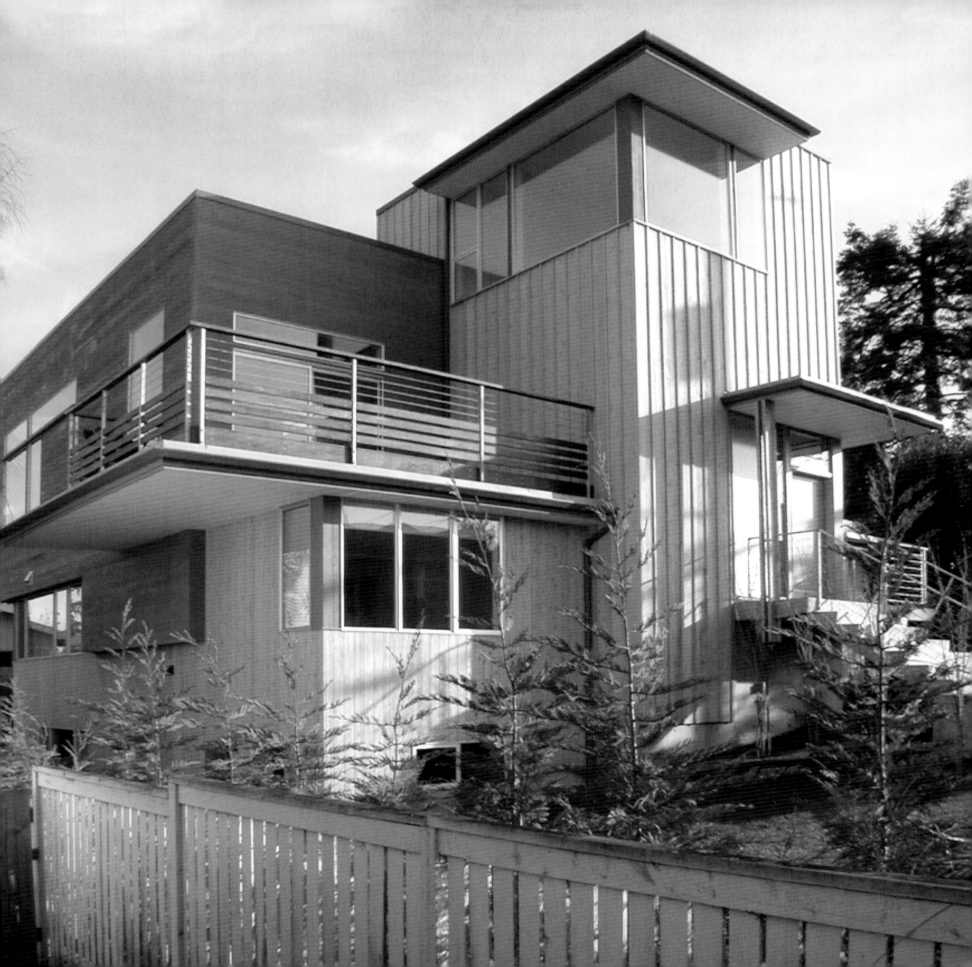

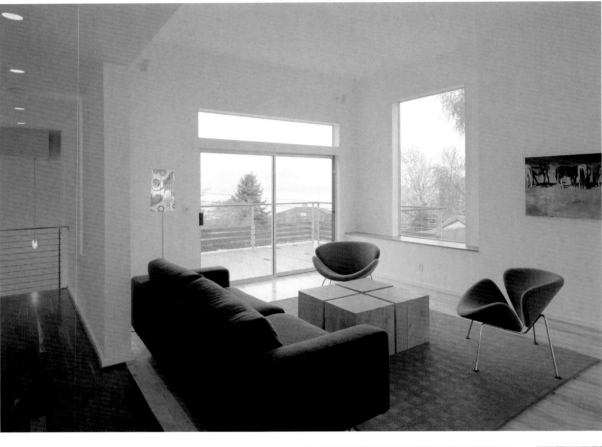

Above, Left, and Right: The living, dining, and kitchen areas were placed on the top floor to take advantage of the views.

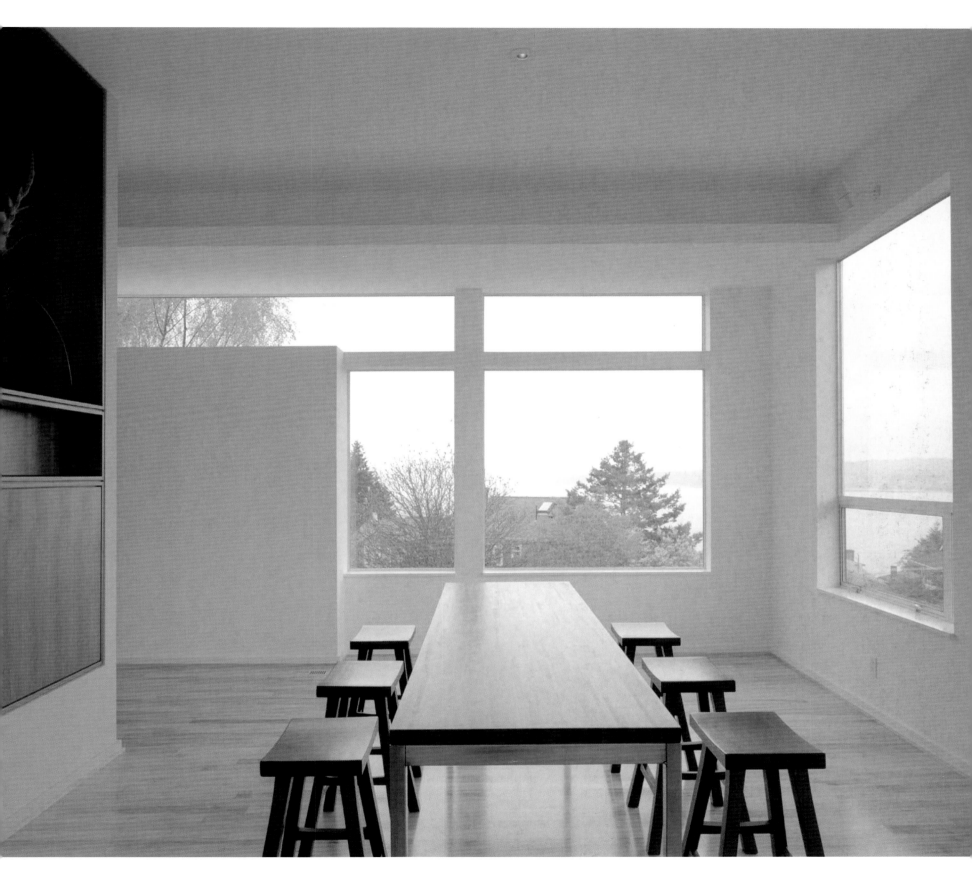

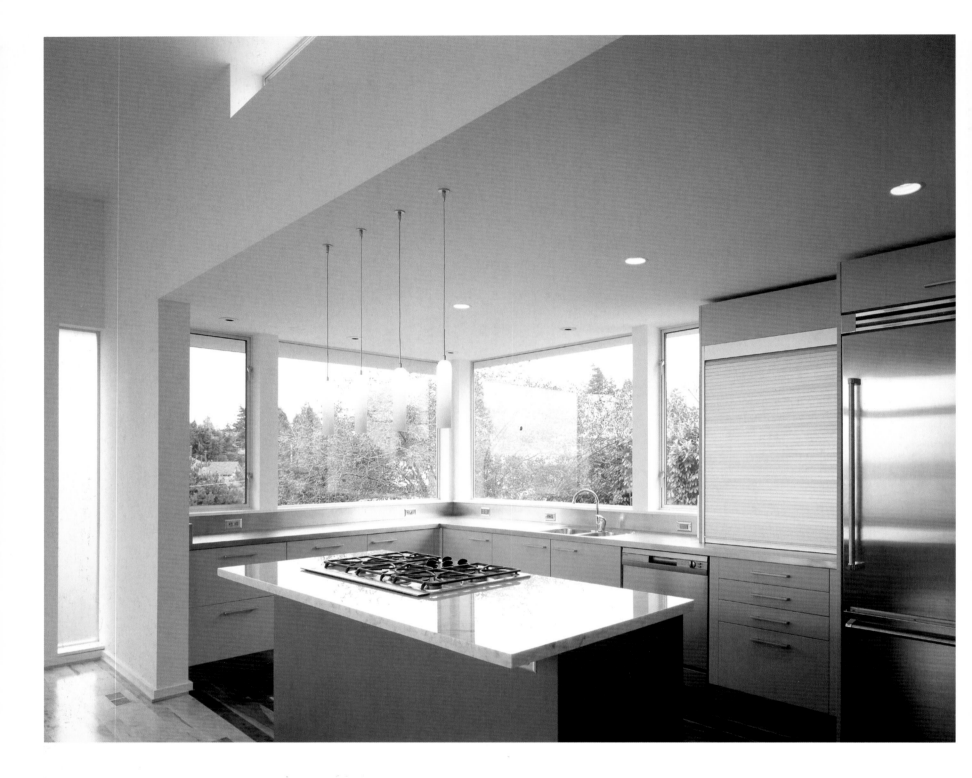

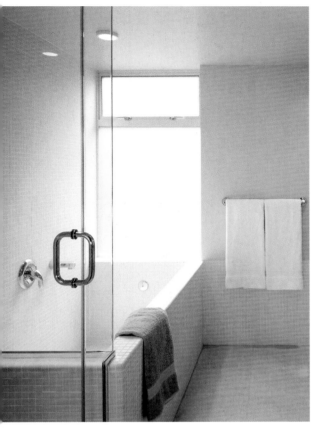

Left: The kitchen
Above: The master bathroom with a custom tile tub and shower.
Right: The entry to the house is between the second and first floors.

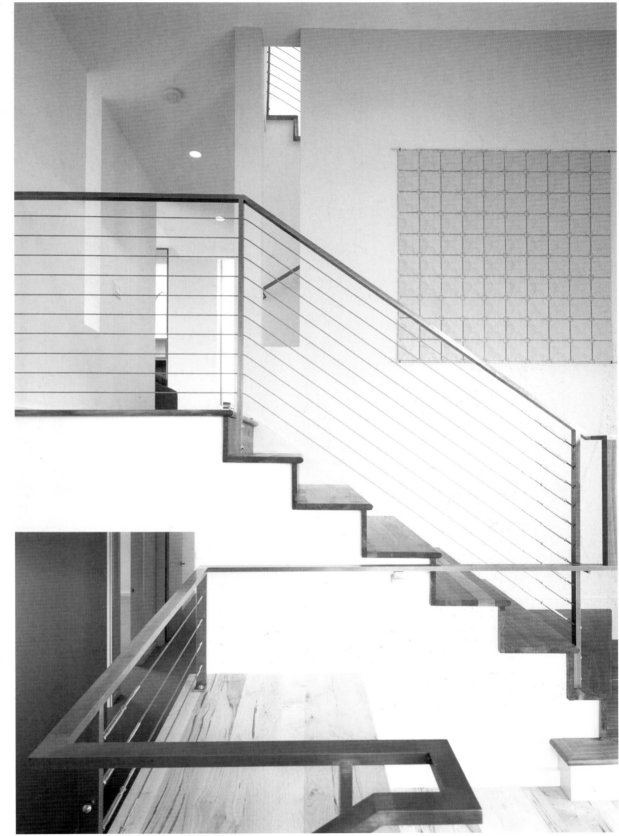

Burke House

1500 Square Feet

Brad Burke, Architect
Photography: David Hewitt and Anne Garrison, Paul Body, Brad Burke

Set within the foothills east of San Diego, the design of this home was inspired by both its rural context and the rich history of housing experimentation in Southern California.

The barn-like form was constructed using a post and beam system of exposed composite wood members. Full-sized glass and fiber cement panels used for exterior wall construction. The house utilizes both passive and active energy sources, such as sunlight and solar energy respectively. It is powered by 3,600 watts of photovoltaic cells, and is heated by a hydronic radiant floor system.

The architect designed this home for his family of five. Although it contains a modest 1500 square feet of interior space, it has an additional 1500 square feet of exterior roofed space, which equally divides activity between outside and inside.

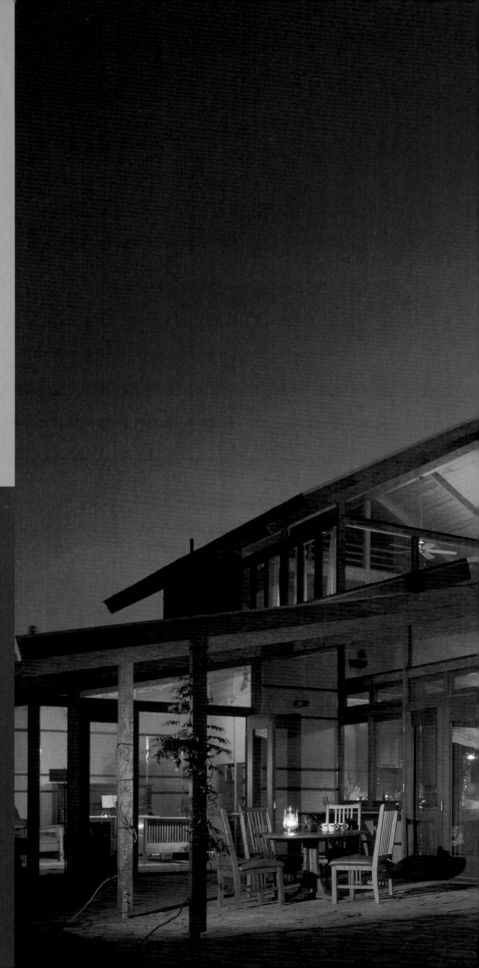

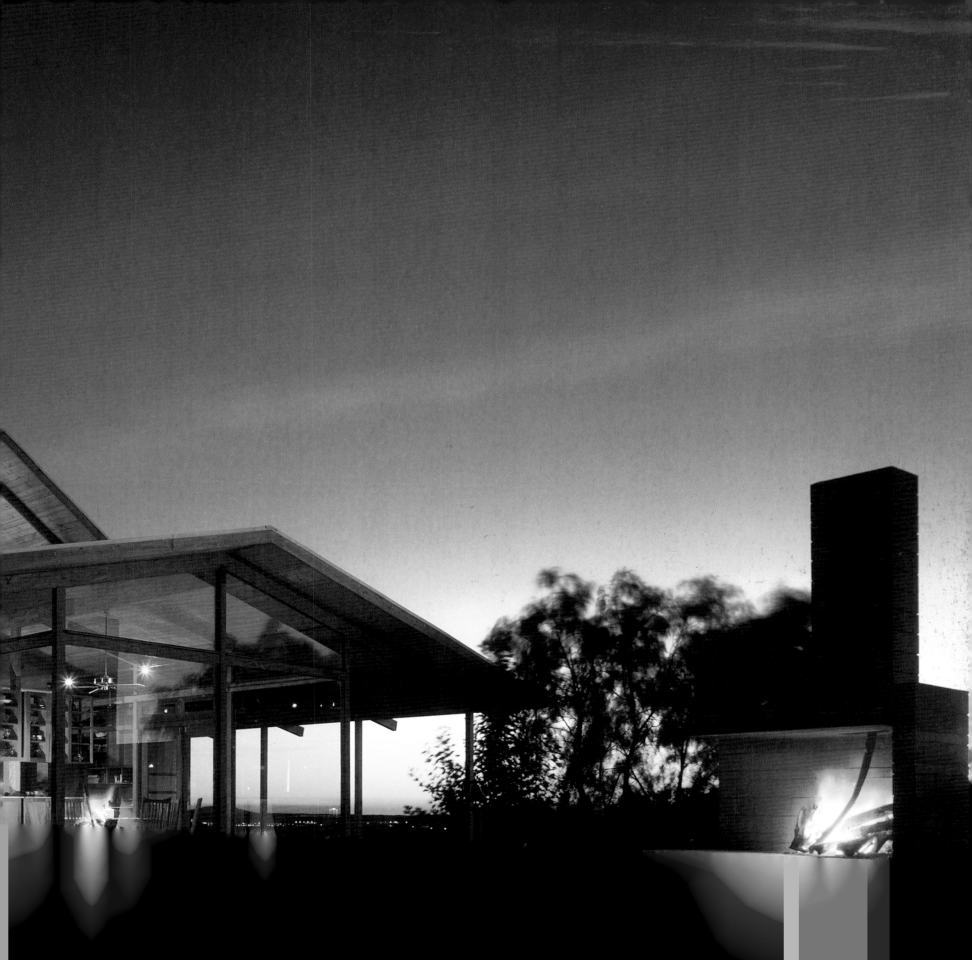

Floor Plan

space to...

1 eat
2 cook
3 store
4 sleep
5 bathe
6 recreate
7 alleviate
8 pontificate
9 contemplate

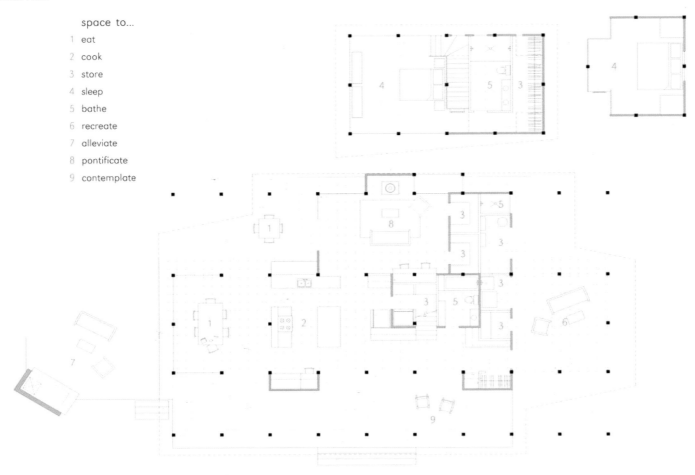

Computer Model

Previous Pages: Large roof overhangs allow domestic activities to take place both inside and outside the house.
Below: Photoelectric cells used to generate electricity
Right and Below Right: The barn-like design of the house was inspired by its rural setting.

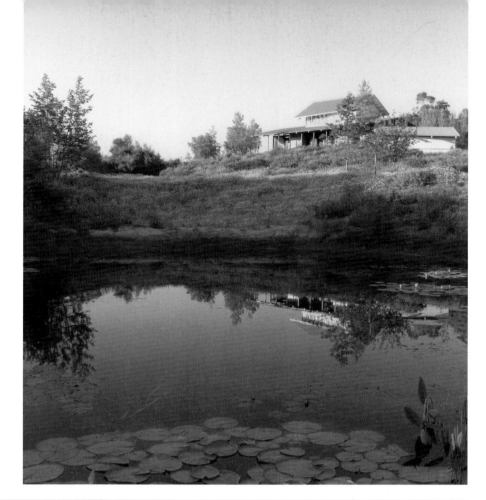

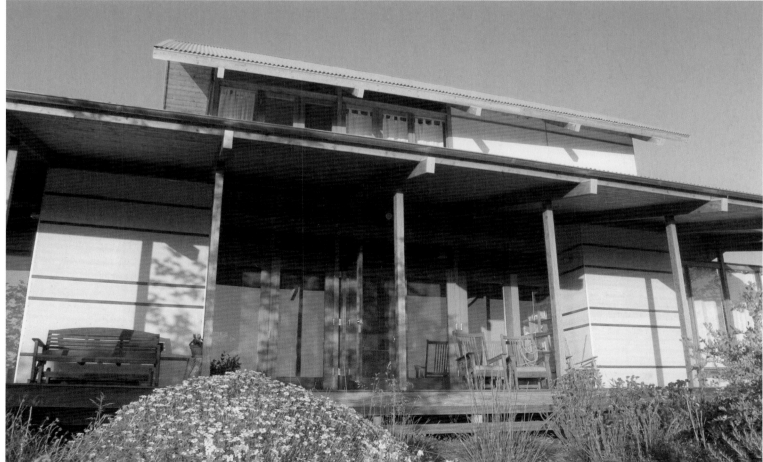

173

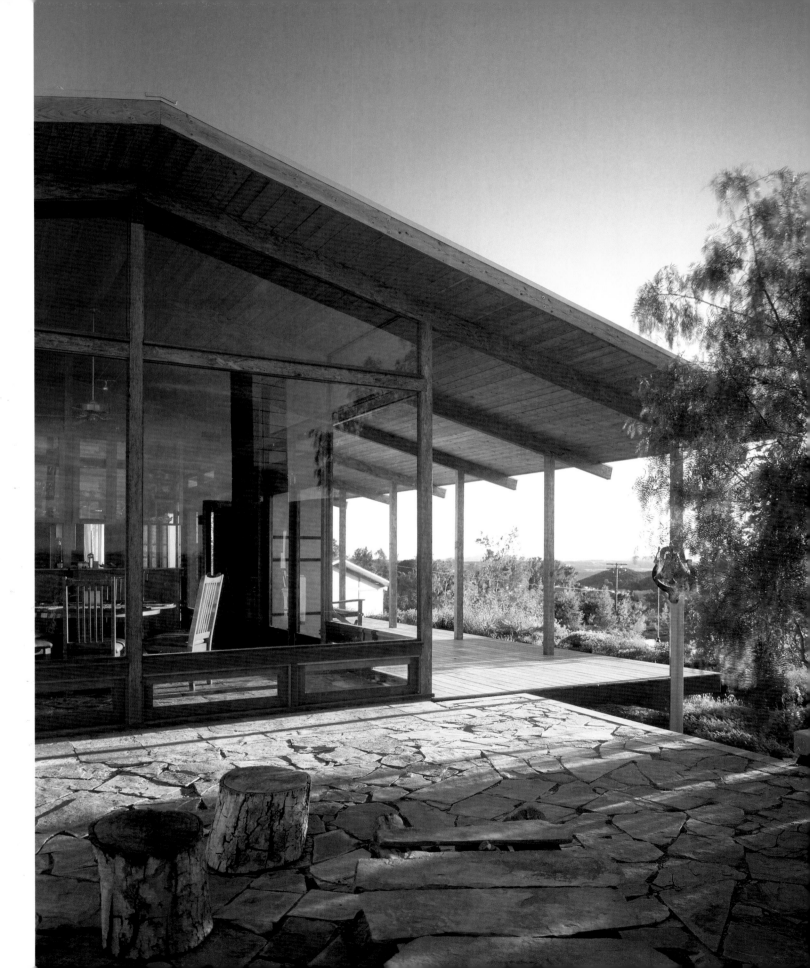

Right and Far Right: The mild San Diego climate encourages the use of outdoor dining spaces such as these.

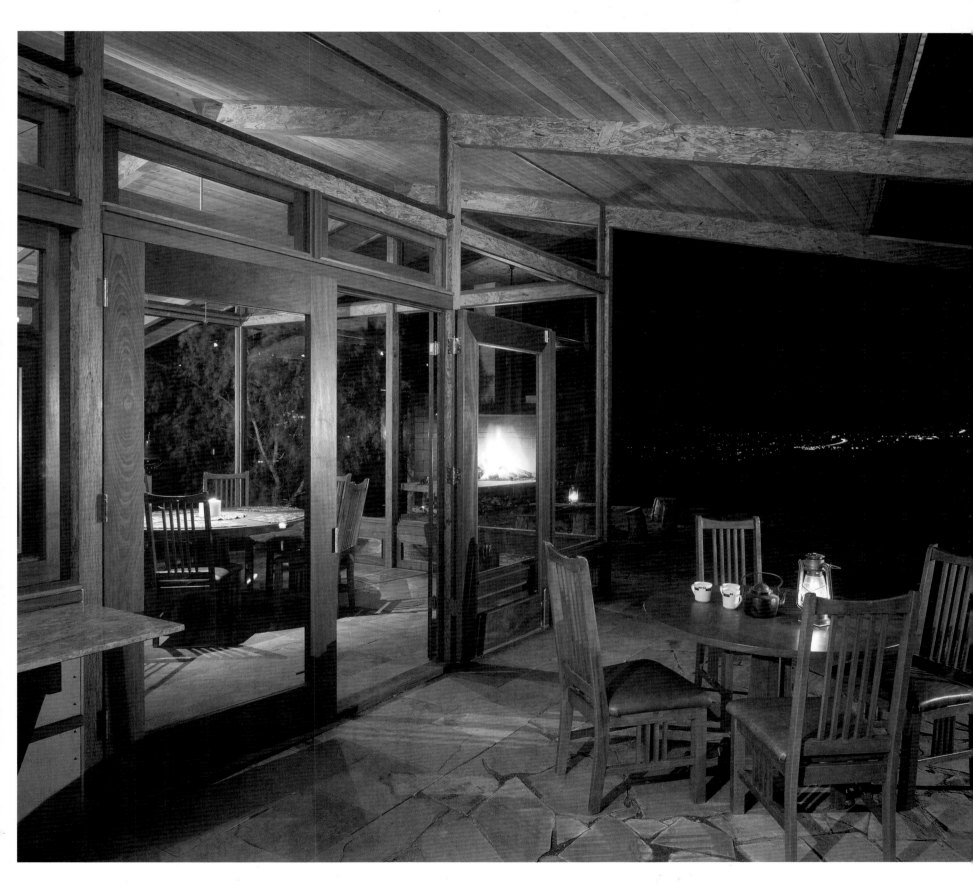

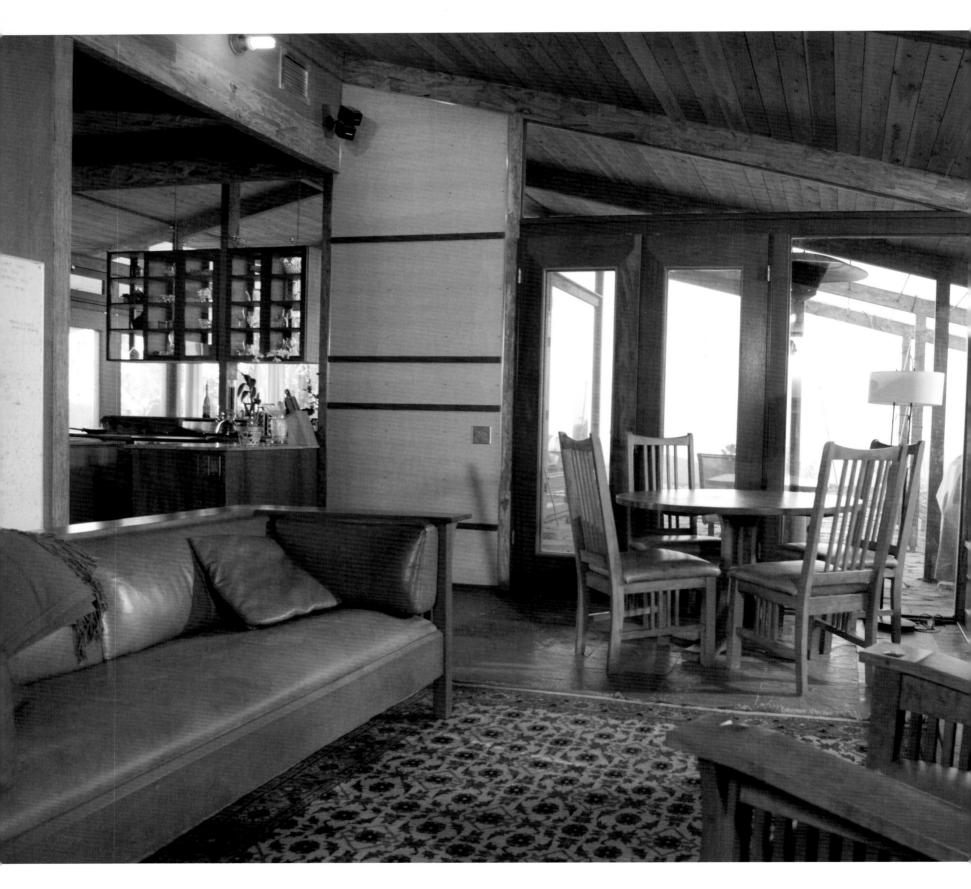

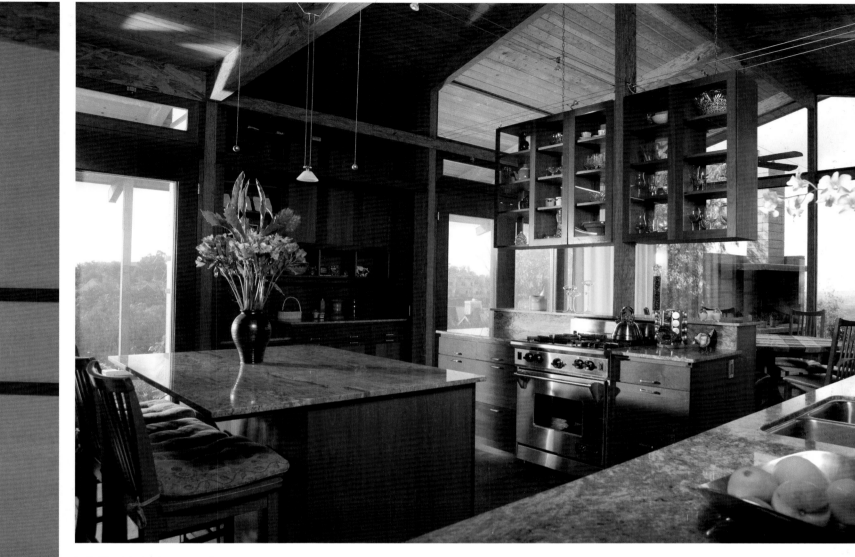

Left: The interior is compact yet bright and airy due to extensive windows.
Above: Open cabinets provide the kitchen with both light and views.

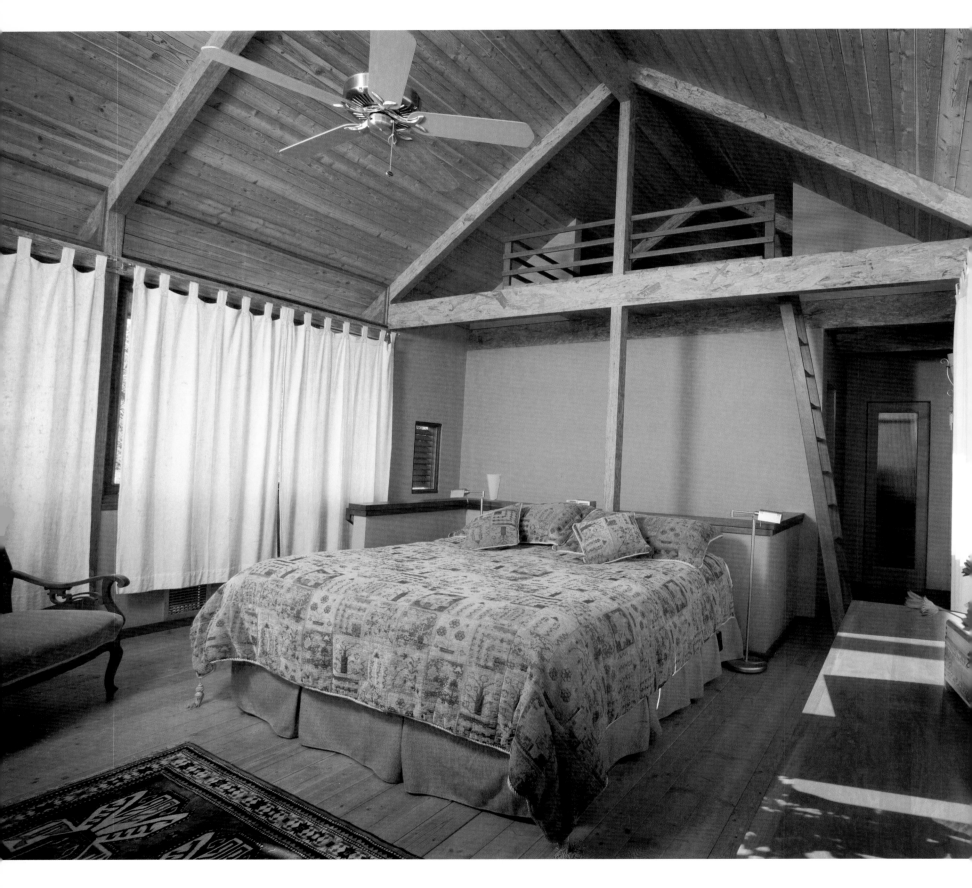

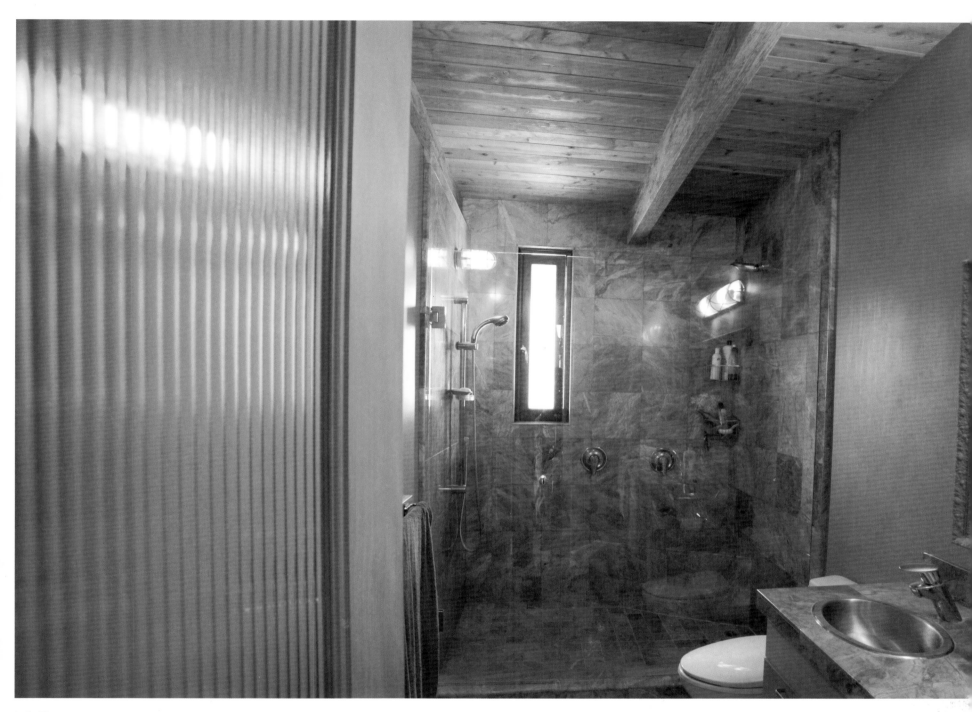

Left: The post and beam construction is evident in the master bedroom.
Above: Master bathroom

Harrington Residence

2800 Square Feet

Heliotrope Architects
Photography: Benjamin Benschneider

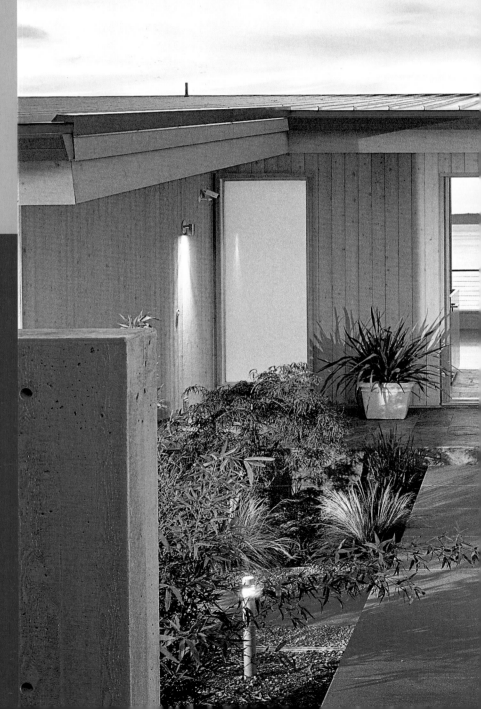

THE REMODELING OF THIS 1959 RAMBLER IN NORTH SEATTLE BEGAN WITH THE REPLACEMENT OF THE ORIGINAL LOW-LYING ROOF AND THE ADDITION OF EXTENSIVE WINDOWS, RECLAIMING OF THE EXTENSIVE VIEWS OF PUGET SOUND AND THE OLYMPIC MOUNTAINS. THE INTERIORS WERE RECONFIGURED TO ACCOMMODATE THE EASY LIFESTYLE OF A YOUNG FAMILY, AND STRIPPED DOWN TO SIMPLE WHITE WALLS, HIGH-END FIXTURES, CUSTOM CABINETS AND THE OCCASIONAL HIGHLIGHT OF STONE OR STEEL. OUTSIDE, NEW WOOD AND CONCRETE STRUCTURES SCREEN THE HOUSE FROM THE STREET, WHILE CONCRETE BRIDGES, LARGE CUSTOM WOOD, ANDGLASS PIVOT DOORS DEFINE THE ENTRY.

WORKING ON A TIGHT BUDGET, THE REMODEL WAS EXECUTED USING STRAIGHTFORWARD CONSTRUCTION METHODS. THE LOW-LYING, HIP ROOF WAS REPLACED WITH A SHED ROOF—LOW AT THE STREET AND RISING UP AND EMBRACING THE VIEW.

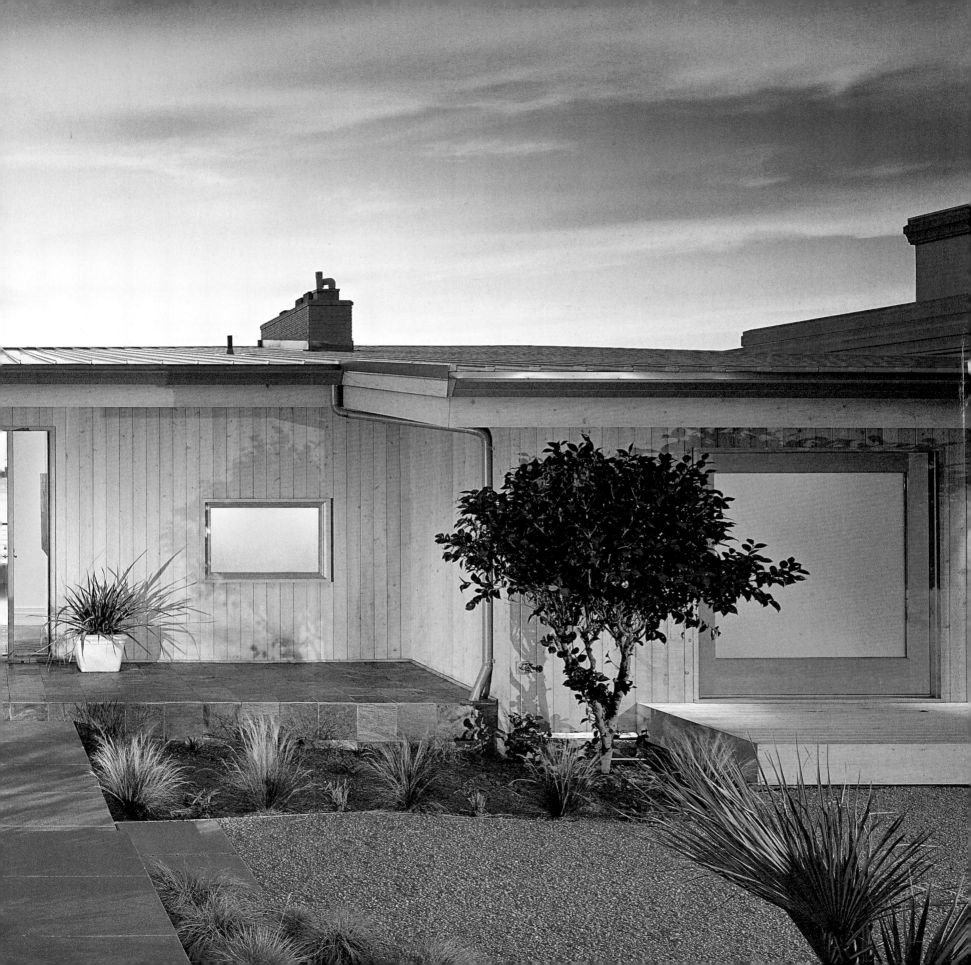

Floor Plan

Previous Pages: A view of the street elevation at dusk. Two large glass pivot doors greet the visitor: one at the entry and to the right, the other opens to the garden window.
Right: View of the dining area from the front entry

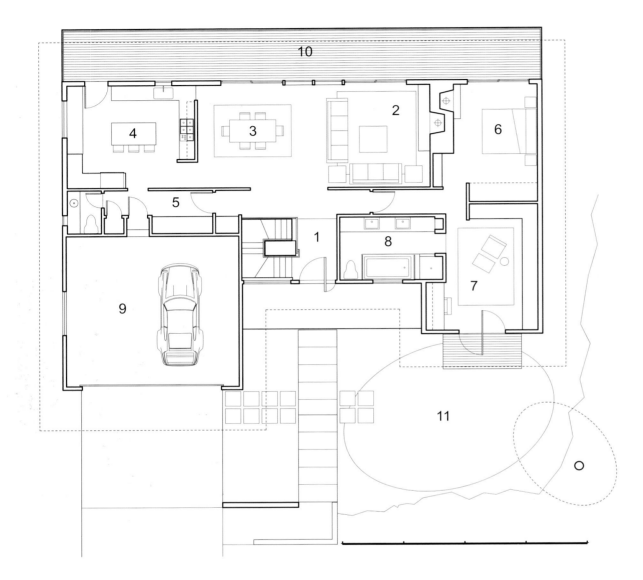

1.	ENTRY	7.	DRESSING/STUDY
2.	LIVING	8.	MASTER BATHROOM
3.	DINING	9.	GARAGE
4.	KITCHEN	10.	DECK
5.	PANTRY	11.	GARDEN COURT
6.	MASTER BEDROOM		

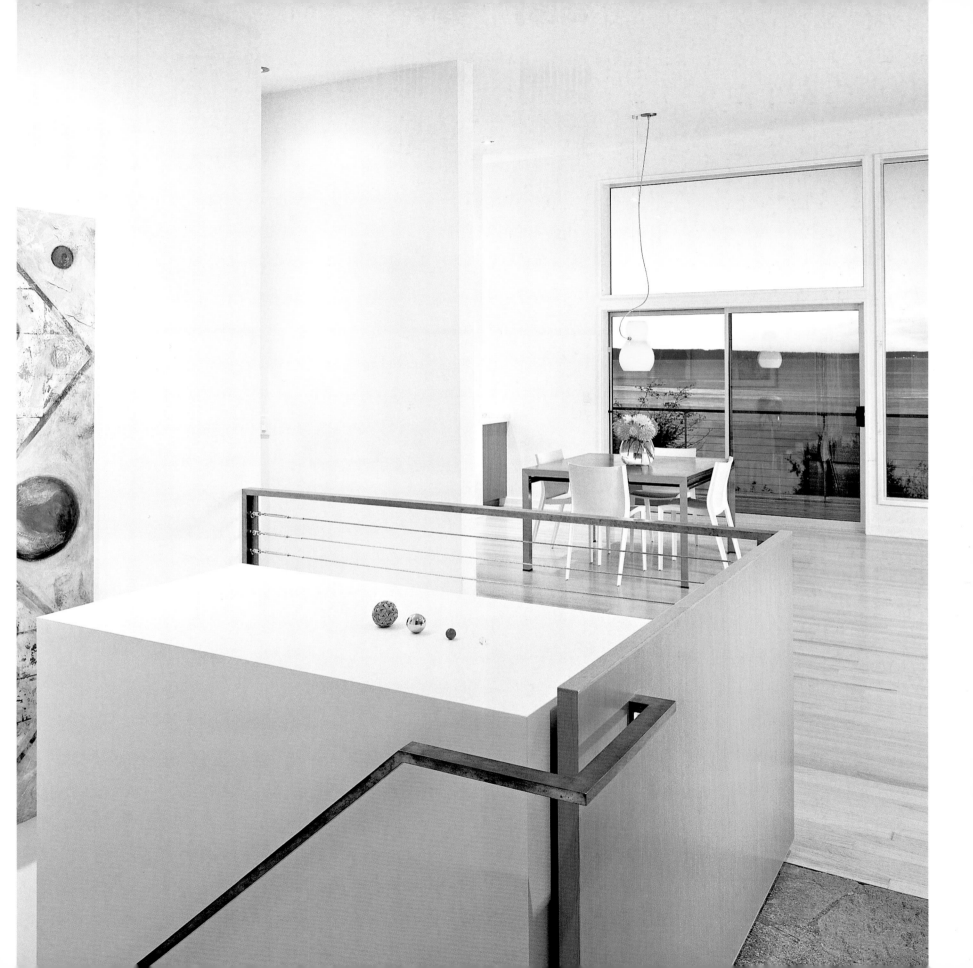

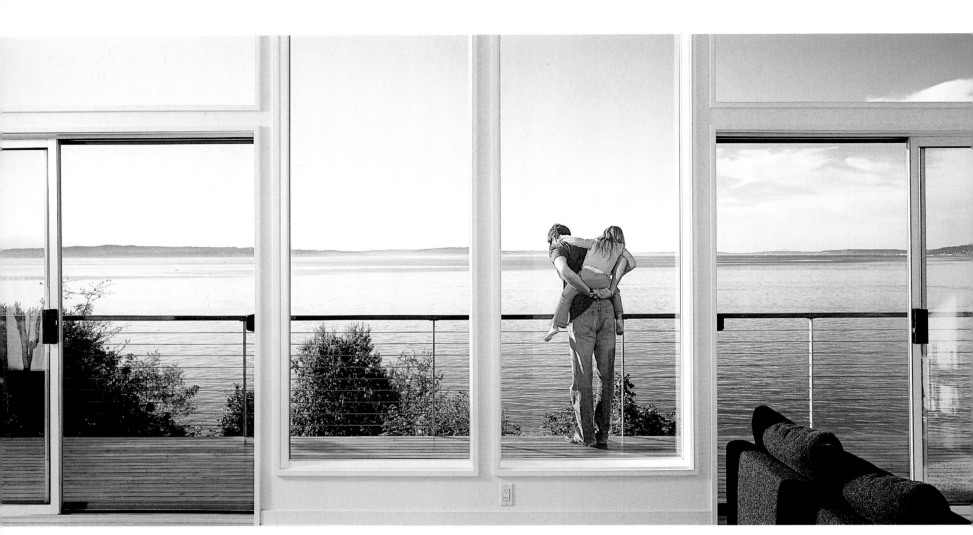

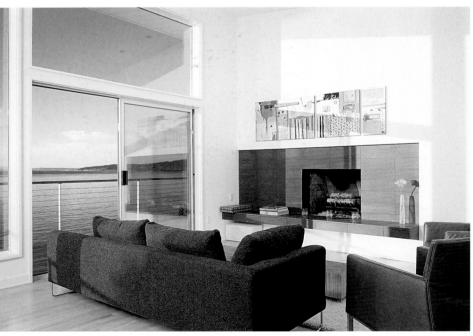

Above: The shed roof flips up, allowing for a tall expanse of windows, maximizing the view.
Left: From the living room, a view north over Puget Sound

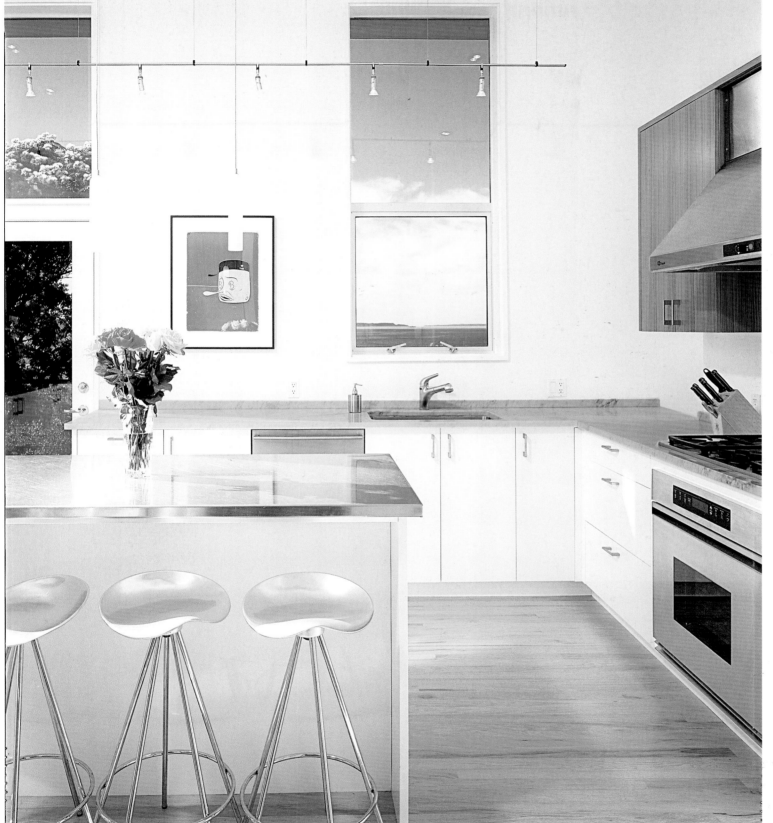

Left: The design for the kitchen is clean and simple with walnut cabinets and marble and stainless steel countertops.

Above: The dressing room functions as another living space and opens onto the garden court.
Above Right: Walnut cabinetry is used in the master bathroom.

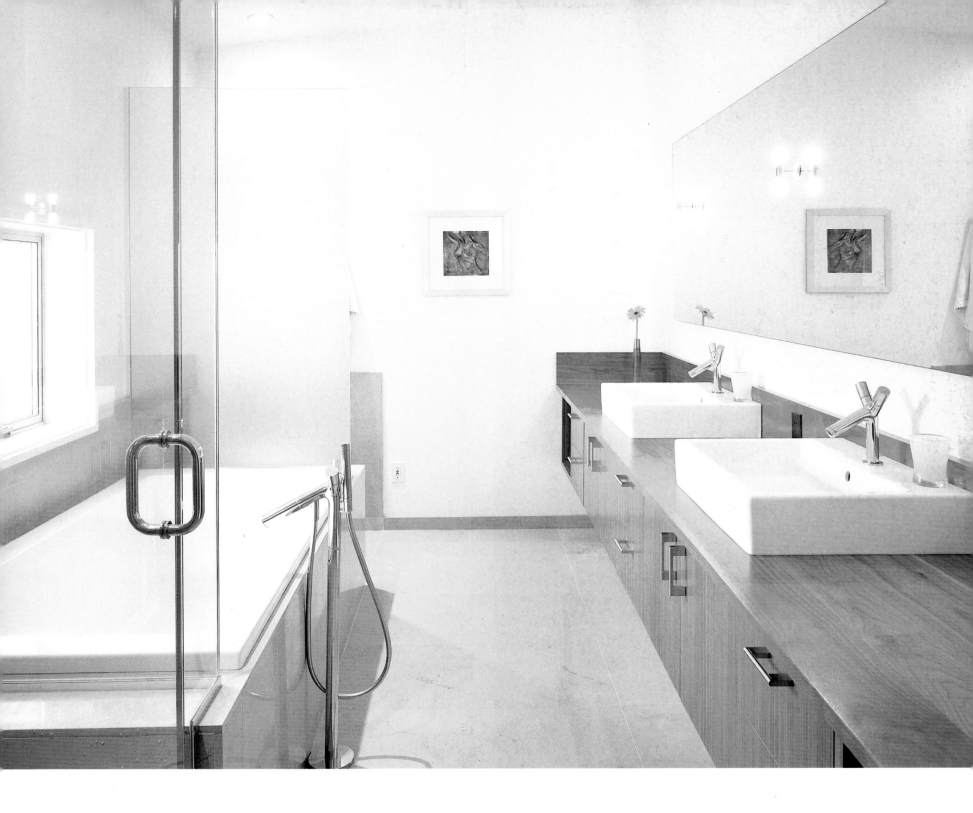

Guide House

1340 Square Feet

Michelle Kaufmann Architect
Photography: Michelle Kaufmann

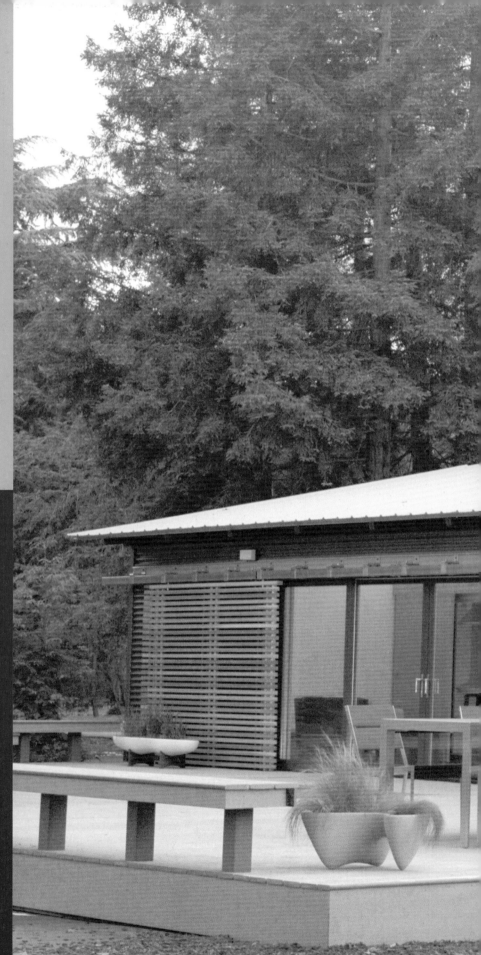

Frustrated with being unable to find an affordable, eco-friendly house in the San Francisco Bay area, the architect designed this moderately priced, prefabricated home with significant "green" features. It can be configured in four different sizes, from 672 square feet for a one-bedroom house to 2016 square feet for a three-bedroom courtyard version. Organized storage is achieved through the use of a series of bars with sliding doors that conceal media, books, clothing, and cooking utensils.

The house has a number of sustainable design features. It is designed as a series of shallow buildings to allow for natural ventilation and light. Exterior materials consist of low maintenance metal and cement board. Inside is bamboo flooring, and countertops are made of recycled paper and fly ash.

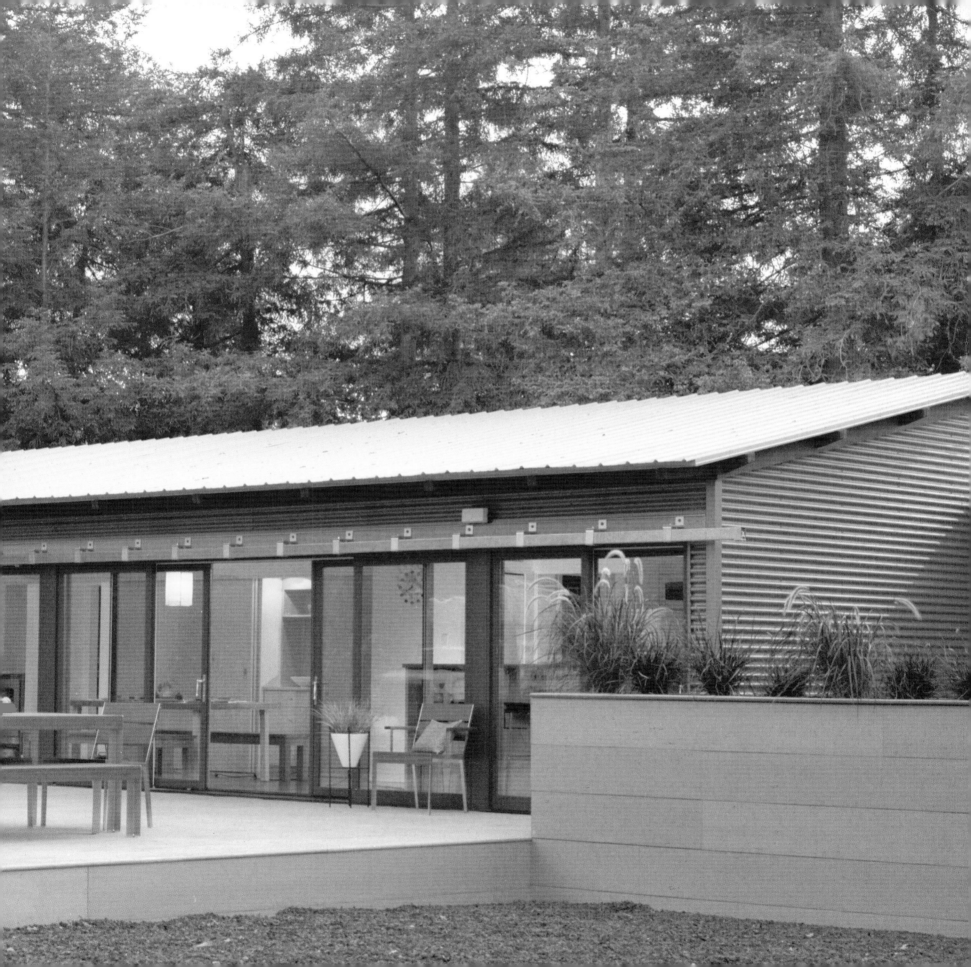

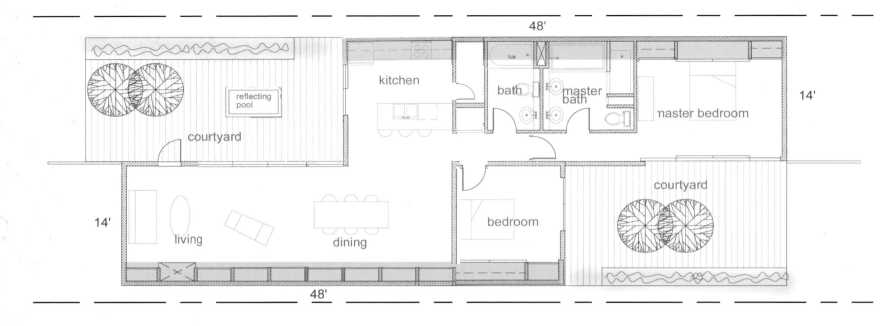

48'

14'

reflecting pool

courtyard

kitchen

bath

master bath

master bedroom

14'

living

dining

bedroom

courtyard

48'

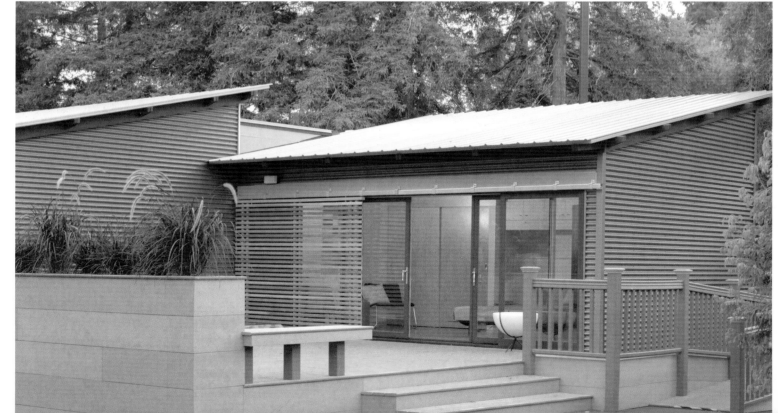

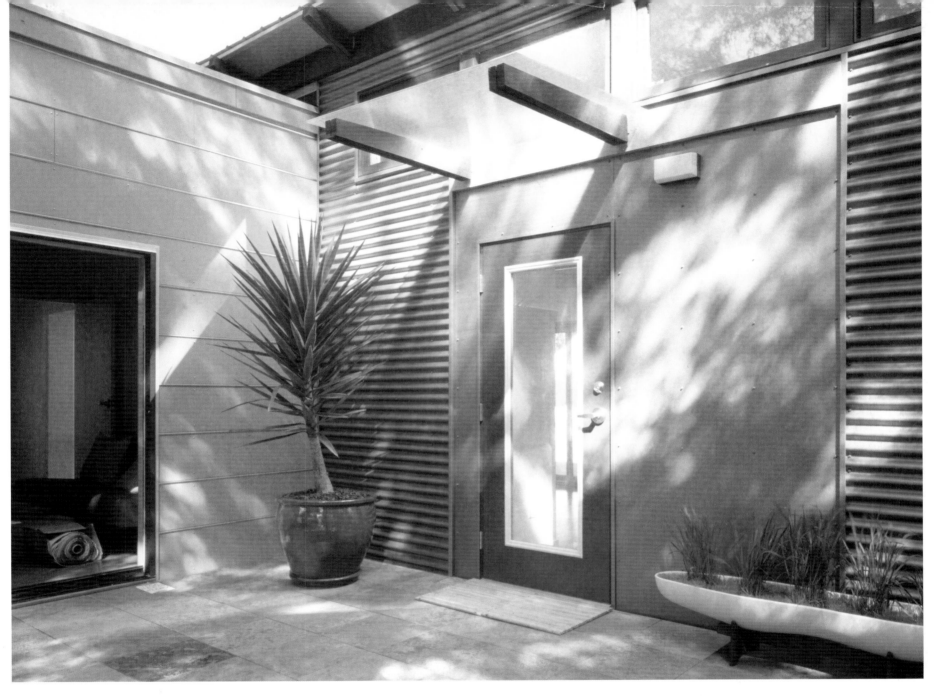

Previous Pages: The living, dining, and kitchen areas open onto a broad terrace.
Left: The master bedroom terrace
Above: The entry

Roof Detail

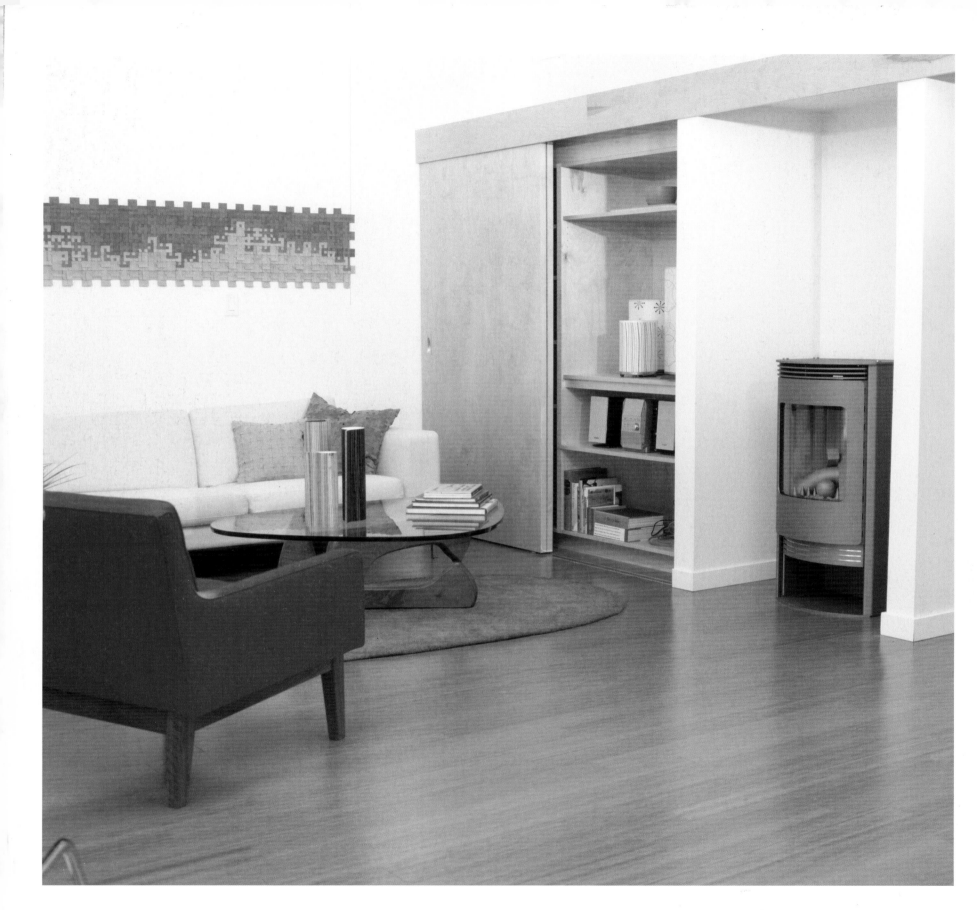

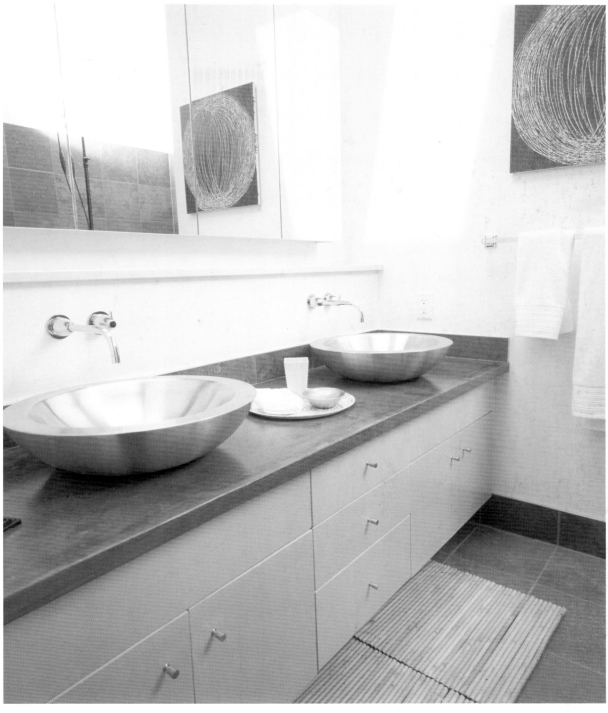

Left: Clerestory windows in the master bedroom open to allow for cross-ventilation.
Above: The master bathroom with recycled countertops

Burton House

3000 Square Feet

Luce et Studio
Photography: Paúl Rivera, Arch Photo; Tim Street-Porter

ENTRY TO THIS TIGHTLY COMPOSED MODERNIST HOME ON THE CALIFORNIA COAST IS VIA A MASSIVE, STAINLESS STEEL SLIDING WALL. FULLY OPEN, IT RECEIVES GUESTS AND CIRCULATES THE CROSS BREEZES FROM THE OCEAN. CLOSED, IT ENSURES THE INNER SANCTUM REMAINS PROTECTED BY THE DOOR'S SHEER SIZE AND MASS.

AN OPEN STEEL STAIRCASE IS CENTERED IN THE ENTRY HALL. THE CHILDREN'S QUARTERS ARE ON THIS FIRST LEVEL ALONG WITH THE GARAGE AND A WINE CELLAR. ON THE SECOND LEVEL, THE STAIRS ARE FLANKED BY AN OPEN, CANTILEVERED DINING ROOM ON ONE SIDE AND THE LIVING AREA ON THE OTHER. A FULLY EQUIPPED COMMERCIAL KITCHEN RUNS THE FULL LENGTH OF THIS PUBLIC AREA, REFLECTING THE OWNERS' PASSION FOR FOOD AND ENTERTAINING. WHILE THE HOUSE IS ALMOST ENTIRELY CLOSED OFF FROM THE STREET, THIS EXPANSE IS DOMINATED BY A FOLDING WINDOW SYSTEM THAT OPENS TO A TERRACE THAT RUNS THE LENGTH OF THE HOUSE WITH VIEWS OVER ROOFTOPS TO THE OCEAN.

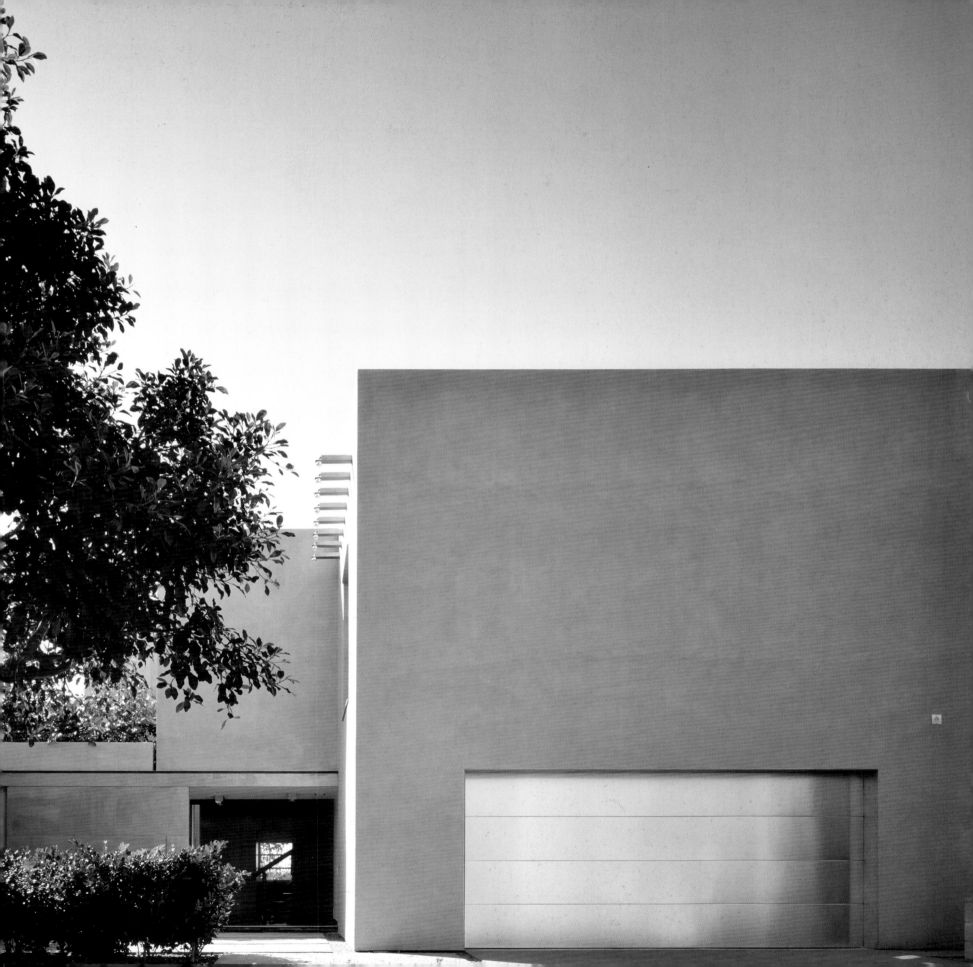

Second Floor Plan

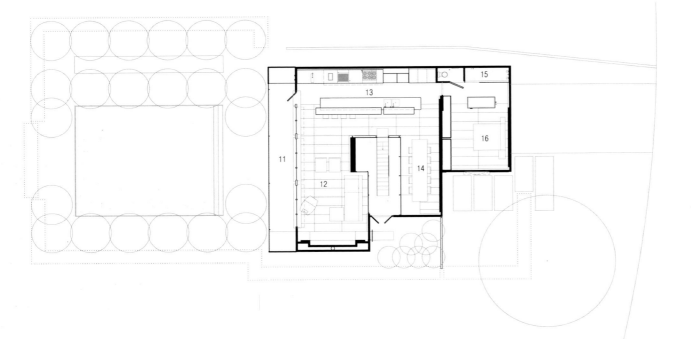

Previous Pages : From the street, little is revealed about what lies beyond the massive stainless steel door.

Right: The owners are landscape architects and their firm, Burton Landscape Architecture Studio designed the garden, which consists of artificial turf set on three inches of decomposed granite and framed with Corten steel.

11	BALCONY
12	LIVING ROOM
13	KITCHEN
14	DINING ROOM
15	MASTER BATHROOM
16	MASTER BEDROOM

First Floor Plan/Site Plan

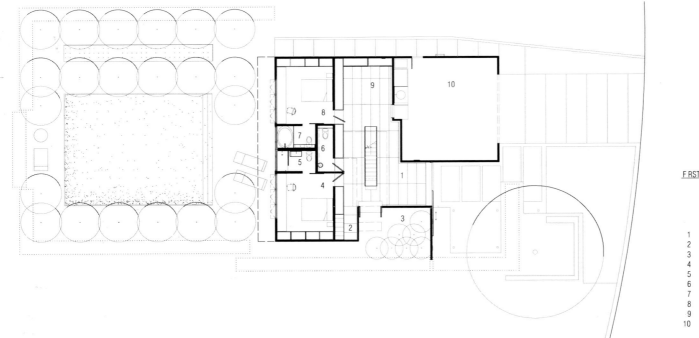

FIRST FLOOR PLAN

1	ENTRY
2	WINE
3	GARDEN
4	BEDROOM 1
5	BATHROOM 1
6	POWDER ROOM
7	BATHROOM 2
8	BEDROOM 2
9	LAUNDRY
10	GARAGE

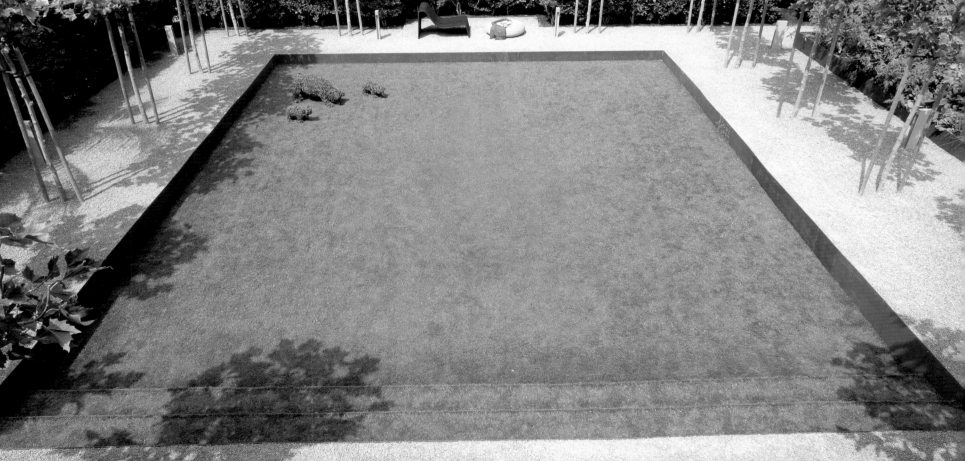

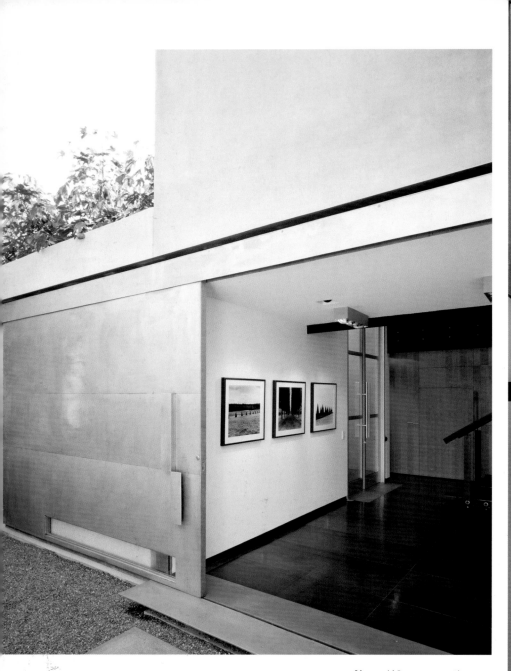

Above: When open, the stainless steel door reveals a generous entry foyer.
Right: An open steel staircase leads to the living, dining, and kitchen areas and the master bedroom suite. The floors are hot-rolled steel plate, and the walls are paneled in hemlock.

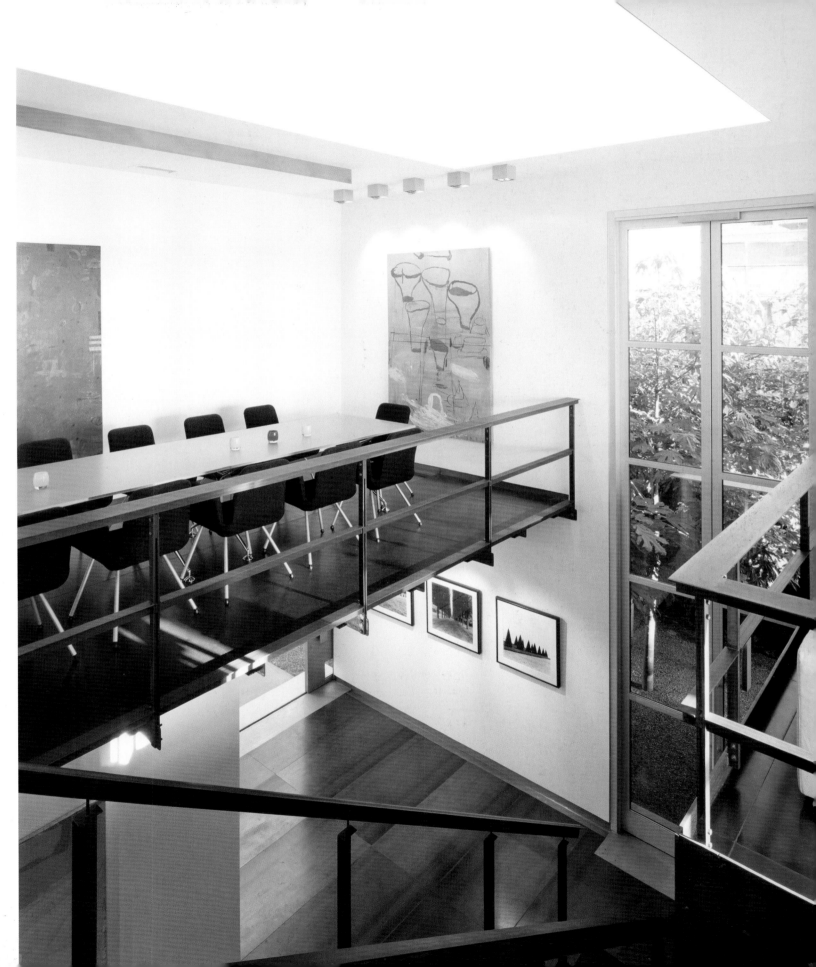

Right: The dining area is cantilevered over the foyer on a steel platform.

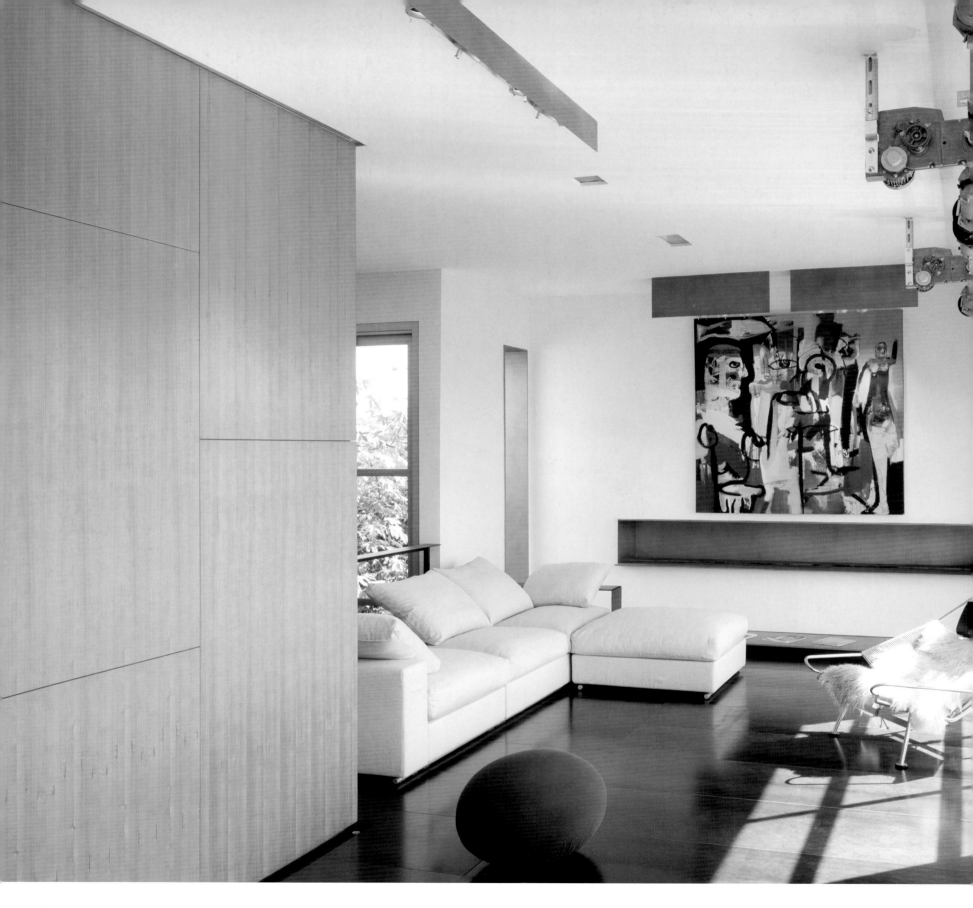

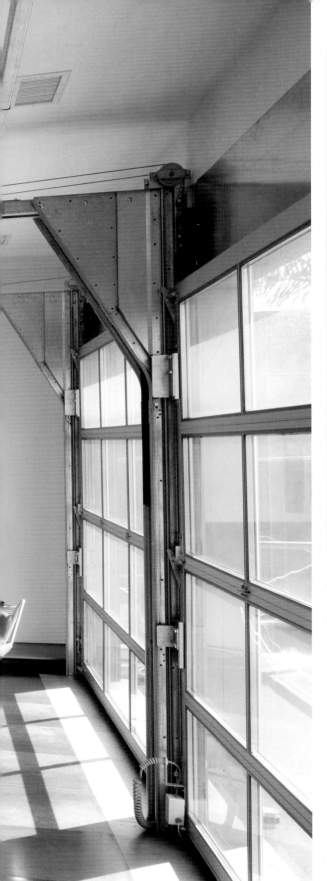

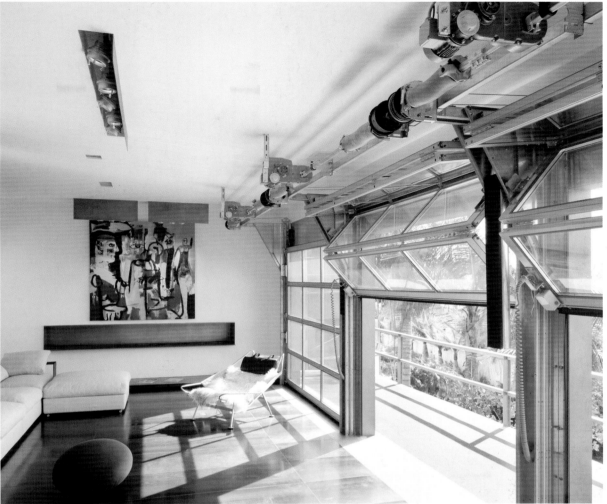

Left: A stainless steel gas fireplace punctuates the living room wall. Along the west wall, electrically operated firehouse doors imported from England allow rooftop views of the ocean.

Above: These doors can be partially or fully opened, extending the living area onto the terrace that runs the length of the house and overlooks a garden designed by the owners who are landscape architects.

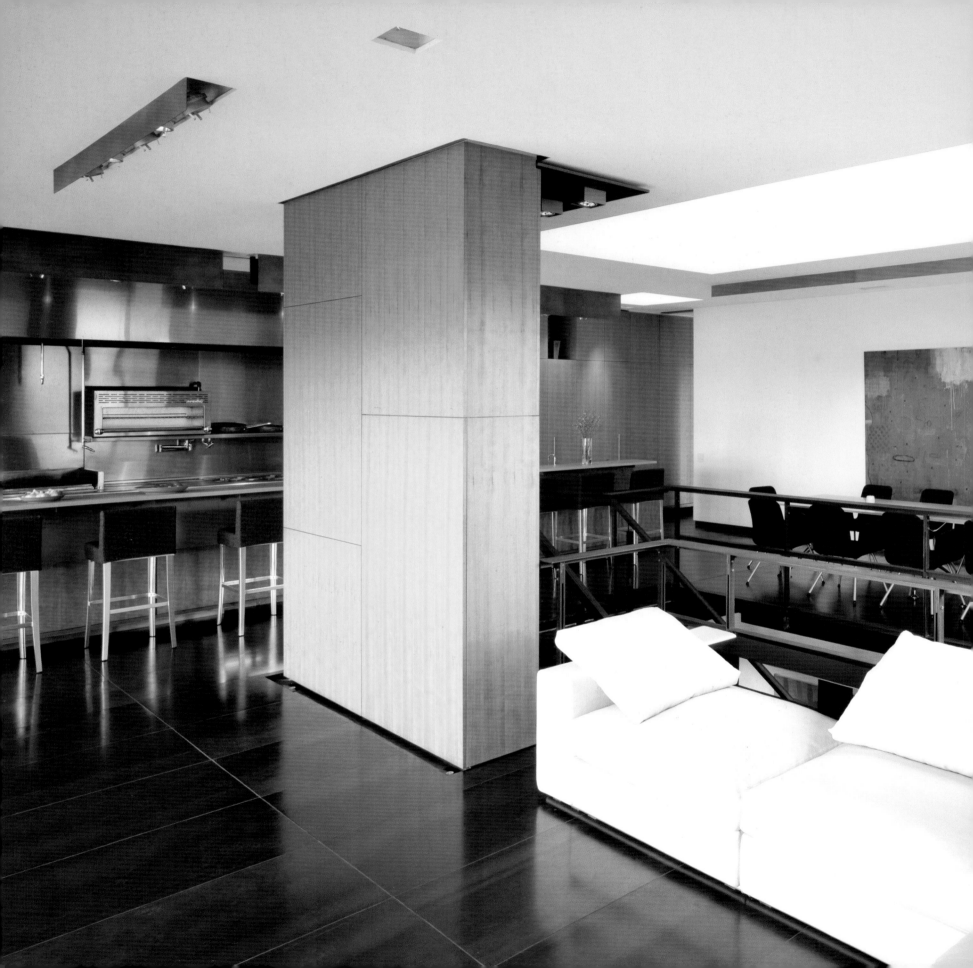

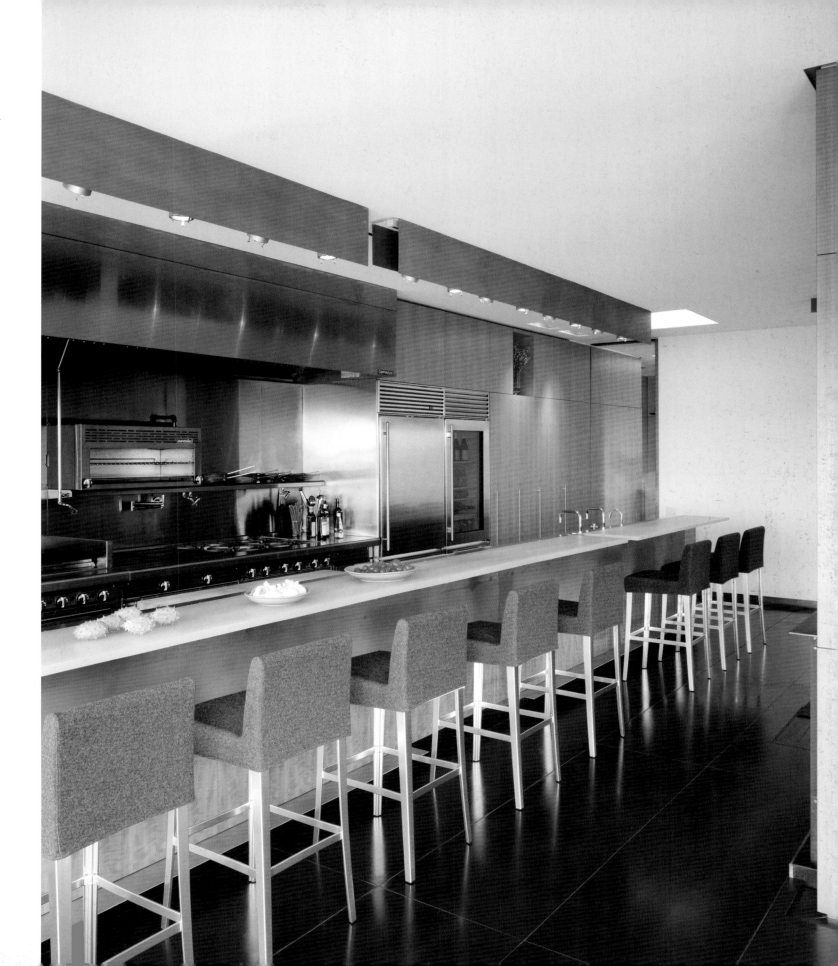

Left: The hemlock-paneled center wall conceals electronics for the firehouse doors
Right: The commercial-grade kitchen is open and spacious.

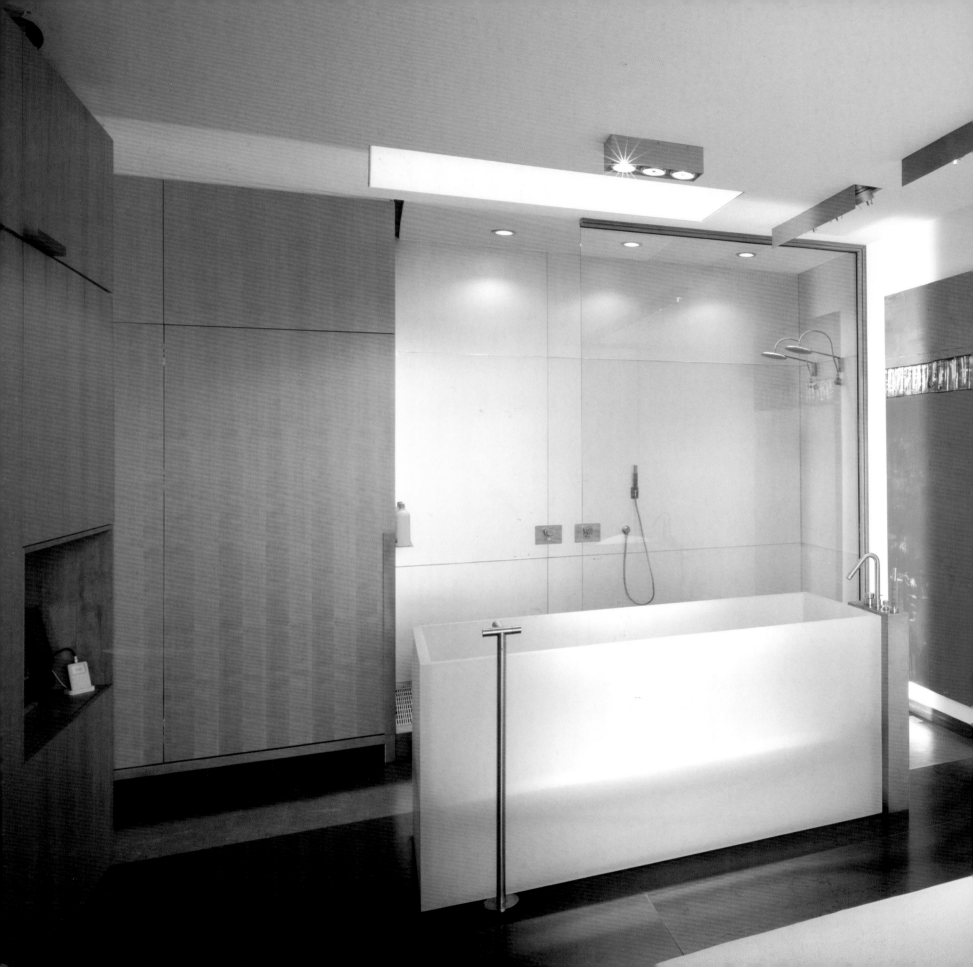

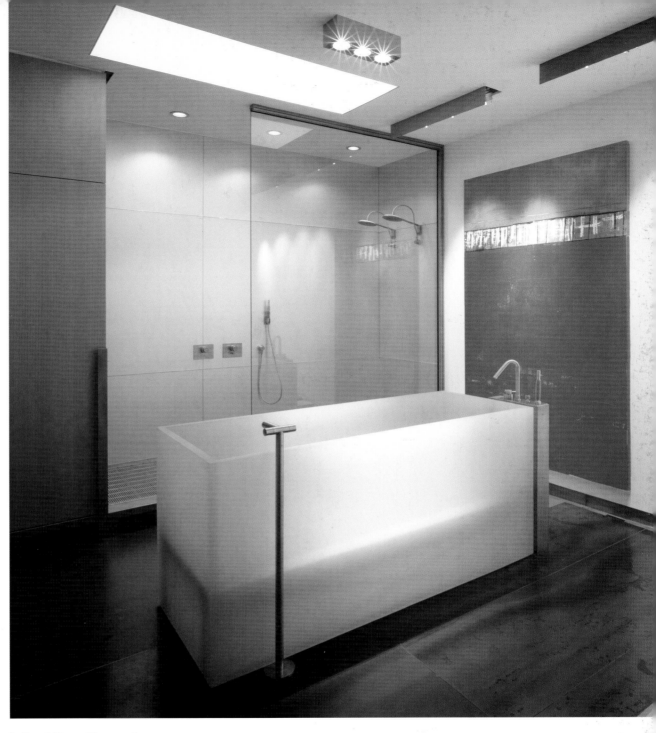

Left and Above: The master bathroom and bedroom are one. The poured resin bathtub doubles as the vanity and was designed by the architect.

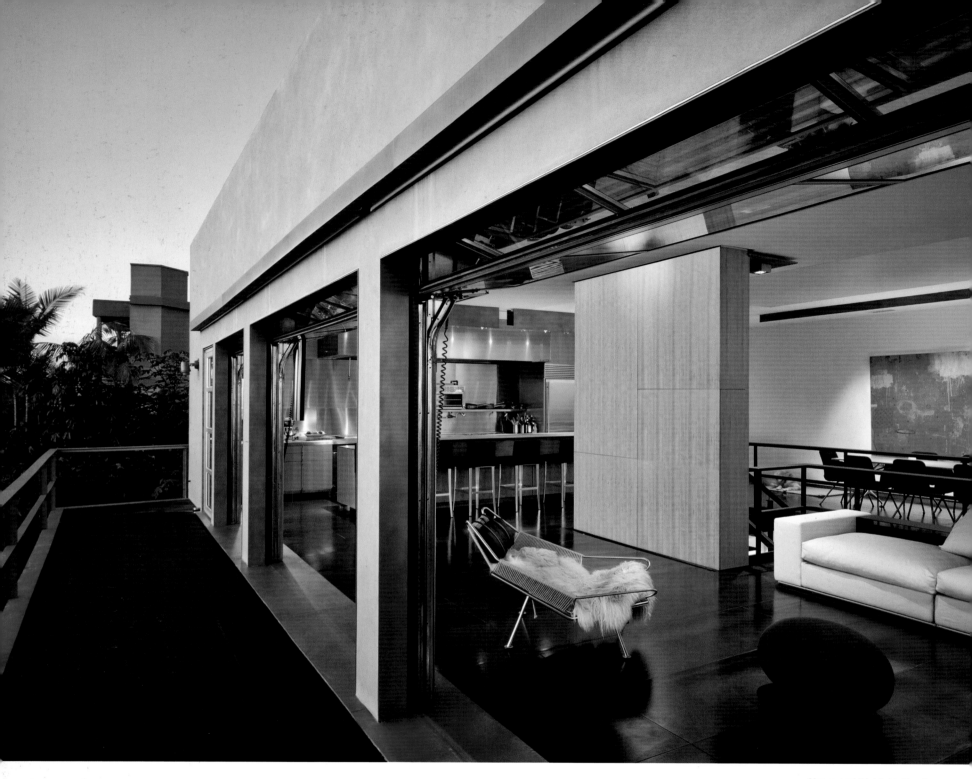

Above and Right: Unlike the entry façade, the rear of the house is open and revealing.

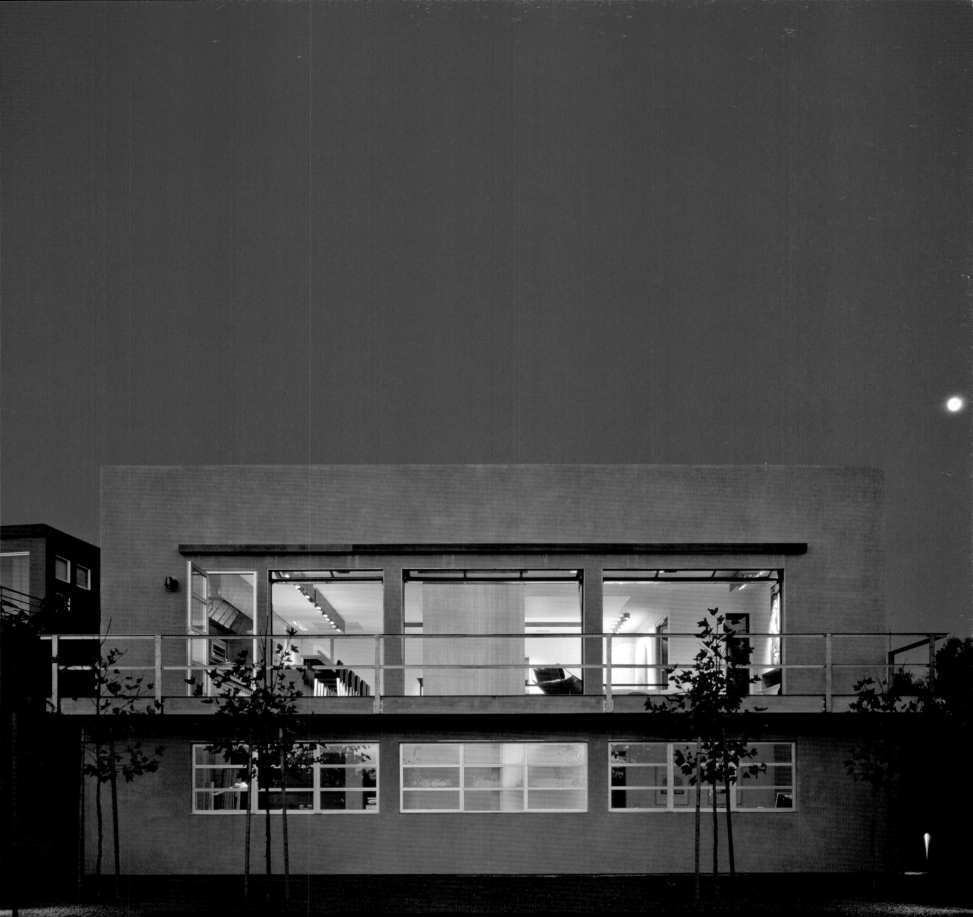

Fisher/Castellano House

2000 Square Feet

Lindy Small Architecture
Photography: Marion Brenner

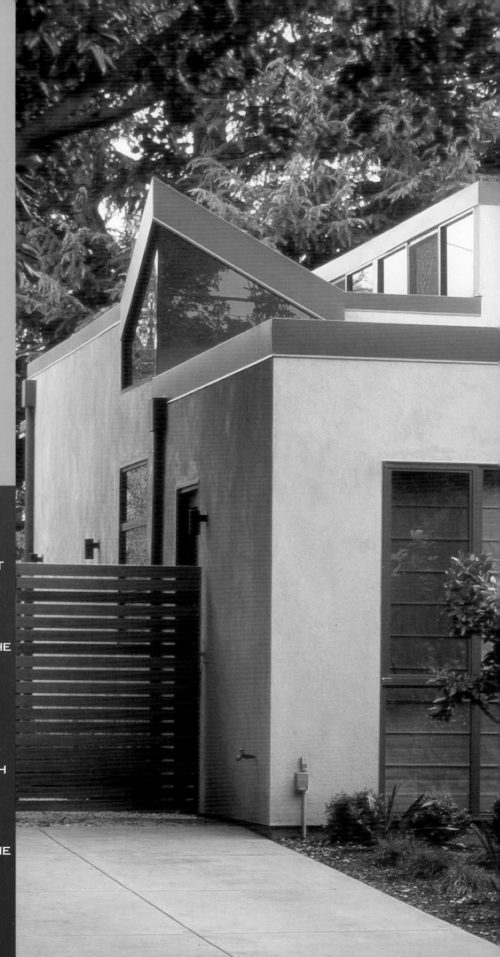

WHILE SMALL IN SIZE, THIS TWO-BEDROOM HOUSE ON A NARROW LOT IN PALO ALTO, CALIFORNIA, OFFERS BIG IDEAS FOR BRINGING MAXIMUM LIGHT INTO EVERY CORNER OF EVERY ROOM. IT DOES THIS THROUGH THE USE OF TRANSLUCENT PARTITIONS BETWEEN SPACES, LONG BARREL VAULTS WRAPPED IN PLYWOOD, A POP-UP TRIANGULATED WINDOW, AND EXTENSIVE WINDOWS ALONG THE LIVING AREA AND MASTER BEDROOM SUITE THAT OVERLOOK THE GARDEN.

SEPARATING THE ENTRY AREA FROM THE LIVING AREA IS A FLOOR-TO-CEILING TRANSLUCENT GLASS WALL THAT IS INTE-GRATED INTO THE CASEWORK. A SKYLIGHT RUNS THE LENGTH OF THIS RECTANGULAR SPACE. THE LIVING, DINING, AND KITCHEN AREAS ARE OPEN WITH PANORAMIC VIEWS OF THE SMALL GARDEN. AN IPE WOOD TRELLIS RUNS FROM THE LIVING ROOM TO THE MASTER BEDROOM AND STUDY, MODULATING THE NATURAL LIGHT.

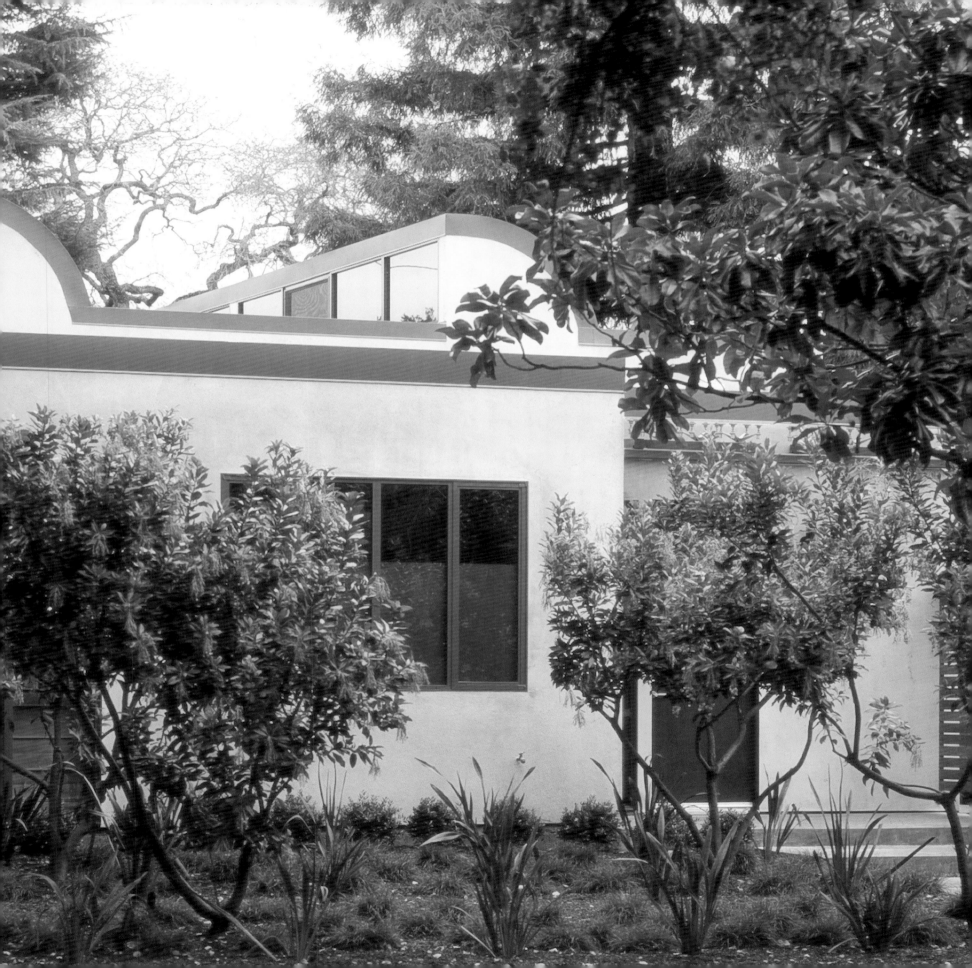

Floor Plan

Previous Pages and Below:
The barrel vaults over the living area are visible from the street elevation.
Right: The entry is bathed in light from a skylight running its length. The translucent wall filters this light into the living area beyond.

North-South Section

East-West Section

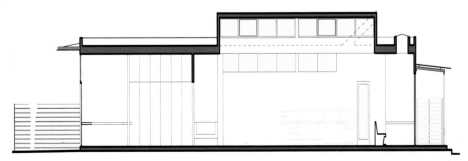

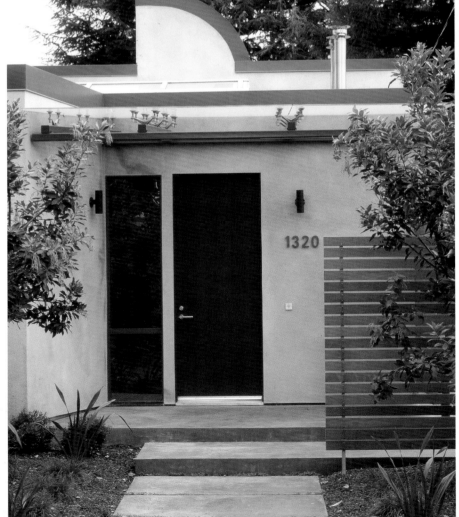

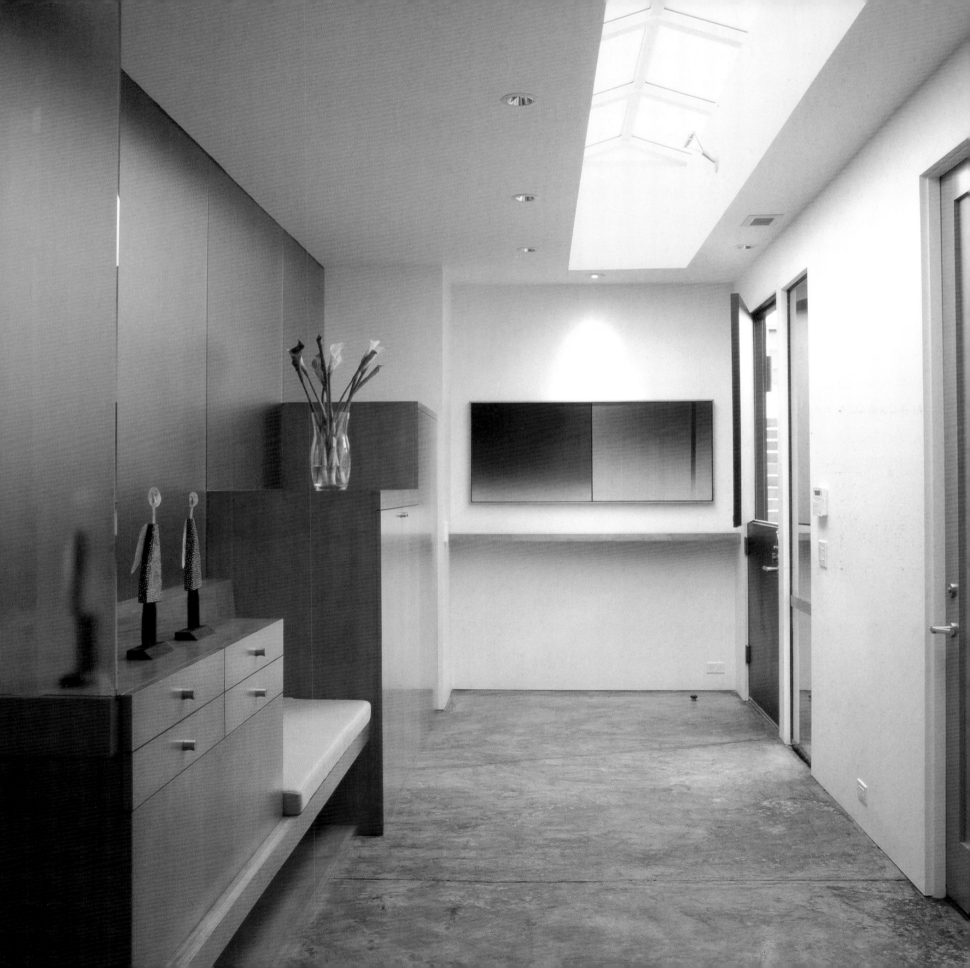

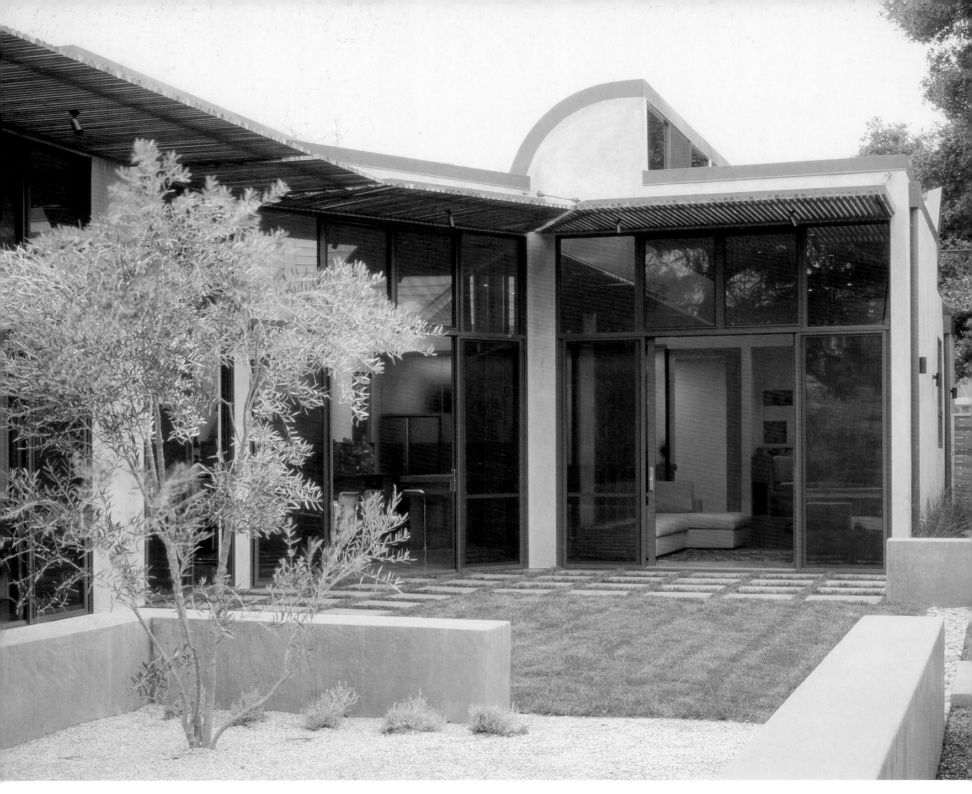

Above: The house embraces the small garden.

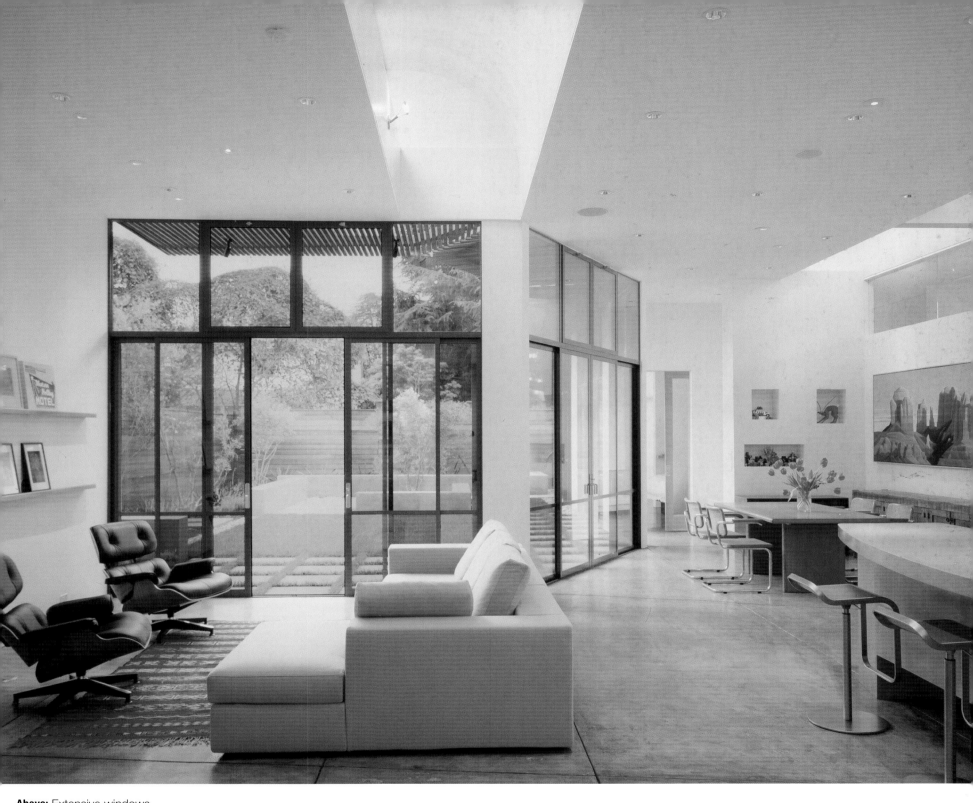

Above: Extensive windows extend the living area into the garden.

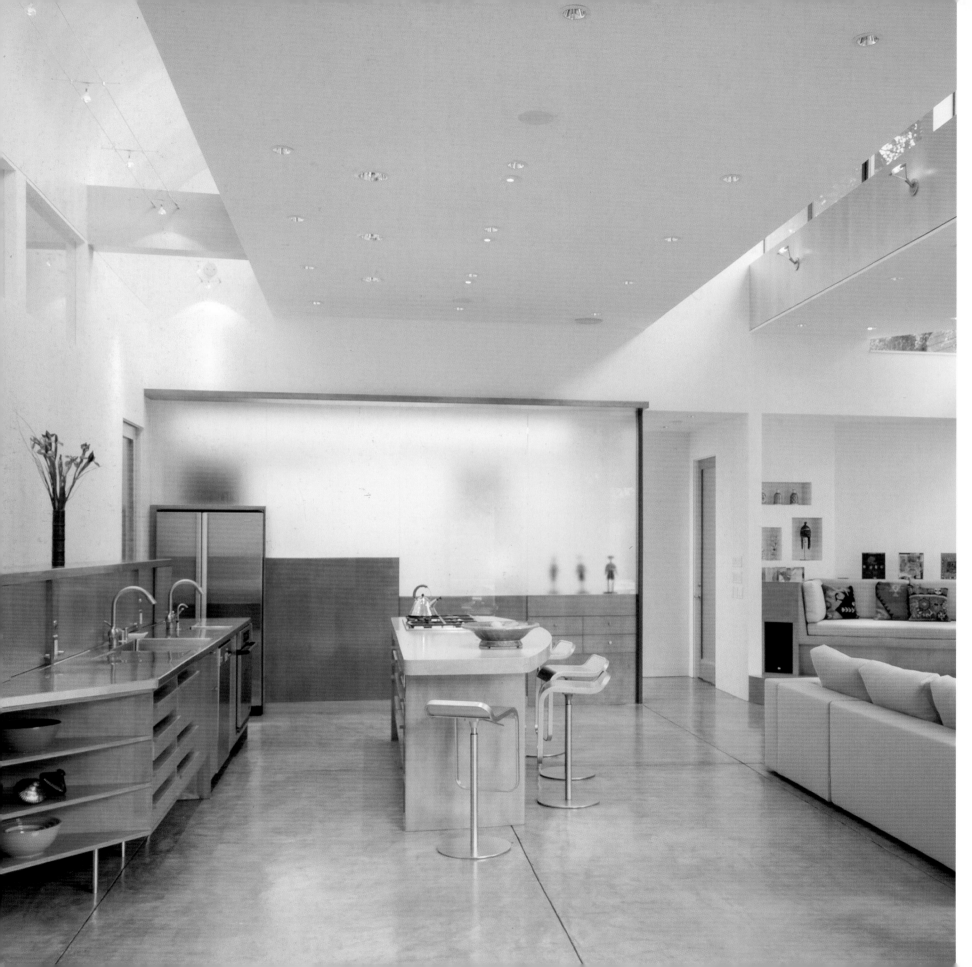

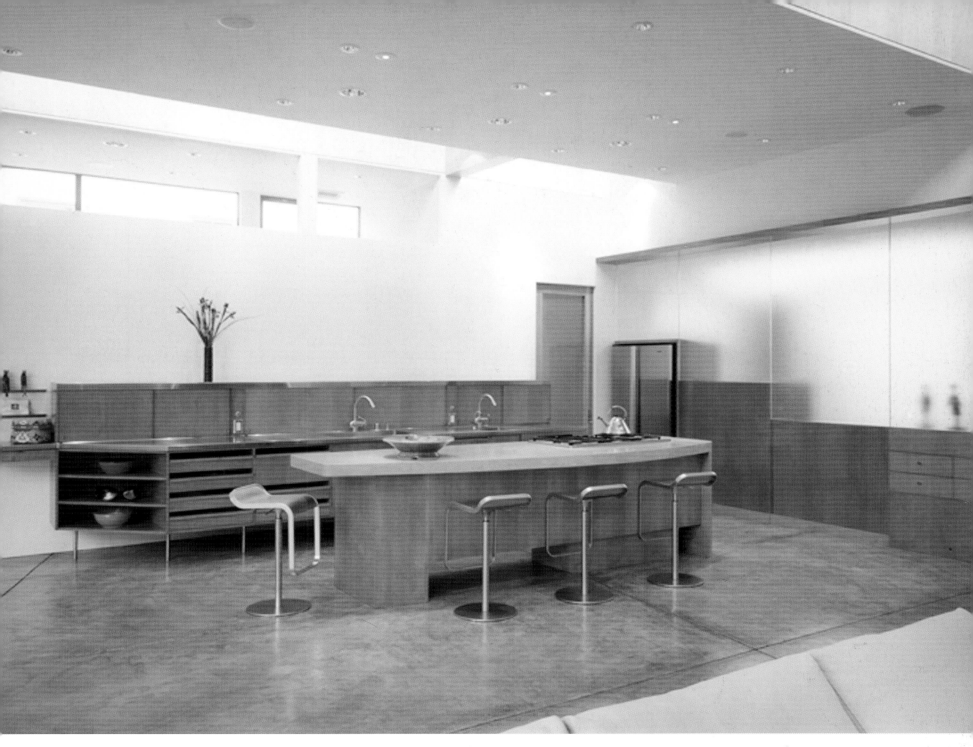

Left: A view of the translucent glass wall separating the entry area from the kitchen and living areas.
Above: The kitchen

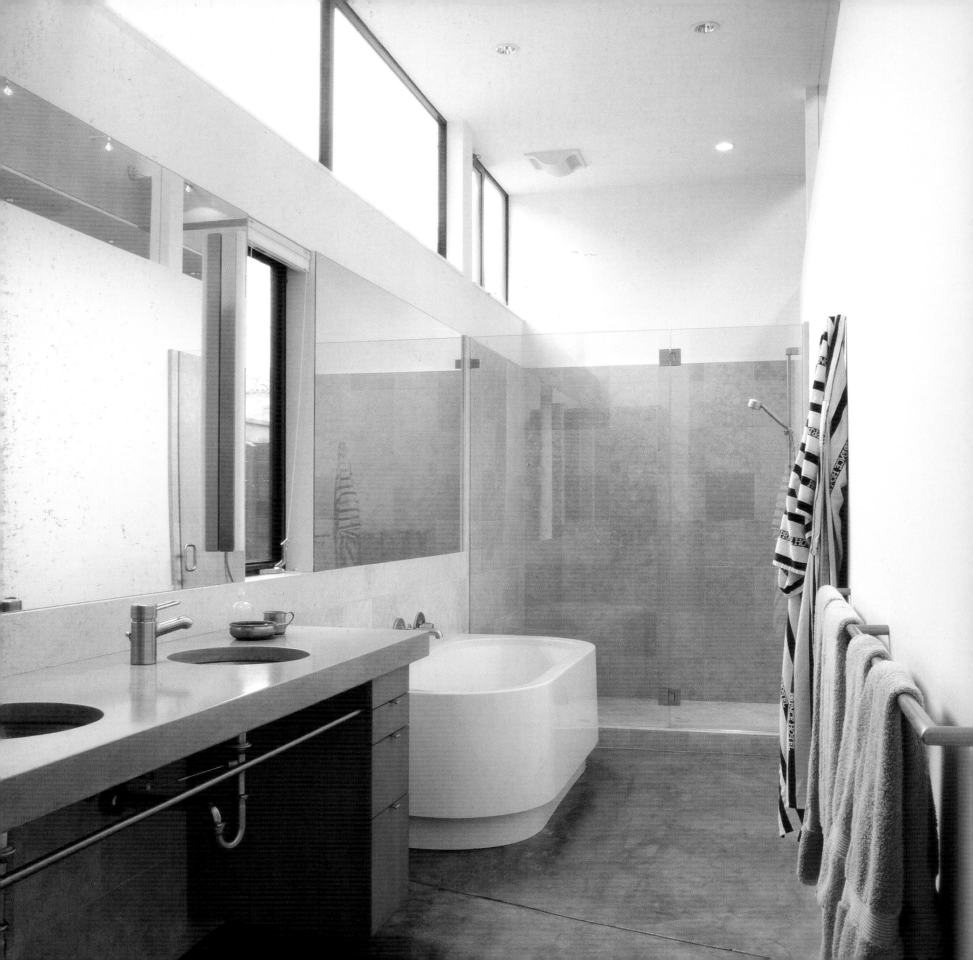

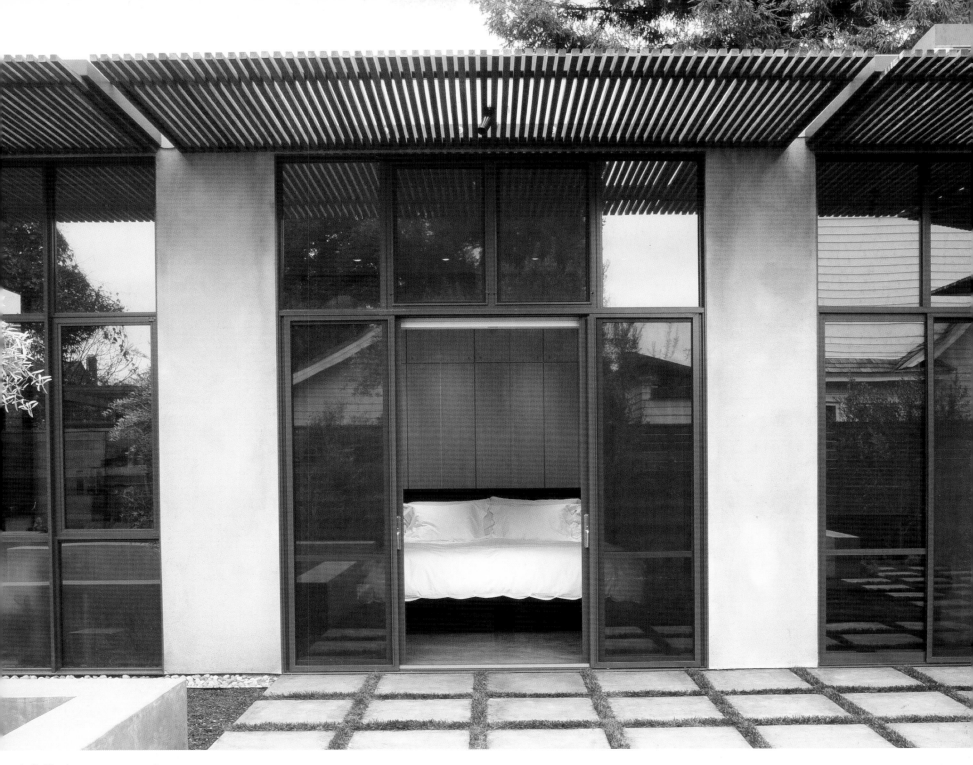

Left: The long, narrow master bathroom is brightend by clerestory windows.
Above: The master bedroom opens onto the garden.

Seward Park Residence

2062 Square Feet

Balance Associates, Architects
Photography: Steve Keating

THIS NEW HOME IS LOCATED IN A SEATTLE NEIGHBORHOOD WITH AN ECLECTIC MIX OF OLDER AND NEWER HOMES. IT IS SET ON A CONCRETE BLOCK PLINTH THAT RELATES IN HEIGHT, TEXTURE, AND SCALE TO THE ADJACENT HOUSES. THE UPPER FORM STEPS BACK TO REDUCE THE IMPACT OF ITS HEIGHT WHEN VIEWED FROM THE STREET. THE HOUSE IS SIDED IN A DEEP RED STUCCO THAT ECHOES THE COLOR OF THE SURROUNDING BRICK AND TILE HOUSES. THE ROOF HAS LARGE OVERHANGS THAT ARE SUPPORTED BY EXPOSED TAPERING GLUELAM BEAMS.

THE LOWER FLOOR IS SET INTO THE SITE AND CONTAINS A GARAGE AND TWO BEDROOMS. THE LIVING, DINING, AND KITCHEN AREAS ARE ON THE MAIN LEVEL AND ARE LOFT-LIKE WITH 12-FOOT CEILINGS. A STEEL STAIRWAY LEADS UP TO THE MASTER SUITE ON THE UPPER LEVEL, WHICH IS SET INTO THE ROOF WITH CATHEDRAL CEILINGS HOVERING ABOVE A BAND OF HORIZONTAL GLASS. THE BEDROOM OPENS OUT ONTO A SMALL BALCONY WITH A VIEW OF LAKE WASHINGTON.

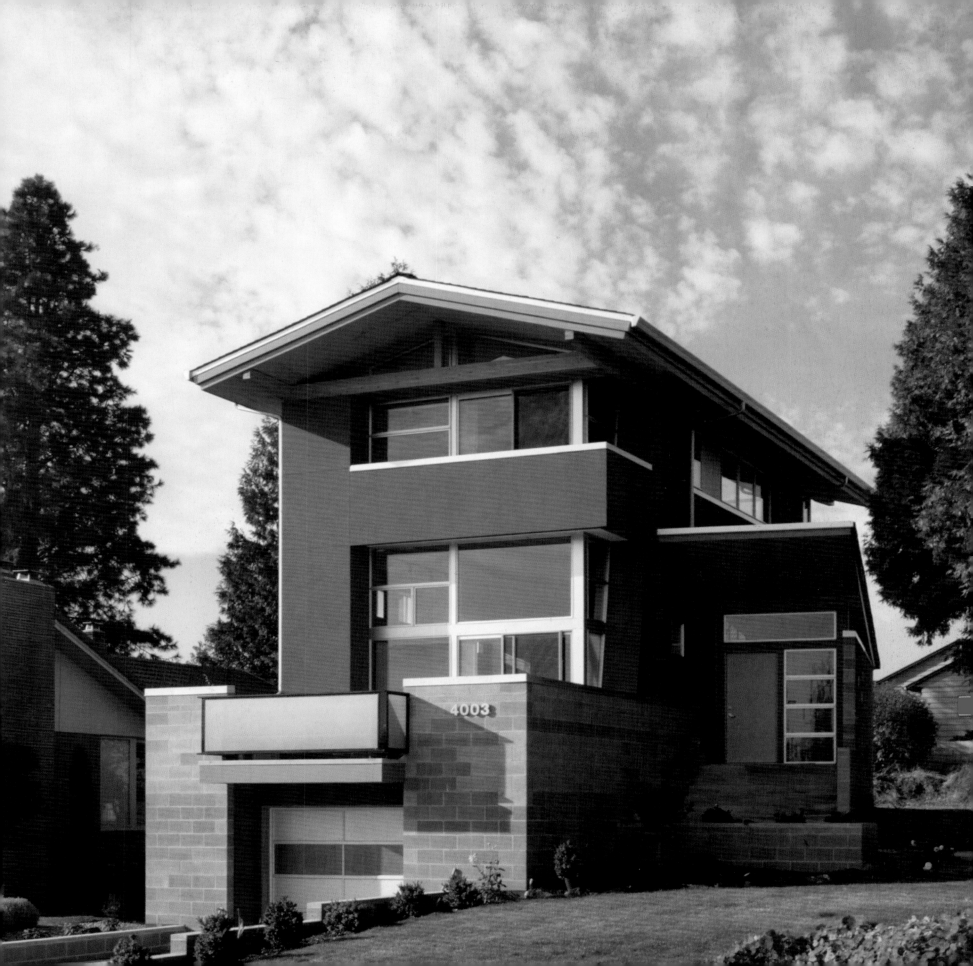

Upper Floor Plan

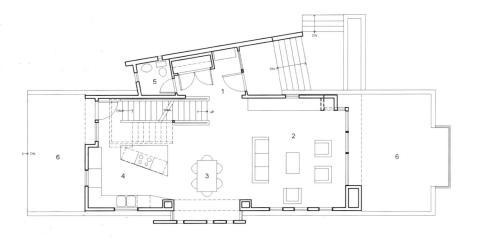

Main Floor Plan

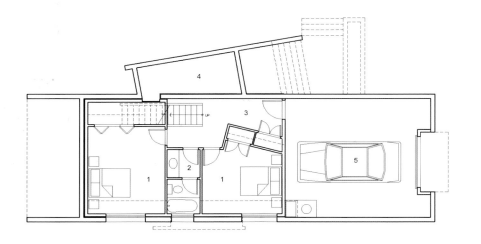

Lower Floor Plan

UPPER FLOOR PLAN

1 BEDROOM
2 BATH
3 CLOSET
4 HALL

MAIN FLOOR PLAN

1 ENTRY
2 LIVING ROOM
3 DINING ROOM
4 KITCHEN
5 BATH
6 DECK

LOWER FLOOR PLAN

1 BEDROOM
2 BATH
3 HALL
4 STORAGE
5 GARAGE

East Elevation

North Elevation

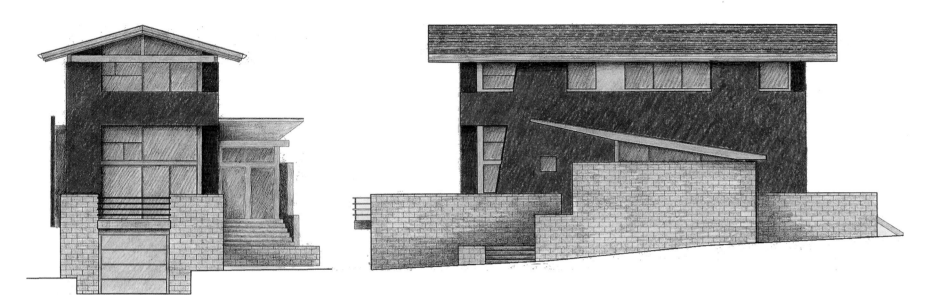

West Elevation

South Elevation

223

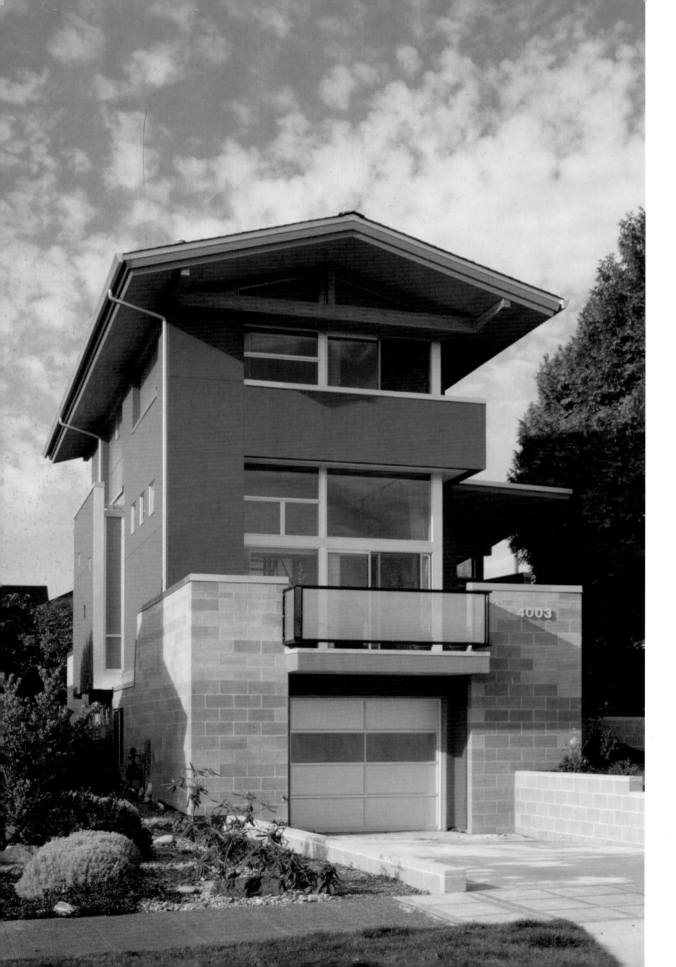

Left: The second and third stories are set back, to minimize the height of the building from the street.
Right: The second level entry is angled away from the house, inviting visitors to enter.

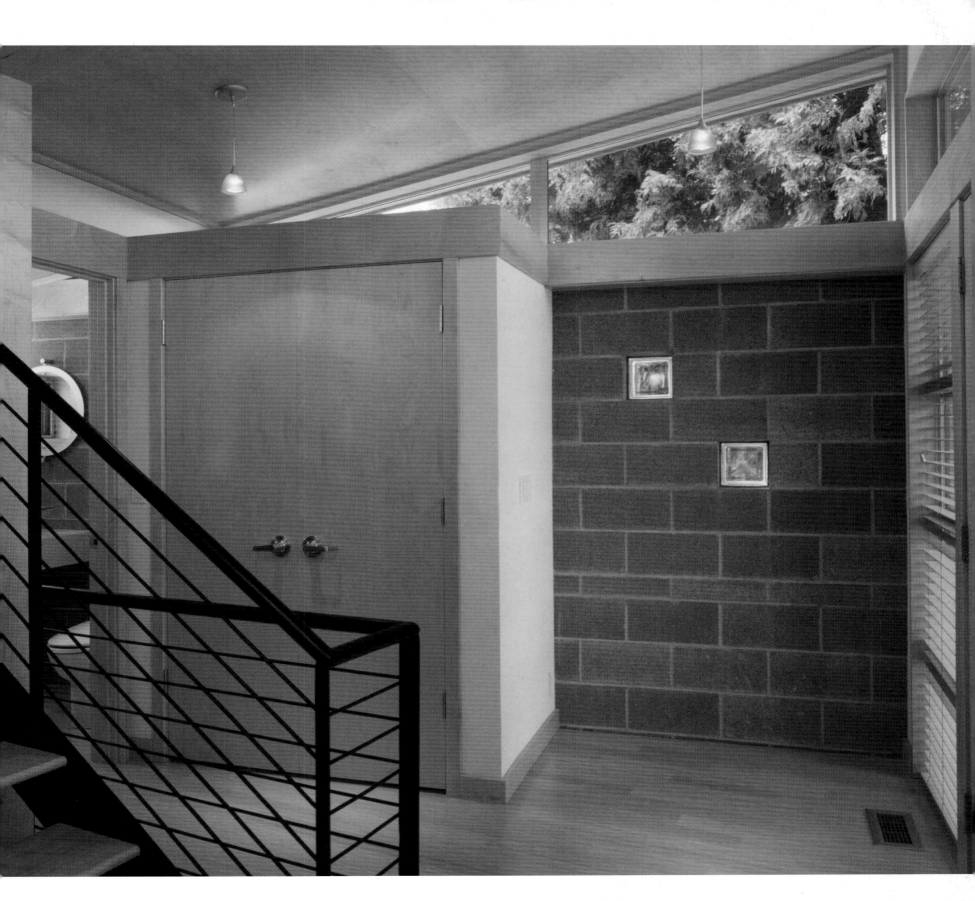

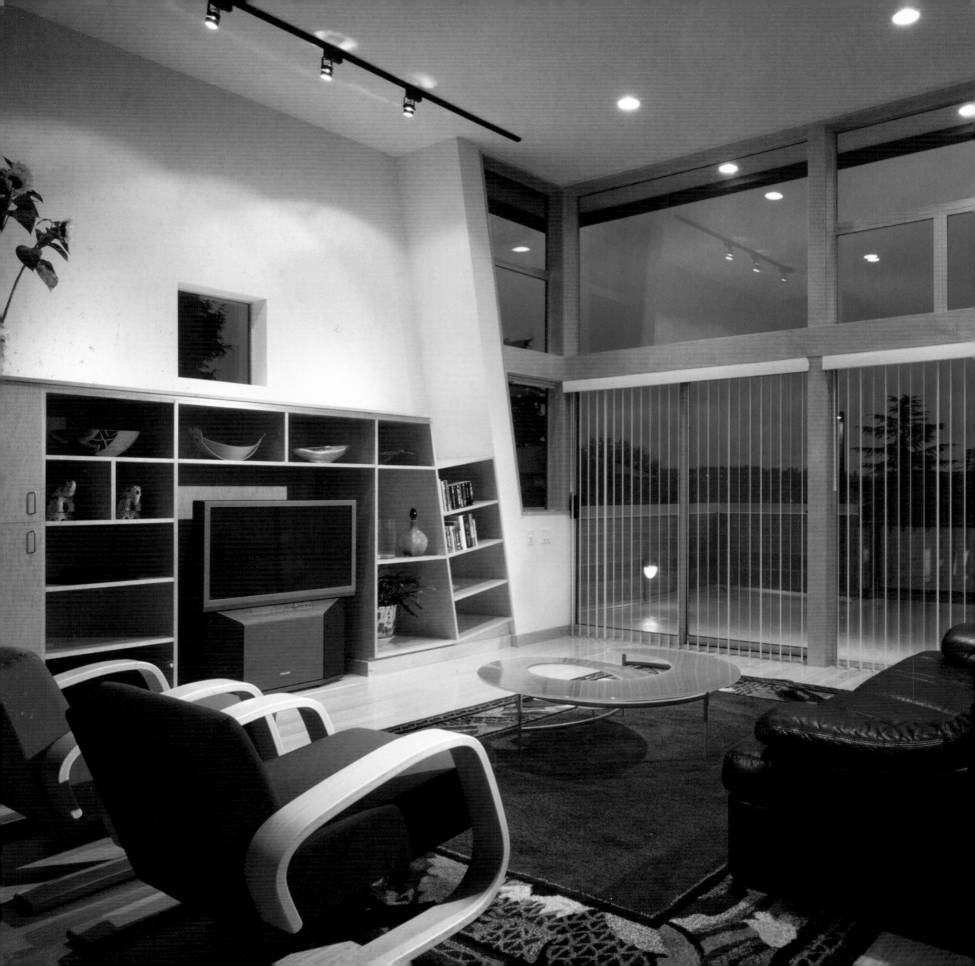

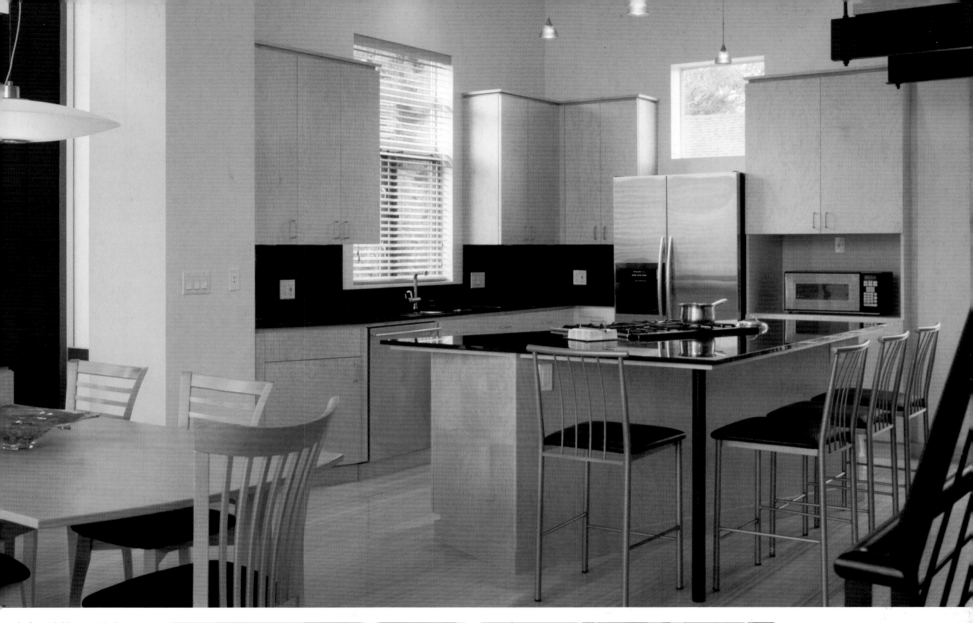

Left and Above: 12-foot ceilings in the living, dining, and kitchen areas give the main level a loft-like appearance.

Right and Far Right: A pop out with continuous side glazing on the southern edge of the house at the dining area was created to provide southern light without exposing the interior of the home to the adjacent neighbor.

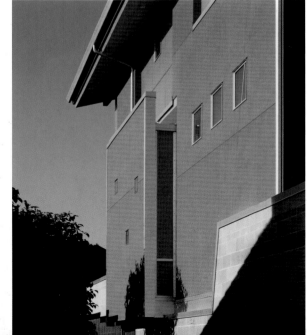

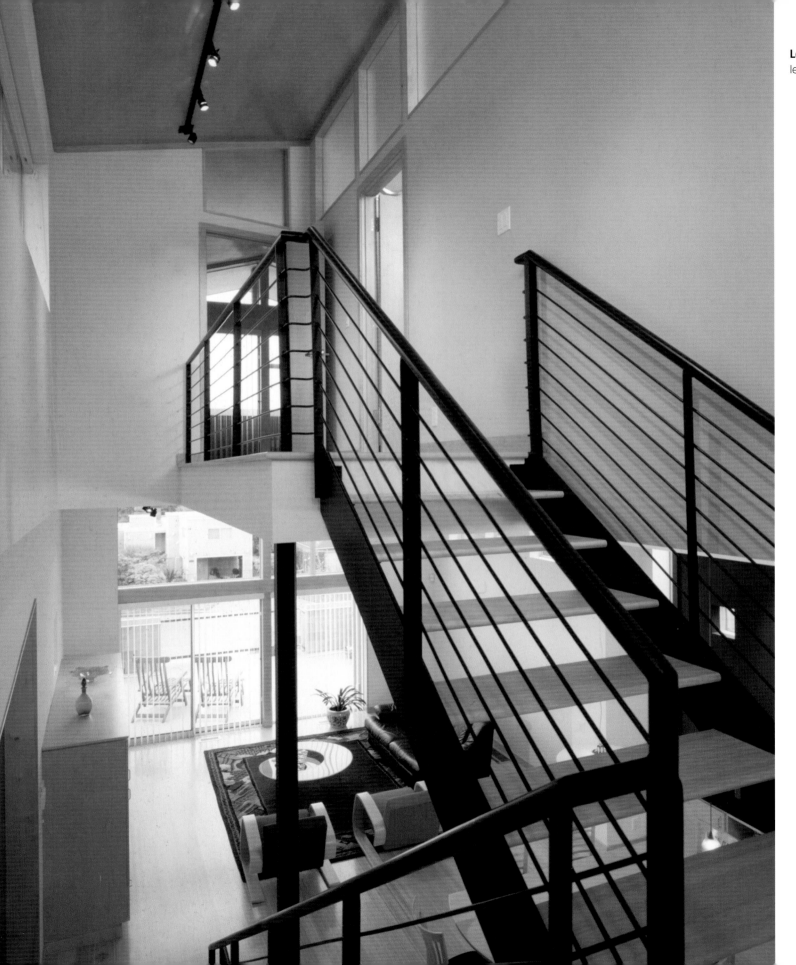

Right and Below Right:
The master bathroom and bedroom are tucked under the roof with cathedral ceilings.

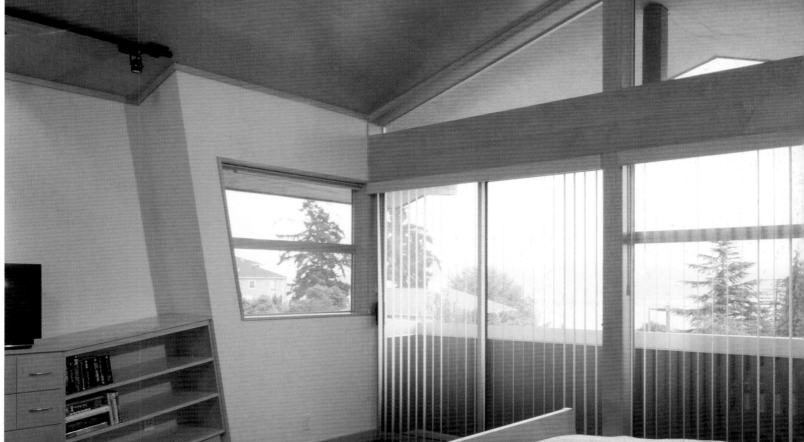

Fung/Blatt Residence

1970 Square Feet

Fung + Blatt Architects

Photography: David Hewitt and Anne Garrison, Deborah Bird, David Lauridsen, Alice Fung

LOCATED IN A HILLY AREA NEAR DOWNTOWN LOS ANGELES, THIS HOUSE, DESIGNED BY THE ARCHITECTS FOR THEMSELVES, WAS CONSTRUCTED ON THE NORTH-FACING SLOPE OF A SHALLOW CANYON. THE CONCEPT CALLED FOR HIGHLY FLEXIBLE AND EXPANDABLE SPACES TO ACCOMMODATE ANTICIPATED CHANGES FOR THIS YOUNG FAMILY OF FOUR.

LIGHT, SPATIAL COMMUNICATION, AND ACCESS TO THE OUTDOORS WERE PRIMARY CONSIDERATIONS AS WAS THE BUDGET. SQUARE FOOTAGE WAS KEPT TO A MINIMUM WITH OUTDOOR SPACES BECOMING EXTENSIONS OF INTERIOR SPACES. THE GARAGE AND ATTIC WERE DESIGNED WITH FUTURE EXPANSION AND FLEXIBLE USE IN MIND.

MATERIALS WERE USED IN THEIR NATURAL STATE WHEREVER POSSIBLE; THE USE OF PAINT AND OTHER FINISHES WAS KEPT TO A MINIMUM. MATERIAL WASTE WAS AVOIDED BY THE USE OF PRE-CUT STEEL FRAMING AND ROOFING COMPONENTS, AND BY ADHERING TO A 4-FOOT BUILDING MODULE.

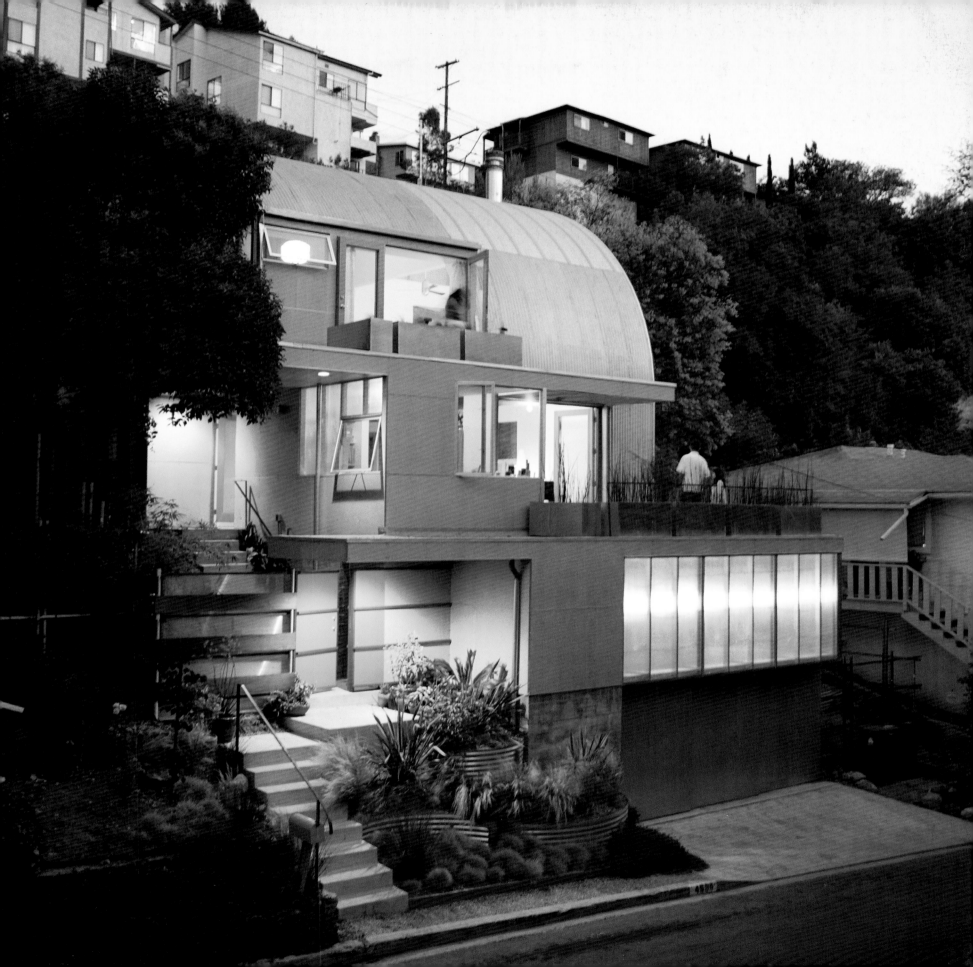

Second Floor Plan

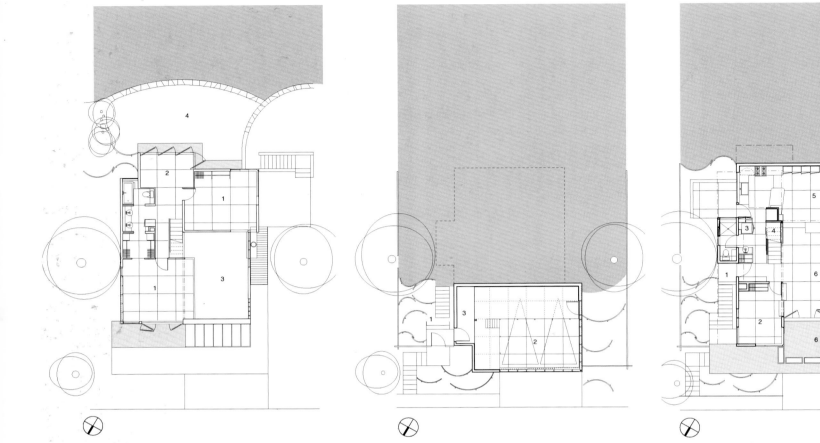

Second floor plan 1 bedroom 2 sunroom 3 open to below 4 garden

Garage/Mezzanine Floor Plan

Garage / Mezzanine plan 1 entry 2 garage 3 storage / hvac

First Floor Plan

floor plan 1 entry 2 study 3 laundry 4 storage 5 dining / patio 6 living / terrace

Site Plan

Section Through Canyon

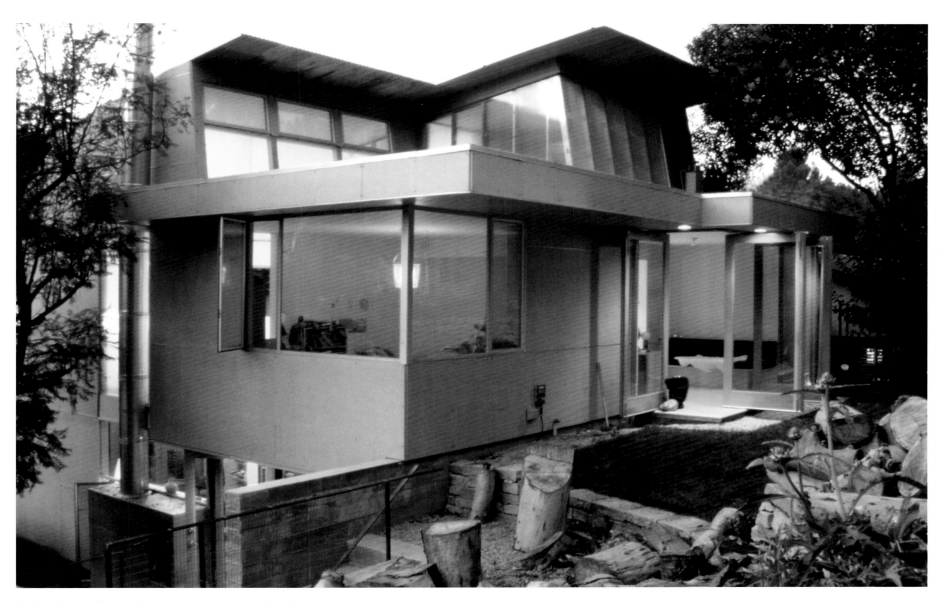

Previous Pages: Recycled materials used include the fiber cement siding, steel framing, and broken concrete site walls.

Above: The south-facing clerestory of the 24-foot-high living room is designed to provide passive solar heating in the winter while providing convection-based ventilation in the summer. Additional passive heating is provided by the sun-room at the upper level.

Section

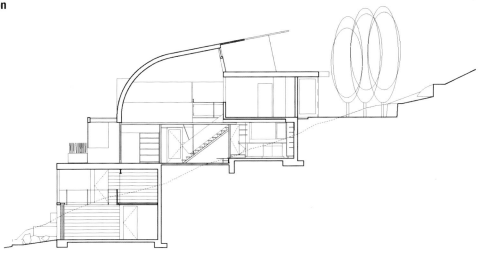

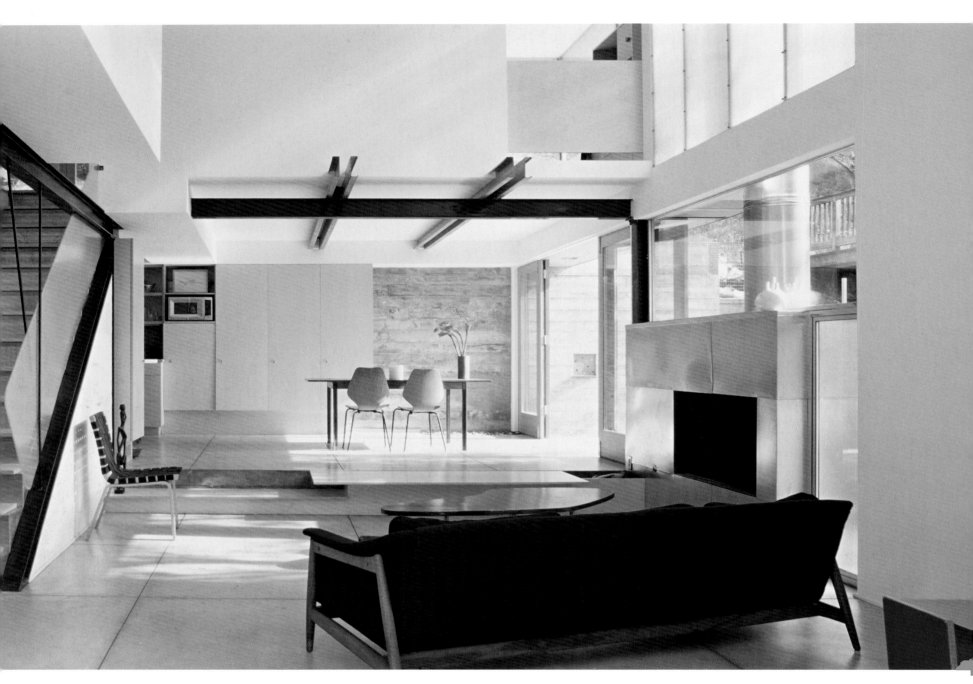

Above: A view of the living
area with the dining area
and kitchen beyond

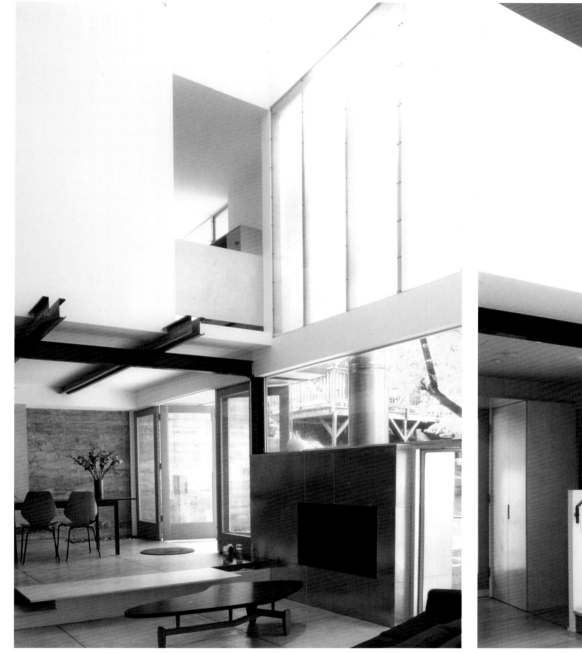

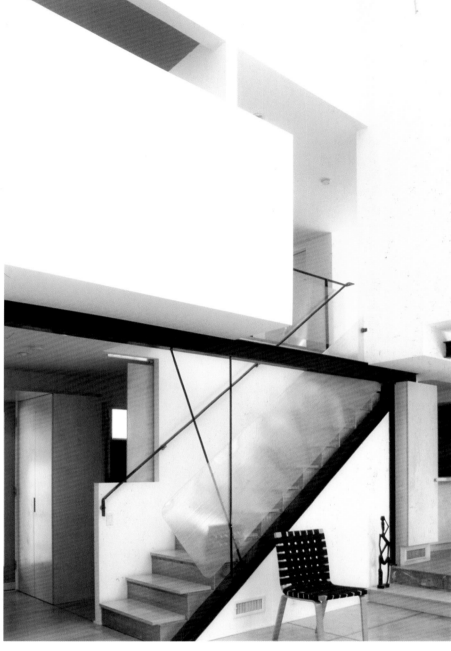

Above: The living space soars to culminate in north-facing clerestories that provide even light and passive cooling throughout the day.

Above: A central open stair bisects the public spaces below into living and service functions, and aligns a private study to the private spaces above.

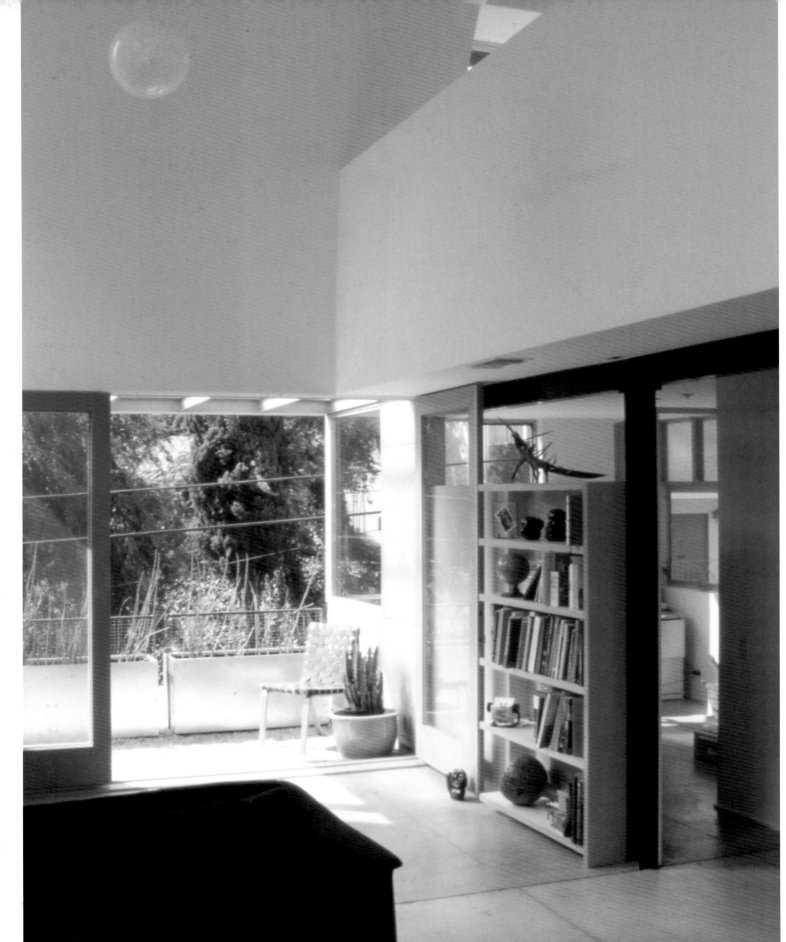

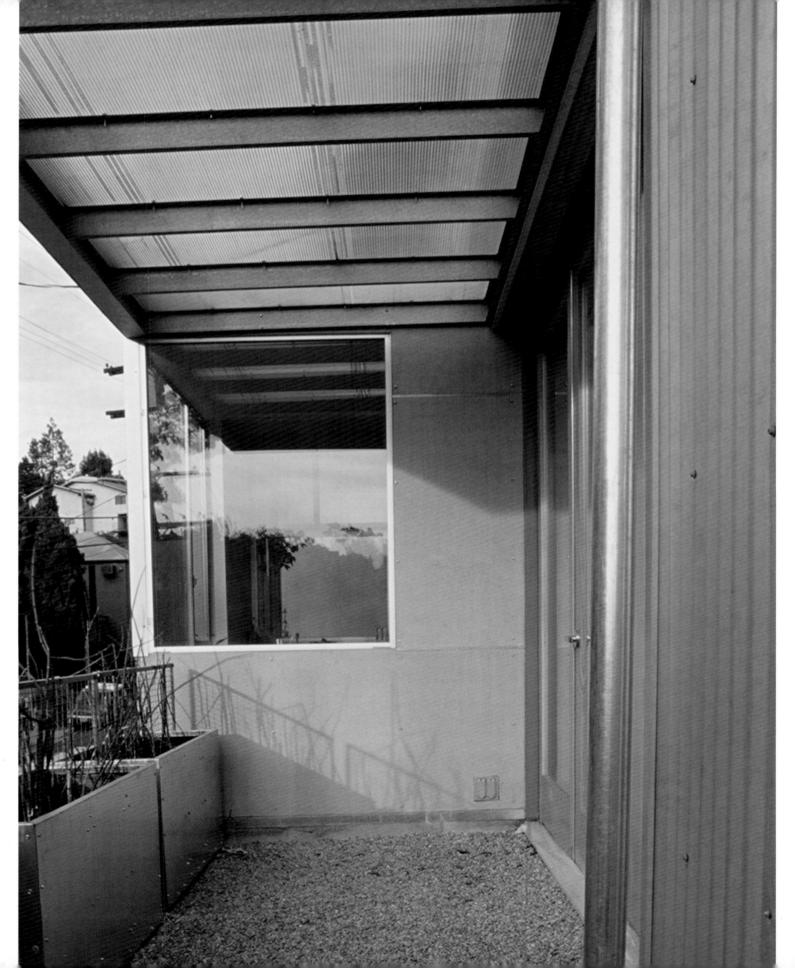

Above: A view of the living area with the dining area and kitchen beyond

Floating Meadows

2900 Square Feet

Feldman Architecture
Photography: Paul Dyle, Feldman Architecture

Located in a nature preserve in Carmel's Santa Lucia Mountains, this home's stunning site, with its oak forests and steep meadows, both constrained and inspired the design of this project. To reduce its impact, the architects designed a series of grass-roofed "pavilions" and sank them into the hillside below a large oak grove.

The house consists of a series of retaining walls, slab floors, and overhanging planted roofs. Divided into discrete buildings, the owners' suite and the guest bedrooms are positioned at opposite ends of the house for maximum privacy. Between them are the public spaces including the kitchen, living room, dining room loft, and outdoor terraces. The clerestory windows in the double-height living room provide a view of the oaks in the grove above and bring late afternoon sun onto the living room ceiling.

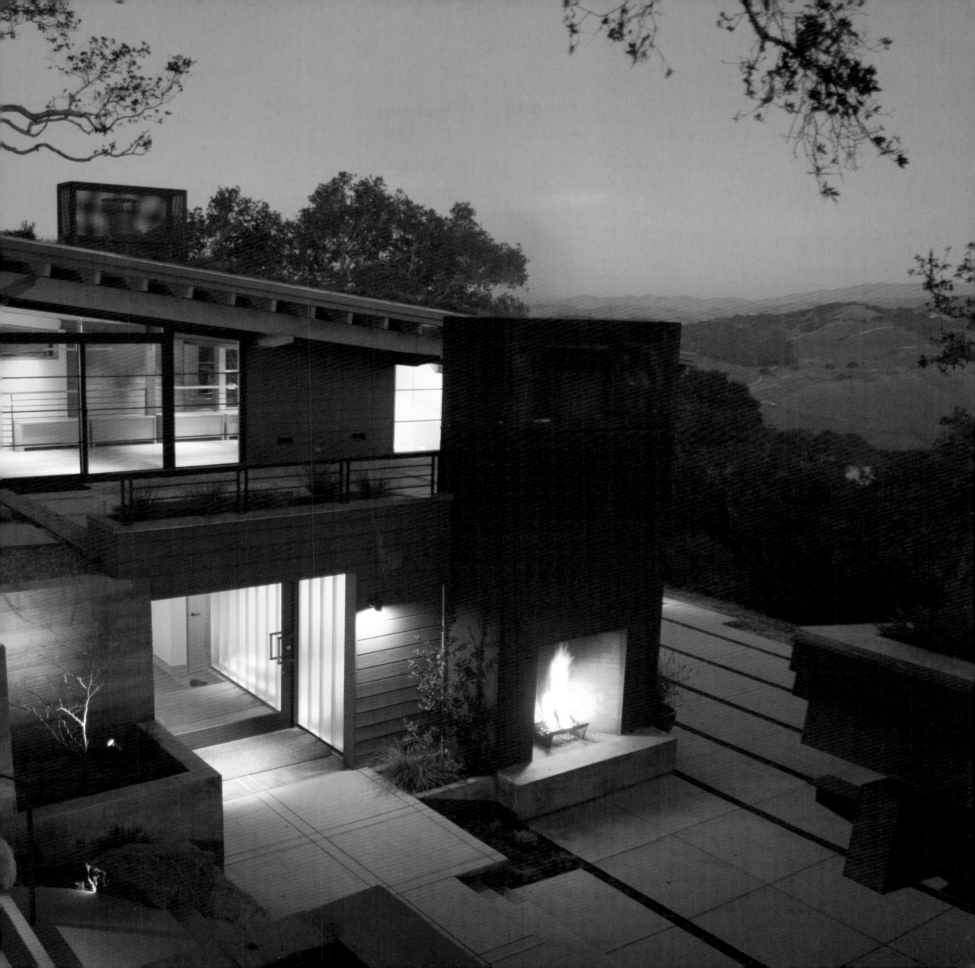

Floor Plan

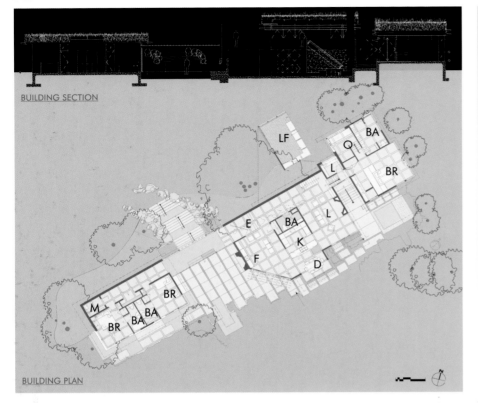

BUILDING SECTION

BUILDING PLAN

Elevations

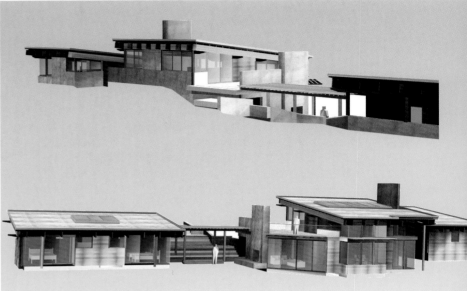

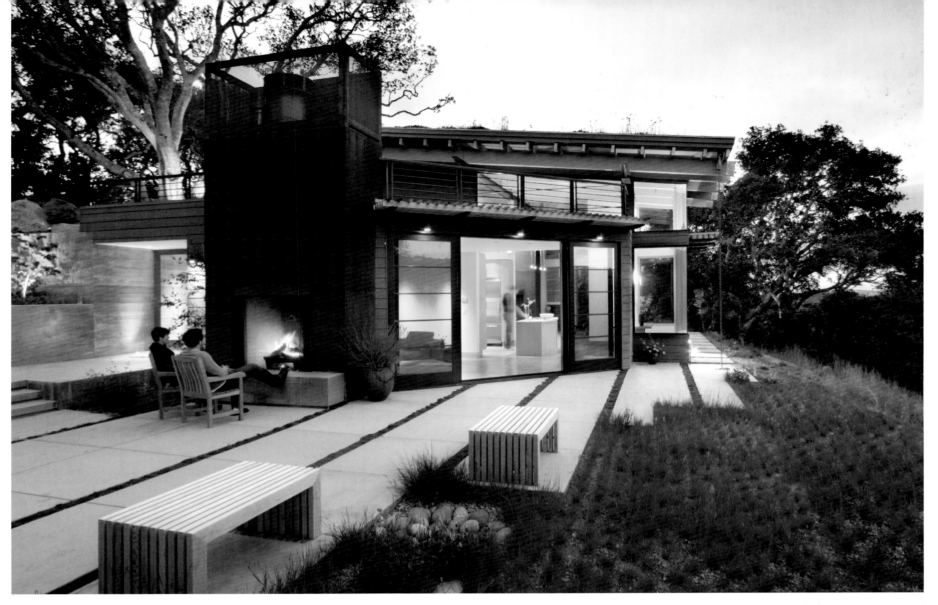

Previous Pages and Left:
The house is tucked into
the hillside beneath a grove
of oak trees.
Above: The terrace functions
as an outdoor room.
Right: The roof is planted
with native grasses
and wildflowers.

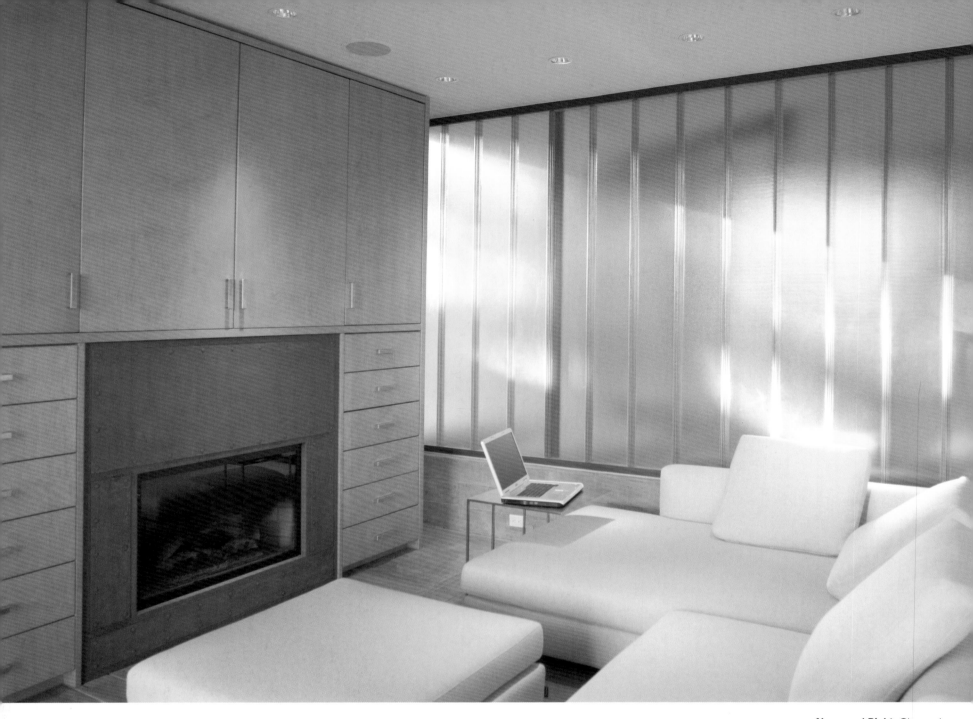

Above and Right: Channel glass separates the living room and the corridor.
Top Right: A large pivot door opens onto the terrace. Sand-blasted form boards created concrete retaining walls with a soft, silvery wood-like texture.

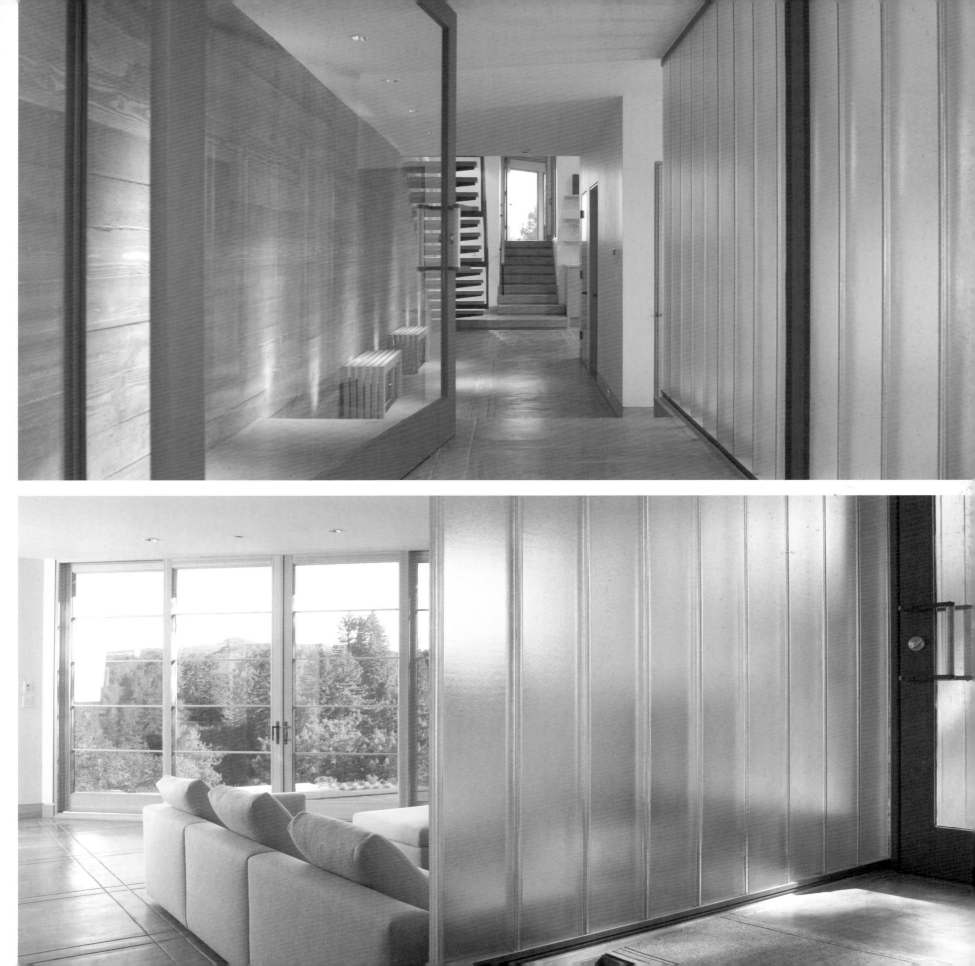

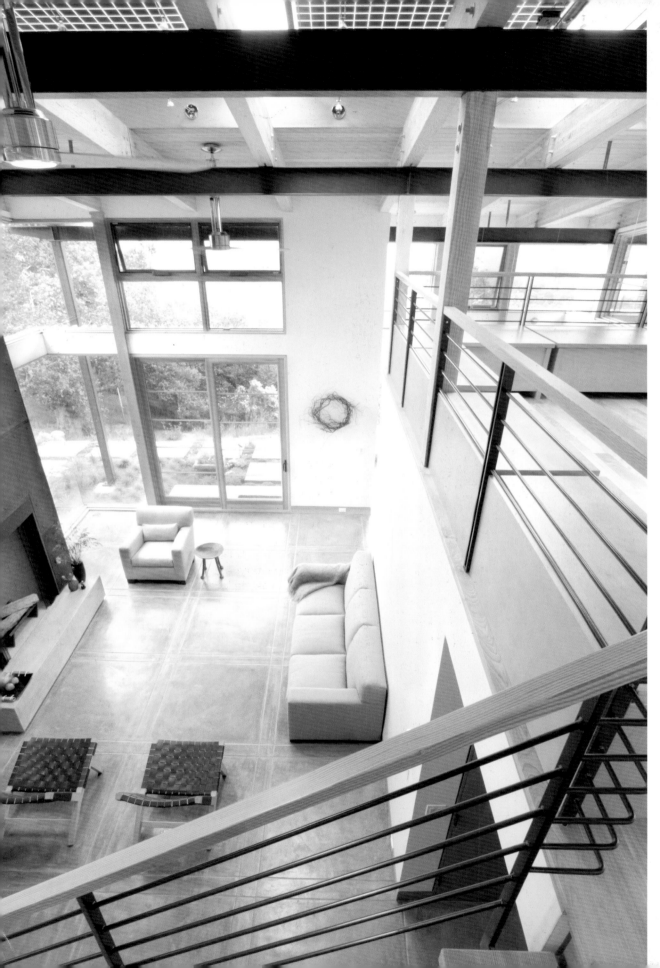

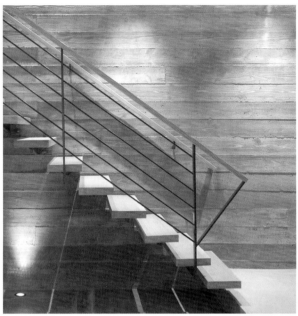

Above: Stair detail
Left: View of the living room

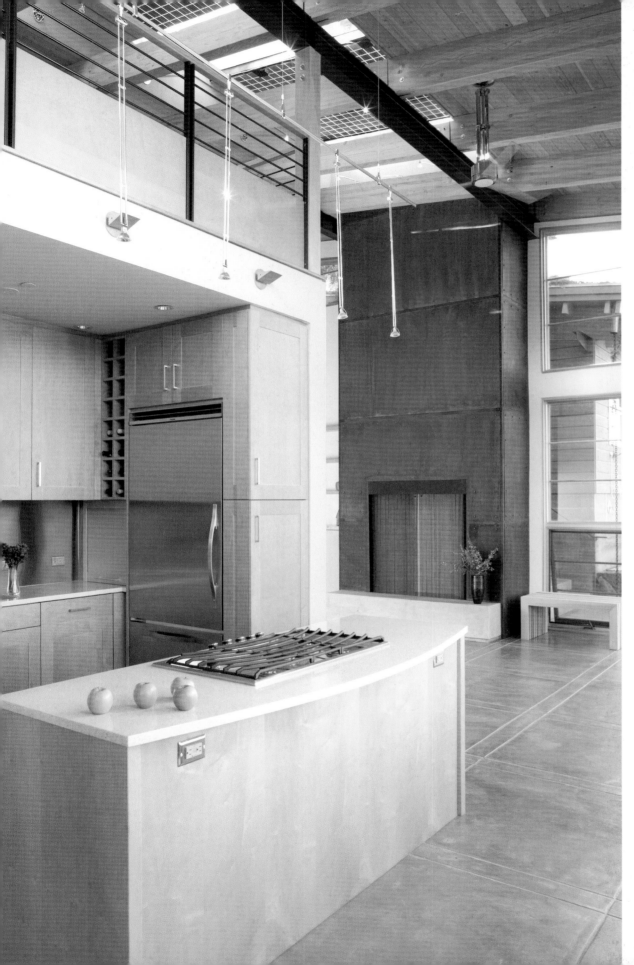

Above: A detail of the photovoltaic skylights that are a primary design element. They bring additional light into this hillside home.

Left: View of the kitchen and the living room with the photovoltaic skylights visible above.

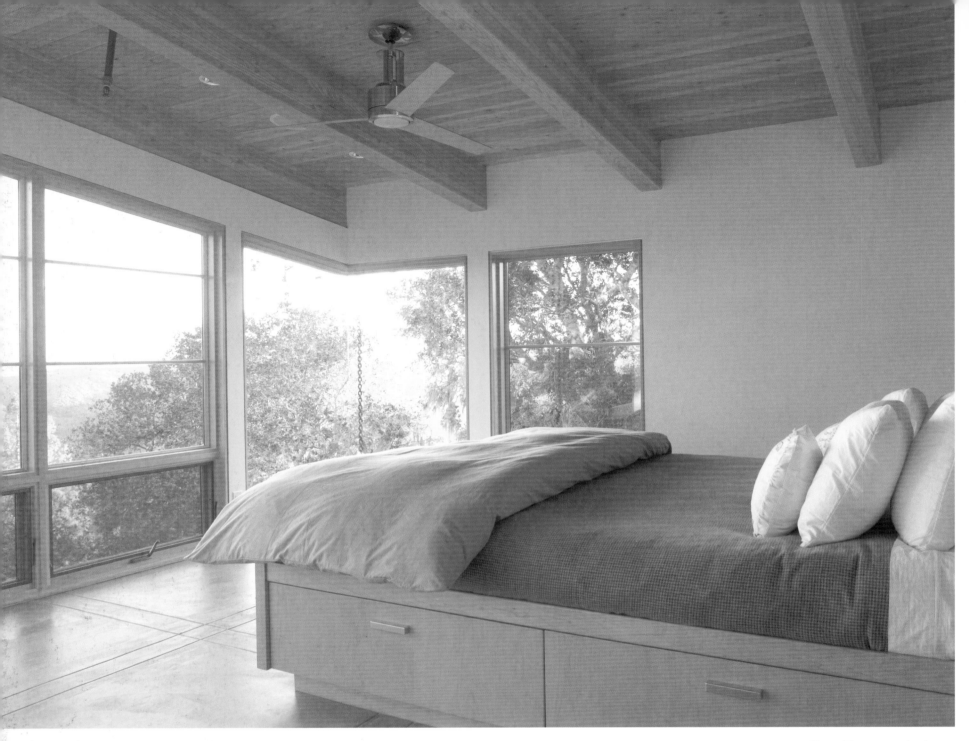

Above: The master bedroom
Right: The master bathroom

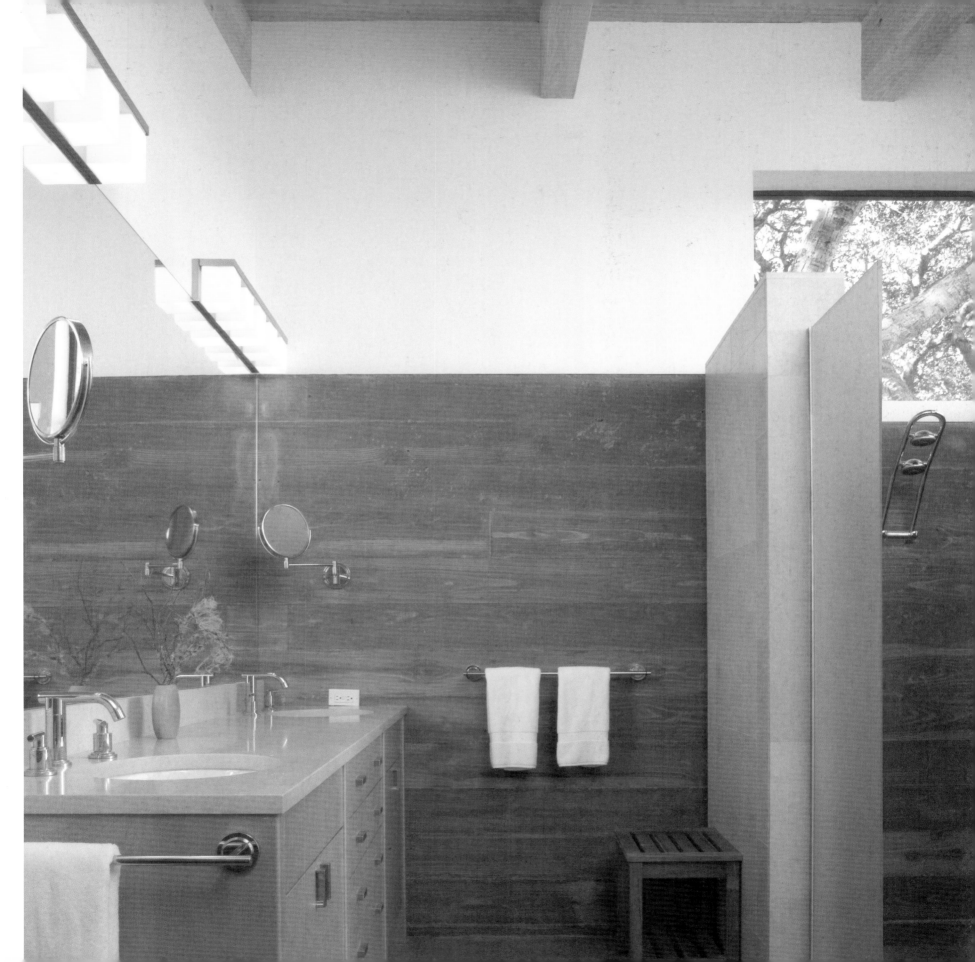

Boathouse

1600 Square Feet

Lee Ledbetter Architects
Photography: Richard Sexton

THIS LAKEFRONT BOATHOUSE WAS GUTTED AND RE-DESIGNED AS A LOFT TO TAKE ADVANTAGE OF VIEWS. FACING LAKE PONTCHARTRAIN IN LOUISIANA AND BACKING UP TO A LARGE MARINA, THE BOATHOUSE IS ONE IN A ROW OF DOZENS ON A NARROW SLIP OF LAND. THE BATHROOM WAS DESIGNED AS A GLASS BOX AND FLOATS IN THE CENTER OF THE SPACE. IT SEPARATES THE PUBLIC LIVING AREA AND KITCHEN FROM THE MASTER BEDROOM.

THE EXISTING SHEETROCK CEILING WAS REMOVED TO EXPOSE STEEL BEAMS, TENSION RODS, AND A CORRUGATED ROOF. TWO ROWS OF SKYLIGHTS WERE ADDED THROUGH THE SPACE, EMPHASIZING ITS LENGTH WHILE WASHING THE WHITE SURFACES WITH NATURAL LIGHT. THE EXTERIOR OF THE BOATHOUSE IS FINISHED IN WHITE STUCCO AND ALUMINUM CHANNELS.

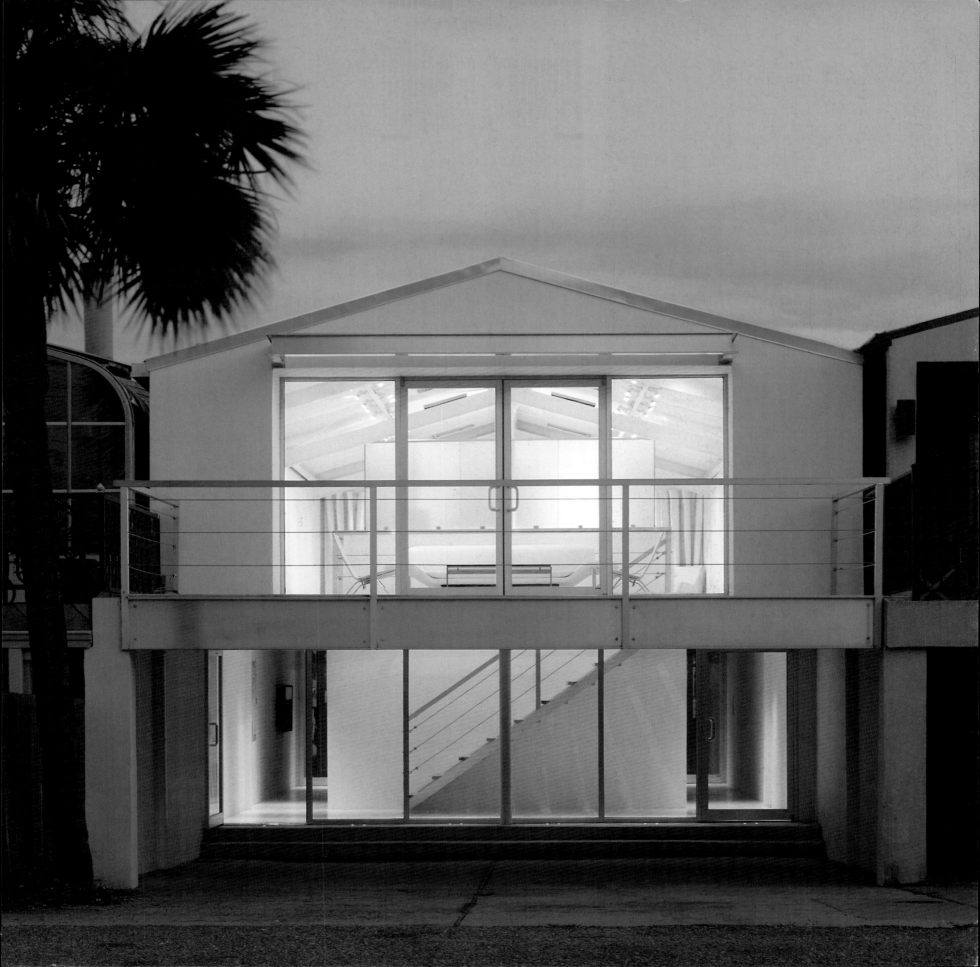

Upper Level Plan

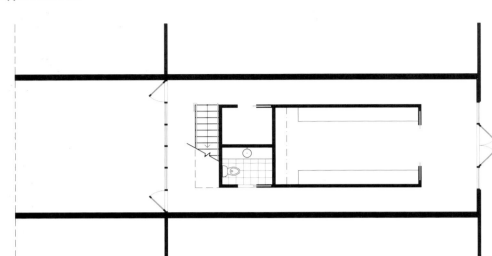

Lower Level Plan

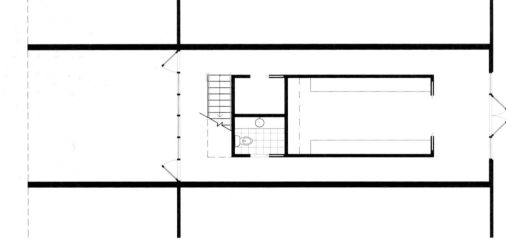

Section

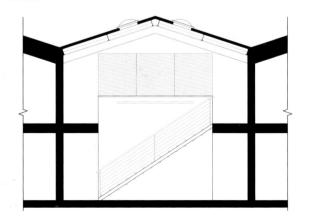

Previous Pages: The main living area is on the second floor. Entry is from the first floor, which contains a powder room and storage.
Right: The all-white living space overlooks the lake.

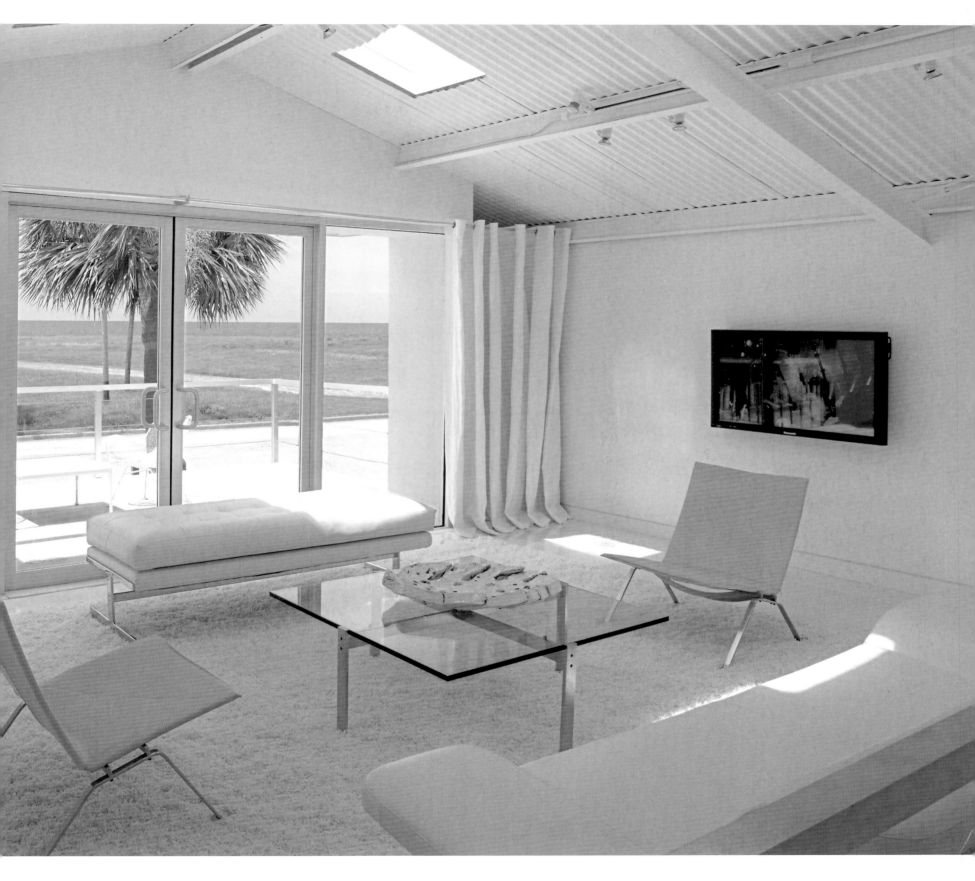

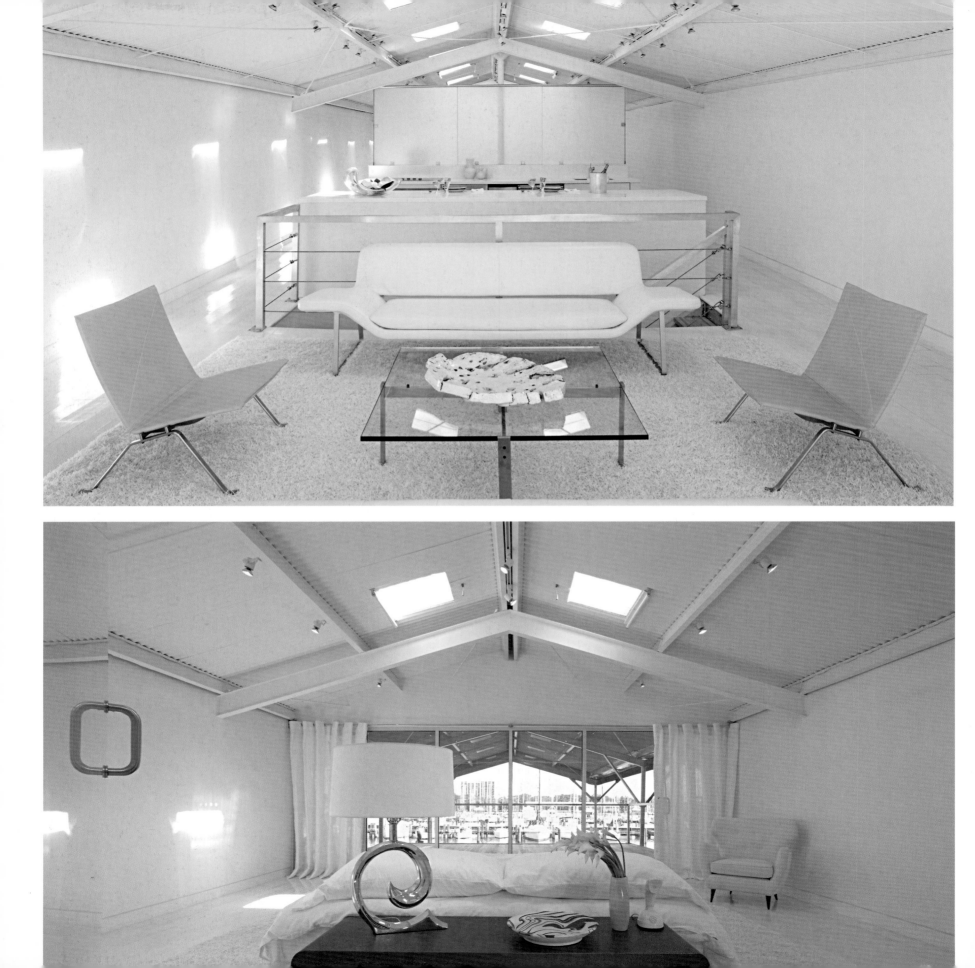

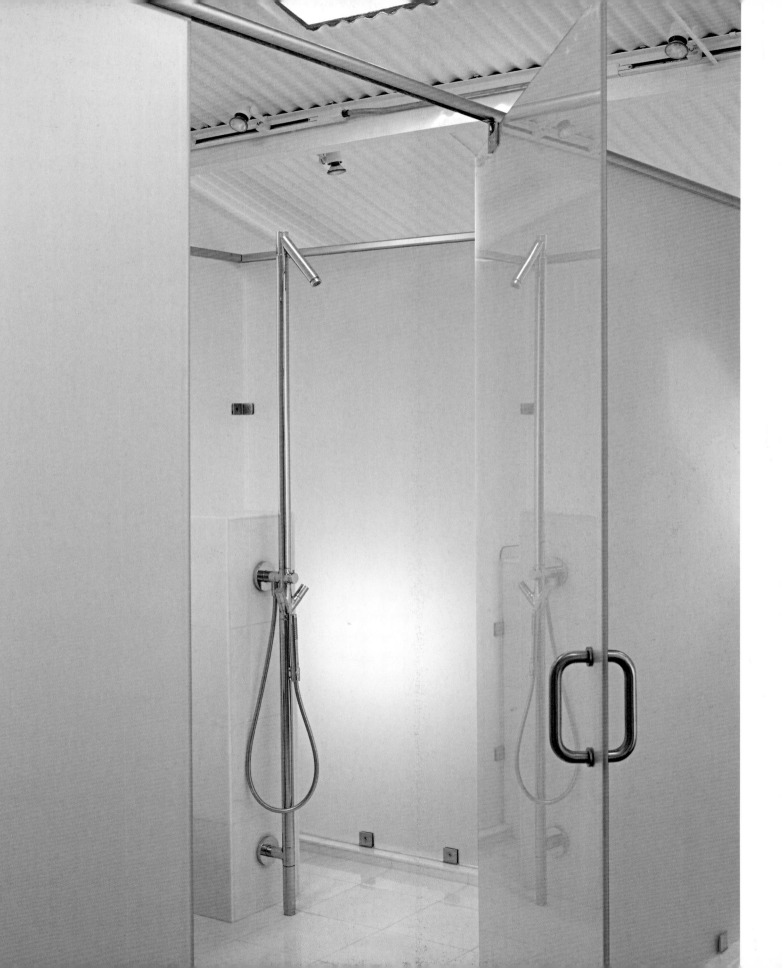

Left: The bathroom is a glass box and it separates the living and kitchen areas from the bedroom.
Below Left: The bedroom as viewed from the bathroom.
Right: The glass box contains all of the common bathroom fixtures.